T0256154

Imagistic Care

Thinking from Elsewhere

IMAGISTIC CARE

Growing Old in a Precarious World

CHERYL MATTINGLY AND
LONE GRØN, EDITORS

Drawings by Maria Speyer

Foreword by Lisa Stevenson

Afterword by Robert Desjarlais

FORDHAM UNIVERSITY PRESS
New York 2022

Library of Congress Cataloging-in-Publication Data available online at https://catalog.loc.gov.

Printed in the United States of America

24 23 22 5 4 3 2 1

First edition

CONTENTS

FOREWORD

LISA STEVENSON

It's strange, I know, to begin a foreword to an extraordinary book about care at the *end* of life with some reflections on *beginnings*. But still, it's the question that preoccupies me as I read the chapters and look at the images in this book: What can we say about what it is to begin, and to begin again? And what might the answer to that question have to do with the end and with endings more generally? In a touching essay about the painting of Paul Cézanne, Maurice Merleau-Ponty suggests that Cézanne's paintings were his attempt "to depict matter as it takes on form, the birth of order through spontaneous organization" (1964, 13). We have only to think of Cézanne's paintings of the trees that seem to be in the process of disentangling themselves from the blue streaks of sky around them to see what Merleau-Ponty means. What he particularly admired in Cézanne's work was his ability to make visible, or slow down, through his painterly form of attention, the coming-into-focus of the world. This, I will argue, is what the chapters and drawings in this volume also do.

This question of beginnings also preoccupied Walter Benjamin. In an essay on the history of photography he suggests that while it is possible, "however roughly, to describe the way somebody walks, . . . it is impossible to say anything about that fraction of a second when a person *starts to walk*" (Benjamin 1972, 7). For Benjamin, the moment of beginning to walk is an example of a perceptual experience that resides in our "optical unconscious" (7), one that only photography—(and previously psychoanalysis) might bring to our attention. I wonder what might have happened had Cézanne

tried his painterly hand at portraying the instant someone begins to walk, or better—begins to speak.

Merleau-Ponty, in the essay on Cézanne, is also interested in this kind of beginning—what we might call the beginning of expression. Not only does Cézanne's art attempt to portray the "beginnings" of vision—or what I am calling a "coming-to-see"—but the very act of putting brush to canvas (to make visible that process of coming-to-see) is also its own beginning. As Merleau-Ponty puts it, "Cézanne's difficulties are those of the first word. He considered himself powerless because he was not omnipotent, because he was not God and wanted nevertheless to portray the world . . . to make *visible* how the world *touches* us" (1964, 19). Merleau-Ponty thus locates the story of Genesis (of the first word) in each of our lives and asks, What is it to begin to speak? Or to begin to paint? Or even—to begin to howl? And importantly for this volume, *What is it to begin at the end?*

In a theater workshop for Colombian migrants to Ecuador, one of the participants was a woman who was living in a kind of prolonged despair about the loss of her family, the health of her child, and the seeming impossibility of a return to the everyday. At one point, my friend—anthropologist and theater director Cristiana Giordano—asked each person in the group to interact in some way with the theatrical affordances of the room, beginning with the simple statement "I begin" and ending with "I end."[1] People stood inside doorframes, slid along the floor, rapped on the glass windows. When it was her turn, this woman was stymied, seemingly unable to begin. Then she said the required words, "I begin," walked over to the wall, and slowly moved her finger along the smooth crevice between the painted bricks. When she had finished, she began to weep, and a friend caught her jubilantly in her arms. She had begun. Tracing the line between the bricks was a first word.

It seems to me that in his essay on Cézanne, Merleau-Ponty is interested in that moment when tracing one's finger along the wall is also a first word. It's the point where perceiving the world and the possibility of expression meet—the point where to see or perceive is also to express. So, when Cézanne says of his process of painting, "The landscape thinks itself in me and I am its consciousness," Merleau-Ponty adds, "[Art] is a process of expressing" (1964, 17). Seeing (becoming conscious) is a process of expressing, and expression a process of seeing. Merleau-Ponty continues, "There is nothing but a vague fever before the act of artistic expression, and only the work

itself, completed and understood, is proof that there was *something* rather than *nothing* to be said" (19).

Merleau-Ponty acknowledges that in this attention to beginnings—this attention to what it is to come-to-see, this attention to the first word—so much is at stake, and that Cézanne often wondered if he were equal to the task. There is a sense that for Merleau-Ponty, Cézanne is working at the beginning of the world—perhaps one could say at the beginning-end of the world, at the point where life shades into death. In what is, for me, one of the most important lines of the essay, he writes, "If one looks at the work of other painters after seeing Cézanne's paintings, one feels somehow relaxed, just as conversations resumed after a period of mourning mask the absolute change and give back to the survivors their solidity" (Merleau-Ponty 1964, 16).

In the space remaining, I want to draw an analogy between the authors in this volume and Cézanne as a painter. In their mode of paying attention to the lives of the elderly with whom they have sat, talked, and *straggled*, these writers, through their acute and sometimes gutting descriptions, invite us, as their readers, to remain a while longer with the "absolute change," and the lack of solidity, that death—or dying, or living on the cusp of death—entails. This space of change (absolute or not) that is old age, where determinate forms seem to dissolve, is also the space of much, very revealing, expressivity.[2]

This is not to say that the "resumed conversations" of "other painters" aren't important, and even the most subtle form of kindness. There is relief in the resumption of conversation. There is solace even, as the game of life, of polite conversation, of social roles, of familiar ways of being, start up again, and the skin of social life closes over the wound of death, masking its "absolute change." But to extend Merleau-Ponty's analogy—if other painters provide the relief of polite conversation, then Cézanne, and the authors in this volume, provide us, I suppose, with something more akin to the mourner's cry. Let me explain. The mourner, in witnessing (seeing) the absolute change that death brings, is simultaneously expressing it. But the mourner's lament, while expressing something, is not, I think, formulating anything. If you were to ask the person crying what they were crying *about*, would they not either rebuff the question or say something like, "Everything. And nothing."? Is it not difficult—and perhaps impossible—for the anthropologist to say exactly what a mourner's cry means, or to translate it into a

sentence, with a subject and a predicate, or a story with a beginning, middle, and end? In this sense, the cry is actually an expression of a kind of being-in-the-world, where perceiving and expressing the world cannot be separated. What might it mean for an artist or a scholar to remain with the mourner's cry—that is, to remain at the beginning, on that knife's edge between expression and silence, walking and standing still, living and dying?

The elderly people who come to life in *Imagistic Care* live on the precipice between voice and its impossibility, between expression and the muteness of the world, between bodily life and death. As Rasmus Dyring calls it so evocatively, they are participants in a "still life" (Dyring, this volume). And for this reason, this volume allows us to pay attention to the moments of beginning (again) to see, to speak, and to act.

What is so beautiful about so many of these chapters is that they record this coming-to-see in Merleau-Ponty's two senses: first, the coming to see (composing) of a specific elderly person; and second, the coming to see and to express (the first word) of the anthropologist. As we say in English, the reader of this volume is given the chance to watch as something "swims into focus." That is, it's as if we watch as something (a fish, a child, a whale?) moves through the murky seawater, at first revealing only a whorl of bubbles, or a moving panel of color, until suddenly it is so close that we sense what or who we are dealing with. As anthropologists, we usually congregate in that moment after the swimming happens; we remain with what has come into focus, helping others see what it affords. But here, in this volume, the anthropologists are staying with the perception, or image, of what we might call a beginning, a first word.

I am thinking here of Lone Grøn's description of Birgit tracing her finger around the hair band that has been carefully placed on her napkin (Grøn, this volume). Her friend, who seems to think a hair band does not belong at the table or on a napkin, asks her whether it should be in her hair. Birgit's finger moving around the napkin is expressive. There are no words, no syntax in her moving finger, and yet they trace an outline, an imaginary one, around the napkin as if to say . . . But as if to say what? It feels as if any translation would only be approximate. Would we use the subject "I"? Why? Is she expressing something, or is the world—the actuality of an elastic band on a napkin—expressing itself through her? An anthropologist, congregating in the world of solid bodies and formalized conversations, might say,

"She wished to communicate x, y, and z," and thus entirely avoid giving us the image of the finger tracing. Instead, Grøn is a painter in words of a coming-to-see.

I want to turn now to the question of images that threads itself through all these chapters and is what makes the book so conceptually innovative. It is my contention that much of anthropological theorizing relies on images or pictures of lived experience. But the imagistic nature of those "snapshots from the field" or "ethnographic vignettes" or "scenes"—or whatever they are called—remains undertheorized in our discipline. *Imagistic Care* is the first volume to dwell in the moment of the image's emergence. It changes the way we think about how images work in our writing, in our fieldwork, and in our lives.

Still, the question of *what* an image is, remains a tricky one, and most image theorists deflect the question, choosing to ask related questions instead, such as, What do images want (Mitchell 2004)? What can images do (Didi-Huberman 2008)? Do images have voice and can we hear them (Campt 2017)? Are images spirits (Taussig 2011; van de Port 2017)? (All important questions and ones I too have been preoccupied by.) But what if we were to say, tentatively, that for Cézanne, and for many of the authors in this volume, an image is what is produced at the juncture of perceiving and expressing? (And thus, not all pictures, or things we have previously called images, *are* images.) And so, the elderly men and women who people this book, because they are often (but not always) unable or unwilling to engage in the solidity of conversations after the fact, produce images, and often important ones. We could say that at the juncture of perceiving and expressing they produce images that change our understanding of how things are and happen in the world.

At the risk of providing "spoilers" for a book that should be read in its entirety, let me give a few salient examples of what I mean. Rasmus Dyring (this volume), for example, gives us an image of Keld, a man in a dementia ward in Denmark. Keld is slowly (very slowly) turning the pages of a magazine. He pauses to consider a drawing of a young couple in a romantic embrace.

Then, very slowly, but with great determination, he extends his index finger and begins to scratch the surface of the page with his fingernail. Resolutely, he scratches. Perhaps there is a stain of some sort. Perhaps

the words on the pages are mere stains. Perhaps he is scratching the words—scratching the word-stains.

Keld scratching away the words is an image. His scratching occurs at the intersection of perception and expression. The point for Dyring is not to decode the image so that it may hang limply on the wall of his essay, but to stay with the image. What happens when words (with all their semantic and propositional content) become, or are revealed as, word *stains*? When scratching is a beginning?

Here's another: Helle S. Wentzer (this volume) gives us the image of Ben who, in his seventies, begins to fall down the stairs. Once a physically strong man—a blacksmith before he became a social worker—Ben requires multiple hospitalizations for his falls. But then we learn that Ben was at the bottom of a set of stairs when his son climbed the stairs to find his own mother (Ben's ex-wife) dead at the top. She "drank herself to death," we are told. Falling downstairs (over and over again) becomes the inverted image of Ben's son falling upstairs, to the body Ben could not bear to find. Experience and expression coincide as Ben falls and falls down the stairs. Something similar is going on in Maria Louw's chapter (this volume). An elderly woman from Kyrgyzstan, Gulbara, tells Louw that, although she had two husbands, neither ever laid a hand on her. But now, when she is living alone, the walls have started to beat her. This image of a world that has become increasingly difficult to navigate weds experience to expression, in a way that defies precise formulation. Do the walls really beat her as she stumbles into their grasp?

Another unforgettable image surges up in Cheryl Mattingly's chapter (this volume). There we receive the image of an African American family "straggling" down the halls of a hospital. This straggling—the "pushing and dragging" required to get a family from one appointment to another when the elderly caregiver of a severely disabled grandson also requires a wheelchair and oxygen—is a kind of corporeal tableau, a formation of bodies that is expressive in and of itself. Straggling, as a bodily image, expresses their insistence that they not be forgotten, as well as the family's refusal to capitulate to the hegemonic ideas of what kinds of people are lovable and deserve care. *Here we are again, straggling down your hallowed halls.* In a related way, Harmandeep Kaur Gill (this volume) describes an elderly Tibetan woman in exile in India, whose daughter has moved to Canada,

despairing of ever being cared for as she deserves. In one poignant scene we find the elderly woman almost jumping up and down in her chair and yelling, "Go, go, go!" as she watches a reality TV show in which an Indian girl is attempting to escape from her kidnapper. Who, exactly, needs to escape?

And then, sometimes it is the anthropologist, as painter, who is mourning. And the ethnography that is a beginning. The expression of that mourning experience is the ethnography itself, as image. I think particularly of Lotte Meinert's image (this volume) from eastern Uganda of a man whose health is beginning to fail, surrounded by a house that is falling down and walls that are decomposing. In the villages of the Ik mountains, labyrinthian fences work like contour lines to separate self from other, and the disintegration of a fence is mirrored by the disintegration of a self. In the baldness of her image, Meinert expresses everything: "There used to be mud between the poles of the walls. Now mainly only the poles remain. Like the bones in a body with little flesh left." Susan Reynolds Whyte (this volume) does something similar when she describes, again in eastern Uganda, the difficult death of Musa. She describes the night after his death when his body lay in his sister's collapsing house. Grass had been thrown on the roof to cover some of the worst holes. In the sparest of prose, Whyte comments that, "luckily, it did not rain."

I want to end by drawing attention to the remarkable images by Maria Speyer that punctuate the pages of this book. Black birds' nests of charcoal life, Speyer's images seem to suggest the human form without making it determinate. In one image, multiple faces emerge in the nodes of black lines; in another, adult fetuses sleep in a darkened womb; in yet another, arms-cradle-heads-cradle-arms. Like Cézanne, Speyer eschews classical rules of perspective or of outline and instead records the process of coming-to-see. As Merleau-Ponty says of Cézanne, "To trace just a single outline sacrifices depth—that is, the dimension in which the thing is presented not as spread out before us but as an inexhaustible reality full of reserves" (Merleau-Ponty 1964, 15). For Speyer, too, the image is not a copy, however imperfect or lacking, of some already determinate referent out there in the world. The image instead records what befalls the artist (her experience) in the act of encountering an Other. Thus, Speyer (this volume) says of the black charcoal lines she lays down, "I leave them behind as a sort of trace of a reaching."

Speyer's word and charcoal images, like the chapters they accompany, are not the record of an unfeeling machine, taking one's vital signs, or of a

preformed idea, applied to a life, but rather the record of a reaching toward, a coming together, a becoming "we," of the artist and someone in the last stages of life. Speyer holds open the possibility that we may all be "still becoming" and, I would add, *still beginning*, as in *still-life* even as we reach finality. And this explains, perhaps, why I want more, even as the book comes to an end. I want to begin again.

NOTES

1. See Giordano and Pierotti (2020) for an elaboration of this technique and the possibilities of collaboration between theater and anthropology.

2. One commentator on Merleau-Ponty's essay put it well: "The crisis of expression is essentially a crisis of finitude; the attempt to confront expression at its birth disintegrates everyday platitudes as does an encounter with death" (Toadvine 1997, 549).

REFERENCES

Benjamin, Walter. 1972. "A Short History of Photography." *Screen* 13 (1): 5–26.

Campt, Tina M. 2017. *Listening to Images*. Durham, NC: Duke University Press.

Didi-Huberman, Georges. 2008. *Images in Spite of All: Four Photographs from Auschwitz*. Translated by Shane B. Lillis, 3–29. Chicago: University of Chicago Press.

Giordano, Cristiana, and Greg Pierotti. 2020. "Getting Caught: A Collaboration On- and Offstage between Theatre and Anthropology." *TDR/The Drama Review* 64 (1): 88–106.

Merleau-Ponty, Maurice. 1964. "Cézanne's Doubt." In *Sense and Non-Sense*. Translated by Hubert L. Dreyfus and Patricia Allen Dreyfus, 9–25. Evanston, IL: Northwestern University Press.

Mitchell, W. J. T. 2004. *What Do Pictures Want? The Lives and Loves of Images*. Chicago: University of Chicago Press.

Taussig, Michael. 2011. *I Swear I Saw This: Drawings in Fieldwork Notebooks, Namely My Own*. Chicago: University of Chicago Press.

Toadvine, Theodore A., Jr. 1997. "The Art of Doubting: Merleau-Ponty and Cézanne." *Philosophy Today* 41 (4): 545–53.

van de Port, Mattijs. 2017. "The Possibility of Spirits: An Essay Film." *Journal of Anthropological Films* 1 (1), [e1316]. https://doi.org/10.15845/jaf.v1i1.1316.

Imagistic Care

INTRODUCTION

Imagistic Inquiries: Old Age,
Intimate Others, and Care

LONE GRØN AND CHERYL MATTINGLY

How can imagistic inquiries help us understand the complex entanglements of self and other, dependence and independence, frailty and charisma, good and bad aging and care, and norms and practices of care in old age?[1] And how can imagistic inquiries offer grounds for critique? These are some of the questions that run through the chapters in this book, which explore *the body as a speaking image, imagistic gestures, imagistic steps, imaginations of self and other, imagistic fences, resonance images, unchanging images,* and *haunting images and drawings underneath* among elderly who age in challenging and uncertain circumstances in Denmark, Kyrgyzstan, Uganda, and the US and among exiled Tibetans in Dharamsala, India. Such questions arose out of conversations and collaborations that took place over several years among a group of anthropologists, philosophers, and artists. At the outset, none of us were certain of our destination. In our dialogical travels, we could not have predicted that a collected volume would be one result. A later section of the introduction details more of what was at stake in this genre-bending journey.

But first, before even addressing the opening questions, it is necessary to offer a preliminary sketch of what we mean by the imagistic. What form of inquiry might this be?

Our consideration relies heavily upon anthropological voices and scholarly traditions as they have been put into conversation with phenomenological philosophy and art. It resonates with recent calls for an "anthropology of possibility" inspired by aesthetic modes of engaging with experience and lifeworlds (Pandian 2019), for attention to phantasmal dimensions of life that extend beyond the "apparently real" (Desjarlais 2019), and for an exploration of the similarity between anthropology and art as modes of engagement with the world (Ingold 2019). What is imagistic about an image?, Stevenson (2014) has asked. She suggests, following Foucault (1993, 36), that an image "expresses without formulating" (2014, 12; 2019) and that images "drag the world along with them" (2014, 11). The imagistic leads us to "dimension[s] of experience that resist articulation" (Crapanzano 2004, 18) or even seem to recede or disappear with articulation, and therefore tend to be ignored, as William James (1992) noted more than a century ago. Or, put differently, this collection engages a kind of poetic "negative capability" in the sense invoked by John Keats, the "capability of being in uncertainties," of exploring mysteries "without any irritable reaching" for decisive facts and summations (Keats 1958, 193, cited in Jackson 1998, 14).

Three overarching claims are offered under the banner of the imagistic: (1) Images are more than just representations; (2) The imagistic speaks to domains of everyday lived experience that are often neglected, undertheorized, or even excised by scholars; (3) The imagistic offers a mode of critique that troubles generalizing and taken-for-granted concepts through presentations of obstinate perplexities and vivid singularities. We sketch the first two propositions in broad strokes. The third one operates as a metaclaim about the critical potential of the imagistic and its capacity to disturb fixed images and stereotypes. It is elaborated in sections that trouble common-sense notions of the good old age, of intimate others, and of care. We conclude by reviewing the variety of ways the chapters adopt an imagistic approach as a mode of critique.

Taken together, these claims are suggestive rather than exhaustive, but they are made with the aim of bringing greater clarity to a topic that is necessarily elusive. The real stakes of these abstractly outlined points will become more visible in the later sections of the introduction when we discuss individual chapters.

Image beyond Representation

An image may be understood as something that is merely an "imitation," or semblance of reality, a "visible appearance" that reproduces a likeness of a person, object, or scene. Etymologically, this speaks to a key definition of the term. The word refers not only to physical manifestations but also to mental "counterparts" or representations—often of a visual object—preserved in memory or conjured through imagination (*Oxford English Dictionary*). These common understandings of an image are precisely those from which contemporary anthropologists of the imagistic have sought to distance themselves. Visual anthropologists have been particularly vocal. MacDougall (2005) notes, "As a product of human vision, image-making might be regarded by some as little more than secondhand or surrogate seeing" (3). The image as a "mirror . . . of social life and human subjective seeing" is a view that visual anthropologists have been at pains to refute (Suhr 2019, 25). They call for a different apprehension of what is being created and perceived in image-making and, indeed, in seeing itself. In the medium of film, Pandian (2015) remarks, the world is not dominated by factual truths ("real world") but by constant emergence, creativity, and possibility ("reel world"). An image can even, paradoxically, allow us to explore the invisible through what is visible. In other words, an image can "make present by a certain absence the invisible ground of the visible world" (Willerslev and Suhr 2013, 4). Some film scholars turn to phenomenology to investigate the nuances of perception (MacDougall 1998; Sobchack 1992; Suhr 2019). They note how films present people and objects with a complexity that "implicitly resists" even the very "theories and explanations . . . the film enlists" to explain them (MacDougall 2005, 6).

The imagistic, as we are conceiving it in this book, also disturbs a naïve or unproblematic relation between an image (verbal, pictorial, or some other form) and the reality to which it presumably refers. The imagistic has the potential for calling its theories and explanations into question through the stubborn tenacity of its sensory richness and materiality. Imagistic inquiries may concern "perplexing particulars" (Mattingly 2019) encountered in ethnographic fieldwork. Perplexity arises in "an encounter that not only surprises, in the sense of striking unexpectedly, but also eludes explanation. Such a particular (it could be a person, a scene, an event, an object) emerges with an irreducible singularity. It has a stubborn concreteness that cannot

easily be erased by subsuming it under general concepts. And yet it is entangled with concepts. This is because, at the same time that it exudes a singular presence, it confounds or disturbs concepts and categories themselves" (2019, 427). Such perplexities may abound in ethnographic fieldwork, but how do we approach them? Do we leave them behind in the pursuit of more robust interpretations or do we foreground them as a way to "defrost" (Arendt 2003; Mattingly 2019) our stiffened, unchanging, or frozen images of the world and others, as a way to "wake them up with empirical trouble" (Meinert, this volume)? These questions and lines of consideration move us well beyond notions of image as "mere representation." Instead, the imagistic is connected to a way of thinking, a mode of theorizing, and an avenue for approaching the world.

Recent explorations of the imagistic in anthropology belong to a longer history that begins outside the discipline. The term itself is most clearly identified with "imagism," a modernist literary movement initiated by Ezra Pound in the early decades of the twentieth century.[2] Pound, in turn, relied on recent work in psychology to formulate his concept. An image, he states, "is that which presents an intellectual and emotional complex in an instant of time," a complex which Pound believed offered a "sense of sudden liberation, that sense of freedom from time limits and space limits; that sense of sudden growth" (1954, 4). Pound believed that this was what some works of art were able to create. Instead of an imitation of reality, an image (of a certain kind) offered a kind of freedom from the ordinary limits of reality.

Although anthropologists do not use the term in Pound's precise fashion, current calls for an imagistic anthropology owe a debt to formulations from poetry and the arts. Much could be said about the field's literary and artistic sensibilities throughout its history, but an explicit acknowledgment of common ground between anthropology and the expressive arts was probably most pronounced at the height of anthropology's "crisis of representation" in the late 1980s. This penchant for looking to literary and visual styles of evocation was not merely decorative. It was a call to reflect on the limits and potentialities of ethnographic description, generating experiments with literary, photographic, and filmic images. Highly evocative and reflective work explores images not only as a supplementary means of conveying ethnographic insights but as a radically different way of arriving at them. Contemporary scholars have turned to sensory, imagistic, fantastical, artistic—as opposed to more conventionally discursive or didactic—

anthropological modes of knowing. Ingold (2019) sees an intimate connection between art and anthropology because both practices are engaged in an open-ended search for truth which necessarily overflows the bounds of objectivity.

And yet, despite this long history and the vitality surrounding contemporary forays into the imagistic, it turns out to be rather difficult to answer Stevenson's question: What is imagistic about an image? Nearly two decades ago Crapanzano observed that while anthropologists have always written about the imaginative features of human life, they have done so "largely by indirection," so that the imagistic does not become an explicit focus of attention (2004, 15). It is easy to see why this has been so challenging. To return to Stevenson's wonderfully provocative suggestions about how images can unsettle life, questions immediately arise. Do all images do this?

Obviously not. They may never "merely" represent something, but they certainly have the power to reify something. It is immediately apparent that images can fix and freeze rather than unsettle. Images may problematically offer a kind of "clarity and security . . . that too easily confirm preconceived understandings of the immediately visible" (Suhr 2019, 74). Images may function as ideal types, abstractions that reduce complexity and nuance into reified, unchanging "types." In fact, according to the phenomenological sociologist Alfred Schutz, typification is a key function of the image, a kind of fading picture in which the rich intersubjective space of co-presences no longer provides the same kind of nuance, movement, and dimensionality. As he puts it, "I am no longer in contact with the living you, but with the you of yesterday. . . . I carry your image with me, and it remains the same" (1972, 178, cited in Whyte, this volume). Not only do we carry images in memory, he argues. We also actively construct pictures of a person. This pictorial construction is based not only on past experiences of that particular individual but also on something else—"ideal types" that we have built up which are based on experiences of more than one person (see Whyte, this volume).

Images as ideal types are present not only in Whyte's piece but throughout the other contributions in this book. These powerful fixed pictures render the subtleties of others and their experiences invisible or, at least, difficult to discern. Nearly every aging person featured in this book struggles with what it means to be fixed by images of aging that cast them in marginal positions, where they feel barely recognized or respected.

If images have this power to reduce experience and complexity, to abstract and typify, what then renders an image imagistic? Is this quality of unsettling inherent in a particular, singular image (as a kind of sensory object or impression), or do imagistic powers and capacities depend upon social context? In other words, does an image become imagistic for some people under some circumstances, and not for others? The artist Maria Speyer (this volume) considers what is at stake in creating visual and word images that resist a reductive representational quality—that do not simply "illustrate" something. She treats this as a relational task. In her chapter, she uses words as well as drawings to create a relational space with her readers and viewers that asks us to think (and feel) imagistically. She invites her viewers (and the readers of her piece) to come along on a journey with her in which it becomes clear that figure drawing is not drawing an object so much as presenting an "opening" that "we move ourselves toward"; a move toward "action." She asks the reader to "imagine" drawing the figures with her, attempting to evoke this action, this orienting to another just as she is oriented to the imagined other of the reader.

In the move beyond representation, we've discovered an opening. If the imagistic is an opening, as Stevenson suggests, if it even opens worlds, as Louw remarks (this volume), what sorts of worlds do imagistic images unlock, or drag with them? Everyday worlds? The contributors to this book attend in considerable detail to the everyday lives of their aging interlocutors. Does an imagistic mode of attention offer an opening into a version of everyday life we otherwise might not see?

The Imagistic and the Lifeworld: Refiguring the Everyday

These last questions direct us to our second claim, in which we turn to the ontology of the everyday. Attention to the imagistic, in anthropology at least, is being called upon to challenge certain well-accepted versions of ordinary life which, it is often presumed, are governed by something like common sense. The everyday is often depicted as a domain of prereflective, commonsense awareness. Contributors to this book disturb this depiction through imagistic considerations of very quotidian events, practices, and encounters.

To consider what is at stake in this disturbance, we turn to Schutz's (1972, 1973) influential portrayal of the everyday as the domain of commonsense

experience. Even though Schutz provides a compelling and nuanced portrayal of the everyday, our imagistic approach amplifies life's uncertainties in ways that he does not. Schutz distinguishes what he calls "common sense" reality from other domains (like science, religion, and art). He describes "the natural attitude" of our commonsense world as a highly practical one, presenting us with ongoing challenges and tasks that we must address. He links this commonsense sphere to everyday problem-solving capacities and understandings we acquire to meet those challenges. He does refer to a horizon of uncertainty, which surrounds the commonsense lifeworld, but defines it as a "determinate indeterminacy" and a "potential problem" that in extreme situations might pose a more fundamental threat to commonsense reality. But he also claims that this indeterminacy can be ignored or set to the side because most times we are situated firmly within the structures of the everyday commonsense reality where the lifeworld is primarily a world of rational and pragmatic action.

Clifford Geertz, in a rather Schutzian manner, interrogates what gives common sense its authority and its ability to keep indeterminacy at bay—what kind of sense is it? What are its features? It operates with an "unspoken premise," namely that it "presents reality neat," he states. Geertz looks at common sense culturally, which is to say, as a system of thought that, in content, varies widely from society to society but, in form, shares something across this cultural diversity. "As a frame for thought, and a species of it, common sense is as totalizing as any other: no religion is more dogmatic, no science more ambitious, no philosophy more general. Its tonalities are different, and so are the arguments to which it appeals, but like them it pretends to reach past illusion to truth, to, as we say, things as they are" (1983, 84). Common sense operates with "an air of 'of courseness,'" the authority of self-evidence (1983, 84). The certainty of certainty, in other words.

When Geertz speaks of this quotidian domain, he is thinking in relation to a hugely influential body of philosophical work developed primarily in the early and middle decades of the twentieth century. From the ordinary language philosophers (e.g., Wittgenstein, Austin, Ryle) to the continental phenomenologists (e.g., Husserl, Schutz, Merleau-Ponty) to the (earlier) American pragmatists, Geertz argued, the "hum drum" everyday reason was "a central category, almost *the* central category" for philosophical consideration. In every case, he continued, it was variously characterized by a tacit, prereflective certainty (1983, 76–77; italics in original).

But the "common sense" and "of courseness" that Schutz and Geertz elaborate do not sum up the experience of the lifeworld. We can see this in recent anthropological considerations of the everyday in "ordinary ethics" (Lambek 2010, 2015; Das 2006; Mattingly 2018), where it is immediately apparent how precarious the "taken for granted" turns out to be. Even as anthropologists have also looked to ordinary language philosophy for their conceptions of the ethical, it is uncertainty and doubt that permeate so much of their ethnographic works and their analyses. Their "descents into the ordinary" (Das 2006) offer portraits of "ordinary tragedy" (Han 2020) or "slow-moving crisis" (Singh 2015).[3]

Anthropological work in ethics has particular relevance for this book. Ideals of how to age, how to live among intimate others, and how to care and be cared for are primary topics. Ethical uncertainties abound; providing good care for the elderly often provokes fraught and fractious relations. Several of the chapters call upon phenomenology to explicate ethical uncertainty as a lived experience, finding within phenomenology a resource for revealing how the everyday lifeworld, far from being securely anchored to an unquestioned certainty, is rife with destabilizing potential.

Doubt also characterizes imagistic approaches to the everyday, not only revealing how deeply it is embedded in ordinary experience but amplifying its features, bringing it to explicit awareness for the reader. Stevenson's work, as one example, showcases a stark contrast between an ordinary governed by commonsense certainty and an ordinary shot through with puzzles and perplexities. She offers a way of doing anthropology which takes seriously what our interlocutors doubt, what they do not know, as a "form of productive or even hopeful uncertainty" (2014, 2). While all the contributors to this collection emphasize the uncertainties their interlocutors face, Grøn moves uncertainty to a central, indeed foundational, claim about the ontology of the everyday. Reflecting on imagistic inquiries, she writes: "Are they about uncertainty and indeterminacy? Yes, most definitely, but, I would add, with certainty. Imagistic approaches point with certainty to the ungroundedness of experience—and of concepts and other ordering devices."

It is worth returning to Schutz once again, for he offers an interesting entrance into the more uncertain terrains that Stevenson and Grøn insist upon. He recognizes that common sense—with its certainties—is not all

there is to lived experience. "Nevertheless, the lifeworld embraces still more than the everyday reality. Man sinks into sleep day after day. He relinquishes the everyday natural attitude in order to lapse into fictive worlds, into fantasies" (Schutz and Luckmann 1973, 21). When Schutz turns to fantasy, he opens a dimension that speaks to much of what we consider throughout this book. Schutz puts several different heterogeneous modes of experience under the heading of fantasy worlds: daydreams, games, fairy tales, jokes, and poetry, stressing that they have common features when seen in relation to the commonsense lifeworld (Schutz and Luckmann 1973, 21). And we could add from the chapters in this book: memories, ghosts, ancestors, and other virtual or spectral domains and presences.

Schutz gives only cursory attention to fantasy worlds but notes that it would be important to investigate them further. This is what the imagistic inquiries collected here have done, but with a twist, a disturbance. Contributors explore the way imaginative possibility and indeed fantasy are completely entangled with the everyday rather than sequestered as a separate domain. The imagistic, Crapanzano proposes, is linked to a foundational human sensibility grounded in imaginative possibility. He renders this as a kind of hinterland, a horizon that "extends the insistent reality of the here and now" into shadowy, subjunctive domains which we intuit but which we cannot decisively know (2004, 14).

As our explorations demonstrate, the heterogeneous domains of fantasy worlds emerge not as distinct from the commonsense lifeworlds of our interlocutors, but as imagistic dimensions of experience, which deeply inform, underlie, intersect, and embrace rational, deliberate, and pragmatic ideas and actions. We contend that the separation of imagistic domains of experience from common sense and everyday concerns and lives comes with too high a price. This is especially so when we enter into aging worlds marked by increasingly frail bodies and minds, by solitude and loneliness, by impermanence and the closeness to death—and where spectral and imagistic dimensions of experience might be all there is.

Desjarlais (2019) offers an extended anthropological consideration of the imaginal qualities of human experience. Notably, as with many others taking an imagistic approach, his style of writing also evokes his argument. He suggests a move from descriptive ethnography to phantasmography, a "writing of phantasms, a graphic inscription of the flows and currents of fantasy

and fabulation" (2019, ix). Through self-reflective writing, he explores the perplexities of perception, where "all is multiple, shifting, spectral, a surge of phantasms in which the actual and the imagined are endlessly blurred and intertwined" (2019, vii). Louw (this volume), like Desjarlais, expands the domain of "apparently real things" (Desjarlais 2019, ix) to include dimensions significant to her interlocutors. She sees the imagistic not as a form of representation but as an entrance into "the realms of the invisible, the spectral, and the possible," recognizing that being is so much more than what actually unfolds.

GENRE-BENDING CONVERSATIONS: ANTHROPOLOGY, PHILOSOPHY, AND ART

This volume is an experiment that "integrates the creative and the critical through bending genre" (Kondo 2018, 5). Art figures centrally. The collection is framed by the contributions from the artist Maria Speyer, who has created drawings that precede and accompany the chapters as well as "word extracts" with "imagistic qualities," as she describes them. These words were extracted from earlier presentations of the chapters and became an inspiration for the series of drawings. In starting each chapter with Speyer's drawings and words, the imagistic qualities of the chapters are amplified and given a concrete and tangible—if ethereal—presence throughout the book. In her own chapter, Speyer meditates on imagistic uncertainty in the creative process she engaged in while collaborating with the other contributors. She reflects on the process of responding to words with images, as a revisiting of the "drawing underneath," the act of drawing before a surface or resolution is reached, echoing the indeterminacy and open-endedness that runs through most of the chapters in the book. In fact, Speyer writes, resolution is fictive. Drawings, like fieldwork and academic writing, we could add, are abandoned, left behind as traces. When an image is striking, who strikes? she asks. The drawing, us, the artist?—and suggests that an image is something we feel moves us, when we move ourselves toward it. She explores the complex interplay of passivity and agency, of self and other, of movement and being moved.

Genre-bending also characterizes the work of the contributing philosophers and the anthropologists in a mutual engagement that, for some of

them, began more than two decades ago.[4] The collection can be read as another entry into a broader conversation which considers what a philosophical anthropology might look like if it was developed in "the ground between" (Das et al. 2014).[5] Das and her colleagues ponder what might be asked of philosophers to facilitate this venture. "For philosophy to have value in our [anthropological] world," they contend, "it must learn to respond to the puzzles and pressures that an ethnographic engagement with the world brings to light" (2014, 2–3).

The philosophers in this volume do just this. They explore old age within specific sociohistorical settings based upon forms of fieldwork they have conducted. They carry out an engaged philosophy that depends on some level of personal immersion within a field site, on face-to-face encounters with interlocutors who are featured in their texts, and on reliance on detailed field notes of what they have witnessed.

The contributing artists played a central role. Their engagement with philosophers and anthropologists provoked some of the most surprising effects of this collaboration, facilitating a mode of thinking with art (Grøn 2017) that generated unexpected insights in the field and reencounters with their own written texts. The collaboration with artists initially centered on the task of creating an exhibition at Moesgaard Museum (MOMU) in Aarhus, Denmark, which was curated by Tove Nyholm and featured five large drawings by Speyer.[6] We developed ideas for the exhibit over three years, during which we met for yearly collaborative seminars at Klitgaarden, a retreat for scholars and artists located in Skagen, Denmark. During this period, the anthropologists and philosophers were also doing fieldwork. This meant that the research and artwork developed together. Over the years, the cross-fertilizations and genre blurring became more pronounced and deeper than anyone anticipated at the outset. Not only were philosophers doing fieldwork, but the artists, as well as anthropologists, were reading and writing about philosophy. Artists and philosophers were giving papers at anthropology conferences. Anthropologists and philosophers were invited into the artists' studios, assisting with the exhibit curation and drawing with Speyer. The collaborations outgrew an initial concern with experience near and aesthetic representation of research findings into the formulation of a mode of thinking which we have termed "imagistic inquiry."

IMAGISTIC TROUBLINGS OF AGING, INTIMATE OTHERS, AND CARE

Troubling the Good Old Age

What can we learn about aging through ethnographic, philosophical, and artistic projects that take seriously the diversity of ways in which old age is lived and experienced? How do people search for good old lives, when aging under challenging and uncertain life conditions? These are key questions that have guided our yearslong collaborations. Contrary to attempts to frame the good life in old age as successful and healthy aging (Rowe and Kahn 1987), we have explored searches for the good in situations of old age marked by challenging and often radically uncertain life circumstances, such as hunger, poverty, racism, cognitive and physical decline, and extreme forms of loneliness. There is a wealth of scholarly work from critical gerontology exploring the ideological and political economic dimensions of the aging process and how inequality marks the aging experience for many (Biggs, Lowenstein, and Hendricks 2003; Baars et al. 2006; Moody 1988, 1993) and also a widespread critique of the good life in old age framed as successful, active, and healthy aging (Lamb 2014, 2017). Critiques of the successful aging framework argue that a disease-free, active older age is unrealistic for most people and highlight the biomedical and western cultural bias of the model. Furthermore, critical anthropological studies have demonstrated how medicalization of old age—and distinctions between "normal" and "pathological" aging (Cohen 1994, 1998) or "function" and "dysfunction" in old age (Katz 2006; Katz and Marshall 2004)—have marked geriatric and gerontological conceptions. This has led to what Cohen termed early on the "geriatric paradox": in the pursuit of adequate medical treatment for the old, we have ended up defining "normal" aging in ways that exclude and indeed stigmatize "pathological" aging (1998, 60–70).

The chapters in this book consider a range of socially normative notions of how to age. Often these do not fit the gerontological discussions of successful aging. But local normative expectations of "good aging" are often not easily realized either. The chapters reveal such normative notions of aging as frozen images or ideal types that eclipse the lived aspirations and vexations surrounding the experience of aging for actual people. In her exploration, Grøn (this volume) renders aging experiences that not only

depart from local ideals of successful aging but in fact represent the worst possible end of life in contemporary Danish society: that of residents in a specialized dementia ward, a designated space for those whom neither family nor regular nursing homes can accommodate. Reminding her readers of the haunting images of dementia that we all hold, Grøn invites us into social worlds of imagistic signatures and responsive events between residents, between residents and staff, and between residents and herself, arguing that intersubjective life and dementia socialities exist beyond the point where commonsense language has ceased. This is a matter less of deeming life at the ward "good" or "successful"—the responsive events concern intense suffering, ever-present alterity, connection, and inclusion as well as disconnection and attempts to exclude—but more of showing the vitality of the aging experience in ways that destabilize those very concepts and distinctions.

Meinert (this volume) shows us how occupying the position of "an elder" comes with its own challenges in the Ik mountains in Northern Uganda, an interdependent world where elderly people share wisdom, blessings, alcohol, and tobacco, in exchange for others' labor, food, water, firewood, and care. You can strive, Meinert writes, to live up to the qualities of "an elder"— being wise, blessing others, taking responsibility—but you can only accomplish and maintain the status of an elder through the recognition of others, who experience you as responsible and thus respect you as such. When this succeeds, it reflects local ideals of the "good old life" in the Ik context. But when bodies (and fences) deteriorate, this position might only be held momentarily and fleetingly, as when Meinert's interlocutor, Komol, is able to hand someone a pinch of his tobacco through what used to be the wall of his house.

Gill (this volume) notes that acceptance of aging and decay and letting go of attachments are accentuated as ideals for old age among Tibetan Buddhists. These high ideals, however, do not capture what Gill experiences throughout her year of giving massages to Mola Tsering Wangmo. Mola was one among the several elderly Tibetans in exile who became central in Gill's fieldwork. Mola's mind is most often agitated, not calm, especially when it comes to the paid caretakers she has come to rely on. This does not mean that she does not live by the local virtues and ideals—she refers to the massages of Gill as the practice of the Buddhist virtue of *chos* (Buddhadharma: the teachings of the Buddha)—but it does mean that this notion fails to

capture fully the concerns and struggles in her life. What matters to Mola, the good she searches for, is to be seen in her singularity, not as a failing old body: to be seen as someone who has led an independent life taking care of herself and her daughter, and who throughout her life has practiced the virtue of generosity toward others. (Even though, paradoxically, as Gill astutely notes, she refuses to see the paid caretakers in their singularity.)

Troubling Intimate Others in Old Age

How might relationships with intimate others change with old age and what roles do intimate relations play in old people's search for good lives for themselves and their significant others? Who are the intimate others in old age—kin, friend, stranger, hired help, ancestors, ghosts, TV characters, or the state or NGO other?

In Wentzer's contribution (this volume) it is the welfare state, not a family member, who enables her elderly informant, Ben, to transform his life. Transformation occurs through the health care workers' engagement with his corporeal singularity. Wentzer provides an imagistic consideration of her philosophical points. She offers striking images of stairs as places where therapists train elderly Danes to be active and independent but also as sites of traumatic memories and falls. The body serves as a vital metaphor, a "living image," and stairs become an ethical site, as Wentzer explores rehabilitation work that moves between hospital and home, between professional and family intimate others. And where homes and families emerge as troubling and contested intersubjective sites.

Whyte's chapter offers one of the most nuanced examples of the virtues and vexations that can arise in family life. Drawing upon her long-term fieldwork in a community in northern Uganda, she explores a series of intense family conflicts over her interlocutor Musa's care, death, and burial through first-, second-, and third-person perspectives. The family conflicts extend into the afterlife as Musa's grave is dug at a distance from those of his parents, because, writes Whyte, "his father was a drunkard and their ghosts might quarrel if they are too close."

Several chapters deal specifically with spectral and imagistic presences in old age, presences which may press more insistently upon those who are aging alone, without the company and care of their intimate others. As Gammeltoft (2014) notes, absences and losses, as well as spectral and ghostly

presences, are intrinsic to forms of belonging: "Belonging is enacted . . . in the presence of ghosts, specters of social figures that have been lost or set aside yet continue to hover, haunting and troubling people" (226). Or ghostly presences may provide company and care. The spectral looms large in Louw's contribution. She suggests that understanding and caring for Kyrgyz elderly people, left behind by their migrating children, demands taking "imagistic steps" into the invisible, the spectral and the possible. One of her interlocutors is regularly visited by ancestors. They come to her in dreams, giving her omens and advice about what to do. When she is sick, they counsel her about best remedies. They stop by to drink tea or to nap. Her deceased husband visits so often she has made up a bed for him in her little kitchen, as this is now evidently his preferred place to sleep. Spectral presences inhabit the lives and homes of elders in other ways. In Gill's study of Tsering Wangmo (this volume), some of Tsering's most important experiences are with people she meets on television, like the Bhutanese children participating in a song contest. She follows the fates of the young singers closely, and their performances elevate her to heights of emotional surges of tears, joy, and anger.

Across these chapters, then, commonsense notions and ideals about who the intimate other(s) in old age should be are unsettled. The chapters also trouble notions of self and other. How do we distinguish self and other in situations where it is hard to know where one person ends and another begins? Mattingly offers the notion of "interbodies" in her chapter as she considers a family of three elderly African American women caring for Nicholas, a severely disabled and utterly dependent child. Life among the three women seems to complicate or at least amplify even the embodied versions of the intersubjective self that phenomenology posits. Finitude, manifested as being-toward-death, is a shared and pressing experience. This experience weighs upon them not as an existential or biological condition of individual bodies but as a quite particular practical matter: care of Nicholas. They are old *together* in virtue of this task of care and the urgent worry about what will happen to him when they are gone.

Meinert considers two kinds of trouble with selves and others in an exploration of relationality, old age, and care among elderly in the Ik mountains in Northern Uganda. There is the Ik elders' practical trouble with their intimate others, with fences, and with sustaining a sense of self; and there is the conceptual trouble with relationality—of delineating self and other

in theoretical work and ideas about the social and individual in anthropology. Through insistence on radical empiricism (Jackson 1989) and attention to the perplexing particular (Mattingly 2019), she "sees through fences" to defrost notions of "the social" and "the individual." She troubles the anthropologist Colin Turnbull's infamous image of the "suffering, selfish Ik," but also doxa (including her own) about collectivity, sociality, and care that have been highlighted in scholarship in African contexts, where individuality has not been emphasized. Seeing with and through fences suggests a form of imagistic knowing that allows her to pay critical attention to the deeply ambiguous features of practical relationality and of cultivating "others" and space—keeping close, but still at some distance, being together by being apart.

Louw and Meinert look to the feminist phenomenologist Lisa Guenther's (2013) work on solitary confinement in US prisons to argue that subjectivity should be seen not as a point but a *hinge*, "a self-relation that cannot be sustained in absolute solitude but only in relation to others" (xiii). When isolated from others, people's sense of who they are may erode. Louw argues that her elderly interlocutors in Kyrgyzstan age in the absence of their migrating children by being hinged to ancestors and other spectral presences. Meinert, by contrast, explores the need to be unhinged, to carve out a space for oneself when embedded or almost dissolved into the life of others in a sharing economy. What these two chapters share is attention to what it means to be hinged, or unhinged, as a precondition for being able to be someone who can come to care for others, to be an elder.

Grøn and Dyring turn to the question of intimacy and difference or intersubjectivity and alterity, which they have argued elsewhere points toward a differential social ontology (Dyring and Grøn 2022). Grøn suggests that the exploration of "imagistic signatures" and "responsive events" offers an approach to thinking about our coexistence with those experienced as cognitively different. Unlike the figure of the cultural other, this otherness appears within familiar cultural spaces, even one's family. Grøn explores imagistic signatures in intersubjective encounters in a dementia ward as events which come to meet, to invite the other, to respond. Such responsive events, in both enticing and haunting forms, are central to everyday life on the ward. Grøn suggests that while this becomes especially fraught and visible in the dementia ward, it is also true for life outside the ward. In the words of the contemporary phenomenologist Bernhard Waldenfels, "The

human being is an animal which responds"—responds to alterity, to the other, across divides of sometimes radical differences (2007, 27).

Along the same lines, Dyring sets out to show us the critical and prediscursive potential latent in experience as he reformulates the notion of intimacy through observations of small moments in a dementia ward where he carried out fieldwork. Intimacy is an anarchic in-between, he tells us. Intimacy exceeds biographical familiarity or sharing everyday routines. It does not lie in the elimination of distance. Rather, intimacy rests at a more subterranean level, speaking to the opening of an interval. He writes: "*Inti*-macy is about an *intus*, about the sharing of the interior space of an interval in which the non-exhaustive, non-possessable, and therefore *anarchic*, openness of intercorporeal being-with others in a shared world resonates." Interruptive intimacy, in Dyring's understanding, is an event that opens and configures the spaces in which bodies, minds, and relations are allowed to concretely take place.

Troubling Care in Old Age

Uncertainties permeate practices of care in these chapters. Life itself poses heightened uncertainty as people face their own nearness to death. As T. S. Wentzer points out, "Finitude is not just another word for the biological fact of human mortality. It expresses a guise of life that is intelligible only in light of the immanent awareness of its essential limitation. Finitude therefore denotes a mode of being rather than a property" (2016, 188). Finitude is both a feature of our limited knowledge and of life itself, "the opaqueness of our mortal existence" (Wentzer 2016, 188). In this collection, we variously explore these senses of limitation: the opaqueness which is part of mortal life, life's finite knowability, the limits of human understanding and control which intensify as life nears its end and one becomes more dependent on others.

When finitude is a pressing matter and dependence upon others grows, care is necessarily a central focus in people's lives. Every chapter highlights the considerable ambiguity of intimate relations when it comes to care. These explorations direct attention not only to care for the frail elderly but to the broader topic of care itself. Anthropology has produced substantial scholarship on care through critical appraisals of institutional forms of care, often globally circulated. A proliferation of ethnographies over the past two

decades has powerfully articulated dehumanizing care practices[7] as well as fallacies of care even when intensions are good (Leibing and Dekker 2019). But it has been much more difficult to articulate forms of care that speak in any compelling way to *good* care. What some of these works reveal is that even when it may be clear what beneficial or "real" care is *not*, it is not always so evident what care might look like, if positively figured (Mattingly and McKearney, forthcoming).

Some of these powerful ethnographies explore "good care" not as something easy to locate or even to define but rather in the mode of uncertainty, perplexity. In her study of everyday care practices within indebted family and friend networks in Chile, for example, Han (2012) moves beyond normative fixities by relying on her own embeddedness in the worlds she writes about (in more recent work including also memories of her own childhood [Han 2020]) to discover a more nuanced and unruly on-the-ground reality, in which dangers and affordances are intermingled. (See also Das 2006.)

What these evocative and moving ethnographies reveal is that good care explored in the mode of uncertainty might involve practices deemed thoroughly unethical from an outside normative view: like sharing antidepressants (Han 2012) or heroin (Garcia 2010), and even the practice of suicide (Stevenson 2014). In this volume we pay attention to the way people seek to cultivate what they think is good (Robbins 2013), even if this "good" seems absurd, imaginary, and nonrealizable, and even when people strive for the good in circumstances that are marked by profound suffering and insecurity.

One perplexity that arises in several chapters concerns *who* is being cared for. It may seem obvious that the vulnerable elderly are, or should be, the recipients of care. But when looking closely at their lives, something else becomes visible. Intriguingly, many frail elderly attach tremendous importance to being able to provide care to others (see, in this volume, Louw, Mattingly, Meinert, Gill; see also Dyring and Grøn [2022]).

Louw offers a view of care that is at once imagistic, uncanny, and expansive—care as worldbuilding. Care, she notes, "always and necessarily comes with a 'world'; a world which is a moral world in the sense that it comes with a larger context or horizon of meaning . . . to which it seeks to connect the object of care" (this volume). But what happens if that world is in disarray or seems to have disappeared? She ponders this in considering her elderly informants in Kyrgyzstan who grow old in the absence of close

family, in their homes, which they continue to occupy, "made uncanny by their absence" (this volume). They live with ghosts who must also be cared for. The ethical task of old age is not so much the ethical self-care of cultivating virtues, and it is certainly not practicing some version of successful aging for independent living. Rather, it is the task of caring for those who might come after them as well as the ghosts of those who have departed. Care, Louw tells us, involves "confirming or creating the presence of something or someone in a moral world," and for the elderly people she came to know, it posed a central ethical task: "how to patch up a moral world where there is room for the virtues the absence of others has made homeless" (this volume). Care for spectral presences and for "homeless virtues" materialize in unexpected ways, even as mounds of dusty plastic bags that fill a corner of a house.

Whyte offers a series of thoughtful critiques of existing approaches to care. She notes a lacuna in the feminist care literature, and in the anthropological studies of care more broadly, especially those undertaken in the global North. Much of this work seems to be either dyadic—care giver and care receiver—or focuses on the political economy of care, and therefore "the role of the state in providing for vulnerable citizens" (this volume). But this misses something important about the sociality of care that her Ugandan site brings to the fore: that care is often carried out by caregiving networks comprising both family and friends: a "constellation of caregivers" (this volume). Even those who recognize "the family as a network of potential caregivers" do not necessarily investigate "the collaboration and conflicts that might characterize such a network" (this volume). Africanist literature, by contrast, is replete with studies that reveal the complexities and vexations that accompany composite care.

Asymmetrical features of care are particularly highlighted by some contributors. Here, Levinas proves useful. For Levinas, Wentzer tells us, the origin and the measure of ethics is based on the infinite request of the Other. This request exceeds or falls outside universal normative principles (as in deontic Kantian ethics) as well as consequentialist calculation (as in utilitarianism). Wentzer calls on Levinas, but she also amends him. As Wentzer remarks—and as many others have noted—Levinas's Other can seem disembodied, even abstract. Following Altez-Albeba (2011), who has argued that the ethical encounter is guided by corporeality, Wentzer shows us how this corporeal ethicality, the body as a living image, plays out in the life of

her informant, Ben, whose deteriorating bodily condition becomes the center of concern. Ben's body is not reducible to the "somatic realm" of health care or his physical injuries; rather, it emerges as the root of transcendence. The body conditions, challenges, tames, and directs consciousness. The ethical good in the encounter with the embodied Other, argues Wentzer, is conditioned by a sensibility toward the body dwelling in the world.

CONCLUDING REMARKS: IMAGISTIC INQUIRIES AND THE POSSIBILITY OF CRITIQUE

As we opened the introduction, we posited three central claims regarding the imagistic. First, we claimed that the imagistic is not reducible to a mere image-as-representation or reproduction formula. Instead, the imagistic offered singularities that unsettled perception. But, since clearly images can fix and "settle" all too easily, this must mean that the imagistic is a quality of experience, a relational quality, rather than a feature of an object. Second, attending to the imagistic qualities of experience enlarges the domain of the everyday to encompass the spectral, the alien, and the fantastical, countering a reduction of everyday life to a practical, prereflective, and commonsense reality, a reality of certainties. This is especially important in studying the experience of those in late life.

The third metaclaim is that the imagistic offers a potent mode of critique through presentations of perplexing particulars and singularities that resist reduction. This point has already been elaborated in considerations of how contributing authors trouble core ideals and concepts surrounding aging, relationality, and care. But perhaps the most explicit formulation of this third claim emerges as Mattingly and Dyring stake out two rather different articulations of a critical phenomenology of relationality. For Dyring, the critical is bound up with a reconsideration of Edmund Husserl's *epoché*. Instead of treating the *epoché* as a kind of method in which one consciously brackets everyday assumptions, putting the natural attitude into question through a "willful act," Dyring reformulates the *epoché* as "something that *befalls* us in the form of an experiential *interruption* that . . . 'emplaces' lived experience differently in the world (if ever so slightly), thus unleashing new . . . potentials" (this volume). For him, experience contains its own critical potentiality. Experience brings with it a capacity to interrupt our ordinary way of perceiving and inhabiting our world (our "natural attitude").

An "'epochal disclosure of potentiality'" is experienced at a very primordial level. In his formulation, critique is tied to potentiality, and it emerges more primordially than where anthropologists would ordinarily locate critical capacities (i.e., at a discursive ethico-political level).

Mattingly offers a version of critical phenomenology that is decidedly wedded to the social and structural conditions of particular lifeworlds. She finds the discursive or genealogical critical traditions that have shaped much of critical anthropology insufficient, and in some ways highly problematic. Dominant critical traditions tend to treat lived experience as epiphenomenal, an effect of large-scale historical conditions that make them possible. Building upon earlier anthropological work in critical phenomenology (cf. Desjarlais and Throop 2011; Jackson 1996; Mattingly 2019; Zigon and Throop 2022) and calling upon Glissant's notion of the "right to opacity," she advocates, instead, an imagistic critical phenomenology that takes the singularities and alterities of experience seriously and resists reducing people or situations to "tokens of a type"—or what Glissant refers to as "transparency."

The imagistic dimensions of Mattingly's analysis are especially apparent when considering historicity (or historical consciousness) as shaped by the untimely deaths of children that, like so many ghosts, haunt a single family through generations. An everyday scene, a hall closet stacked with clean towels, provides an entrance into a world in which the untimely birth of a child is revealed as a singular gift. His very vulnerability, the severity of his disabilities, does not diminish the blessing of his presence for the aging family members who care for him. He is a joy, they say. The measure of this gift, indeed its singular immeasurability, must be read in light of a multi-generational family history of racial trauma in which the ability to provide for children was repeatedly, cruelly denied. An amended Levinasian ethics of the gift is linked to a critical exploration of how depriving families of the gift of giving reveals a particularly brutal manifestation of structural violence.

In sum, throughout this book we try to show that even as a mode of critique, the imagistic does not operate as a purely negative capacity. Instead, it offers perplexities and singularities that exceed normative ideals and typifications, "defrosting" them for further thought. It opens vistas that expand a sense of the everyday in ways that are not readily reconciled with local or academic instantiations of the taken for granted. We hope the claims

we have set out in general terms are given life through the imagistic moments offered in the following chapters and the art that frames them.

ACKNOWLEDGMENTS

This book would not have been possible without a generous grant from VELUX FONDEN that supported our interdisciplinary research and exhibition collaborations. We thank Tove Nyholm, the curator of our exhibition at MOMU, Aarhus, Denmark, who was such a big part of the work and perspectives presented in this book. We thank also several outstanding scholars who have commented on the development of the exhibition and on earlier versions of the chapters: Joel Robbins, Lawrence Cohen, Jason Danely, Robert Desjarlais, Sverre Raffnsøe, Thomas Schwarz Wentzer, and Tine Rostgaard at the Klitgaarden seminars; Doug Hollan, Bernhard Leistle, and Joel Robbins at the SPA meetings 2019; Lisa Stevenson and Anand Pandian at the AAA meetings 2019. Matthew McCoy provided helpful assistance in the final preparation of the introduction and some of the chapters. Also heartfelt thanks to the two excellent anonymous reviewers and several amazing editors of the Thinking from Elsewhere series at Fordham University Press. We would especially like to thank Tom Lay, Clara Han, and Bhrigupati Singh. Your enthusiasm for this book project and your critical insights and suggestions have been crucial for our thinking through the imagistic travels and approaches presented in the edited collection. Also a special thanks to the meticulous work of the copy editor, Nancy Basmajian. Finally, we want to express our gratitude to Robert Desjarlais and Lisa Stevenson: we thank you for opening up and pioneering the concern with the imagistic dimensions of experience, and for agreeing to write the foreword and afterword for this book.

NOTES

1. Mattingly and Grøn have contributed equally both to the editing of the book and to the writing of the introduction.

2. Matthew McCoy (personal communication) pointed this out and directed us to some of Pound's works.

3. Stanley Cavell's philosophical skepticism has been a key inspiration in their considerations.

4. This interdisciplinary collaboration has resulted in several edited volumes and journal special issues: Liisberg, Pedersen, and Dalsgård 2015; Mattingly et al. 2018; Wentzer and Mattingly 2018; as well as multiple individual publications, e.g., Mattingly and Jensen 2015.

5. In addition to *The Ground Between* (Das et al. 2014), other notable collections that speak to a philosophical anthropology include Fassin's *Moral Anthropology* (2014), and *Subjectivity*, ed. Biehl, Good, and Kleinman (2007).

6. The five drawings featured at the exhibition accompany the chapters by Mattingly, Grøn, Louw, Gill, and Meinert. The exhibition ran at Moesgaard Museum, Aarhus, Denmark, from February to August 2020 with some periods of close-down due to COVID-19 restrictions. A film documenting the exhibition can be seen at https://projects.au.dk/thegoodoldlife/.

7. Some influential works include Das 2006; Zigon 2011, 2019; Biehl 2005; Ticktin 2017; Han 2012; Stevenson 2014; and Garcia 2010.

REFERENCES

Abu-Lughod, L. 2008. "Culture and Women's Rights: The Challenge of the Particular—A New Preface for the Twenty-First Century." In *Writing Women's Worlds: Bedouin Stories*. 2nd ed. Berkeley: University of California Press.

Altez-Albeba, F. R. 2011. "The Body and Transcendence in Emmanuel Levinas' Phenomenological Ethics." *Kritike* 5 (1): 36–50.

Arendt, H. 2003. *Responsibility and Judgment*. Edited by J. Kohn. New York: Schocken Books.

Baars, J., D. Dannefer, C. Phillipson, and A. Walker, eds. 2006. *Aging, Globalization and Inequality: The New Critical Gerontology*. Amityville, NY: Baywood.

Biehl, J. 2005. *Vita: Life in a Zone of Social Abandonment*. Berkeley: University of California Press.

Biehl, J., B. Good, and A. Kleinman, eds. 2007. *Subjectivity: Ethnographic Investigations*. Berkeley: University of California Press.

Biggs, S., A. Lowenstein, and J. Hendricks, eds. 2003. *The Need for Theory: Critical Approaches to Social Gerontology*. Amityville, NY: Baywood.

Cohen, L. 1994. "Old Age: Cultural and Critical Perspectives." *Annual Review of Anthropology* 23:153–78.

———. 1998. *No Aging in India: Alzheimer's, the Bad Family, and Other Modern Things*. Berkeley: University of California Press.

Crapanzano, V. 2004. *Imaginative Horizons: An Essay in Literary-Philosophical Anthropology*. Chicago: University of Chicago Press.

Csordas, T. J. 2008. "Intersubjectivity and Intercorporeality." *Subjectivity* 22:110–21.

Das, V. 2006. *Life and Words: Violence and the Descent into the Ordinary.* Berkeley: University of California Press.

Das, V., M. Jackson, A. Kleinman, and B. Singh, eds. 2014. *The Ground Between: Anthropologists Engage Philosophy.* Durham, NC: Duke University Press.

Desjarlais, R. 1997. *Shelter Blues: Sanity and Selfhood among the Homeless.* Philadelphia: University of Pennsylvania Press.

———. 2003. *Sensory Biographies: Lives and Deaths among Nepal's Yolmo Buddhists.* Berkeley: University of California Press.

———. 2019. *The Blind Man: A Phantasmography.* New York: Fordham University Press.

Desjarlais, R., and J. Throop. 2011. "Phenomenological Approaches in Anthropology." *Annual Review of Anthropology* 40:87–102.

Dyring, R., and L. Grøn. 2022. "Ellen and the Little One: A Critical Phenomenology of Potentiality in Life with Dementia." *Anthropological Theory* 22 (1): 3–25.

Dyring, R., C. Mattingly, and M. Louw. 2017. "The Question of 'Moral Engines': Introducing a Philosophical Anthropological Dialogue." In *Moral Engines: Exploring the Moral Drives in Human Life,* edited by C. Mattingly, M. Louw, T. S. Wentzer, and R. Dyring. New York: Berghahn Books.

Fassin, D., ed. 2012. *A Companion to Moral Anthropology.* Malden, MA: Wiley-Blackwell.

Foucault, M. 1997. "What Is Critique?" In *The Politics of Truth,* edited by S. Lotringer, 41–81. Los Angeles: Semiotext(e).

Gammeltoft, T. 2014. *Haunting Images: A Cultural Account of Selective Reproduction in Vietnam.* Berkeley: University of California Press.

Garcia, A. 2010. *The Pastoral Clinic: Addiction and Dispossession along the Rio Grande.* Berkeley: University of California Press.

Geertz, C. 1983. "Common Sense as a Cultural System." In *Local Knowledge: Further Essays in Interpretive Anthropology,* 73–93. New York: Basic Books.

Grøn, L. 2017. "The Wonder of Things as They Are: Theorizing Obesity and Family Life with Art." In *Cultivating Creativity in Methodology and Research: In Praise of Detours,* edited by C. Wegener, N. Meier, and E. Maslo. Cham, Switzerland: Palgrave Macmillan.

Guenther, L. 2006. *The Gift of the Other: Levinas and the Politics of Reproduction.* Albany: State University of New York Press.

———. 2013. *Solitary Confinement: Social Death and Its Afterlives.* Minneapolis: University of Minnesota Press.

Han, C. 2012. *Life in Debt: Times of Care and Violence in Neoliberal Chile.* Berkeley: University of California Press.

———. 2020. *Seeing Like a Child: Inheriting the Korean War.* New York: Fordham University Press.

Ingold, T. 2019. "Art and Anthropology for a Sustainable World." *Journal of the Royal Anthropological Institute* 25 (4): 659–75.

Jackson, M. 1989. *Paths toward a Clearing: Radical Empiricism and Ethnographic Inquiry.* Bloomington: Indiana University Press.

———. 1995. *At Home in the World.* Durham, NC: Duke University Press.

———, ed. 1996. *Things as They Are: New Directions in Phenomenological Anthropology.* Bloomington: Indiana University Press.

———. 1998. *Minima Ethnographica: Intersubjectivity and the Anthropological Project.* Chicago: University of Chicago Press.

James, W. 1992. "Psychology: A Briefer Course." In *Writings, 1878–1899,* 1–443. New York: Library of America.

Katz, S. 2000. "Busy Bodies: Activity, Aging, and the Management of Everyday Life." *Journal of Aging Studies* 14 (2): 135–52.

———. 2006. "From Chronology to Functionality: Critical Reflections on the Gerontology of the Body." In *Aging, Globalization and Inequality: The New Critical Gerontology,* edited by J. Baars, D. Dannefer, C. Phillipson, and A. Walker. Amityville, NY: Baywood.

Katz, S., and B. L. Marshall. 2004. "Is the Functional 'Normal'? Aging, Sexuality and the Bio-marking of Successful Living." *History of the Human Sciences* 17 (1): 53–75.

Keats, J. 1958. *The Letters of John Keats, 1814–1821.* Vol. 1. Edited by H. E. Rollins. Cambridge: Cambridge University Press.

Kondo, D. 1990. *Crafting Selves: Power, Gender, and Discourses of Identity in a Japanese Workplace.* Chicago: University of Chicago Press.

———. 2018. *Worldmaking: Race, Performance, and the Work of Creativity.* Durham, NC: Duke University Press.

Lamb, S. 2014. "Permanent Personhood or Meaningful Decline? Toward a Critical Anthropology of Successful Aging." *Journal of Aging Studies* 29:41–52.

———, ed. 2017. *Successful Aging as a Contemporary Obsession: Global Perspectives.* New Brunswick, NJ: Rutgers University Press.

Lambek, M. 2010. *Ordinary Ethics: Anthropology, Language, and Action.* New York: Fordham University Press.

———. 2015. *The Ethical Condition: Essays on Action, Person, and Value.* Chicago: University of Chicago Press.

Leibing, A., and N. L. Dekker. 2019. "Fallacies of Care—A Short Introduction." *Journal of Aging Studies* 51 (100795).

Leistle, B., ed. 2017. *Anthropology and Alterity: Responding to the Other.* New York: Routledge.

Liang, J., and B. Luo. 2012. "Toward a Discourse Shift in Social Gerontology: From Successful Aging to Harmonious Aging." *Journal of Aging Studies* 26:327–34.

Liisberg, S., E. O. Pedersen, and A. L. Dalsgård, eds. 2015. *Anthropology and Philosophy: Dialogues on Trust and Hope*. New York: Berghahn Books.

MacDougall, D. 1998. *Transcultural Cinema*. Princeton, NJ: Princeton University Press.

———. 2005. *The Corporeal Image: Film, Ethnography, and the Senses*. Princeton, NJ: Princeton University Press.

Mattingly, C. 2014. *Moral Laboratories: Family Peril and the Struggle for a Good Life*. Berkeley: University of California Press.

———. 2018. "Ordinary Possibility, Transcendent Immanence, and Responsive Ethics: A Philosophical Anthropology of the Small Event." *Hau: Journal of Ethnographic Theory* 8 (1–2): 172–84.

———. 2019. "Defrosting Concepts, Destabilizing Doxa: Critical Phenomenology and the Perplexing Particular." *Anthropological Theory* 19 (4): 415–39.

Mattingly, C., R. Dyring, M. Louw, and T. S. Wentzer, eds. 2018. *Moral Engines: Exploring the Ethical Drives in Human Life*. New York: Berghahn Books.

Mattingly, C., and P. McKearney. Forthcoming. "The Ethics of Care." In *Cambridge Handbook of the Anthropology of Ethics and Morality*, edited by J. Laidlow. Cambridge: Cambridge University Press.

McKearney, P. 2018. "Receiving the Gift of Cognitive Disability: Recognizing Agency in the Limits of the Rational Subject." *Cambridge Journal of Anthropology* 36 (1): 61–79.

Meinert, L. 2019. "Still Held by Locham in the Wheelbarrow: Melting Stereotypes with Images." Paper presented at AAA panel.

Merleau-Ponty, M. 1962. *Phenomenology of Perception*. London: Routledge and Kegan Paul.

Moody, H. R. 1988. "Toward a Critical Gerontology: The Contribution of the Humanities to Theories of Aging." In *Emergent Theories of Aging*, edited by J. E. Birren and V. L. Bengtson. New York: Springer.

———. 1993. "Overview: What Is Critical Gerontology and Why Is It Important?" In *Voices and Visions of Aging: Toward a Critical Gerontology*, edited by T. R. Cole, W. A. Achenbaum, P. L. Jakobi, and R. Kastenbaum. New York: Springer.

Noddings, N. 1984. *Caring: A Relational Approach to Ethics and Moral Education*. Berkeley: University of California Press.

O'Byrne, A. 2010. *Natality and Finitude*. Bloomington: Indiana University Press.

Pandian, A. 2015. *Reel World: An Anthropology of Creation*. Durham, NC: Duke University Press.

———. 2019. *A Possible Anthropology: Methods for Uneasy Times*. Durham, NC: Duke University Press.

Phillips, J. E., K. J. Ajrouch, and S. Hillcoat-Nallétamby. 2010. *Key Concepts in Social Gerontology*. London: Sage.

Pound, E. 1954. *Literary Essays of Ezra Pound*. Vol. 250. New York: New Directions.

Robbins, J. 2013. "Beyond the Suffering Subject: Toward an Anthropology of the Good." *Journal of the Royal Anthropological Institute* 19 (3): 447–62.

Rowe, J., and R. Kahn. 1987. "Human Aging: Usual and Successful." *Science* 237 (4811): 143–49.

Schutz, A. 1972 [orig. pub. 1932]. *The Phenomenology of the Social World*. Translated by George Walsh and Frederick Lehnert. London: Heinemann.

Schutz, A., and T. Luckmann. 1973. *The Structures of the Life-World*, vol. 1. Translated by R. M. Zaner and D. J. Parent. Evanston, IL: Northwestern University Press.

Singh, B. 2015. *Poverty and the Quest for Life: Spiritual and Material Striving in Rural India*. Chicago: University of Chicago Press.

Sobchack, V. 1992. *The Address of the Eye: A Phenomenology of Film Experience*. Princeton, NJ: Princeton University Press.

Stevenson, L. 2014. *Life beside Itself: Imagining Care in the Canadian Arctic*. Oakland: University of California Press.

———. 2019. "What There Is to Fear: Scenes of Worldmaking and Unmaking in the Aftermaths of Violence." *Ethnos* (prepublished online).

Stoller, P. 1989. *The Taste of Ethnographic Things: The Senses in Anthropology*. Philadelphia: University of Pennsylvania Press.

———. 1997. *Sensuous Scholarship*. Philadelphia: University of Pennsylvania Press.

Suhr, C. 2019. *Descending with Angels: Islamic Exorcism and Psychiatry; A Film Monograph*. Manchester: Manchester University Press.

Ticktin, M. I. 2011. *Casualties of Care: Immigration and the Politics of Humanitarianism in France*. Berkeley: University of California Press.

Tronto, J. C. 1994. *Moral Boundaries: A Political Argument for an Ethic of Care*. New York: Routledge.

Waldenfels, B. 2007. *The Question of the Other*. Hong Kong: Chinese University Press.

———. 2011. *Phenomenology of the Alien: Basic Concepts*. Evanston, IL: Northwestern University Press.

Wentzer, T. S. 2016. "Finitude." In *Blackwell Companion to Hermeneutics*, edited by N. Keane and C. Lawn, 188–96. Oxford: Blackwell.

Wentzer, T. S., and C. Mattingly. 2018. "Why We Need a New Humanism: An Approach from Philosophical Anthropology." *Hau: Journal of Ethnographic Theory* 8 (1–2): 144–57.

Willerslev, R., and C. Suhr. 2013. "Montage as an Amplifier of Invisibility." In *Transcultural Montage*, edited by C. Suhr and R. Willersley, 1–15. New York: Berghahn Books.

Williams, R. 1985. *Keywords: A Vocabulary of Culture and Society*. New York: Oxford University Press.

Zigon, J. 2011. *"HIV Is God's Blessing": Rehabilitating Morality in Neoliberal Russia*. Berkeley: University of California Press.

———. 2019. *A War on People: Drug User Politics and a New Ethics of Community*. Berkeley: University of California Press.

Zigon, J., and J. Throop. 2022. "Phenomenology." In *The Cambridge Encyclopedia of Anthropology*. http://doi.org/10.29164/21phenomenology.

Zoanni, T. 2018. "The Possibilities of Failure: Personhood and Cognitive Disability in Urban Uganda." *Cambridge Journal of Anthropology* 36 (1): 61–79.

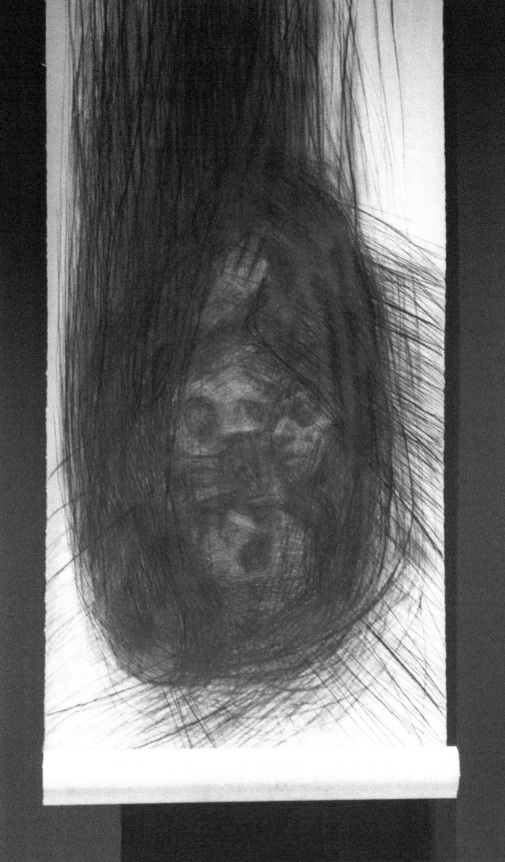

For Somebody That Needs It
not . . . in isolation . . . confronted throughout
children and this continues
even in their most frail years, by kin
Turning to . . . others
together . . . *who* is aging
cause you need her and she needs you
something to do for somebody that needs it
the joy they take in his . . . care
a call from elsewhere, a call of alterity
to the otherness of the other
precisely . . . his vulnerability
mothering . . . insisted . . . humanity
he's a gift to us. He's not a burden
harshly denied at other times
moments of natality
disrupt a . . . history . . . brutally . . . absent
left without names
permeating
to live . . . passed down, relived, and recreated

Overleaf: Figure 1. Drawing for Cheryl Mattingly, *For Somebody That Needs It*, charcoal and chalk, 2020, 450 × 115 cm (section)

THE GIFT

An Imagistic Critical Phenomenology

CHERYL MATTINGLY

TOWELS

The first time I visited them at home, Leanna let me in, smiling politely in a distant way and then quickly disappearing into a back room. Her sister Camille, who had invited me, moved more slowly toward me as I entered, navigating her walker carefully over the living room rug. The white paint on the outside of their wooden house was beginning to peel and their small lawn was the familiar browning green of unwatered Los Angeles grass. But the door opened to a cozily arranged room with couch and armchairs, soft browns, dusty pinks, and beiges. Family pictures on end tables. Camille insisted on showing me around. She paused at a hall closet laden with a fluffy stack of towels, perfectly folded. These, too, were browns, beiges, muted rose. "These are Nicholas's towels," she told me with quiet pride. Her hand rested reverently on the downy surface. "We always need a lot for him."

Nicholas was born with cerebral palsy. He died in 2017 at the age of twenty-three. At the time I first came to know his family, more than twenty years ago, he was four years old. He was cared for by three women who comprised a single household. In 1998, I first met his great-grandmother Gigi, age eighty-one, his grandmother Camille, age sixty, and his great-aunt Leanna, age fifty-seven. Gigi and Camille both died a few years later. Only Leanna is still alive. Nicholas also sometimes received care from his father, Charles, who was in his early thirties (in 1998) but was in and out of prison

and not reliably present. His mother, Norinne, died shortly after his birth. She was twenty-nine. Nicholas also nearly died during childbirth and was born a month premature.

Nicholas was so affected that he could not speak, walk, or use his hands and arms. He was nearly blind, although he might have been able to see shadows out of one eye. Absolutely everything had to be done for him—he could not in any way care for himself. He was also severely cognitively impaired, a condition that only worsened over time, exacerbated by seizures that were very difficult to control and led to further brain damage. Not so long ago, children with his level of impairment would not live long or would die at childbirth. But as medicine and medical technologies continue to advance, so do the ages to which such medically fragile children live. In this chapter, I concentrate primarily on the years when Gigi and Camille were still alive (1998 to 2001), although with some reference to later events in family life.

During these years, when the women consider their lives, they emphasize the *family's* physical precarity and what their individual health problems (recurring cancer for Leanna, lupus for Camille, growing frailty for Gigi) could mean for Nicholas's future. In light of their physical precarities, aging becomes an urgent ethical and practical family matter: Who will take care of Nicholas when they die or become too frail to do even the smallest caretaking tasks? How will they manage when even one of them can no longer participate in their collective child-rearing task that is already a precarious endeavor?

Urgency is palpable in a 1999 interview as Camille describes her attempts to recruit Nicholas's father to take on more care.

> I told Charles I would really like for him to work on getting his life together. Because everybody in this house, as much as we love Nicholas— and we would rather have him here with us—but the three of us, well. My mother's eighty-two. I got lupus. And my sister has cancer and asthma and fibromyalgia, she has so many things. 'Til it's just an effort for us to get up in the morning. And it's really not easy. And we really care about his, Nicholas's welfare, but I want his dad to get hisself together.

As the three women grow increasingly frail, Camille's worry mounts. "I'm not doing too well," Camille confesses. Camille is visibly sicker than a year earlier. She must stay close to her portable oxygen tank because of the

severity of her lupus and has become unable to even pick Nicholas up or help transfer him to his wheelchair. She is recovering from pneumonia as well, having been recently discharged from the hospital where she was taken when she suddenly fainted in the kitchen and the paramedics had to be called. At the hospital the doctor diagnosed pneumonia and pleurisy, advising her it would be many months before she got her strength back because she'd run a high fever for so long. "I have a feeling that I'm in a [health] crisis," she stated quietly. Her sister Leanna is not doing much better. Her cancer has weakened her, as has the chemotherapy she is undergoing. Leanna also has severe asthma, which prevents her from getting any radiation. While it is Leanna who carries out the more demanding physical care tasks with Nicholas, this is becoming difficult for her as well.

IMAGISTIC INQUIRIES: OPACITIES AND TRANSPARENCIES

"Thinking thought usually amounts to withdrawing into a dimensionless place in which the idea of thought alone persists. But thought in reality spaces itself out into the world. It informs the imaginary of peoples, their varied poetics, which it then transforms, meaning, in them its risk becomes realized" (Glissant 1997, 1).

This complex set of sentences introduces a section titled "Imaginary" in Édouard Glissant's *Poetics of Relation*. In this work Glissant contemplates the birth of a radically new sociality in the Americas forced upon enslaved Blacks. Those who survived the Middle Passage faced not only enchainment and torture but incalculable loss. A loss of loved ones, of course, but also language, land, ancestors, the smells and sounds and tastes of home, all they had once possessed. They had lost their "varied poetics." Had they also lost their future? No, insists Glissant (and so many Black studies scholars).[1] The "tomb" of the Middle Passage (the ship's hold, the sea itself) is also a "womb," a "womb abyss" in which new forms of relation, new poetics of relation, are born from an impossible present (Glissant 1997, 6).

What makes this creation possible? Glissant suggests that it demands a poetic, opaque form of thinking. In the quotation above, he tells us that thought, when it is "in reality" and not merely a withdrawal into a "dimensionless place," not only informs the imaginary of people, the poetics of people, but also transforms them. This implies that thought is the mover behind imaginaries and poetics of diverse peoples, their transformer. But

then there is a twist. What *this* means, Glissant continues, is that these imaginaries, these poetics, do something to thought. Not merely revealing thought but realizing the *risk* of thought. In the dialectical reversal that Glissant performs, he suggests that when imaginaries and poetics act on thinking, thinking is put at risk and, in his vocabulary, loses its transparency. Glissant abhors "transparency," taking it to be the enemy of thought because it presumes to show clearly what cannot be shown clearly and cannot be settled. He advocates instead a "thick (opaque) experience of the world" (1997, 15), thought as errantry, as detour. Moten (2018), inspired by Glissant, leans into the poetics of everyday Black social and expressive life as he insists that theory making (theory that revitalizes) is a practice inextricably bound up with a "thingly," fleshy, "fugitive" poetics.

Even if we anthropologists are not necessarily poets, can the stubbornly disturbing particularities that emerge in our fieldwork, as we remember, represent, and try to think with them, help us not merely to see something *as* something but to see something *through* something? Can the particular act as a scrim, refiguring transparency into generative and vitalizing opacity? Can it impose a necessary detour, setting us (and our readers) on an errant voyage into the space of ideas?

Aging and Care as Imagistic Matters

This chapter, like others in this collection, is a meditation on problems that can be formulated existentially but are inhabited very concretely. How to live with an aging body when facing the palpable specter of death? What does it mean to care and to be cared for when one has become increasingly dependent and frail? What is a good life, or a good enough life, when life itself is plagued by precarities and can sometimes seem barely livable at all? When the aspirational good is equivalent to surviving? Or when life seems to demand "making a way out of no way," as the African American saying goes?

Generational precarity, including extreme financial insecurity, and extended kinship networks are dominant features of family life for many African Americans. Precarity is heightened when multiple members of a household, including children, have significant and chronic health conditions or disabilities.[2] If a child's disabilities mean she will always need substantial care, this can create a family crisis. This is especially difficult

when, as in my study, the primary familial caregivers are elderly or medically fragile. A key issue arises: Who will care for this child when I am gone? Because care for family dependents looms so large, the good (old) life is intertwined with or even subordinate to what elderly or medically fragile caregivers discern as the best good life for the children under their care. Racial inequality and economic insecurity deeply shape these elders' possibilities and strivings for a good life as they age. These social conditions invite a critical approach to the structural injustices surrounding aging.

What does it mean to take an imagistic approach to these questions? Certainly, it does not mean piling up images for display, like so many fluffy towels, as though these could tell us something in any direct way, or could merely represent aging bodies, care, or family life. But a humble stack of towels upon which a hand is *reverently* placed may invite imagistic inquiry, imagistic perplexity. Why the tenderness of this gesture? Why the lingering pause to point out something so mundane? Why does Camille slow down time for such lowly fact? Am I facing a sacred hall closet, an altar made of towels? If so, what world has summoned me?

To proceed from an imagistic direction, some paths will not do as starting places, however invaluable their analytic powers. Rejected beginnings: Gerontological ones that foreground the aging physical body. Sociocultural ones that isolate a demographic population treated collectively. Political ones that interrogate conditions of structural violence for the racially and economically marginalized. Existential ones that speak to aging as universal experience, inextricable from the human condition. My beginning—the beginning of this chapter—is elsewhere. An immediate plunge into sensory experience. With this as my starting place, I ask: How is aging and the immanence of death lived *somewhere*, at a particular moment in time? I began with a *situation*. The careful placement of the towels, Camille's tender reach, usher me into a world whose natality can be traced to the untimely arrival of a motherless child.

If I take my beginning seriously, can a sacred altar of towels offer a "scene of instruction" (Stevenson 2020)? Can it instruct our gaze, disorienting what Glissant calls transparencies, Arendt calls frozen concepts, and Schutz calls ideal types? Can a scene of instruction defrost the typified? Can even a mundane domestic scene lose its stereotyping power, the certainty of its hold? Can we let the towels speak a language of opacity? Or rather, can a single gesture release them from their humdrum existence as household objects

into an expanse far denser, less readily dismissed? To address these questions, I distinguish an imagistic approach from a transparent one. Trafficking in transparencies means attending to social facts, frozen images, fixed maps of social positions, what is typically the case.

Transparencies: Aging, Kinship, and Care in the African American Community

When I first met them, Camille and Leanna were not old from a gerontological point of view. But their bodily infirmities in late middle age are common in the African American community. African Americans face unique challenges that have a direct consequence for aging, as comparative studies with white populations demonstrate. There is a wide health gap between Blacks and whites along the entire life span. The gap among older adults is merely one iteration of a disparity visible across a wide range of diseases. But it has particular significance because the unequal prevalence of disease accumulates over the life course: health risks for Blacks as compared to whites increase over time until late old age. American Blacks also seem to age faster than whites. This has been attributed to a complex interplay of negative influences (economic, social, environmental) that may actually accelerate aging.[3]

In the face of bleak conditions and health problems, older African Americans often evince a certain muted and plainspoken stoicism that is exemplified in commonly voiced refrains, such as "you've got to deal with what life offers you," take it "one step at a time," and realize that "others are worse off."[4] Earlier experiences of discrimination and hardship are often viewed as resources when facing the life difficulties associated with aging. "What I've been through made me strong" is a familiar expression that speaks to a lifetime of challenges. Notably, African American elders do not characteristically view bodily suffering in isolation from other problematic situations they have confronted throughout their lives. Infirmities of age are merely another of "life's difficulties" that must be faced.[5]

Family patterns play a crucial role in shaping elders' experiences of aging. African Americans stand out in their reliance on intergenerational and extended family caregiving (Stack 1995; Luckey 1994). Extended networks of care allow for pooling scarce resources and greater flexibility for childcare. The matriarchal family, with mothers or grandmothers at the

helm, is a well-established social constellation. The central role of women in family life is reinforced because it tends to center around care of children, and this continues to be a highly gendered task (Fabius 2016; Revell and McGhee 2012). Raising children does not necessarily end as one ages. Grandmothers and great-grandmothers often continue to "mother" the younger members of their family, including providing advice or more active assistance to adult children. They can play key informal leadership roles beyond the family, especially in their churches and neighborhoods (Ralph 2014).

Older African Americans also tend to live with family, relying far less on formal institutions than do their white counterparts (Stewart 2008). Historically, economic realities have always played a key role in the maintenance of these extended and informal caregiving arrangements among African Americans in which young and old are called upon to care for one another. Because they have been so systematically barred or impeded from getting the benefits of formal structures of care, they have been forced to rely on informal family networks. But powerful normative assumptions are also at work. It is expected that older adults will live with family members, if at all possible, with informal and intergenerational care networks providing elder care.[6] Even young children are expected to help.[7] Thus, one reason elders play a vital role in family life is because they are cared for, even in their most frail years, by kin.

Growing old in the African American community provides a stark contrast to the dominant American model of successful aging in which the good life for the elderly has been reframed as a medical and individual lifestyle problem that can be successfully controlled. For most African Americans, especially from low-income communities, self-sufficiency is not the primary way adversity is handled, including adversities that arise with late life. Dependence and interdependence are anticipated throughout the life course. Turning to significant others in times of trouble is expected and considered necessary.

OPACITIES AND DISTURBANCES

I have just sketched a typified description of the African American family, a configuration forged, in part, by systemic economic and racial oppression and unequal health access. This depiction reveals the sheer predictability

of Nicholas's family arrangement. However, it obscures the alterities and perplexities of care that bear directly on the experience of aging. I will try to disturb things both through describing ethnographic moments and through the resources of phenomenology, including its feminist and anti-racist retoolings.[8] What might an imagistic and phenomenological approach offer to this third-person kind of account in which cultural patterns of familial caregiving and structural violence go hand in hand? How might it speak to cultural typifications of extended kin networks and histories of racial inequality in ways that destabilize or make perplexing these generalized social facts?

First Disturbance: The Intercorporeal Body

In Nicholas's family, aging is not an individual matter. Biological old age seems to be something shared rather than an attribute attached to a particular person or body. Their life together makes perplexing exactly *who* is aging. Phenomenologists have long considered the intercorporeal dimensions of intersubjective experience. Responsive phenomenology decenters an individualistic "I," insisting that intersubjectivity—a "we" or an "us"—precedes any individual subjectivity. However, this claim is abstract. Who, exactly, is the "we" that the philosophers refer to? This abstraction gains traction and its true radicality is exposed when explored in locally lived "we" relational situations (Mattingly 2017). Life in Nicholas's family provides an excellent example. It seems to complicate or at least amplify even the embodied versions of the intersubjective self that phenomenology posits. Finitude (manifested as being-toward-death) is a shared and pressing experience among these women. It is not felt primarily or first of all as an existential condition or cultural or statistical fact but as a quite particular practical matter: care of Nicholas.

For these women, the body is old not simply in years or even because of bodily precarity and the threat of death. It is in relation to care that their age takes on the meaning that it does. I don't want to exaggerate. They do experience their bodies as in one sense their own—they each have different ages, body histories, and infirmities. But they also share an "interbody" because of their shared project of care. They are old *together* in relation to the demands of care placed on them because of Nicholas. And this is how they describe their own bodies.

Despite their difficulties, they find Nicholas a shared gift who has helped create their "we-ness." A conversation with Camille and her mother Gigi illustrates.

Camille: I consider it a joy.

Gigi: Because I told Nicholas, all the time, I say, "You know what, Nicholas? Your mamma's not . . . there, I don't know what to do. I know! I'll send you to your nana, cause you need her and she needs you." [Gigi is "Nana."] And it worked, that's the truth.

In Gigi's complex statement, there is a blurring of temporality and of selfhood. Who is this "I" she refers to? In her reported address to Nicholas, she returns to an earlier time when Nicholas was born and his mother has died. Who will take care of him? she asks. She states that it is she, herself (the pronominal "I") who has the idea he should come and live with Nana (now using a third-person pronominal to refer to herself and also her daughter Camille—they are both "Nana"). An added confusion is that, in fact, it was not Gigi's but Camille's efforts that have brought Nicholas to her. This involved an arduous process of gaining custody of Nicholas from his father, Charles.

Furthermore, it is not Nana's house where Nicholas lives, it is Leanna's. Leanna is the "backbone" of the family, Charles once said. A few years earlier, when Camille became so sick with lupus that she could not care for herself, Leanna instructed her to move into her home. As Gigi got older and grew feebler she moved from her home in Texas to Leanna's house. We might read Gigi's answer as the result of a confused mental state—she has become more "forgetful," she announces—but I think something else is operating. Her language also speaks to the blurred we-ness of the three women as they have come to take on care of Nicholas.

THE BEDTIME TOUCH Gigi describes her experience of caring for Nicholas, with Camille joining her.

Gigi: So that baby's the joy of my life. Oh, I love him to death. I talk to him and he's so good. I got him on a schedule. He don't know what a schedule is, but he go to bed every night at 7 o'clock and he know that. He goes to bed and then he stay awake. I say, "You can go to sleep, you know?" He'll go to sleep—but now [Gigi says with joking indignation] she [Camille] starts something!

Camille: I come in there and lay down with him.

Gigi: She all just lay down with him. She, they both get on the same pillow where they noses is rubbing. She just right there . . . And then he goes to sleep and then she gets up.

Camille: Cause see, he doesn't see very well. But he has to know that you're there. You know, if your face is in his face, he loves you to be in his face. You see he can tell that you're there physically. And you know, he don't have to wonder where I am. He knows I'm right there with him. And he don't have to look.

Gigi: Cause like I can come and stare at that bed and Nicholas don't know I'm there. But now my sister [referring to one of Gigi's sisters who lives nearby] come and stand at the bed.

Camille: [Interrupting] Yea, but she comes in talking. He sleeps with her [Gigi].

Gigi: Yeah, but he know.

Camille: He knows our voices. So, I need him and he needs me.

Gigi: He's helped me in the sense that it's something to do for somebody that needs it. And appreciates me. He don't know nothing about appreciating, but I don't know what would have happened [to me]. Cause I'da been going to Vegas, and flying places, and just living. And the Lord knew.

Camille: I think Nicholas is a very important person.

This dialogical interchange centers on a co-narrated account of bedtime. The women underscore Nicholas's importance to the household and the joy they take in his intimate care. Gigi invites Camille into the co-narrated account by describing the way that Camille comes into her bedroom—where Nicholas sleeps—and lies down with him, even if he is already sleeping. Gigi complains in a humorous way: Why does Camille come in even when he is already asleep? But her jokey words paint a tender scene—Camille and Nicholas lying side by side, facing one another and rubbing noses until Nicholas drifts off to sleep.

Second Disturbance: A Reversal of Authority

We might say that Nicholas has issued an authoritative call. Gigi, in particular, invokes religious language to give additional weight to this call: the "Lord knew" what she needed in her life. This is a call from elsewhere, a call

of alterity, not only in the spiritual sense (a call from God) but also in the most basic bodily sense. If the three women form a community of embodied sameness (even an interbody), Nicholas, the centripetal force that has propelled this level of intertwined bodilyness, is decidedly different. His body and its vulnerabilities are *not* shared. To be connected to him demands other avenues of relationality. Touch assumes vital importance. Rubbing noses is a shared pleasure where relationality arises across a deep bodily divide.

Nicholas's alterity brings the second-person perspective into high relief precisely because it calls attention to the relational other *as other.* Levinas insists that the ethical requirement means attending to the otherness of the other. He offers a stringent conceptual resistance to ideals of care based on sameness. The Levinasian other who issues the ethical demand is irreducible and cannot be subsumed into a "we" of shared identity or experience. Importantly, the one who addresses, who issues the command, is not a categorically situated subject or socially designated identity. The one who addresses exudes an elusive presence that cannot ethically be ignored. The ethical demand is a "command that forbids assimilation, categorization, or comparison," Guenther remarks (2013, 201).

From a Levinasian perspective, Nicholas's very presence places an ethical demand on others. He is not ethically worthy of care because of particular attributes that can be assigned to him; his human-ness cannot be reduced to what he shares with the able-bodied. Rather, his authority resides in his very vulnerability. Because he is so physically fragile, so easily rendered as an object, so defenseless to neglectful or violent responses, he commands care. His care is experienced as an ethical demand precisely in virtue of his vulnerability. Raffoul describes this Levinasian move as a "reversal of responsibility" in which "the author becomes the respondent" (2010, 164). "I" becomes "me"—the subject of an address issued from elsewhere. This "I" "responds to others, even if in manners of abandonment and neglect, and thus is already in relations of responsibility or ethics" (Taylor 2005, 219).

As one "whose moral vulnerability is exposed to the potential violence of our own arbitrary freedom," as Lisa Guenther puts it (2013, 202), Nicholas invests the women's freedom with responsibility. This is not an abstract philosophical point; it is of the essence for these mothering women who *insisted upon his humanity* to clinical and school caregivers as part of their daily project of care.

I return to Gigi's explanation of why Nicholas is an ethically consequential person.

He's helped me in the sense that it's something to do for somebody who needs it. And appreciates me. He don't know nothing about appreciating, but I don't know what would have happened [to me]. Cause I'da been going to Vegas, and flying places, and just living. And the Lord knew.

Gigi might seem to be complaining when she says that without him she would be "going to Vegas, and flying places, and just living." But instead, she suggests that Nicholas gave her a home because he needed her. There is something more profound to life, more joyful, than "just living." "Just living" might even be her description of autonomous freedom, living as an individual doing things she likes—being an independent "I" who can fly here and there unencumbered, making trips to Las Vegas to play the slots. Instead, she has been pulled into the making of a "we" to which she has been ethically called. Notice too how she corrects herself as she tries to explain what is so rewarding about providing care for Nicholas. It is not because he appreciates what she does: "He don't know nothing about appreciating." He cannot even offer her the gift of gratitude. Why does she say that she needs him? Because he needs her, whether he is able to register this or not.

This comes through even more clearly in the following exchange when Camille and Gigi are asked what they would tell other parents caring for a medically impaired child. Camille immediately responds: "I would tell them that Nicholas, uh a child [like that] would be a very rewarding thing." Gigi chimes in.

Gigi: See, he's a gift to us. He's not a burden.
Camille: You might think that it's going to be real hard but the rewards outweigh the hardships.
Gigi: And what's so good about it
Camille: [Interrupting] You really get attached.

Their words could ring banal, the sort of idealized description any family would feel obliged to offer in the face of these interview questions. But this misses the joy they bring to their ability to provide care. Why such joy? Here is another perplexity. What *is* the gift that Nicholas gives? This is not the sort of gift Mauss theorizes, which introduces a demand for reciprocity that indebts the recipient.

Nicholas's very dependence is part of what he offers. He needs the women and will continue to need them. His embodied alterity also seems to offer something.[9] But the depth of the gift that Nicholas bestows is best illuminated when placed in history.

Third Disturbance: Disrupting a Haunted History—the Gift of Natality

Within the tradition of responsive phenomenology, interruptions of various kinds are central to its analytics. (See Dyring, this volume.) One form of ethically and politically significant interruption is Arendt's concept of natality (Arendt 1958). She sees natality as an inherent potentiality of action itself. She refers to the possibility of beginning something new, interrupting the predictable (or, in the language of transparency, interrupting the already typified). This potentiality to generate "second births" has been richly explored (Meinert 2018; see also O'Byrne 2010).[10] Natality, in the Arendtian sense, offers a way to understand what Nicholas bestows upon this family as an ethical gift. Nicholas's literal birth makes possible an ethical rebirth in the sense that it opens a horizon of care harshly denied at other times. This horizon is grounded in material history of life in "flesh-and-blood terms" (O'Byrne 2010, 48). The historical consciousness that belongs to this family is marked by racial trauma and the ghosts of dead children that haunt their lives and shape their experience of caring for Nicholas. I look to three historical moments of particular salience in their lives.

Nicholas's life is threatened from the start. He is born in a moment of danger: premature, multiply disabled, without a mother, a father unable to care for him. But he is not the first threatened child to be born in this family. There have been other, earlier, moments of danger for children who did, in fact, die. The capacity to offer this exquisitely attuned care to a child as medically fragile as Nicholas (and to receive medical services to support such care), the scenes of Nicholas's home—his face lighting up when Alicia Keys sings on the radio, the bedtime cuddles—these are moments of natality in a profound sense. They disrupt a family history in which the capacity for care has been brutally or tragically absent, a family beset by dangers that belong to an African American history.

"History does not belong to us, we belong to it," Gadamer (1975) has said. This does not mean that we are passive victims of history but that our own history, which we inherit, presses upon us, posing questions to be asked

anew and made our own. Nicholas's care, the gift of this care, could be considered a response to a question—How can we care for our children who are in grave danger? As practical actors, when we face a situation, Gadamer has also said, we do not merely ask, "What is this situation?" but "What is this situation asking of me?" In every generation, the care of children under threat poses a situation to which these three women have had to respond. How might we consider this demand to respond imagistically?

FIRST IMAGE: SEVENTEEN CHILDREN: ELEVEN ABOVE AND SIX BELOW GROUND As part of making a kinship chart with Camille, we ask about Gigi's family. Camille tells us Gigi was the youngest of seventeen, but she can only remember the names of about seven of her aunts and uncles. Gigi happens to enter the room while Camille is talking, and she asks her for help.

> Gigi: Whose name do you want to know?
> Camille: All of them.
> Gigi [astonished]: What do you mean all of them? Everybody dead but me.
> Camille: I'm trying to make a family tree.
> Gigi [even more incredulous]: Oh Lord! I mean, they didn't have no, my mother didn't read and write. And so they didn't have no nothing, you know? But I can tell you what I know."

Gigi is also surprised that Camille has reported a family of seventeen. Camille retorts that this is what Gigi's mother told her.

> Gigi: The only thing I remember is she'd always say, when [people asked her mother] "Mrs. Ford, how many children you got?" She'd said, "I got eleven living and six dead." "Eleven above and six below." At that time you just died. They didn't take you to the doctor like they do now. They just gave you some hot tea. It was a laxative. They believed in laxatives. And some other kind of tea. It was nasty!

Gigi grimaces at the bitter memory, tasting it again.

If these dead siblings haunt this family, it is not as individuals. They are left without names and can only be numbered on the kinship chart. Their very namelessness, a kind of absence of images, marks a period when getting seriously sick meant "you just died." It speaks not only to an earlier era and a rural community but what it meant to be Black and poor from Texas

in the late 1800s and early 1900s. Gigi, surprised to be asked, gives only the barest matter-of-fact account. She had never said much about her own childhood, and these deaths would have gone unmentioned if not more or less accidentally prompted.

SECOND IMAGE: THE MURDER In 1955, when Leanna was fourteen, a fourteen-year-old Black boy, Emmett Till, was murdered. Leanna has never forgotten the pictures she saw of him. The memory of his death has haunted her whole life.

Emmett Till was a Black boy in the South. They say he had gone, I don't know what southern town, visiting some relatives. He had come from Chicago, or somewhere. Anyway, the story goes that he whistled at some white woman. And he was crucified. They tortured him and killed him and mutilated his body. And I always remember, as a child, I will never forget it. When that happened, my mother made a decision that she is gonna send us from Texas. (That was the height of the civil rights movement.) She was gonna send us from Texas to California. Fourteen years old, and they hung him. They threw him in the river. They did a little bit of everything. They mutilated him so badly that his mother didn't even recognize him. I remember looking at this Black magazine, *Jet* magazine, and seeing the picture of this body. And it scared me to death and it scared my mother too.

This child's death became a historic event, not because he was murdered (which would soon have been forgotten) but because his mother's actions forced a public acknowledgment of racial brutality. Emmett, visiting from Chicago, was accused of insulting a white woman working at a grocery store in a small Mississippi town. He had smiled at her and perhaps he whistled. Her husband and brother kidnapped Emmett a few days later, beat and tortured him, and then shot him and threw him in a river. But it was his image that made a lasting impression. His death became a national event when his body was returned to Chicago because his mother insisted on an open-coffin funeral to publicly expose his mutilated body and his bloated, water-soaked face. Thousands attended his funeral. Pictures of the open casket were printed in local and national newspapers and magazines, stirring outrage among Blacks and public sympathy and shock among many Northern whites.

Leanna, born in 1941 in the rural South, had grown up accustomed to discrimination. "I've experienced racism, you know, being in Texas and riding the back of the bus. Not being able to eat at places. Going to the movies, you had to go through the back." This was just part of the everyday. Yes, life was unfair and white people would cause you trouble, but it was the way of things. Until the death of Emmett Till. Leanna and her mother were struck with fear. His graphically portrayed death not only gave a face to the potential threat permeating Black lives but disclosed a world: not so much a new world as one that was hidden under the weight of its sheer ordinariness. His face—a singular ghost—exposed the possibility that lurked under the guise of routine racism. For Gigi and her children, it was a mirror that reflected a violent potentiality that should not be underestimated, where the small act of a child, a smile at the wrong time to the wrong person, could be lethal. A condoned violence, since Till's killers unrepentantly admitted what they had done and yet were pardoned by their all-white jury. But Emmett's face also disclosed a potential world that was not yet theirs, an imagined world, where a mother, though unable to protect her son, could still act in protest against racism.

Gigi lost no time. She too acted. She moved north, quickly finding work in Chicago, where she lived with her sister Gertrude. But it wasn't safe to bring her children. Gertrude was a "mean sister," violent with her own children and stepchildren. Gertrude didn't just spank them, she "whipped them." She even occasionally "beat her husband." "She was a bitch," Gigi summed up succinctly. To spare her children, Gigi had to send them two thousand miles away to Los Angeles where, for several years, they were raised by another sister.

THIRD IMAGE: THE UNTIMELY DEATH OF A DAUGHTER Camille remembers Nicholas's birth with horror. Charles had called her to the hospital. When she arrived, the doctor said he wasn't sure he could save both mother and baby. Camille remembers, anguished, that she wanted to tell the doctor, "Save Norinne," but she never managed to.

It happened, it was so fast we really thought both of them was gonna die. And the stuff they was pumping off of her stomach. It looked just like coffee grounds. It was dark, dark brown.

Norinne, like her mother, also had lupus. Two days after she gave birth, although she was still very sick, the hospital discharged her, keeping only Nicholas in the hospital. She went to stay with Camille but had to be rushed to the hospital after just two days at home. She went into cardiac arrest, fell into a coma, and died fifteen days later.

Charles also carries an image that he cannot seem to shake.

When I got down to the hospital, I remember going to the emergency room and she was sitting up, sitting on the gurney. And she had a look in her eyes like, she knew she was just sick . . . She was like scared to death. I just see fright all on her. So I was like "what's wrong?" And she's like "nothing." But I could see fear all in her eyes.

These unrelenting specters live on, shadowing the present with their own stubborn singularity. They are not so much perplexing as haunting, with all the uncanniness that Freud alerts us to.

Norinne had always been very sick, and as she grew into adulthood, she did not take care of herself. She was a "party girl," Camille and Charles said. She tried to hide her illness from others, avoided doctors, and did not take the medications that would have helped her. Camille hadn't even known Norinne was pregnant up until the time she gave birth:

When Norinne was pregnant, I didn't know she was pregnant. Charles pointed out to her, "See, your mother is looking at you funny . . . She really checks you out." So they thought maybe I was suspecting. But I didn't.

In fact, Camille was looking for marks on Norinne's legs, a sign that lupus was worsening. Norinne didn't tell her, she concludes, "because she knew I would get upset. And worried. I would." Only when Norinne was eight months along, and going into labor, did she call her mother, at Charles's urging.

Camille wonders why she didn't see this earlier. But she is clear that clinical neglect played a decisive role.

My feelings about what happened . . . Norinne did not have any insurance. Nothing. And they sent her home too fast from City hospital. That's what I know happened. It was all about money . . . she was so sick.

Camille could not save her only daughter's life. She could not even seem to speak up to ask that the doctor to save her daughter's life first. Remembering this moment, her voice drops to a whisper. She did not find a way to challenge the hospital when they sent her daughter home just two days later.

The Natality of Nicholas

Natality is part of historicity, O'Byrne notes. "We are natal, generational beings. . . . We are generated by our parents; we become a generation in the company of our contemporaries; we are capable of generating, in turn; we eventually pass away" (2010, 6). Natality, in this family, takes on a particular meaning as it is related to a history of racial violence and abandonment. To live generationally, if one belongs to a community in danger, is to live with trauma as it is passed down, relived, and recreated in new forms over generations. History has the capacity to haunt through the restless activity of unhappy ghosts who are not easy to lay to rest even if one wants to, or which should not be laid to rest—which we neglect at our peril (Derrida 1994; Gordon 2008).[11]

Three generations of dead children continue to haunt this family, though in very different ways. There are Gigi's dead brothers and sisters, including the six who died in childhood, almost forgotten, nameless. As a response to this moment from the first decades of the twentieth century, Nicholas offers a potentiality that could not be realized in Gigi's childhood. He offers the gift of a visible, cherished humanity. "He is a human like anyone else," a home health nurse once told me. For a Black child with this level of profound disability to be considered, by healthcare professionals, as a "human like anyone else" is a far cry from the attitude toward Gigi's siblings, who were deemed so little worth saving that there was no doctor to treat them when they fell sick.

In another era, at the dawn of the civil rights movement in the mid-twentieth century, there is Emmett Till, whose graphic images and widely circulated story suddenly refigures the experience of southern racism. A world is disclosed that is at once familiar and alien, not only discriminatory in the accustomed way but stunningly, capriciously dangerous even to children. Till's image prompts a reimagining of family life as Gigi flees her home. Care for children means losing her daughters. She can support them

only by living with her mean sister Gertrude and sending money for their care to another sister.

Norinne's death speaks to the racial dangers of yet another generation, those who came of age in the 1980s in cities like Los Angeles. Her death is also untimely. Like the other wrongful deaths from earlier generations, it discloses a tragedy that could have been averted. Camille is viscerally haunted when she speaks of losing a daughter who might have been saved if the hospital had responded differently, and if she—Camille—could have protected her. In the 1980s, Los Angeles was a party town and cocaine was a popular drug of choice, especially among the Hollywood elite. It was also a period of new traumas for African Americans. Industrial jobs that had once attracted migrations of Blacks from the South were virtually gone. Unemployment was high. South Central LA, once a vibrant home of African American arts and commerce, was deteriorating. But in the early eighties, it was decimated. Los Angeles became an epicenter of a cheaper street version of cocaine, "crack." Selling drugs was one of the few lucrative jobs. Gangs became more dangerous as they took on street distribution, battling for control of neighborhood territories. Young Black men became a focused target of a wave of mass incarceration and police brutality thanks to the infamous Reagan-era "war on drugs" that swept up many in its net, including Nicholas's father Charles.

The hospital's neglect of Norinne after childbirth can be contrasted with the kind of intensive medical care Nicholas receives, thanks in large part to the efforts of Leanna and Camille, who have become knowledgeable advocates skilled in navigating the bureaucratic mazes of clinical care. Camille's familial connections with Nicholas also differ dramatically from her estranged and difficult relationship with Norinne. Norinne avoids seeking care from her mother until it is too late. Nicholas, by contrast, offers the gift of receiving love and care. "He's such a happy baby," the women say. They work together to "anticipate what he wants, when he's cold, when he wants water," the music he likes. They are even chastised by his occupational therapists for being too quick at this, so that he doesn't learn how to ask for what he wants. Camille and Gigi do not tire of telling stories about his pleasure at their presence. He waits for them at night to come into his bedroom and when they call out his name, "Oh, he gets so happy. He starts moving his legs real fast," Camille reports with a smile.

CONCLUSION: AN IMAGISTIC ENTRANCE
INTO CRITICAL PHENOMENOLOGY

An imagistic approach to critical phenomenology provides a path for challenging portrayals of social life that reduce it to either the reproduction of cultural forms or the overdetermined effects of structural power and violence, while not dismissing either of these. The challenge, analytically, is how to refuse categorical reductions while still acknowledging that attention to categories of social difference is crucial. Feminist critical phenomenologists offer some direction. Guenther, for example, puts the problem this way. How does one reckon with the force of structural violence and its "token of a type" othering demarcations while also attending to a singular "otherness as a source of ethical command" (Guenther 2011, 196)? She argues that these two types of otherness require two distinct concepts: Otherness as political exclusion speaks to *difference*, which "refers to the multiplicity of relational, historically specific modes of differentiation"—in other words, difference as social positionality. Otherness as *singularity* or *alterity* directs us to a contrasting phenomenon: "a singular . . . otherness of one who remains irreducible to anything or anyone else" (196).

An imagistic approach suggests how a "singular otherness" can manifest itself in even the most quotidian ways. A momentary gesture, Camille's reverential reach toward a stack of towels, can open a world. In gestures like this, Nicholas emerged as a singular presence that suffused the life of this household. Even everyday objects, the food blender where his meals were carefully prepared (he could not swallow solid food), the many towels he required, were cherished vessels for his care. But the gift of his presence also pointed to a history that he interrupted. To reckon with the ethical power of this disruption, the analytics of singularity and social difference must be brought to bear. Both play a part in shaping why caring for Nicholas was so ethically consequential. It is against a historical backdrop of race and class violence that the stakes for this familial project are shaped.

History is not merely backdrop or prologue. It infuses the present with the ghosts of dead children. Their images continue to live in different ways: As *absences*. Children who can be counted but not named (six below). As an *iconic murder*, a child whose tortured death stirs a nation and leaves an imprint that Leanna cannot shake. As a daughter who dies too young, a *care-*

less ejection from the hospital while critically ill. What is born from these moments and their haunting images? One might say, an intimation of new worlds, children not yet born, lives not yet lived. A past that could have—should have—been otherwise. But what is also born from these images, quite specifically, quite singularly, is Nicholas and the family world his arrival begets. Nicholas as gift, as excess, as source of surprising joy. The infant Camille wanted to ask the doctors to sacrifice if this could save her daughter.

The imagistic approach I have sketched offers structural critique while insisting that experience exceeds generalizing categories, possessing a singularity and alterity that is irreducible. Thinking with perplexing or disorienting images can suggest this haunting irreducibility. Attention to singularity is not merely a matter of attending to the messy complexity of lived experience. It is about concept building, allowing singularities to disturb the doxa of our own taken-for-granted theories and frameworks. In the face of the event of Nicholas, Who is aging? What is care? What is a gift? Can natality, as interruption, as disruption, be a form of critique-in-action? By turning conceptual certitudes and social facts into conceptual perplexity, even well-worn concepts may be given a second birth.

Foucault famously registers critique as an excavation of *contingency* of forms of governmentality that are revealed (genealogically) as effects. As contingent effects, this discovery reveals an opening for a future, a not-yet. Through questioning history and its truth discourses, Foucault states, critique shows itself as "the art of voluntary insubordination" (1997, 47; Butler 2002). What can critical phenomenology teach us about the art of insubordination?

Consider how possibility, contingency, and critique manifest in the register of "straggling." This word was traditionally used among African American slave women in which "'straggle' had an invented meaning—not just to stray, as the dictionary would have it, but to struggle, strive, and drag all at once . . . persevering against the odds . . . imagining a better future and making your way" toward it (Miles 2008, 101–2). How might critique show up as straggling? Take the response of Nicholas's trio of mothers to his unexpected arrival. Their actions state: Nicholas will not die as his ancestors did, not if we can help it. He will not die by the same governance (as social abandonment) that led to so many child deaths in

his great-grandmother's time. Nor by white violence, as his grandparents were threatened when they were children, nor by care-less clinical abandonment as his mother was.

How will they "not be governed like that"? Not through any dramatic act of protest, but through steady efforts of care. Critique also involves experimentation. There are home-based clinical experiments as Leanna worked closely with the pediatric neurologist to discover the cause of Nicholas's seizures, shifting medications and diets as she created meticulous records documenting seizure patterns, food and medication intake. She and his doctor, trading notes and hypotheses, became co-experimenters. There are experiments in family configuration as Camille tried (ultimately failing) to bring Charles into their circle of family care. There are the sensory experiments in pleasure that all three women initiate. What pleases Nicholas? When does he light up? What provides him a sense of comfort and community—what gives him a relational world? "Touching noses" is a discovery. A bedtime ritual was once an experiment in connection.

These "straggling" efforts and experiments in natality are also critiques-in-action. They are refusals of a normative (white/ablest) gaze that would dismiss Nicholas as less than human, less worthy of care and cherishing, because of his disability and his race. Attending to small-scale acts and the unpresuming worlds they create demands a gaze that "open[s] out to life differently . . . allowing for a wider range of the tragic and the comic, the contestable and the forceful" (Singh 2014, 84). An analytics of the modest, the close-at-hand. The effects of these acts may be fleeting, taken one by one, but the practices that live on, through families, over generations, of experimenting, of straggling, can open up small spaces of alterity again and again. They may also be the very ground which—at certain historical moments—nurtures refusals that rise to large-scale projects of social reimagining.

I conclude with a final imagistic scene.

I once happened to catch sight of Nicholas and his family in a hospital corridor. They were impossible to miss. Two wheelchairs advancing slowly down the hallway side by side, one with Nicholas, the other with Camille. A home health aide pushing Nicholas. Leanna pushing Camille as Camille pulled her portable oxygen tank alongside her chair. This was the parade that regularly accompanied Nicholas on his visits to doctors and therapists. A mobile network of carers pushing and dragging—resolutely straggling—all at once.

ACKNOWLEDGMENTS

I want to thank the families who allowed me into their lives. Grant funding from VELUX FONDEN, the John Simon Guggenheim Foundation, and the National Institutes of Health (HD-38878) supported this work. I also thank the helpful comments from Fordham's wonderful editorial board and two reviewers. Special gratitude goes to Lisa Stevenson, Lone Grøn, Lotte Meinert, Rebecca Muller, Mary Lawlor, Anne O'Byrne, and Matthew Mccoy for their excellent comments and conversations that helped shape the many rewrites of this chapter.

NOTES

1. See, for instance, Moten 2018; Hartman 2019; Wynter and McKittrick 2015; Spillers 2003.

2. The context for my exploration is an ethnographic study of African American grandmothers (and other family elders) in Los Angeles who are the primary caregivers of children with severe impairments or chronic illnesses. My study of aging builds upon earlier, interdisciplinary and longitudinal ethnographic research that followed a cohort of nearly fifty African American families raising children with chronic illnesses and disabilities over more than fifteen years (Mattingly 2010, 2014).

3. According to the Weathering Hypothesis, negative effects of exposure to hazardous physical, social, and economic environments "accumulate over the lifespan and contribute to premature health deterioration" (Levine and Crimmins 2014, 27; Geronimus et al. 2006).

4. Quotations are from Hopp et al. 2012, 160; Mattingly 2010; and McMullen and Luborsky 2006, 435, respectively.

5. See, for instance, Coats et al. 2017, 639; Black 2012; Black et al. 2011; Fabius 2016; Lincoln, Chatters, and Taylor 2005.

6. See Shellman 2004, 313; McCoy 2011; and, for informal and intergenerational networks, Luckey 1994 and Fabius 2016.

7. For children's roles as helpers in elder care, see Stewart 2008, 77; Stack and Burton 1993.

8. I also build upon the critical phenomenology tradition in anthropology. (See, for instance, Desjarlais and Throop 2011; Throop 2018; Zigon 2019.)

9. Notably, McKearney found that institutional carers of people with profound cognitive disabilities who "inhabit the world in a different way" described providing care as a gift they received (2018, 41; see also Grøn, this volume). McKearney points to a large body of (mostly theological) literature that sees moral value as something

"given to us by others" and in the institutional communities he studies, this gift of moral value is bestowed on the carers by those they care for. There is much that resonates with Levinas's reversal of responsibility.

10. Natality is one of the richest concepts in the phenomenological lexicon, articulated most influentially by Arendt. While phenomenology has primarily emphasized finitude or "being-toward-death," Anne O'Byrne, following Arendt, states that it is the "natal character of our finitude that leads us to renew the world" (2010, 12).

11. Whether ghosts are real or metaphorical, their appearance reveals the co-presence of a living past that is not finished but makes demands on the present. Unhappy ghosts—those who have not died properly or justly—may require specific appeasement. Or, they may require "the mobilization of [societal] outrage . . . [a] remembrance of atrocities" (Lincoln and Lincoln 2015) and a "call to fight on behalf of the dead against those who sought to erase them" (Gordon 2008, 67; Lincoln and Lincoln 2015, 195; Good 2020).

REFERENCES

Arendt, H. 1958. *The Human Condition*. Chicago: University of Chicago Press.

Black, H. K. 2012. "The Influence of African American Elders' Belief Systems on Health Interactions." *Journal of Religion and Spirituality in Social Work: Social Thought* 31 (3): 226–43.

Butler, J. 2002. "What Is Critique? An Essay on Foucault's Virtue." In *The Political: Readings in Continental Philosophy*, edited by D. Ingram, 212–26. London: Blackwell.

Coats, H., et al. 2017. "African American Elders' Serious Illness Experiences: Narratives of 'God Did,' 'God Will,' and 'Life Is Better.'" *Qualitative Health Research* 27 (5): 634–48.

Desjarlais, R. 2019. *The Blind Man: A Phantasmography*. New York: Fordham University Press.

Desjarlais, R., and J. Throop. 2011. "Phenomenological Approaches in Anthropology." *Annual Review of Anthropology* 40:87–102.

Fabius, C. D. 2016. "Toward an Integration of Narrative Identity, Generativity, and Storytelling in African American Elders." *Journal of Black Studies* 47 (5): 423–34.

Foucault, M. 1997. "What Is Critique?" In *The Politics of Truth*, edited by S. Lotringer, 41–81. Los Angeles: Semiotext(e).

Gadamer, H. G. 1975. *Truth and Method*. Translated by J. Weinsheimer and D. Marshall. 2nd ed. New York: Continuum, Seabury Press.

Geronimus, A. T., et al. 2006. "'Weathering' and Age Patterns of Allostatic Load Scores among Blacks and Whites in the United States." *American Journal of Public Health* 96 (5): 826–33.

Glissant, É. 1997. *Poetics of Relation.* Ann Arbor: University of Michigan Press.

Good, B. J. 2020. "Hauntology: Theorizing the Spectral in Psychological Anthropology." *Ethos* 47 (4): 411–26.

Gordon, A. F. 2008. *Ghostly Matters: Haunting and the Sociological Imagination.* Minneapolis: University of Minnesota Press.

Guenther, L. 2006. *The Gift of the Other: Levinas and the Politics of Reproduction.* Albany, N.Y.: SUNY Press.

———. 2011. "The Ethics and Politics of Otherness: Negotiating Alterity and Racial Difference." *philoSOPHIA* 1 (2): 195–214.

———. 2013. *Solitary Confinement: Social Death and Its Afterlives.* Minneapolis: University of Minnesota Press.

Hartman, S. 2019. *Wayward Lives, Beautiful Experiments: Intimate Histories of Riotous Black Girls, Troublesome Women, and Queer Radicals.* New York: Norton.

Hopp, F. P., N. Thornton, L. Martin, and R. Zalenski. 2012. "Life Disruption, Life Continuation: Contrasting Themes in the Lives of African-American Elders with Advanced Heart Failure." *Social Work in Health Care* 51 (2): 149–72.

Jackson, M. 1998. *Minima Ethnographica.* Chicago: University of Chicago Press.

Levinas, E. 1985. *Ethics and Infinity: Conversations with Philippe Nemo.* Translated by R. A. Cohen. Pittsburgh: Duquesne University Press.

Levine, M. E., and E. M. Crimmins. 2014. "Evidence of Accelerated Aging among African Americans and Its Implications for Mortality." *Social Science and Medicine* 118:27–32.

Lincoln, K. D., et al. 2005. "Social Support, Traumatic Events, and Depressive Symptoms among African Americans." *Journal of Marriage and Family* 67 (3): 754–66.

Lincoln, M., and B. Lincoln. 2015. "Toward a Critical Hauntology: Bare Afterlife and the Ghosts of Ba Chúc." *Comparative Studies in Society and History* 57 (1): 191–220.

Luckey, I. 1994. "African American Elders: The Support Network of Generational Kin." *Families in Society* 75 (2): 82–88.

Mattingly, C. 2010. *The Paradox of Hope.* Berkeley: University of California Press.

———. 2014. *Moral Laboratories: Family Peril and the Struggle for a Good Life.* Berkeley: University of California Press.

———. 2019. "Defrosting Concepts, Destabilizing Doxa: Critical Phenomenology and the Perplexing Particular." *Anthropological Theory* 19 (4): 415–39.

McCoy, R. 2011. "African American Elders, Cultural Traditions, and the Family Reunion." *Generations* 35 (3): 16–21.

McKearney, P. 2018. "Receiving the Gift of Cognitive Disability: Recognizing Agency in the Limits of the Rational Subject." *Cambridge Journal of Anthropology* 36 (1): 40–60.

McMullen, C. K., and M. R. Luborsky. 2006. "Self-Rated Health Appraisal as Cultural and Identity Process: African American Elders' Health and Evaluative Rationales." *The Gerontologist* 46 (4): 431–38.

Moten, F. 2018. *The Universal Machine.* Durham, NC: Duke University Press.

O'Byrne, A. 2010. *Natality and Finitude.* Bloomington: Indiana University Press.

Pandian, A. 2019. *A Possible Anthropology: Methods for Uneasy Times.* Durham, NC: Duke University Press.

Raffoul, F. 2010. *The Origins of Responsibility.* Bloomington: Indiana University Press.

Ralph, L. 2014. *Renegade Dreams: Living through Injury in Gangland Chicago.* Chicago: University of Chicago Press.

Revell, M. A., and M. N. McGhee. 2012. "Evolution of the African American Family." *International Journal of Childbirth Education* 27 (4): 44–48.

Sharpe, C. 2016. *In the Wake: On Blackness and Being.* Durham, NC: Duke University Press.

Shellman, J. 2004. "'Nobody Ever Asked Me Before': Understanding Life Experiences of African American Elders." *Journal of Transcultural Nursing* 15 (4): 308–16.

Singh, B. 2014. "How Concepts Make the World Look Different: Affirmative and Negative Genealogies of Thought." In *The Ground Between: Anthropologists Engage Philosophy,* edited by V. Das, M. D. Jackson, A. Kleinman, and B. Singh, 159–87. Durham, NC: Duke University Press.

Spillers, H. J. 2003. *Black, White, and in Color: Essays on American Literature and Culture.* Chicago: University of Chicago Press.

Stack, C. B., and L. M. Burton. 1993. "Kinscripts." *Journal of Comparative Family Studies* 24 (2): 157–70.

Stevenson, L. 2014. *Life beside Itself: Imagining Care in the Canadian Arctic.* Berkeley: University of California Press.

Taylor, C. 2005. "Lévinasian Ethics and Feminist Ethics of Care." *Symposium* 9 (2): 217–39.

Throop, J. 2018. "Being Open to the World." *Hau: Journal of Ethnographic Theory* 8 (1–2): 197–210.

Wynter, S., and K. McKittrick. 2015. "Unparalleled Catastrophe for Our Species? Or, to Give Humanness a Different Future: Conversations." In *Sylvia Wynter: On Being Human as Praxis,* edited by K. McKittrick, 9–89. Durham, NC: Duke University Press.

Zigon, J. 2019. *A War on People: Drug User Politics and a New Ethics of Community.* Berkeley: University of California Press.

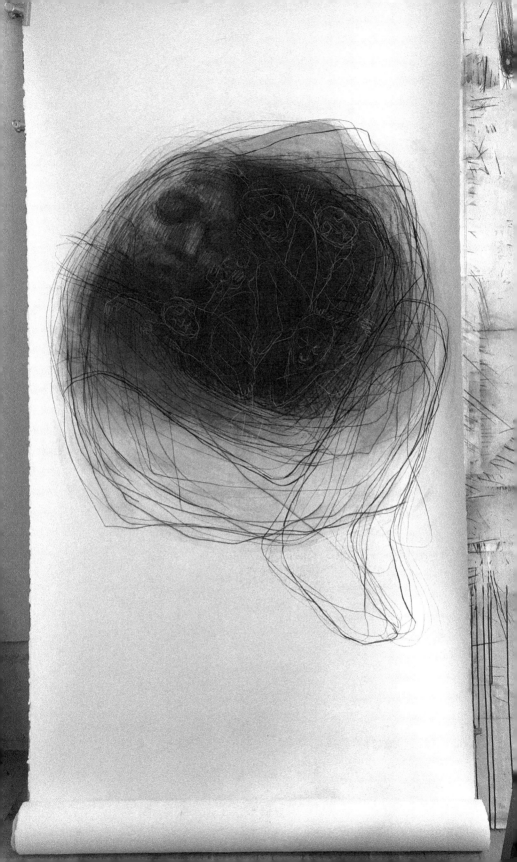

With Unlived Lives
layers of dust
She does not mention her sons
silent . . . unable to live . . . the absence of others
ghosts . . . spirits . . . settle
invisible . . . so much more
presence . . . of their absence
but for bodies that are failing
now found herself alone
What . . . *could* I have . . . if
When she was young, she remembers
She wants to create . . . beautiful
you are so precious to me
A pattern . . . repeated
maintaining, continuing . . . repairing
what . . . someone is or should be
spirits . . . communicate with the living . . . insist
"I live with them," she said
barely visible to others
bursting with unlived lives

Overleaf: Figure 1. Drawing for Maria Louw, *With Unlived Lives,* charcoal and chalk, 2020, 450 × 115 cm (section)

VIRTUOUS AGING IN UNCANNY MORAL WORLDS

Being Old and Kyrgyz in the Absence of the Young

MARIA LOUW

My body is too tight for my soul.

—TAJINISA, MARCH 2020

DUST

"Don't worry, everything is clean," Tajinisa says as she places teacups and small bowls with jam, honey, and sweets in front of my field assistant Aizat and me after having moved away scraps of paper—notes, bills, prescriptions from the doctor—from the table and the couch where we are seated.[1] Aizat sneezes. And sneezes again. Her eyes turn red. Thick layers of dust cover most of the surfaces in Tajinisa's apartment. Piles of stuffed plastic bags fill up the living rooms, the kitchen, and the hallway. Carpets and mattresses are invaded by moths. In the adjacent room—even more impassable than the one we are seated in—a cupboard is decorated with childhood pictures of Tajinisa's children, also covered by dust. She rarely talks with the children, she says. Her two daughters migrated to Europe. They became like Russians, she says, and never married. She does not mention her sons.

As we sit and talk, the room gets darker. It is lit only by the daylight that enters through her balcony's broken windows. A writing table beside the window in the living room is packed with plants. Tajinisa says that she enjoys taking care of the plants, but when she is hospitalized, as she often is,

suffering from chronic bronchitis and heart problems, they tend to wither. In winter it gets cold in here. Sometimes she has to go and sleep in cafés to keep herself warm. She tells us that she bought the apartment when she moved to Bishkek together with her husband and four children. They were poor; Tajinisa's husband studied for his doctoral degree in *onomastics* (the study of names), and she provided for the family, teaching handicrafts and selling cigarettes and liquor in the street. She got up at four o'clock in the morning to cook for her family to give them the energy to study well at school and at the university. She made clothes for her children by hand as they could not afford to buy them. Her husband used to say that things would improve when he finished his doctoral degree. But then all of a sudden, he married another woman. That was around 2000, when she was fifty years old.

This chapter focuses on people in Kyrgyzstan who grow old in the absence of their close family and spend the last part of their lives in homes made uncanny by their absence: homes covered by thick layers of dust, homes that are eerily silent, and homes filled with the haunting presence of lives the elderly people are unable to live in the absence of others. With a point of departure in a concept of care that sees it as confirming or creating the presence of something or someone in a moral world, I will argue that a central concern of the elderly is how to patch up a moral world where there is room for the virtues the absence of others has made homeless; a world where such virtues can be present. Focusing on how, in the homes of the elderly, the ghosts of the past may settle, serving as caring hinges to these unlived lives and virtues and as accomplices in the patching up of broken moral worlds, in conclusion I will argue that both understanding and caring for the elderly and their worlds demand taking imagistic steps into the realms of the invisible, the spectral, and the possible. Understanding and caring for them demand that we recognize that being is so much more than what actually unfolds; that the world of the empirical, as Anand Pandian has put it, is "more elusive than the givenness of the here and now, its actuality always open to critical shades of virtual presence and possibility" (Pandian 2019, 17; cf. also Desjarlais 2019, ix; Mattingly 2014, 9, 28).

What, then, does it mean to take "imagistic steps"? It means, I will argue, to follow the openings to other worlds that images present us with. In my use of the term "image" I am inspired, notably, by Lisa Stevenson (2014)

who, in a discussion of "images as method," has suggested that what is peculiar about images is that they, rather than being straightforward representations, "express without formulating" and "drag the world along with them" (13). As such, they often appear as puzzles that leave us in doubt. On the other hand, in all their ambiguity, sometimes they may better capture the richness and density of experience: "We do not always want the truth in the form of facts or information; often we want it in the form of an image. What we want, perhaps, is the opacity of an image that can match the density of our feelings. We want something to hold us" (Stevenson 2014, 13). Building on Stevenson's insights, I see images, not as representations of worlds, but as openings toward worlds. Images as openings toward worlds become particularly important when the worlds we seek to understand are spectral and blur the distinction between the actual and the imaginary, as the worlds of my interlocutors often did: they were worlds of possibility; worlds that could become and worlds that could have been if circumstances had been different. Worlds that were hardly observable and often seemed to resist articulation, but nevertheless meaningful worlds in which it was possible to dwell and live the virtues the world of the actual had made homeless.

First, let me situate the argument in the broader context of Kyrgyzstan and the recent developments which, for a growing group of elderly people there, have meant that they spend their old age in the absence of the younger generations.

BEING OLD AND KYRGYZ IN THE ABSENCE OF THE YOUNG

In Kyrgyzstan, a good life as an elderly person has traditionally and normatively been defined in relation to the extended family as well as the wider local community. Being an "elder" requires more than being of a certain age: as they grow older, people are supposed to gradually learn to comply with "elderliness" in expected ways, most notably through the performance of high moral integrity and authority, for instance, through the mediation of conflicts; the passing on of advice; the giving of blessings and moral education to family and members of the larger community, and taking decisions in regard to family property (cf. Beyer 2010 and 2013; Dubuisson 2017, 6–7, 25–28; Ismailbekova 2014). Younger family and community members, in

turn, are expected to help and provide for the elderly, economically and practically, and to treat them with care and respect. Such relations of obligation between the generations are perceived to be an ethnic, and religious, marker, often seen in contrast to the perceived neglect of Russian elders and notions about life in "America" and "Europe." Normative notions about elderliness are thus intimately bound up with normative notions of being Kyrgyz and being Muslim (cf. Dubuisson 2017, 55).

Such normative notions about elderliness have been increasingly challenged. They have been challenged by general social changes in the aftermaths of the breaking up of the Soviet Union—which not only was the dissolution of an empire and a political system, but also meant that large parts of what whole generations had learned about life seemed increasingly irrelevant to the lives their children and grandchildren came to live and to strive for. People may not necessarily have been particularly devoted to communism or Soviet ideology more generally—but nonetheless, to many, what disappeared with the Soviet Union was a whole way of life with a range of possibilities for life trajectories, and with ideas of what was meaningful, virtuous, and admirable (cf. Lear 2006): a way of life which has been replaced by something that still seems a mystery to many of the older generation, although they know the terms people use to describe it: independence, market economy, liberalism, democracy.

Normative notions about elderliness and relations between generations have also been challenged, as more elderly people have been left behind by their families and relatives, among other reasons because of the large-scale migration of the working-age population that followed from the economic crisis that hit post-Soviet Kyrgyzstan.[2] This has bereft the elderly not only of vital social and economic support in a context where pensions do not cover basic needs, and where the unravelling of socialist infrastructures and securities left those without a strong social network highly vulnerable (cf. Dubuisson 2017, 11–12), but also of the intersubjective relations in which elderliness and its virtues are traditionally experienced, performed, and acknowledged.

In the project this chapter is based on,[3] my focus has been on elderly people in Kyrgyzstan who become old in the absence of younger family members: some because of labor migration; others because they divorced and lost contact with their children, or because their children were taken away from them; some because their children died; and others because they

never had any children. I have explored how they experience becoming old, and how they live and redefine elderliness and its moral virtues.

VIRTUOUS AGING IN THE ABSENCE OF INTIMATE OTHERS

As Mikkel Bille et al. have convincingly argued in their introduction to *The Anthropology of Absence* (Bille, Hastrup, and Sørensen 2010, 4), phenomena may have a powerful presence in people's lives precisely because of their absence. Absent younger relatives indeed often have a very strong presence in the lives of Kyrgyz elderly people who grow old without them. Absent relatives are most obviously present in the ways the homes of the elderly are transformed into uncanny spaces that stand in stark contrast to the usually flawless rooms that meet guests when they are received in Kyrgyz homes. In Tajinisa's apartment all sorts of unwanted beings and substances had settled. The absence of her relatives was felt in the layer of dust that was not wiped away, in the accumulating piles of plastic bags, in the invasion of moths, in the withering of her plants, in the darkness of the living room and in the bitter cold that crept in through her broken windows during winter.

In other cases, the uncanniness may be less obvious: the home spaces in themselves may seem welcoming to the visitor, but for bodies that are failing—and in the absence of the care that could make up for the failing—they are experienced as full of hidden dangers. Take Gulbara,[4] for example: an elderly woman who lived by herself in a little house in the outskirts of Bishkek. After a long life that had been dedicated to the care of others—her mother died when Gulbara was a teenager and after that she took care of her seven younger siblings—Gulbara now found herself alone. All her siblings had died. Her husband had died. She never had any children of her own except for one whom she gave birth to when she was a teenager and who died as an infant. And her nieces and nephews never visited her: "They do not come and drink tea; they do not ask how I am doing." In spite of being nearly deaf and blind, Gulbara managed by herself. Other *babushkas* she knew of had children and grandchildren who would help them cook, eat, wash, and go to the bathroom, and that made them weak. Doing her housework, Gulbara pointed out, kept her from aging too fast. But her senses started failing her. She laughingly pointed out that neither of her husbands (she had been married twice) had ever laid a hand on her, but now the walls

of her house had started beating her—and demonstrated how she would bump into the walls because her failing vision made orientation difficult in her home.

Absence of significant others—the ones who would have filled the house with noise; who would have helped them to their feet if they fell; who would have helped remove the dust, the moths, and the plastic bags, and who would have paid the bills and fixed the windows so that the house would have remained warm during winter—also meant an absence of particular versions of the elderly themselves, the presence of unlived lives (cf. Phillips 2012) which indeed hinged on the existence of intimate others who were absent. What kind of elder *could* I have become if my children were not absent? If my partner had not died or left me? Haunting reminders of virtuous elderly lives and, more generally, of the relational constitution of virtues as such.

Notions of virtue imply some notions of selfhood as the seat of ethical character and the agentive locus of ethical action (cf. Dyring et al. 2017, 11). As Sara Ruddick has pointed out in one of her important contributions to feminist philosophy, virtues are commonly represented as characteristics of individuals (whether as states, dispositions, capacities, or traits of character), but are created between people and inseparable from relationships (Ruddick 1999, 51–53; see also Mattingly and McKearney forthcoming). This is generally so: the relational quality pertains to virtue at any age, "but it may be especially evident in the moral lives of the elderly, and of young children and their parents" (Ruddick 1999, 53). A person, that is—in this case an elderly person—is able to perform high moral integrity and authority only if she can create the occasions, with others, for doing so; if, to stay within the context of Kyrgyzstan and common ideas about what it means to be a virtuous elder, there are others who willingly listen to her moral advice and gratefully receive her blessings—and who care for her to compensate for what may be her physical frailty. Without caring relationships, virtues become homeless, so to speak.

Seeing social relationships as constitutive of personhood is, of course, not new to anthropology. Nonetheless, in recent anthropological approaches to ethics there has been a pronounced tendency to focus on the individual as the site and object of ethical work. Many have found inspiration in Foucault's understanding of ethics (Foucault 1990) and focused on self-formation and self-care in relation to discursive regimes of power (see, e.g., Faubion 2001, 2011; Hirschkind 2006; Laidlaw 2012; Mahmood 2005; Robbins 2004), or

on how individuals aspire in terms of various moral registers or models (Rasanayagam 2011; Schielke 2009, 2015). What approaches such as these tend to miss, however, is how humans are interdependent beings who care for and care about others (cf. Mattingly 2014), and who respond to each other and are involved in each other's lives in ways that are not easily captured through a focus on self-formation. The elderly I focus on do obviously engage in practices of self-care in the absence of the care of others, but these practices seem rather different from what Foucauldian perspectives tend to focus on. They are not so much oriented toward a particular telos, or at building up virtuous characters, but rather at the patching up of a world the absence of others has left damaged: a world their sense of self and what it means to be a virtuous elder are intimately connected with—a patching up of a world for their virtues through acts of care.

THE COLOR WHITE

"You are the very first guests I have received this year!" Tajinisa says before disappearing into the kitchen where she is preparing *plov* (pilaf) for us and where she starts searching among the many piled-up plastic bags: she bought a new pair of slippers the other day because she knew we would be coming, she explains, but now she does not remember where she put them. She apologizes and brings us some of her own slippers instead: it is January and cold, and she does not want us to sit there with cold feet. "The new year started well, with guests! I love to receive guests!" She changes her dress: puts on a white shirt, a white scarf and a pink knitted waistcoat. Her favorite color is white, she says. It is pure, clean. She remembers a picture that was taken when she was a schoolgirl, at some point during the years after World War II. Times were tough; many men—fathers, sons, brothers—had not returned from the war. All the children in the picture were wearing old and dirty clothes—except her; her shirt was white and impeccably clean. She finds the picture and shows it to us, her fingers running over it as if caressing it, bringing her in touch with the child she was, and I notice the dresses that hang on her wardrobe: white dresses, clean and ironed, in the midst of the chaos and decay that is her home. The childhood picture becomes an image, and the color white becomes an image: openings to a world of beauty and cleanliness that is also Tajinisa's. When she was young, she remembers, she had a lot of talents. She had a beautiful voice; she made

things with her hands; and she wrote songs and poems. She still does, when she has the time and energy. She searches among the plastic bags again; the dust swirls up around us as she pulls out knitworks, handmade rugs and carpets, feltworks, and embroidered pillowcases from some of the bags: one beautiful and carefully crafted piece after the other. She has a project, she says. She does not want the kind of life she has lived to repeat after her. In Kyrgyz culture, she explains, there is the idea that when two young people marry, during the first forty days of their marriage they have an invisible veil between them. If they insult each other, talk badly to each other—or even if they merely think badly about each other—the veil will break, and it will be difficult for the couple to live together. For forty days the veil should be kept undamaged; after this, it will be very difficult to break it, and the foundation of the marriage will be very strong. She wants to create a beautiful house for newlywed couples where they can stay for the first forty days of their marriage. For forty days they should stay there, surrounded by beautiful things, and served the most delicious meals—all this to help them not to say any bad words to each other, not to quarrel with each other. Then their marriage will be blessed; they will stay together and live in peace.

Family is a precious thing, she emphasizes. When her grandmother got married, she had several miscarriages. According to Kyrgyz custom, then, she took a bag and knocked on all doors in the village to ask people to pray to God for a child. Also her father—who was eventually born—had difficulties conceiving children when he grew up and married: it took seven years before Tajinisa was born. "When I grew up, my grandmother told me that she prayed to God with her tears. 'I bought your father and you from God with my tears. Your soul is in my liver; you are so precious to me that I would sacrifice my life for you.'" She shows us a small amulet she has sewn, with patchwork depicting a star in red, blue, and green cloths. Previously, for their Kyrgyz ancestors, it was a tragedy if a couple divorced, she explains. In order not to divorce, the couple would mix blood from their fingers. The red color symbolizes the mixing of blood as well as the love of the mother. The green color stands for the life given by the father, and the blue color stands for the child—a pattern that should be repeated generation after generation, but that has been forgotten among many Kyrgyz today, including her own children.

Such is Tajinisa's project: a project that works through the moving force of beauty, the sense of which runs through her family line and that she has

somehow managed to keep intact through all these years where other concerns have kept her busy. She is unsure, however, how she is to accomplish it: which government office she should go to, or which businessmen she should approach. Once, she went to the ministry of culture, but they did not let her in. Maybe, she reasons, it could be done through the internet, but she does not know how, and her children do not want to help her. They have different ideas about life, she says.

Tajinisa, in other words, was looking for a home, a world, for her virtues; a world through which she could live and pass on moral values and knowledge to the younger generations. In fact, as I will argue, she was patching up such a world, felting, sewing, and weaving; watering her plants and buying slippers for the rare guests in her home; in short, through acts of care. If images are openings to moral worlds, I will argue, acts of care draw the contours of worlds and are indeed worldbuilding. Indeed, it is impossible to conceive of moral worlds without conceiving what it means to care—and vice versa.

CARE AS WORLDBUILDING

The concept of care connotes a broad range of experiences and practices, from the more pathic experience of being moved by or concerned with something—and thus involved—to efforts at making that something into what one thinks it should be; or, in the words of Arthur Kleinman and Sjaak van der Geest, from the more technical meaning of carrying out activities for others who may not be able to do them alone to the more emotional meaning of concern, dedication, and attachment (Kleinman and van der Geest 2009, 159). But basically, it is a concept that puts "emphasis on interconnection and interdependency" "as the ontological state in which human beings and countless of other beings unavoidably live," as María Puig de la Bellacasa has put it (2017, 4), and that "we are, above all, relational beings and that our very survival, as individuals and as a species, depends upon giving and receiving care," as Cheryl Mattingly and Patrick McKearney have put it in a discussion of feminist care ethics and its claim that "care is not merely one ethical concern or good, among others, but the ontological ground of ethics" (forthcoming).

Care, however, has been relatively marginal to moral theory and, as Joan Tronto convincingly argued in her classic contribution to the ethics of care,

Moral Boundaries: A Political Argument for an Ethic of Care (2009 [1993]), has led a barely visible existence in Western political and philosophical thinking, as well as in social life as such. Care work, in most societies, is distributed by gender and class, and often by race and ethnicity as well, and values associated with caring—attentiveness, responsibility, nurturance, compassion, meeting others' needs—traditionally associated with women have most often been excluded from public consideration (Tronto 2009, 2–3), variously idealized and denigrated, and "for the most part, questions of natality, mortality, and the needs of humans to be cared for as they grow up, live, and die, have not informed the central questions of philosophers" (3; cf. also Puig de la Bellacasa 2017, 10–11).

In her book, Tronto proposes this definition of care—one she developed with Berenice Fisher: "On the most general level, we suggest that caring be viewed as a species activity that includes everything that we do to maintain, continue, and repair our 'world' so that we can live in it as well as possible. That world includes our bodies, our selves, and our environment, all of which we seek to interweave in a complex, life-sustaining web" (Tronto 2009 [1993], 103). I find Tronto and Fisher's definition inspiring in the way it points, not to the self, but to "our 'world'" as the site of ethical work. But the definition also raises a lot of questions: What is a "world"? And what does the "our" in "our world" refer to? How does it feel to be included in a "world" through care? Is the world that includes me also "our" world from my perspective? What kind of "world" is Tajinisa maintaining, continuing, and repairing, using her sparse energy to sew an amulet that may inspire others not to live the kind of life she has lived? Do others want to be included in this world? Does it matter to her world if others want to be included in it or not?

My intention here is not to go into deeper ontological debates about the nature of (human) worlds (see Piña-Cabral 2014a and 2014b for a discussion of the ways the concept has been engaged by anthropologists). Instead, I wish to proceed from the basic proposition that care—ex- or implicitly—always and necessarily comes with a "world"; a world which is a moral world in the sense that it comes with a larger context or horizon of meaning—an orientation to the good (Robbins 2013) or to *eudaimonia*, to (human) flourishing[5]—to which it seeks to connect the object of care. Such a moral world does not necessarily consist—perhaps even rarely consists—of a clear and

coherent worldview. Very often, it appears as something fuzzier, or a sense that something is "wrong," that a world needs repair, rather than a clear idea of what has to be done to repair it. Sometimes the very act of care may even bring up the nature of such a "world" as a pressing existential question, for the caregiver as well as the care-receiver alike, as when Tajinisa politely, but persistently, refused to let Aizat and me help her clean up her apartment, and we were left wondering what, then, it could mean to care about Tajinisa and her world, and what it would mean to her to flourish.

In that sense, care is worldbuilding and world-repairing, and very often world-questioning, and as such there is always a kind of subjunctive quality to it, even in its most ordinary forms; a way into the space where the actual meets the possible. Caring for someone implies an idea, however vague and incoherent, of what that someone is or should be, and that idea does not necessarily match easily with what that someone thinks he or she is or should be. And just as the absence of care may undo (cf. Puig de la Bellacasa 2017, 1), deny the presence of a person in a world, care may be destructive of agency and selfhood, presencing forth a version of a person that person cannot identify with and a "world" that person does not want to live in. Just as care should be rescued from its marginalization in ethical theory, so it should be rescued from what has equally often been its idealization; the normative undertones that tend to associate it with positive outcomes. There is always the risk, as Emmanuel Levinas has taught us, that responding to the ethical demand of the other reduces the other to a token or type, doing violence to the singularity of the other (Levinas 1969; see also Rasanayagam 2017). Care can do good—and it can oppress and convey control (Puig de la Bellacasa 2017). We exist (socially) through acts of care—but we may also be destroyed through acts of care, and sometimes the distinction between what makes us exist and what destroys us is not very clear. The lack of care helped Gulbara to stay fit, but fit for what and for whom?

With these reflections in mind I would like to give Tronto and Fisher's definition a twist, suggesting that we may see caring as a way of presencing forth something or someone (through affection—emotional stances or attitudes—or more concrete actions); of confirming or creating the presence of something or someone in a moral world—the nature of which is, at the same time, brought up for reflection: What kind of "world" is it that is being maintained, continued, and repaired through this particular kind of

care? What defines this world? Shared values, shared history, a shared situation, or something entirely different? And what is the nature of our involvement with each other in this world?

IN THE COMPANY OF CHINGGIS AITMATOV

Tajinisa pulls out a faded newspaper clipping from a plastic bag: a tribute to Chinggis Aitmatov, the famous Kyrgyz writer, written by her and published in the newspaper upon his death in 2008. She tells us that she has seen Chinggis Aitmatov several times in her dreams. After he died, he came to her, kissed her cheeks, and gave her his hand. That was an *ayan*, an omen: the channel through which ancestor spirits most often communicate with the living, giving them signs, warnings, and advice and insisting on being remembered (Louw 2010; Dubuisson 2017). She usually celebrates his birthday, on December 12.

She does some writing herself, mainly poems, but she is not a true poet, she says: to be that, you need to read a lot, but she does not read. She gets her ideas when she is waiting for the bus or doing something else; they come from her heart and are about her experiences. She does not, however, love her writing as much as she loves her needlework: when she sews, embroiders, weaves, or felts she forgets everything around her; she disappears into a world of beauty.

Such talents run in her family. Her father was also very talented; he built his own house, decorating it with beautiful ornaments carved in wood. When he finished school, he wanted to study at the university, but his mother did not allow him to leave the village, being afraid that she would die in his absence. And then he stayed at home and started to build his house. Also her great-grandfather was a well-educated man. Once she had an *ayan* where he came to her and gave her a leather bag and other things. Receiving things from him was a blessing.

Chinggis Aitmatov also came to her in her dreams when he was alive. Once he came when she was pregnant with her youngest son—and later, the son went to school with one of Chinggis Aitmatov's grandchildren. But her son, she says, does not understand her and her project. Last time he visited her, he made a scene; threw out her notes and her things. She wanted to call the police, but he had already told the police that she was crazy, and they would not have believed her.

Among the Kyrgyz, the *arbak*, ancestor spirits, remain involved in the world of the living, following the lives of their living relatives and often seeking to interfere with them (Dubuisson 2017; Louw 2010). There are certain elements that serve as meeting points between the living and the dead. Dreams, for example. Candles. Or certain smells. Words read from the Qur'an. But basically, what ancestor spirits demand is to be remembered and cared for, to be included in the worlds of the living.

Tajinisa's story is not unique. As I have learned, the spirits of the past often settle in the homes of elderly people who become old in the absence of their families, being uncanny hinges to lives they could have lived and persons they could have been—and thus involved in the patching up of broken moral worlds. Ghosts become imagistic presences, which question common distinctions between the actual and the imaginary and offer openings into the moral worlds of the Kyrgyz elders. Gulbara—whom I mentioned earlier—devoted many thoughts to those who had died who had a very vivid presence in her home and her life. "I live with them," she said. They came to her in her dreams, giving her *ayan*, omens, and advice about what to do. When she was ill, they would come to her and encourage her to persevere: "eat well," "rest well," they would say. Sometimes they would sleep in her house, taking a nap and leaving again. They would come and drink tea. She had recently put up a bed for her husband in her little kitchen, as this was the place he preferred to sleep when he visited her.

In order to understand what is often the central role of the ancestor spirits in the lives and worlds of elderly Kyrgyz who grow old in the absence of their living relatives, I have found inspiration in Lisa Guenther's critical phenomenological explorations of the relationality of human existence, the lived experience of being-with. In her book *Solitary Confinement: Social Death and Its Afterlives* (2013), Guenther examines experiences of solitary confinement in America and reflects on what such experiences may tell us about what it means to exist socially, and what the connection is between our relations with others and our perception of the world and our subjectivity. She tries to show that a good deal of what we take to be our own, intrinsic properties are social practices that rely on interaction with other social beings; that subjectivity should be seen not as a point but a hinge, "a self-relation that cannot be sustained in absolute solitude but only in relation

to others" (xiii). Isolated from others, people's sense of who they are, of their bodies, and of the time and space they move in, may erode: "They see things that do not exist, and they fail to see things that do. Their sense of their own bodies . . . erodes to the point where they are no longer sure if they are being harmed or are harming themselves" (xi).

The Kyrgyz elders I focus on are not isolated from others as such. Tajinisa, for example, emphasized that she enjoyed good relations with her neighbors. However, the people she had defined herself and her life in relation to—those with whom her existence had been hinged and in relation to whom virtue among the elderly is primarily defined—were absent, and that very likely also contributed to creating what may be described as an increased porousness of the self (Taylor 2007) or sensibility to the spectral dimensions of the world. Unlike the persons Guenther focuses on, the Kyrgyz elders inhabit a world in which beings do not necessarily have to be visible to others in order to "exist," where ghosts are often recognized and cared for and seen as just as important parts of social worlds as the living, and where certain people are known to possess the gift of being porous and responsive to them (Louw 2019).

Tajinisa and Gulbara were hinged with the ancestor spirits—and those hinges allowed them to be other—more virtuous—versions of themselves than the versions they were able to live in the company of the living. The spirit of Chinggis Aitmatov allowed Tajinisa to partially live the artistic self her life had not allowed her to live, and which, to the living, was hidden behind the dust and the garbage that filled her rooms. Also, Gulbara's ancestor spirits presented forth a more virtuous version of herself than she was able to live in the company of the living: welcoming visitors to her home and being asked about how she was doing; being generous and receiving care, as elderly are supposed to do. Simple and everyday acts of care and concern that were both ordinary and essential to her sense of self.

Real as they were to Tajinisa and Gulbara (cf. Orsi 2016), however, no one else saw or sensed the spirits. Although *arbak* are widely recognized in Kyrgyz culture, people's experiences with them are not always recognized by others. There is often a very fine line between being seen as open and sensitive to the worlds of the invisible and being seen as mentally ill (Louw 2019), and dreams that are seen as *ayan* by one person may be seen as meaningless or the mere expression of personal hopes and fears by others. The virtuous self they helped Tajinisa live, and the moral world they were

accomplices in creating, were largely unrecognized, and others, she told us, had started to doubt her sanity. Several times during our visits she interrupted the conversation with the rhetorical question "Am I crazy?," apparently referring to the ways other people were judging her.

Furthermore, the ways of the ancestors were not always clear to Tajinisa and Gulbara themselves: Gulbara told me that she had recently had a dream in which she saw her father. He came with two other men. They were on horseback, and they took her and rode up a hill. There they left her and went away. When *arbak* take a person with them in a dream it is usually interpreted as a sign that the person will soon join them. Gulbara did not understand why her father left her and did not take her with him. She was prepared to leave this world, but the spirits encouraged her to persevere, and she did not understand why. Tajinisa, similarly, did not understand the connection between Chinggis Aitmatov and her youngest son, who had never really appreciated her artistic talents, who had dropped out of university, and who had thrown out her artwork because he was unable to distinguish it from the garbage she had not managed to throw away. But if the ancestor spirits were uncanny, the ways of the living were even stranger: at first, Gulbara had been angry with her relatives for their neglect of her, but she had gradually realized that they just acted like everyone did these days. She did not understand why, and she did not bother to learn why: her time in this world had come to an end anyway. Tajinisa asked me if I, as a scholar, could please tell her if it was really possible to take a doctoral degree in *onomastics*, as her ex-husband allegedly spent so many years doing? Could I please tell her if I knew the name of the company where her son said he worked? (The last time she saw him he came in a big new car, like the ones used by the members of parliament, but the name of the company did not ring a bell with her.) The metaphysical boundaries that separated them from the spirits of the past, that is, were at times felt as thinner than the moral boundaries that separated them from their absent living relatives, and the ancestor spirits were sometimes easier to reach out to and hinge oneself to than the living.

The last time I visited Tajinisa, in the early spring of 2020, however, the spirit world had become more disturbing: Tajinisa's ex-husband had recently passed away after a period of illness, and upon his death he had started appearing in her dreams. She did not know how to respond. Maybe, she reasoned, his appearances were signs that he had realized that it was a mistake

to leave her. But she had not read the Qur'an for him as she would usually do when she encountered the spirits of the past in her dreams. She did not know if he were to be included in her world.

FIXING BROKEN WINDOWS

Being hinged with ghostly presences, as the examples of Tajinisa and Gulbara show, may lend ghostly qualities to one's very subjectivity, the ghost being a form through which something barely visible or lost makes itself known. If the ancestor spirits allowed them to be more virtuous versions of themselves, these versions of themselves, and the virtues that defined them, were themselves ghostly, barely visible to others.

Focusing on ghosts allows us to gaze into that which has been forgotten, repressed, or ignored in a self, in others, or in a society: lives that could have been lived, worlds that could have been made (Gordon 2008), or potentials not yet realized. One does not necessarily have to "believe" in the existence of ghosts for these stories to make an impression. On our way back from one of our visits to Tajinisa, Aizat and I discussed how her stories might look from the perspective of her children. Were the "scenes" she described, where her son threw out her things, in fact her son's attempt to help clean up her apartment? Were they acts of care? Could they be acts of care when Tajinisa herself experienced them as violent and transgressing? Aizat did not really believe in the existence of ghosts. But the ghost stories we were told haunted her as well. If the ghosts, to Tajinisa as well as to Gulbara, were just as real as—if not more real than—the living, for Aizat as well as for other Kyrgyz with whom I discussed the stories they were rather metaphorical or imaginary matters. They were seen as expressing nostalgia—the longing for a past and the inability to adapt to current circumstances—or a falling back on dreams, fantasies, and desires as relations with other people began to fade in the lives of the elderly. But that does not mean that they did not matter. The ghost stories were about *something* and had a critical potential, for Aizat and for others. They were haunting reminders of those who had been excluded from worlds of care in Kyrgyz society; postsocialist landscapes of care and non-care; what had been lost in the appearing neoliberal order. During our trips around Bishkek, Aizat kept returning to the question of what it meant to have a family and how one should balance the concern for oneself with the care for one's family. And why it mattered to have children.

They inspired guilt and sometimes action—as when Aizat a couple of weeks after our visit brought her boyfriend to fix Tajinisa's broken windows. A caring act which, perhaps, repaired her own world as well.

CONCLUSION

"My body is too tight for my soul," Tajinisa said with a sigh when Aizat and I visited her in the early spring of 2020. She did not talk much that day, seeming tired and depressed. But in a way, in this image of a soul struggling to find its place in the snaring space of a physical body, she captured what had become my impression of her and her predicament during the last couple of years when I had been following her, but what had been difficult for me to articulate in writing. Her soul, her world, was one bursting with unlived lives, unlived possibilities: the artist and the poet who had never really materialized in this world, although the potential was there. Sometimes these possibilities were joyful: the caring spirits of the past became hinges to worlds that could host them—spectral, but nonetheless meaningful, worlds in which Tajinisa could dwell. Sometimes they were rather haunting and burdensome, pressing up against an increasingly frail physical body and an outside world that was difficult to understand and navigate.

With a point of departure in a concept of care that sees it as confirming or creating the presence of something or someone in a moral world, I have argued that a central concern of Kyrgyz elderly people who grow old in the absence of their close family is how to patch up a world where there is room for the virtues the absence of others has made homeless. Virtues, I have emphasized, are relationally constituted through acts of care which bring together persons in moral worlds: worlds which may be acknowledged by others or not; which may be experienced as enabling or suffocating; which may be fleeting or lasting; which may include persons and scenarios from past, present, as well as future. Such acts of care may not be very noteworthy at first sight. Care ethics points our attention to the sometimes small things people do which, although seemingly insignificant, are indeed building moral worlds that our sense of self hinges on. Understanding, and caring for, the elderly Kyrgyz people and their worlds, furthermore, and as I hope to have shown, demands that one takes imagistic steps into the realms of the invisible, the spectral, and the possible, recognizing that being is so

much more than what actually unfolds. We may tend to imagine old life as a narrowing of possibilities, as the stiffening of form, perhaps, and possibilities as belonging to youth: as oriented toward the future and actualization. But if we follow the openings to the spectral worlds of elderly people such as Tajinisa and Gulbara—openings offered to us through images—a different picture is drawn where the possible is no less real than the actual, and no less meaningful regardless of whether it is realized or not. Virtues need a world, but the world for Tajinisa and Gulbara—as well as for numerous other Kyrgyz elders—is larger and deeper than the actual world that meets the eye of the visitor to their homes. It is a world in the subjunctive mode, a world that could have been if circumstances had been different, and in such a world it is also possible to dwell and maybe even to flourish.

NOTES

1. For inspiring and constructive comments to this chapter at various stages in the writing process, I am very grateful to two anonymous reviewers, to Aizat Shailoobek Kyzy, and to Thomas Schwarz Wentzer, Lawrence Cohen, Bernard Leistle, Douglas Hollan, Cheryl Mattingly, and Lone Grøn, as well as the other participants in the "Aging as Human Condition" research project. A special thanks to Tove Nyholm for encouraging me to focus on things and to Maria Speyer for drawing what was so hard to articulate.

2. There is a vast literature on migration from Kyrgyzstan and other Central Asian states. For anthropological works that focus on Kyrgyz migrant experiences as well as the experiences of those who are left behind, see Isabaeva 2011; Reeves 2011, 2013, and 2015; Rubinov 2014.

3. Fieldwork for the project was conducted in and around Bishkek, the capital of Kyrgyzstan, during several shorter periods between 2018 and 2020 and in cooperation with Babushka Adoption, an NGO that supports vulnerable elderly people in Kyrgyzstan.

4. Gulbara is a pseudonym.

5. Aristotle used the term *eudaimonia*—composed of the terms *eu* ("good, well") and *daimōn* ("spirit")—as a term for the highest human good.

REFERENCES

Beyer, Judith. 2010. "Authority as Accomplishment: Intergenerational Dynamics in Talas, Northern Kyrgyzstan." In *Eurasian Perspectives. In Search of Alternatives*, edited by A. Sengupta and S. Chatterjee, 78–92. New Delhi: Shipra.

———. 2013. "Ordering Ideals: Accomplishing Well-Being in a Kyrgyz Coopera-
tive of Elders." *Central Asian Survey* 32 (4): 432–47.

Bille, Mikkel, Frida Hastrup, and Tom Floh Sørensen. 2010. *An Anthropology of
Absence: Materializations of Transcendence and Loss*. New York: Springer.

Desjarlais, Robert. 2019. *The Blind Man: A Phantasmography*. New York: Fordham
University Press.

Dubuisson, Eva Marie. 2017. *Living Language in Kazakhstan: The Dialogic Emer-
gence of an Ancestral Worldview*. Pittsburgh: University of Pittsburgh Press.

Dyring, Rasmus, Cheryl Mattingly, and Maria Louw. 2017. "The Question of
'Moral Engines': Introducing a Philosophical Anthropological Dialogue." In
Moral Engines: Exploring the Moral Drives in Human Life, edited by Cheryl
Mattingly, Maria Louw, Thomas Schwarz Wentzer, and Rasmus Dyring, 9–36.
New York: Berghahn Books.

Faubion, James D. 2001. "Toward an Anthropology of Ethics: Foucault and the
Pedagogies of Autopoiesis." *Representations* 74 (1): 83–104.

———. 2011. *An Anthropology of Ethics*. Cambridge: Cambridge University Press.

Foucault, Michel. 1990 (1984). *The Care of the Self: The History of Sexuality 3*.
London: Penguin Books.

Gordon, Avery. 2008 (1997). *Ghostly Matters: Haunting and the Sociological
Imagination*. Minneapolis: University of Minnesota Press.

Guenther, Lisa. 2013. *Solitary Confinement: Social Death and Its Afterlives*.
Minneapolis: University of Minnesota Press.

Hirschkind, Charles. 2006. *The Ethical Soundscape: Cassette Sermons and Islamic
Counterpublics*. New York: Columbia University Press.

Isabaeva, Eliza. 2011. "Leaving to Enable Others to Remain: Remittances and New
Moral Economies of Migration in Southern Kyrgyzstan." *Central Asian Survey*
30 (3–4): 541–54.

Ismailbekova, Aksana. 2014. "Performing Democracy: State-Making through
Patronage in Kyrgyzstan." In *Ethnographies of the State in Central Asia:
Performing Politics*, edited by Madeleine Reeves, Johan Rasanayagam, and
Judith Beyer, 78–98. Bloomington: Indiana University Press.

Kleinman, Arthur, and Sjaak van der Geest. 2009. "'Care' in Health Care: Remaking
the Moral World of Medicine." *Medische Antropologie* 21 (1): 159–68.

Laidlaw, James. 2012. *The Subject of Virtue: An Anthropology of Ethics and
Freedom*. Cambridge: Cambridge University Press.

Lear, Jonathan. 2006. *Radical Hope: Ethics in the Face of Cultural Devastation*.
Cambridge, MA: Harvard University Press.

Levinas, Emmanuel. 1969. *Totality and Infinity: An Essay on Exteriority*. Pitts-
burgh: Duquesne University Press.

Louw, Maria. 2010. "Dreaming Up Futures: Dream Omens and Magic in
Bishkek." *History and Anthropology* 21 (3): 277–92.

———. 2019. "Burdening Visions: The Haunting of the Unseen in Bishkek, Kyrgyzstan." *Contemporary Islam* 13 (3): 1–15.

Mahmood, Saba. 2005. *Politics of Piety: The Islamic Revival and the Feminist Subject*. Princeton, NJ: Princeton University Press.

Mattingly, Cheryl. 2014. *Moral Laboratories: Family Peril and the Struggle for a Good Life*. Berkeley: University of California Press.

Mattingly, Cheryl, and Patrick McKearney. Forthcoming. "The Ethics of Care." In *Cambridge Handbook of the Anthropology of Ethics and Morality*, edited by James Laidlaw. Cambridge: Cambridge University Press.

Orsi, Robert. 2016. *History and Presence*. Cambridge, MA: Harvard University Press.

Pandian, Anand. 2019. *A Possible Anthropology: Methods for Uneasy Times*. Durham, NC: Duke University Press.

Phillips, Adam. 2012. *Missing Out: In Praise of the Unlived Life*. London: Penguin Books.

Piña-Cabral, João de. 2014a. "World: An Anthropological Examination (Part 1)." *Hau: Journal of Ethnographic Theory* 4 (1): 49–73.

———. 2014b. "World: An Anthropological Examination (Part 2)." *Hau: Journal of Ethnographic Theory* 4 (3): 149–84.

Puig de la Bellacasa, María. 2017. *Matters of Care: Speculative Ethics in More Than Human Worlds*. Minneapolis: University of Minnesota Press.

Rasanayagam, Johan. 2011. *Islam in Post-Soviet Uzbekistan: The Morality of Experience*. Cambridge: Cambridge University Press.

———. 2017. "Anthropology in Conversation with an Islamic Tradition: Emmanuel Levinas and the Practice of Critique." *Journal of the Royal Anthropological Institute* 24 (1): 90–106.

Reeves, Madeleine. 2011. "Staying Put? Towards a Relational Politics of Mobility at a Time of Migration." *Central Asian Survey* 30 (3–4): 550–76.

———. 2013. "Clean Fake: Authenticating Documents and Persons in Migrant Moscow." *American Ethnologist* 40 (3): 508–24.

———. 2015. "Living from the Nerves: Deportability, Indeterminacy and the 'Feel of Law' in Migrant Moscow." *Social Analysis* 59 (4): 119–36.

Robbins, Joel. 2004. *Becoming Sinners: Christianity and Moral Torment in a Papua New Guinea Society*. Berkeley: University of California Press.

———. 2013. "Beyond the Suffering Subject: Toward an Anthropology of the Good." *Journal of the Royal Anthropological Institute* 19 (3): 447–62.

Rubinov, Igor. 2014. "Migrant Assemblages: Building Postsocialist Households with Kyrgyz Remittances." *Anthropological Quarterly* 87 (1): 183–215.

Ruddick, Sara. 1999. "Virtues and Age." In *Mother Time: Women, Aging, and Ethics*, edited by M. U. Walker, 45–60. Lanham, MD: Rowman and Littlefield.

Schielke, Samuli. 2009. "Ambivalent Commitments: Troubles of Morality, Religiosity and Aspiration among Young Egyptians." *Journal of Religion in Africa* 39 (2): 158–85.

———. 2015. *Egypt in the Future Tense: Ambivalence, Hope and Frustration in Egypt before and after 2011*. Bloomington: Indiana University Press.

Stevenson, Lisa. 2014. *Life beside Itself: Imagining Care in the Canadian Arctic*. Berkeley: University of California Press.

Taylor, Charles. 2007. *A Secular Age*. Cambridge, MA: Harvard University Press.

Tronto, Joan. 2009 (1993). *Moral Boundaries: A Political Argument for an Ethic of Care*. New York: Routledge.

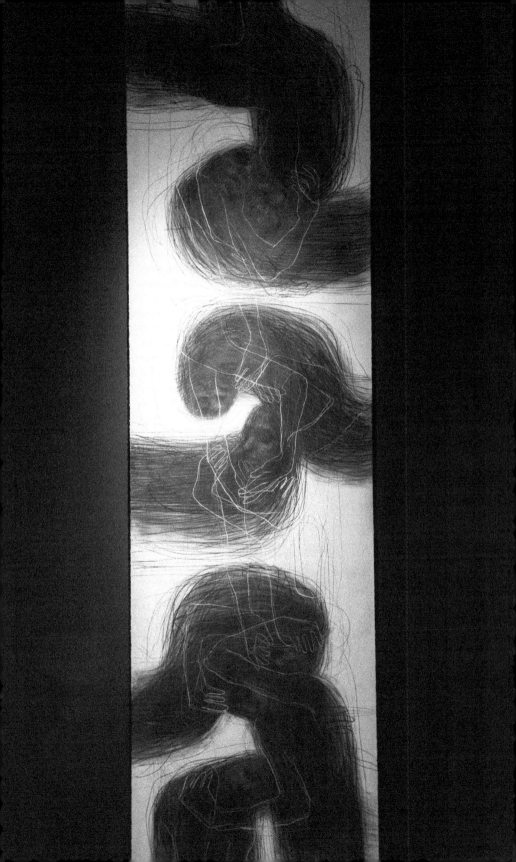

Stay With . . . the Other
cannot fully grasp
walks and walks the infinitely
Still, between them . . . the call
fleeting . . . constant volatile
for those that cannot be contained . . . held within other
"such a good man"
So here we are
meeting between . . . taking place
the deep sound . . . repeated . . . resonates
we both seek
stay with . . . the other
a generosity, however
a different form
"Noooo," "I am afraid," "I am homeless"
in one place, but constantly
walk, then sit a bit, walk and sit
to stay close and gently
but screams, clings, sits, walks, holds
there is more

Overleaf: Figure 1. Drawing for Lone Grøn, *Stay With . . . the Other*, charcoal and chalk, 2020, 450 × 115 cm

"YEAH . . . YEAH"

Imagistic Signatures and Responsive Events in a Danish Dementia Ward

LONE GRØN

Birgit, Ellen, and I are sitting at the big table in the living room of a dementia ward in the suburb of a mid-size Danish city. We are drinking coffee. Next to Birgit's cup and plate is an orange napkin on which she has placed a bright pink hair band. Ellen is sitting next to her. She looks at the band and says: Shouldn't this be in your hair? No, says Birgit and keeps eating her sandwich. Ellen says that she is quite sure that this band is for putting in one's hair. Not once but several times. She does not give up. Birgit first tries to keep eating her sandwich but then, slowly and decisively, she moves her index finger around the edges of the napkin. Four times—without looking at Ellen. Ellen then lets her eat in peace.

What is imagistic about an image? asks Lisa Stevenson (2014). Citing Foucault, she responds that an image can "express without formulating" (Foucault 1993, 36, in Stevenson 2014, 14; Stevenson 2019), which aptly captures what Birgit's gesture of moving her index finger around the orange napkin does. Another take on this expressive or imagistic quality is formulated by Pandian (2015) in a reflection on how we should understand the creative work of painting, poetry, drama, and cinema, for example. Are they best understood to represent some reality that lies beyond them?, he asks, and

suggests instead that "they express that reality in a deeper or fuller fashion, that they give body, that is, to an unseen dimension of its potential" (278).

Imagistic qualities, which are not related exclusively to images as such, reveal the indeterminate and open-ended nature of human experience. They are omnipresent and plentiful in most ethnographic fieldworks. But how do we engage with imagistic qualities? Do we leave them aside and pursue more customary interpretations of discursive and categorical modes of being? Or do we make these qualities the object of our analysis—through fieldwork that "would be less about collecting facts than about paying attention to the moments when the facts falter" (Stevenson 2014, 2)? And how is it that such fieldwork may express reality in a deeper and fuller fashion (Pandian 2015, 278)? What is the unseen dimension, or potentiality, which imagistic approaches can make visible? Finally, could you not get to the same complex and nuanced insights into the indeterminate and intersubjective dimensions of experience by relying on the more well-trodden paths of phenomenological and experience-near anthropology (Desjarlais and Throop 2011). What does a concern with imagistic qualities of experience add to these?

In this chapter, I explore intersubjective exchanges of voices, word-sounds, actual words, and embodied gestures in a Danish dementia ward. Rather than approaching these nondiscursive modes of expression and communication as pathological or as somehow fundamentally lacking, I see them as foundational to human experience and sociality. I work from a basic premise: that experience is ontologically ungrounded and that a responsive relationship exists between the ungroundedness and the "realness" of experience. This ungroundedness displays an anarchic and responsive potentiality of becoming (Dyring 2022; Dyring and Grøn 2022) which comes to the forefront when we take an interest in imagistic dimensions of experience. The imagistic inquiry, thus, takes very seriously the foundational phenomenological claims of indeterminacy, intersubjectivity (Desjarlais and Throop 2011), and alterity (Leistle 2017) as constitutive of human experience. When conducting phenomenological investigations within a more discursively coherent or logocentric (Dyring, this volume) framework, the radicality of these phenomenological claims might not become as apparent. Imagistic approaches foreground the basic ungroundedness of both our experience and our concepts (Mattingly 2019; Brandel and Motta 2021). Take Maria Speyer's drawings, which accompany the chapters in this book: Do they engage with subjectivities or intersubjectivities? Or both?

With interbodies (Mattingly, this volume)? With fences (Meinert, this volume) or the spaces between them (Dyring, this volume)? Are they about uncertainty and indeterminacy? Yes, most definitely, but, I would add, with certainty. Imagistic approaches point with certainty to the ungroundedness of experience—and of concepts and other ordering devices.

The lived experience of ungroundedness is accentuated in old age, where bodily functions, social worlds, and selves deteriorate or transform with a heightened intensity. Where things fall apart (Gill 2020). More specifically, the ungroundedness of experience faces us head on when dementia sets in. The imagistic approach, therefore, has a direct and pressing relevance in relation to my fieldwork at a Danish dementia ward. I hope to show that imagistic inquiries provide avenues for the exploration of lifeworlds marked by cognitive differences, and for engaging with the experience of alterity without pathologizing it, but also without domesticating it, without "losing its sting" (Waldenfels 2007, 1).

Recently McKearney and Zoanni (2018) have asked big questions that unsettle long-standing theoretical, methodological, and ethical assumptions in anthropology. Their main target is the idea of the psychic unity of mankind, a theoretical claim to which the empirical existence of profound cognitive differences between humans is an especially challenging fact. Recognizing the importance of this theoretical cornerstone, the focus on cognitive disabilities compels them to ask if ontological differences exist not only between cultures—as claimed by proponents of the ontological turn—but also between members of the same culture. While these are unsettling and uncomfortable questions to ask, there is no way around them when doing fieldwork at a dementia ward. This is a site where radical differences in how people "reason, exchange, speak and interact" (3) cannot be overlooked. I will add to McKearney and Zoanni's questions concerns that have arisen from my ongoing fieldwork: Given the pervasiveness of difference between people in the ward, how should we think about intersubjectivity and social worlds? And how can we address cognitive (and other) differences in ways that preserve the important methodological, analytical, and ethical implications intended by the idea of the psychic unity of mankind?

My take on these questions will be informed by encounters at the dementia ward and by Bernhard Waldenfels's responsive phenomenology or phenomenology of the alien (2007, 2011). I want to stress that "the alien" is a rather unfortunate translation into English of the German *das Fremde*,

which does not mean an alien thing or person, but something more like alienness or alterity. I also want to clarify that I am not arguing that people living with dementia are "alien," but rather that alienness or alterity is a general feature of human experience. Waldenfels's responsive phenomenology posits what I have called above the basic ungroundedness of experience, as a call from the alien (*das Fremde*) to which we respond. According to Waldenfels, more or less radical forms of alienness envelop our everyday experience: we fall into sleep, into dream; we find ourselves engulfed in a childhood memory; somebody we know very well may suddenly seem like a stranger. This means that we are constantly responding to phenomena and events we cannot fully grasp. Our responses are attempts to order, contain, or domesticate, but they are separated from the "alien call" by a time lag, which adds yet another layer or dimension to our experiential ungroundedness. I argue that the consideration of intersubjectivity and responsivity in the dementia ward should start from the recognition of alterity as constitutive of both—and also that imagistic approaches are especially well suited to this endeavor. I will end by suggesting alterity and responsivity, not the psychic unity of mankind, as constitutive of "the human condition"— even if this fact of our life with others becomes more pronounced when we engage with cognitive disabilities of diverse kinds.

HAUNTING IMAGES IN EPIDEMICS OF ALTERITY

Images can haunt: from ultrasound images that see "beyond the flesh" and reveal that suffering and misfortune has struck unexpectedly (Gammeltoft 2014) to images of Emmett Till's mutilated body, which have haunted generations of Blacks living in the US (Mattingly, this volume), and images of starving in Africa (Meinert 2019; Kleinman and Kleinman 1997), which overshadow more complex engagements with situations of suffering. The condition of dementia comes with its own haunting or monstrous images of the "living dead," "zombies" (Behuniak, 2011), "empty shells" (Snyder, 2001), or people who are "not there" anymore (Dekker 2017).

The lack of certainty that surrounds causation, etiology, and the disease category itself[1] could be part of the explanation for why the condition is so troubling. Margaret Lock (2013) provides a detailed account of the genetic, medical, and clinical discussions surrounding Alzheimer's disease, "the epi-

demic of the 21st century" (1). She documents the formation of two camps, localization theory and entanglement theory, which take quite different stands on issues of both causation and treatment. Yet, Alzheimer's disease remains, she writes, "a stubborn conundrum" (11). There are of course local experiences and responses to this epidemic of alterity (e.g., Cohen 1998; Leibing and Cohen 2006; Lock 2013), which involve ideas about the pernicious effects of modernity, bad families, and angry old women running wild (Cohen 1998; Yahalom 2019) and where care is often a family matter (Brijnath 2014; Yahalom 2019).

In a Danish context the haunting images of dementia are exacerbated by a general consensus on a healthy, active, and successful old age as the ideal, proper, and virtuous way of aging (Rowe and Kahn 1987; Oxlund and Whyte 2014; Mikkelsen 2016; Grøn 2016; Grøn and Olesen 2017), even though in practice people will often search for and cultivate ways to live with finitude (Baars 2017) and meaningful decline (Lamb 2014) that are not captured by the dominant discourses (Oxlund, Grøn, and Bregnbæk 2019)—especially when medical conditions and sicknesses strike. Still, the dependencies that emerge in these situations undermine traditional ideals of how individuals should be able to care for themselves in order to be part of and contribute to the welfare state collectivity, even though care for the vulnerable is simultaneously what the welfare state is all about (Christensen 2020). In Denmark, welfare state institutions and professionals play a major role in how people living with dementia are cared for. Professionals and institutional staff become "curators of (re)cognition" as they seek to preserve the people living with dementia as recognizing, recognizable, and recognized persons in the welfare state collectivity, by means of and within institutions provided by the state (Gjødsbøl, Koch, and Svendsen 2017; Gjødsbøl and Svendsen 2018, 2019). As Felding and Schwennesen (2019) have shown, in the "care-troika" between resident, staff, and kin, kin and staff differ in how they recognize the person living with dementia: kin adhere to a historical memory of their family member and seek to uphold a continuity with this memory, while staff adhere to a situational understanding of the resident aimed at restoring institutional order and harmony.

But what about the voices of those who live with dementia? As we have seen above, they are often understood and explored through the experiences of others, be it intimate family or professional others. Dementia is a

condition that strips the sufferer of cognitive abilities considered distinct to the human condition, and the person with the disease can easily seem to vanish from the picture. Within the personhood turn, however, researchers such as McLean, Basting, Kontos, Driessen, and Taylor have sought to "give voice" to people living with dementia (Cohen 2006). McLean (2006) has argued that we do not need deconstructive accounts that evade the work of text making accomplished by individuals with dementia, but phenomenological attention to the language and coherence work of our interlocutors, while Basting (2006) has used collective storytelling and theater as sites for such "coherence work." Kontos (2006) has focused on bodily movement, gestures, and practices of daily life (like dressing, praying, and dancing) to argue for the persistence of embodied personhood in dementia, while Driessen (2018) has shown people living with dementia as "appreciating subjects." Finally, Taylor (2008) has removed one of the main obstacles to acknowledging the continuity of personhood and subjectivity in people living with progressive dementia, by arguing that mutual recognition is not a prerequisite for the recognition of continued personhood.

My account both follows and departs from work within the personhood turn: I also explore embodied gestures and voices, but I argue not for the continuation of personhood throughout the progressive stages of dementia but for the continuation of responsivity as that which constitutes and undergirds intersubjective encounters and relations across divides of cognitive and other differences.

I have invoked the haunting images of dementia because they are somehow inescapable—we all hold them—and writing or reading about dementia happens against that backdrop. This also means that calling attention to "positive" events in lives with dementia might come off as romanticizing the condition and not paying sufficient attention to the very real pain and suffering involved for sufferers and their intimate others alike. On the other side, documenting "negative" events can trigger or confirm the haunting images and dominating horror story of dementia. In this chapter, I explore heartwarming, fun, tragic, and painful encounters and events in the hope of opening a door that will make it possible to contemplate nuances or vitalities that differ from the haunting images or cannot be subsumed by notions of "good" or "bad" lives with dementia (Leibing and Dekker 2019). I do this by recourse to "imagistic signatures" and "responsive events" in the ward.

IMAGISTIC SIGNATURES

I will explore what I term "imagistic signatures" to convey the particular ways of being in the world of residents of the ward. The notion of imagistic signatures combines Stevenson's (2014, 2020) exploration of very disparate kinds of images: photographs, films, memories, and sound images, which "express without formulating," and Zoanni's (2018) notion of embodied signatures. In an attempt to think about how to "give voice" to people with cognitive disabilities, who do not have language, or maybe even voice, Zoanni has suggested the notion of signature. He writes: "By 'signature' I mean a distinctive, embodied mark of being in the world, an imprint or an impress, elaborated and stabilized through living in relation to others. Signatures, of course, are not always clear or easy to read, nor are they necessarily consistent" (72). Importantly, these allegedly often inconsistent signatures are forceful presences—not effaced or diluted ones, as popular ideas about dementia as disappearance or social death could lead us to think. Also, voice, understood as an "umbilical cord" which "produces an effect in the world" (Rosa 2016, 63), is central in my exploration of imagistic signatures in the ward. In the ward, we come to understand the importance of being able to call, through voice as well as other embodied, imagistic gestures.

I will also draw on Waldenfels's responsive phenomenology (2011) to render visible the pervasiveness of alterity and responsivity in everyday life on the ward. Responding embodies an "ethos of the senses" (2011, 38) and is not restricted to spoken utterances. Ellen is called, affected by the placing of the rubber band on the napkin by Birgit. In responding, she poses an order where rubber bands should be in hair, not at dinner tables. Birgit responds by flatly refusing this order: No! But when Ellen persists, Birgit instantiates a new order by drawing a boundary around the napkin, four times.

Waldenfels also makes an important distinction between responsive content and responsive event:

The claim upon something corresponds to the answer I give. In terms of speech act theory this has to do with the suitable *answer content* which is going to fill in the blank in the propositional content of questions or requests. Such an answer remedies a lack. But the very *event of responding* is in no way exhausted by this. The appeal to me corresponds to a response that fills no hole, but comes to meet the invites and calls of the

other. Responding in its full sense does not give what it has, but rather what it invents in responding. (2011, 38)

Going back to the small event at the living room table, what does Birgit's gesture say in terms of content? Stay out of this napkin and mind your own business? Or: This napkin is a place where hair bands belong? Or something entirely different? This we cannot know, but surely, this is an event in which responding "comes to meet the invites and call of the other" and "[gives] what it invents in responding." Ellen and Birgit are impaired in different ways. As already implied above, Ellen's embodied signature is characterized by her keen interest in the behavior of others; she often remarks on their bad manners. She can form sentences—she tends to repeat them, though, using the exact same words and sentences in loops, as she also walks and walks the infinitely looping hallway of the ward. Birgit's embodied signature is characterized by giant smiles and the word "Yes!" but she can only form single words or few-word sentences. Still, between them they respond to the call of the other. Such responsive events—where the responsive content does not add up to form a coherent and meaningful intersubjective exchange—are central to everyday life of the ward. They are, however, also fleeting, as there is a constant volatile undercurrent or atmosphere, like living in the vicinity of a volcano or walking in a mist. In the ward, alterity is the norm.

THE WARD

The ward is located at a nursing home in a midsize Danish town. The home covers a large area with several residential wards, care wards, activity and day centers, a big institutional kitchen, a dementia day care and activity center, and the dementia ward. The regular day and residential wards include residents living with dementia, but the ward where I did my fieldwork is a special unit, with specially allocated slots for residents with externalizing and challenging behavior, temporary slots for people in need of diagnosis and placement, and relief slots that are used in situations of crisis in an elderly person's home or family situation. Often a crisis occurs when family members cannot handle the care of the person with dementia—or, if the elderly person is living alone, when the maximum allotment of seven daily home visits by the municipality home-helpers are not sufficient. The staff-

to-patient ratio in the ward is higher than in the regular nursing home units, and staff members have specialized knowledge of dementia—both through extensive experience and through education and training.

The nursing home facility is quite large and located at the outskirts of town. Since most residents do not leave, and those who do are transported in buses to the day facilities from their homes and back, the facility has the feel of a small village. In fact, when you walk these institutional spaces you get an almost physical sensation of the "institutional aging process" (Grøn and Olesen 2017) in contemporary Denmark: from day and activity centers, to residential nursing home units, to the dementia day care center, to the dementia ward, people "age" progressively. These institutional spaces are the ones elderly people hope they will never enter (Grøn 2016), and particularly the dementia ward. You do not leave this place, some say, unless in a coffin. This is an institutional space for those who cannot be contained or held within other kinship or welfare state–based care activities or institutions in Denmark. It is indeed and in many ways the last stop.

The ward contains a hallway with access to twenty residential apartments and a few staff rooms, or more precisely four hallways forming a square around an inside garden and surrounded by an outside garden enveloped by a fence. There is only one door that opens into the outside spaces. Other doors are firmly locked. The inside garden is a social space, connected to the large kitchen and dining area, whereas the outside garden is mostly used solitarily: one male resident often sits outside his flat sunbathing and drinking beer; a few other residents walk and walk, searching for ways out (which often means away from their present situation) or ways home (which often means long-lost childhood homes). The heart of the ward is the kitchen and dining room area with large windows opening up to the inside garden. I start out my exploration of imagistic signatures and responsive events in the apartment of one of the residents, Henry.

"YEAH . . . YEAH": IMAGISTIC SIGNATURE AND RESPONSIVE EVENT

I am hanging out with Henry for lunch, attempting to make a recorded interview. Initially, I did not think I would do interviews with residents, but now, in the third year of fieldwork and after extensive communicating and exchanging with residents, I have come to question this approach. Harry is

a tall elderly man, broad shouldered and handsome, too. White hair, aristocratic looking. I have approached him reluctantly because stories circulate in the ward about how he can get quite aggressive. How he can twist or squeeze your arm or push or lash out at you. I had therefore decided against interviewing him (yet another exemption from being interview-able), but his main person among the staff has assured me that Henry is "such a good man" and that I need not worry. So here we are, eating lunch at Henry's dining room table.

> Me: Can you tell me, how is it to live here at the ward?
> Henry: Well, yeah. It is like most things are.
> Me: It is like most things are?
> Henry. Yeah . . . Yeah.
> Me: Yeah.
> Henry: It is OK. (He then says a few words. I cannot figure them out; they are more like mumbled word-sounds)
> Me: Is it OK?
> Henry: Yeah . . . Yeah.
> Me: Yeah. (. . .)
> (Long break. Eating. Small comments about the food and drink)
> Henry: Isn't a place like this, like most?
> Me (eager and almost interrupting): Maybe. Is it good—is it bad?
> Henry: I have not really thought about that. It is like most places where one is. Yeah. Yeah. I think so. (Again we just sit and eat)
> Me: Are people friendly here?
> Henry: I think so. Yeah. So long. I don't think (again mumbled word-sounds) or else I move away. Yeah . . . Yeah.
> Me (remembering Henry's management experience): Do they have it under control?
> Henry (in an insistent voice): Yes, yes. They certainly do! It is the kind of people, who meet in the peace. I think. Now there are probably not others than how I am, so it evens up. I think. I think so. A rare special (again mumbled word-sounds) there where you are.
> Me (latching on to his last words): You should feel good where you are?
> Henry (emphatically): Yes, you really have to! Or, you do not have to, not in that sense, but it is best the way you are.

Me (thinking about the difficulty of being the way one is): But many people cannot do that . . .

Henry: But the thing about dealing with the manager at the closest place that is just . . . There is not so much . . .

Me: It is not so hard?

Henry: No, I don't think so. I mostly do like . . . natural.

Me: It sounds like you are good at being where you are?

Henry: Well, that is better, don't you think? Yeah . . . Yeah. It has to be like that.

What stands out in these sentences are my rather clumsy attempts to conduct this interview and to make sense of Henry's responses. Yet, what these sentences from transcribed recordings do *not* fully convey is the sense this conversation does make while it lasts. It feels to me like a genuine conversation, like a meeting between us is taking place. I ask, he listens, he responds, I listen, I respond. Back and forth. Also, it is an encounter that deepens as it progresses. I put senses into his words that he did probably not intend, but so does he into mine. Sometimes I feel lost. But then I do get something—somehow.

When I get up to leave, Henry lets me know that I am most welcome to return—and I feel as though I have been in the presence of a great man. More, I leave with a sense of having learned something about being "the way you are," about doing things "just . . . natural," and about living in the ward being "like most things are." Considering the situation Henry is in, having left his home and family behind, living now in an institution with intimate strangers, this is no small thing. You could say, of course, that he does not know anymore what is home and family and what is not, but then again: Does that diminish his accomplishments? And can we be sure what he does and does not know?

I am affected by Henry's signature, his "distinctive, embodied mark of being in the world," his "imprint or (an) impress, elaborated and stabilized through living in relation to others" (Zoanni 2018). There is the deep sound of Henry's repeated "Yeah," which resonates from his body to mine, calming my anxiousness about the stories I have heard of him. Henry leaves me with the impression that things are the way he says they are, and that I am fortunate to be in the presence of such a great, indeed charismatic, man

(McKearney 2018). There are the mumbled word-sounds that do not make sense to me, changing into words that do. There are the references to how to deal with managers at a close range and Henry's majestic presence. And there is also—in other situations—how he bosses others around, how he twists arms and lashes out at other residents and staff. It is not just any signature, but an imagistic one, which "expresses without formulating" (Stevenson 2014, 14), and conveys reality to me "in a deeper or fuller fashion, giving body to an unseen dimension of its potential" (Pandian 2015, 278).

In this exchange, as with the earlier one between Ellen and Birgit, we see the importance of Waldenfels's distinction between responsive content and responsive event. If we stay on the content side of things we run into trouble. Henry does not, or indeed cannot anymore, express himself within the expected norms for meaningful conversation. He can form sentences, but often they come off as odd, crooked, and disordered, or words disintegrate into word-sounds. That of course is also why I struggle, as Henry's replies at times do not correspond to the questions I ask in terms of content. But in terms of responsive event, the way we both seek to stay with the alien utterances of the other and to build on them, the way we afford and cultivate a space for interaction between us, the way we both try to "meet the gestures and utterances of the other and give what we invent in responding" (Waldenfels 2011, 38) come to the fore. Time lags and asymmetries abound: "Between question and answer, there is no more consensus than between request and fulfillment. The two collide like two glances that meet" (Waldenfels 2007, 31).

There is a generosity, however, in this encounter, and we both seem to benefit. Henry does invite me back anytime and overall seems pleased with my visit, and I learn something about a different mode of being in the world than my own, though one that concerns my own being in the world. Understanding that life in the ward is like most things are, and that it is best to be what one is, is relevant not only to my present life situation and to me as an ethnographer but also to past experiences of being a granddaughter and daughter of women who lived and died with dementia, as well as to future scenarios of aging with potential physical and cognitive challenges. It is not so much that there is no responsive content as that it comes in a different form: the responsive content *is* the event—emerging, open-ended, surprising—with a genuine and growing interest and appreciation on both ends of the responsive dynamic.

I move now to events that were the most challenging during this fieldwork. I have chosen to write about them to stress my main point in this chapter, that we should not try to "patch up" or, in Waldenfels's words, "domesticate" alterity in our studies of dementia and cognitive difference. I have eased into these events by providing little snippets of ethnography, which demonstrate slightly confusing, humorous, or even deeply joyful moments— in the hope that they have set the scene properly for exploring the more challenging dimensions of everyday life in the ward. There is a real risk in portraying institutional life by sensationalizing the sometimes deeply disruptive and transgressive events that occur, but an equal risk of romanticizing if you do not (Zoanni, personal communication). The following events were indeed disruptive, to staff, to residents, to visiting family members— and to me. They all revolved around one resident, Søren Peter. I will start with field note transcripts from four successive days of fieldwork and then move on to consider how things evolved after that week.

Day 1

Upon arrival I hear a long stretched NOOOOOOO. Over and over. I learn that it is Søren Peter who screams. He has been in the ward for about two months. Today his wife has been visiting. After she leaves, nothing can calm him down. He shouts, "Noooo," "I am afraid," "I am homeless." It is pretty intense.

Søren Peter has somebody with him 24/7. Today it is Karen's job. He does not want to sit in one place, but constantly sits down and gets up again. Sits down, gets up. Ellen, another resident, Annelise, and I are sitting at the dining room table watching him. Annelise rolls her eyes and "talks" to me with her particular sentences that start but never finish. They disappear into thin air. Ellen says that he is lying—she knows that he has a home! And, Ellen continues, why does he always shout? And why is he never satisfied?

In the staff room they talk about Søren Peter. He has been hammering on another resident's door at night and he almost got into a fight with Henry several times. Karen enters—she is exhausted after trying to put him to bed. She spooned him to make him fall asleep—maybe he did not

sleep at all the night before, she says. She thought that she had managed, but no, he is up again.

Day 2

Again today I hear Søren Peter shouting when I arrive. I walk in the opposite direction to where the sound is coming from. He scares me a bit. But after putting my bag in the staff room, I walk toward the sound. I find Søren Peter with a staff member and another resident at the couch corner. They are watching a VHS with *Matador*—the all-time favorite Danish TV series. A staff, Anne, is sitting very close to him, holding his hand. When he shouts "yes" or "no" (mostly "no") or "I want to go home," she tries to fix his attention to the screen. "There is Agnes! There is the Postyard! Who is that—it is Red, isn't it?"

Just before leaving that day I also have a moment with Søren Peter, who is really receptive to holding hands and to eye contact.

Day 3

I walk a few rounds with Søren Peter. I take over for Lena, who seems like she has had it—and she also needs to go to the bathroom. We walk, then sit a bit, walk and sit. I just follow along. I have been watching how Lena's presence has made him calmer. While I walk with him, Birgit and her visiting husband watch us, as though we are their entertainment for the day. Birgit's husband looks both amused and sorry for me and the staff, who have to care for Søren Peter. I walk another round with him, then Lena is back.

Day 4

There is a remarkable calmness around Søren Peter today. He is sitting at the table in the dining room with Helle. They are doing a puzzle. They talk calmly, there is no shouting. Later they come and sit at our table, Søren Peter just next to me. He takes my hand and looks me in the eyes. I am not scared anymore and happy to be able to contribute something positive to

his well-being—and give staff a helping hand. Then he shouts that he does not have his jacket. It is on his chair, and I fetch it for him. Then he cannot bite a biscuit and shouts louder and louder: "Where are my teeth? Get them!" It is getting uncomfortable. I take him to his room to look for his teeth with Helle. She keeps him in there and I leave. I talk to another staff member who explains that they keep close to him but they do not give him excessive physical or eye contact. In a way, he cannot take it; he gets too upset. They also do not get up each time he rises or asks them to get something, but try to stay close and gently ignore him. To keep him calm. I have observed this and the positive effects of this strategy over the last couple of days, but obviously without really getting it.

When he returns to the table, I also try to "stay close and gently ignore," but it is too late. He takes my hand, kisses it, and says that I am very nice. At one point I try to get up and he screams: "Do not leave me!" I feel so regretful to have put him, myself, and others in this situation. Helle helps me out by taking my place, and I leave quickly for the staff offices. Those present repeat the strategy of keeping close while gently ignoring. They tease me, saying that if I am that fond of Søren Peter I am very welcome to bring him home with me. They say he gets upset if you give him intense attention and then stop. They also tell me not to blame myself—they have all been there. This is how it is to work in this place: you do well for a while, then you fail, then you learn and do well—over and over again.

One Week Later

The following week, I have a short talk with the leader of the ward, who tells me that a meeting has been arranged the following day by concerned family members, who are complaining that Søren Peter's presence at the institution is too challenging for their own resident family members. One person has even suggested that he should not be there at all, that this place is not for him. The leader shakes her head. This is an institution with specially assigned slots for people with externalizing and challenging behavior, she explains. This is why they have the experience, the expertise, and the staff ratio they do. She says that she will really have to work with her patience during this meeting, but she will also be very firm that Søren Peter belongs here.

When contacting family members about interviews, the first one who answers my call is Søren Peter's wife. Yes, she will be happy to participate. We agree on a time and place and by the end of the conversation, she asks me: "You do know that Søren Peter has died, don't you?" I respond that I did not, that this is really surprising. She says that he suddenly did not want to get out of bed, he did not want to eat, and both she and the staff agreed that this was OK. The Friday he died, she had been there all day. In the evening, the staff told her to go home and get some sleep. But she woke up in the middle of the night and went there. A few hours later he died. She is so happy that she went; she held his hand and looked into his eyes when he died.

Søren Peter's voice creates cracks in the institutional walls (Dyring and Grøn 2022)—in fact, it creates cracks in everything: institutional routines, care expertise and skill, as well as our human capacity for empathy and inclusion. In this case, the cracks do not stop opening—but get wider and wider—until Søren Peter dies.

The main point to draw from these events is the deeply haunting and unsettling alterity that inhabits the dementia ward. During these weeks I tell friends and colleagues that it feels like the institution is going to burst, to explode—as if a deeply affective and contagious presence is pushing residents, staff, family members, and me outside what we can take. Søren Peter also cannot take it, but screams, clings, sits, walks, holds hands. From staff I hear about internal conflicts that arise between them in the wake of this, and family members are propelled toward exclusion, removal of that which disturbs and haunts. "Alienness," in Waldenfels's words, "is self-referential and it is contagious" (2011, 3). It is not just that something or somebody is different in a third-person kind of way, but that alienness directly affects and troubles the sphere of the own (35). "I" and "we" become persons who cannot take it, who respond in ways that are not in accordance with who we think we are or should be. And while this is certainly an extreme case, it demonstrates the volatile atmosphere that characterizes life in the ward. It is not so much that Søren Peter's presence is radically different from the constant everyday interruptions of alterity (Dyring, this volume); it is more as if the volume has been turned up to where our sense and other faculties

threaten to give up. Something very real, and very disturbing, haunts us and we all (including Søren Peter) respond in the ways we can.

DEMENTIA SOCIALITIES AND THE HUMAN CONDITION

> In the end the ancient definition: "The human being is an animal which has speech or reason" can be reformulated as follows: "The human being is an animal which responds." (Waldenfels 2011, 38)

How should we think about intersubjectivity and social life in the ward, a site where radical differences in how people "reason, exchange, speak and interact" (McKearney and Zoanni 2018, 3) cannot be overlooked? Where nagging words meet index fingers, and screams meet rolling eyes, "staying close and gently ignore," or attempts to exclude. Arguments have been made for an "autistic sociality," which thrives in online media settings and allows for particular ways of sensing and perceiving the world and relating to it and others (McKearney and Zoanni 2018; Ochs and Solomon 2010). Can we speak also of a "dementia sociality," which thrives in the dementia ward and is based on the particular ways in which residents sense, perceive, and relate to others and the world? Or maybe more to the point, can we talk about dementia socialities in the plural? Socialities that emerge through the perplexing and particular imagistic signatures and responsive events of the residents and others at the ward.

Having done fieldwork now for three subsequent years at the ward—observing everyday routines, exchanges, relations, conflicts over time—I would say that we can. There is a very specific feel to social life in the ward—deeply engaging and moving moments, fun ones, conflictual and haunting ones. There are intersubjective engagements and relations, as we have seen in the interactions between Ellen and Birgit, between Henry and me, and between Søren Peter, Ellen, Annelise, staff, and me. I suggest that what characterizes intersubjective life in the ward is a heightened sense of the co-presence and co-emergence of order and alterity. Sometimes order has the upper hand, sometimes alterity—as during the time that Søren Peter lived at the institution. Most days, though, order and alterity interchange and intersect in much shorter spans of time. The volatile, unplannable, and constant interchange between order and alterity makes human responsivity

come to the fore—and while this might also characterize our experience out-side the ward, it is much more palpable here.

Dementia socialities and asymmetrical and imagistic responsivity thrive in the ward, and one can learn, as one does in the company of the residents, to cultivate a mode of being with, which relies on the responsive event—not the responsive content—opening up for momentary intimacies and shared worlds between alien selves and others. Along similar lines, Dyring and I (2022) have argued for a "differential social ontology" which reveals how various ways of responding to the potentiality of interruptions form responsive communities of care that cross often profound differences be-tween people—and between humans and nonhumans. I suggest that Waldenfels's definition of the human being as "an animal which responds" allows us to keep the cognitively impaired or different, people living with dementia, staff, kin, and friends within the realm of those who continually respond to alterity in their search for the good—however fleeting, transient, and momentary their achievements of this pursuit might be.

IMAGISTIC INQUIRIES AND (COGNITIVE) DIFFERENCE

I have throughout this chapter argued that imagistic approaches can help us reveal "in a deeper or fuller fashion" (Pandian 2015, 278) the unground-edness of lived experience, and of the people, things, and worlds which are in it. Take Henry's words and sentences that start somewhere and wind off elsewhere, without any clear direction or consistency, at least on the discur-sive or "content level." Are they about uncertainty and doubt or their op-posites? The grammar and content would seem to indicate the first, his voice and composure the latter interpretation. Or take Søren Peter's screams that convey his voice as an umbilical cord to the outside world (Rosa 2016, 63) and his fear of abandonment. But, whose fear? His screams transgress boundaries of self and other, threatening to tear apart not only his lifeworld, but also shared social and institutional worlds.

I have also argued that we should be careful not to domesticate alterity when engaging in the lives of those who live with dementia. One domesti-cating move can be to overstate how welfare state or family intimate others are able to create or construct the person living with dementia or how per-sonhood persists. Another domesticating move could be to relegate demen-tia to the domain of the just plain horrible. Alzheimer's disease is—in the

words of Margaret Lock—"a stubborn conundrum" (2013, 11), which unsettles long-standing dichotomies in Western thinking between "mind and brain, aging and pathology, gene and environment" (4) and "an elusive mobile target in which brain and mind are not necessarily in sync" (3). I have tried to show that not only mind and brain but also senses of time, space, and belonging are not necessarily in sync in lived experiences of life with dementia.

Even more specifically, I have argued that attention to the imagistic signatures of residents can open up an avenue for exploring lives marked by alterity without domesticating its sting. I hope to have gestured toward the potential of imagistic thinking for exploring responsivity and intersubjectivity in lives lived with dementia. Residents "express without formulating," and at times being in the ward feels like being in a dream world. However, as Hollan (2017) has argued, Freud's notions of condensation, displacement, and projection might not only hold true of uncanny dream images but be characteristic of lived experience more generally. Or as Desjarlais (2019) writes: "So much in life is imagined and not concretely real, and an anthropology attuned to the imaginary—a fantastical anthropology, an anthropology of the phantasmal—needs to account for the force and tenor of the imagined. . . . It is not enough to stick with empirical studies of apparently real things, for life is much more than that" (ix). This is also what residents of the ward do: condense, displace, project, and imagine, reminding us that there is more to life than apparently real things. Through the exploration of imagistic signatures, what emerges are singular presences in the world, which not only defy categories (Mattingly 2019) but resonate with other singular presences across divides of often profound differences.

ACKNOWLEDGMENTS

My deep appreciation and gratitude go to the residents, their family members, and staff of the dementia ward who allowed me to hang out doing absolutely nothing and to ask many questions, who found me a couch where I could sleep overnight, and who basically just tolerated my presence, trusting that something good would come out of it. I will do my best to honor that trust. Thanks also to those who commented on several earlier presentations and drafts of this chapter: Lawrence Cohen, Thomas Schwarz Wentzer, Lisa Stevenson, Anand Pandian, Janelle Taylor, Tyler Zoanni, and

Patrick McKearney; and to the two reviewers for pushing this chapter further than I was able to do myself.

NOTE

1. According to the Danish Research Center for Dementia, the notion of dementia signifies the condition in which one's mental capabilities are affected by disease. The most common cause is Alzheimer's disease, but more than two hundred different diseases can lead to dementia (http://www.videnscenterfordemens .dk). I apply the notion of dementia in this article because the residents of the unit where I have done fieldwork are diagnosed with various cognitive diseases and impairments, not only Alzheimer's disease.

REFERENCES

Baars, J. 2017. "Aging: Learning to Live a Finite Life." *The Gerontologist* 57 (5): 969–76.

Basting, A. D. 2006. "Creative Storytelling and Self-Expression among People with Dementia." In *Thinking about Dementia: Culture, Loss, and the Anthropology of Senility,* edited by A. Leibing and L. Cohen, 180–94. New Brunswick, NJ: Rutgers University Press.

Behuniak, S. M. 2011. "The Living Dead? The Construction of People with Alzheimer's Disease as Zombies." *Ageing and Society* 31 (1): 206–20.

Brandel, A., and M. Motta, eds. 2021. *Living with Concepts: Anthropology in the Grip of Reality.* New York: Fordham University Press.

Brijnath, B. 2014. *Unforgotten: Love and the Culture of Dementia Care in India.* New York: Berghahn Books.

Christensen, L. 2020. "Crafting Valued Old Lives: Quandaries in Danish Home Care." PhD diss., Copenhagen University.

Cohen, L. 1998. *No Aging in India: Alzheimer's, the Bad Family, and Other Modern Things.* Berkeley: University of California Press.

———. 2006. "Introduction: Thinking about Dementia." In *Thinking about Dementia: Culture, Loss, and the Anthropology of Senility,* edited by A. Leibing and L. Cohen. New Brunswick, NJ: Rutgers University Press.

Dekker, N. L. 2018. "Moral Frames for Lives Worth Living: Managing the End of Life with Dementia." *Death Studies* 42 (5): 322–28.

Desjarlais, R. 2019. *The Blind Man: A Phantasmography.* New York: Fordham University Press

Desjarlais, R., and J. Throop. 2011. "Phenomenological Approaches in Anthropology." *Annual Review of Anthropology* 40:87–102.

Driessen, A. 2018. "Pleasure and Dementia: On Becoming an Appreciating Subject." *Cambridge Journal of Anthropology* 36 (1): 23–39.

Dyring, R. 2022. "Dementia Care Ethics, Social Ontology, and World-Open Care: Phenomenological Motifs." In *New Perspectives on Moral Change*, edited by Cecile Eriksen and Nora Hämäläinen, 106–25. New York: Berghahn Books.

Dyring, R., and L. Grøn. 2022. "Ellen and the Little One: A Critical Phenomenology of Potentiality in Life with Dementia." *Anthropological Theory* 22 (1): 3–25.

Felding, S. A., and N. Schwennesen. 2019. "Når omsorgen udliciteres: En analyse af den konfliktfyldte omsorgstrojka mellem mennesker med demens, pårørende og plejepersonale på et plejehjem i Danmark." *Tidsskrift for Forskning i Sygdom og Samfund* 16 (30): 123–49.

Gammeltoft, T. 2014. *Haunting Images: A Cultural Account of Selective Reproduction in Vietnam*. Berkeley: University of California Press.

Gill, H. 2020. "Things Fall Apart: Coming to Terms with Old Age, Solitude, and Death among Elderly Tibetans in Exile." PhD diss., Aarhus University.

Gjødsbøl, I. M., L. Koch, and M. N. Svendsen. 2017. "Resisting Decay: On Disposal, Valuation, and Care in a Dementia Nursing Home in Denmark." *Social Science and Medicine* 184:116–23.

Gjødsbøl, I. M., and M. N. Svendsen. 2018. "Recognizing Dementia: Constructing Deconstruction in a Danish Memory Clinic." *Medical Anthropology Quarterly* 32 (1): 103–19.

———. 2019. "Time and Personhood across Early and Late-Stage Dementia." *Medical Anthropology* 38 (1): 44–58.

Grøn, L. 2016. "Old Age and Vulnerability between First, Second and Third Person Perspectives: Ethnographic Explorations of Aging in Contemporary Denmark." *Journal of Aging Studies* 39:21–30.

Grøn, L., and E. Olesen. 2017. "The Institutional Aging Process: Ethnographic Explorations of Aging Processes and Dimensions in Danish Schools and Eldercare Institutions." *Anthropology and Aging* 38 (1): 1–16.

Hollan, D. 2017. "Dreamscapes of Intimacy and Isolation: Shadows of Contagion and Immunity." *Ethos* 45 (2): 216–31.

Kleinman, A., and J. Kleinman. 1997. "The Appeal of Experience; The Dismay of Images: Cultural Appropriations of Suffering in Our Times." In *Social Suffering*, edited by A. Kleinman, V. Das, M. Lock, and M. M. Lock, 1–23. Berkeley: University of California Press.

Kontos, P. C. 2006. "Embodied Selfhood: An Ethnographic Exploration of Alzheimer's Disease." In *Thinking about Dementia: Culture, Loss, and the Anthropology of Senility*, edited by A. Leibing and L. Cohen, 195–217. New Brunswick, NJ: Rutgers University Press.

Lamb, S. 2014. "Permanent Personhood or Meaningful Decline? Toward a Critical Anthropology of Successful Aging." *Journal of Aging Studies* 29:41–52.

Leibing, A., and L. Cohen, eds. 2006. *Thinking about Dementia: Culture, Loss, and the Anthropology of Senility*. New Brunswick, NJ: Rutgers University Press.

Leibing, A., and N. L. Dekker. 2019. "Fallacies of Care—A Short Introduction." *Journal of Aging Studies* 51:100795.

Leistle, B., ed. 2017. *Anthropology and Alterity: Responding to the Other.* New York: Routledge.

Lock, M. 2013. *The Alzheimer Conundrum: Entanglements of Dementia and Aging.* Princeton, NJ: Princeton University Press.

Mattingly, C. 2019. "Defrosting Concepts, Destabilizing Doxa: Critical Phenomenology and the Perplexing Particular." *Anthropological Theory* 19 (4): 415–39.

McKearney, P. 2018. "Receiving the Gift of Cognitive Disability: Recognizing Agency in the Limits of the Rational Subject." *Cambridge Journal of Anthropology* 36 (1): 61–79.

McKearney, P., and T. Zoanni. 2018. "Introduction: For an Anthropology of Cognitive Disability." *Cambridge Journal of Anthropology* 36 (1): 40–60.

McLean, A. H. 2006. "Coherence without Facticity in Dementia: The Case of Mrs. Fine." In *Thinking about Dementia: Culture, Loss, and the Anthropology of Senility*, edited by A. Leibing and L. Cohen, 157–79. New Brunswick, NJ: Rutgers University Press.

Meinert, L. 2019. "Still Held by Locham in the Wheelbarrow: Melting Stereotypes with Images." Paper presented at AAA panel.

Mikkelsen, H. H. 2016. "Unthinkable Solitude: Successful Aging in Denmark through the Lacanian Real." *Ethos* 44 (4): 448–63.

Ochs, E., and O. Solomon. 2010. "Autistic Sociality." *Ethos* 38 (1): 69–92.

Oxlund, B., L. Grøn, and S. Bregnbæk. 2018. "Introduktion: Sund aldring og sociale relationer." *Tidsskrift for Forskning i Sygdom og Samfund* 16 (30).

Oxlund, B., and S. Whyte. 2014. "Measuring and Managing Bodies in the Later Life Course." *Journal of Population Ageing* 7 (3): 217–30.

Pandian, A. 2015. *Reel World: An Anthropology of Creation.* Durham, NC: Duke University Press.

Rosa, H. 2016. *Resonance: A Sociology of Our Relationship to the World.* Cambridge: Polity.

Rowe, J., and R. Kahn. 1987. "Human Aging: Usual and Successful." *Science* 237 (4811): 143–49.

Snyder, L. 2001. "The Lived Experience of Alzheimer's—Understanding the Feelings and Subjective Accounts of Persons with the Disease." *Alzheimer's Care Quarterly* 2 (2): 8–22.

Stevenson, L. 2014. *Life beside Itself: Imagining Care in the Canadian Arctic.* Berkeley: University of California Press.

———. 2020. "What There Is to Fear: Scenes of Worldmaking and Unmaking in the Aftermaths of Violence." *Ethnos* 85 (4): 647–64.

Taylor, J. S. 2008. "On Recognition, Caring, and Dementia." *Medical Anthropology Quarterly* 22 (4): 313–35.

Waldenfels, B. 2007. *The Question of the Other.* Hong Kong: Chinese University Press.

———. 2011. *Phenomenology of the Alien: Basic Concepts.* Evanston, IL: Northwestern University Press.

Yahalom, J. 2019. *Caring for the People of the Clouds: Aging and Dementia in Oaxaca.* Norman: University of Oklahoma Press.

Zoanni, T. 2018. "The Possibilities of Failure: Personhood and Cognitive Disability in Urban Uganda." *Cambridge Journal of Anthropology* 36 (1): 61–79.

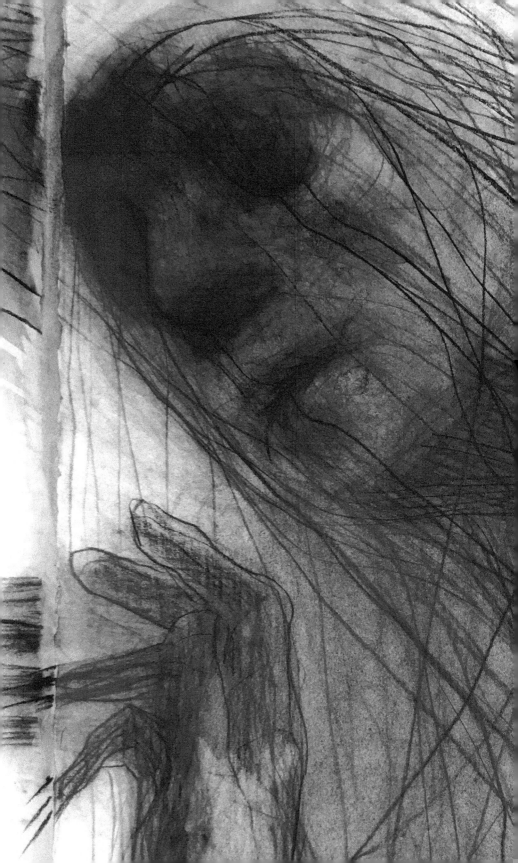

Life . . . Still
scratching at the words
out of language
life in the still
that which eludes the grasp
interrupts orders . . . exceeds, recedes . . . repels ordering
from elsewhere
differently in the world (if ever so slightly)
cuts open the orders of the world
uncontainable . . . undercurrents
suddenly stands still
back turned
gently into the space between them, as if something
into the depths of this . . . opened in between
intervals of indefinite
hesitation
that *demands* something
by extending his hand, reaching for, reaching into
this minute interruption

ON THE SILENT ANARCHY OF INTIMACY

Images of Alterity, Openness, and Sociality in Life with Dementia

RASMUS DYRING

STILL LIFE AND THE THRESHOLDS OF ETHICAL SUBJECTIVITY

There would be little evidence that time does in fact pass, were it not for the drifting clouds that filter the rays of the sun. Pierced by February sunlight, then covered in dull, icy shade, the central courtyard opens—at the heart of the dementia unit—a space exposed to the elements. Shielded behind the large windows of the warm dining room, two residents of the unit, Flemming and Keld, are still at the table, finishing their morning coffee.

Measuring time in its own peculiar way is Keld's regular turning of a page, or a whole handful of pages at once, in the tabloid magazine he is currently studying. With extremely slow movements, he flips the pages, first in one direction, then in the other. At one point, the magazine is opened to a page showing the TV guide. Soon after, to the pages showing the cartoons. Keld pauses to contemplate a drawing of a young couple in romantic embrace.

Then, very slowly, but with great determination, he extends his index finger and begins to scratch the surface of the page with his fingernail. Resolutely, he scratches. Perhaps there is a stain of some sort. Perhaps the

words on the pages are mere stains. Perhaps he is scratching the words—
scratching the word-stains.
 He scratches. The clouds drift. Light supplants shade.
 Scratching.

<div align="right">

[Image #1, Morning Coffee at a Dementia Unit
in Denmark, February 6, 2018]

</div>

The word—*logos*—was there at the beginning, they say. Or logos was the be-ginning, the origin, the *archē*. Now *logoi* may, of course, be many different things: speech, words, principles, a capacity for reason and reasoning, com-municative reason, the rationality of the world as such, not to speak of the God with whom the word was in the beginning, the God who was the word as the beginning, who with words let the world begin and who became in-carnate in the word, who was literally born into the world as the living word. While the history of Western metaphysics to a large extent is the history of the apotheosis of *logos*, the equation of *logos* and *archē* operative herein is not exclusive to more or less strong rationalisms and theological thought. Also in the critiques of modernity and its unwarranted rationalism so cen-tral in the development of anthropological and sociological theory and Con-tinental philosophy, there is a tendency to begin and end with language, the logics of symbolic life, the logistics of linguistic community. The ratio-nality of the Enlightenment turns into myth and ideology in dialectical twists. Human beings are worldbuilding creatures who dwell in that *house of Being* that is language. Meaningful experience is narratively constituted. Subjectivity is discursively constituted. Hence, among both the believers in the enlightening and civilizing powers of reason and the major critics of Western rationalism, *logos* in some shape or form remains absolutely central; remains, as it were, there as the *archē*, as the ordering principle that inaugurates a field of inquiry, thus ruling and shaping everything that follows.

 Whether we define the human being as the creature who possesses the powers of reason and language (e.g., *zoon logon echon, animal rationale, ani-mal symbolicon*) or as a creature possessed by discursive (subjectivating, interpellating) forces, we are—*from the beginning*—on the verge of exclud-ing from the proper field of humanity, of politics, of ethics those who are on the verge of sliding out of language, those, such as Keld, who to a large extent live life in the still mode. If human life, as Judith Butler argues (1997),

is linguistic life, and if it is politically and ethically vulnerable exactly due to its being linguistic (1–2), it seems to follow that those who slip from the realm of language—from the realm in which the ideological *devices*, the *anthropological machines*, the technologies of discursive interpellation are operative—also recede from that realm which conditions the possibility of truly *ethico-political* vulnerability, leaving only room for the utterly passive vulnerability of mere vegetative life. And if "the possibilities of human freedom"—to invoke James Laidlaw's already classic article (2002)—are thought to be premised on the self "subjectivating" itself to ethical regimens discursively "proposed, suggested, imposed" by a culture, society, or group (Laidlaw 2002, 323; cf. Foucault 1997a, 291), where does it leave the possibility of recognizing the *ethico-political potentiality* of life in the still mode? To reformulate Agamben's characterization of the bare life of the *homo sacer*,[1] we might say that within these widely shared "logical attitudes" of critique it appears that *still life*, residing at the outskirts of the *logos*, would be the life of those who can indeed suffer, but who cannot be "sacrificed" in discursive interpellation and who cannot undertake the self-sacrificial task of "subjectivation," which supposedly conditions the possibility of political and ethical subjectivity (Faubion 2011, 4). Hence, be it explicit or implicit, programmatic or residual, the logocentrism of these attitudes seriously impedes the understanding of ethical subjectivity and potentiality in life as it takes place in its still modes. And this depreciation of ethical subjectivity and potentiality will immediately have serious implications for any operative concept of care ethics once it is acknowledged that the specifically *ethical* quality of care hinges not on what we—as a society or as individuals—owe the individual person as a passive recipient of help and assistance, but on nurturing the potentiating *openness* that unfolds between persons (see Dyring 2022; Dyring and Grøn 2022).

In this chapter, I propose a critical phenomenology of the still modes of life with dementia that traces the emergence of this openness into a prediscursive phenomenal field. Invoking this term, *still life*, I do not mean to refer to the life of an individual human being, nor do I mean to identify an individual human life by a supposed deficiency (e.g., the loss of linguistic capacities). Still life refers to registers of lived experience in which, for whatever reason, stillness—Merleau-Ponty would call it the preobjective, prepersonal anonymity of perception[2]—is predominant (on stillness and dementia, see Vermeulen 2021). And yet, still life is not stale life. Stillness

resonates. Breathes and pulsates. In a series of ethnographic *resonance images* sketched during fieldwork at a dementia unit in Denmark, I attempt to capture such fields of resonance to explore registers of life that are generally and profoundly at work in human experience, but often eclipsed in the commotion of daily life and outshouted in the commonsense discourses that delimit our shared worlds. I will trace the emergence of potentiality in these images and conclude by sketching some implications of these analyses for the ethics of dementia care. Drawing on such resonance images, the current explorations are imagistic in two senses: on the one hand, I employ resonance images as a critical phenomenological device, but during the analyses, I also make an image—namely an estranged self-image as it appears in a mirror to a person with dementia—the object of analysis. Before turning to this, however, I will specify what I mean by critical phenomenology and in what way it is critical. To this end, I will turn first to a discussion of critique and alterity.

OPENNESS AND OTHERNESS: CRITIQUE
AND THE PROBLEM OF ALTERITY

The problem with the pervasive logocentric undercurrents of otherwise critical attitudes is not only the latent "epistemic injustice" of pathologizing perspectives that (from the beginning) cast cognitive *difference* as *disorder* in a logic of privation, thereby devaluing and excluding the "anomalous" lived experience as devoid of meaning, as mere illusion, as demented. The deeper problem is that the logical attitudes leave critique itself *experientially unaffected* by the potentiating excesses that reside in these excluded phenomenal fields. The degree to which various kinds of critical theory are experientially open to the unsettling but equally potentiating touch of that which eludes the grasp of "logos" can be made clear in terms of the place that these theories grant alterity. Let me outline some examples of this to clarify the position of the presently proposed critical phenomenology.

Alterity might be conceived as (i) *a function of the homo-logics of the self-same*. This is the case in theories of symmetrical intersubjectivity in which the alterity of the other is never so deeply rooted that it cannot be overcome in the "perfect friendship of the good" (Aristotle 1934, 461, 535), in the dialectics of recognition (Hegel 1977, 111ff.), in the dialogics of "inclusive community" (Habermas 1998). Alterity here gives way, even if as a catalyst

of scientific wonder and curiosity, to the scientist's penetrating grasp of the native's point of view (Malinowski 1984, 19, 25), the interpretative "grasp" of other cultures that reduce the "puzzlement" and bring about "the enlargement of the universe of human discourse" (Geertz 1973, 10, 14, 16), the merging of horizons in the medium of language (Gadamer 2004, 371–72). In sum: Alterity is an obstacle to be superseded and the work of critique is the work, under the auspices of the *logos*, of showing how what appears to be wholly other is really—in *principle*, at the *origin* (*archē*)—not that different.

Opposing this first mode of critique, poststructuralist thinkers take alterity to be (ii) *a function of the ideo-logics of discourse*. The Other, in this second schema, is discursively produced as a marginalized figure under the hegemony of the rational, the Western, the normal, the sane, the healthy; in a word, of the homologous selfsame bolstered in the accounts above (see Butler 1997; Trouillot 2003). In his thorough critique of the ideological workings of anthropological epistemology, Fabian shows how the "production of anthropological discourse" makes "ideological use of time" as a "distancing device" that through the *denial of coevalness* creates the "allochronic" alterity of the Other (2002, 31ff.). Critique in this second mode is the work of exposing how regimes of power (e.g., scientific, political, etc.) make use of the logics of discourse in order to produce, for instance, their research objects or manageable biopolitical subjects, and thus showing how this *othering*, this productive operationalization of alterity, has its principle and origin, its *archē*, in the *logos* of discourse.

All their dissimilarities notwithstanding, the conceptions of "alterity" in these two first accounts have their origin (*archē*) in some kind of encompassing logic, which in effect amounts to dissolving alterity. With a call to take seriously alterity as a starting point for ethnographic analysis (Henare, Holbraad, and Wastell 2007, 12), ontological anthropologists try to come to terms with phenomena of alterity without turning them into immature or alienated expressions of some all-encompassing logic.

Stressing the cosmological implications of the poststructuralist insights into the linguistic construction of the world, leading figures in ontological anthropology take alterity to be (iii) *a function of the onto-logics of referentiality*; "referentiality" here being an attempt to gather such notions as "perspectivism" (Viveiros de Castro 2014), the "obviation of meaning" (Wagner 2016), "semiosis of life" (Kohn 2013), and "anthropogenic conversation"

(Ingold 2018) under one heading. These theories generally propose versions of a more or less[3] "flat ontology" in which everything that exists emerges through a differentiating interplay of (perspectival, dialectical, semiotic) references on an immanent plane. Since everything thus has its origin on this same plane of originary "undifference" (Viveiros de Castro 2014, 204), alterity is a function of a subsequent corporeal differentiation, which brings about different beings with singular perspectives: Hence, "bodies are the way in which alterity is apprehended as such" (Viveiros de Castro 2015, 258). Yet, in the final analysis, the body of the other is simply another "self" that is structurally analogous to my own, but lived from a different, incongruous perspective. All life considers itself "human" from its own perspective, while it will look like, for instance, prey from the perspective of another species that also considers itself human (229).

Critique on this view amounts to the work of deconstructing all notions of a given uniform nature, which prescribes a certain natural hierarchy between living beings, and showing how all difference, being "referential alterity," has its origin and principle, its *archē*, in the play of incongruous perspectives on an immanent surface (Viveiros de Castro 2014, 87). While this third mode of critique is effective against the essentialisms that have long haunted Western metaphysics, the strong collectivism implied in the idea of the perspectival "ontological self-determination of collectives" leaves little room for recognizing difference *within* the given collective (42). Any kind of divergence entails the allocation of the (deviant) Other to a secluded, other perspective (Dyring and Grøn 2022; McKearney and Zoanni 2018). The Other becomes a whole other animal.

This problem is evident in a case of mental illness related by Viveiros de Castro:

> "No longer recognizing kin" means no longer occupying the human perspective; one of the most important signs of metamorphosis (and every illness is a metamorphosis . . .) is not so much the change in appearance of the self in the eyes of others, but the change in the perception by the self of the appearance of others, detectable by these others by a change in the behavior of the subject in question: the sick person loses the capacity to see others as conspecifics, that is, kin, and begins to see them as the animal/spirit who captured his or her soul see them—typically, as prey.

This is one of the reasons why a sick person is dangerous. (Viveiros de Castro 2015, 181; cf. 2014, 56)

In the context of dementia studies, the ontological and ethical implications of such a perspectival ontology are obviously quite problematic. As soon as alterity is understood ontologically as "referential alterity," and the cultural, the pathological, the biological Other is seen as the *referent* of an inaccessible, but positively given, wholly other perspective, there is nothing guarding those living outside the norm from being ethico-politically allocated to an other-than-human "nature." Hence, both the strong homo-logics of the first schema and the ideo-logical othering of the second schema return with a vengeance in this third schema due to its insistence on a most radical ontologization of the *production* of alterity.

Whereas the three approaches discussed above treat alterity as a function and hence as a derivative of some kind of all-encompassing ordering principle (homo-logy, ideo-logy, referential onto-logy), a radical nonreferential kind of alterity can be traced at the fringes of orders and in the interruptions of their encompassing logics. The obtrusiveness of such alterity should not be mistaken for instances of deficiency or dysfunctionality that might cause an order to break down the way the breaking of a cogwheel brings the machine to a halt. This kind of disruption would be just another way of deriving alterity *privatively* from the homo-logics of a preestablished operative order. Instead, radical alterity *interrupts* orders because it is "infinitely" other than any orders, because it exceeds, recedes from, even repels ordering as such (Dyring 2020, 2021; Leistle 2017; Waldenfels 2020). Since such radical alterity would be irreducible to any ordering and founding principle, any *archē*, I will speak of alterity in this mode as being (iv) *an-archic.*

ALTERITY AND THE ANARCHIC OPENNESS
OF CRITICAL PHENOMENOLOGY

The kind of critique that emerges with a developed sensitivity toward experiences of anarchic alterity is a *phenomenological critique* that, to be sure, recognizes the workings of ideology and discourse, but that ultimately channels the impetus of its critical movement from the anarchic excesses of

lived experience (see Dyring, Mattingly, and Louw 2018, 16; Guenther 2006, 98–99; Marder 2014, 71ff.; Mattingly 2018, 174; Zigon 2018, 162). Drawing on phenomenological terminology, I will specify what this sensitivity toward anarchic alterity means in terms of (i) methodology and (ii) the characteristics of the phenomena with which a critical phenomenology is concerned.

(i) Anarchaeological Reduction: The Methodological Impact of Interruptive Openness

Classical Husserlian transcendental phenomenology is pursued within a universal "epoché"—a bracketing of the validity of the "natural" world as something immediately and simply given—which makes possible an exploration of the intentional structures of transcendental (inter)subjectivity in which the meaningful lifeworld is constituted, in which it has its grounding, its *archē*. For Husserl, this shifting of experience was an attitudinal modification effected by the phenomenologist resolutely changing their relationship with the world (Husserl 1970, 145, passim), and this resolute shift allows for the reflective effort of the "transcendental reduction," which traces experience to its constitutive, transcendental elements. With an increased emphasis on the experiential impacts of irreducible alterity, the character of the epoché and the reduction begin to change. As Salamon relates Merleau-Ponty's understanding of the reduction, it becomes about "a rupture, a making-strange of the world" that transforms our stance in the world "into one of wonder, and our relation to the world is one of *felt openness*" (Salamon 2018, 11). The idea I am pursuing here is that experiences of anarchic alterity bring about this "rupturing" phenomenological modification as a pathic event, rather than a willed bracketing (cf. Throop 2012, 85). The epoché now is something that comes from elsewhere, something that *befalls* us in the form of an experiential *interruption* that, circumscribed by pathos, affect, mood, "emplaces" lived experience differently in the world (if ever so slightly), thus unleashing new, or bringing into view previously foreclosed, potentials for being in the world.[4]

As interruptive experiences, such "epochal" disclosures of potentiality cut across life on a most basic affective level, before these sensed potentials may be raised to the discursive level of ethico-political interventions or reflected in the academic critical gaze. In other words, here it is experience itself that turns "critical"—that separates and distinguishes (Gr. *krinō*),

interrupts and cuts open the orders of the world—prior to, and not necessarily dependent on, anyone taking it explicitly upon themselves to be the outspoken critic. The irreducible and uncontainable anarchic undercurrents of lived experience—including lived experience in the still modes of life—are to be recognized as original sources and resources of critical potential. This is an all-important insight when it comes to recognizing the often overlooked openness of life with dementia and the still modes of life in general.

In critical phenomenology, both in its philosophical and in its anthropological variations, several authors point to these experiential reservoirs of critique. While using different idioms and drawing on different sources of inspiration in their theoretical elaborations, many highlight in some shape or form "epochal" impacts of anarchic alterity that lead to a potentiation of lived experience. To mention a few examples: elsewhere, I have explored how the singular and excessive, yet curiously vacuous, phenomenon of Mohamed Bouazizi's public self-immolation at the onset of the Tunisian Revolution provoked a widespread "phenomenological modification" in the general political imaginary that made possible new experiences of "freedom and community." By taking his own life in plain view, by making it a "public thing," Bouazizi's act left behind a bright, potentiated space, where no properly *political* "space of appearances" had existed prior to his spectacle of disappearance; a space that could not readily be closed down, since Bouazizi had already removed himself beyond the reach of the authorities. This potentiated interval thus at once revealed the *limits-of-power* of Ben Ali's regime and served as a threshold where the space for a new revolutionary political gathering opened (Dyring 2015a, 21ff.); Zigon (2019, 89) has described in a more intimate setting these "disruptive hermeneutics of dying-with" in terms of a potentiating experience of ethical community undergone by drug users losing their loved ones; Mattingly (2018, 427) writes of disruptive experiences of "perplexing particulars" that "interweave with concepts and categories so as to call those very concepts and categories in question and reveal their limits"; Throop (2012, 85, cf. 2018) details how an "ethnographic epoché" arises as "a form of phenomenological modification that is intersubjectively and passively generated in the subjectivity of an anthropologist who must recurrently and actively face frustrations arising from the limits of his or her abilities to understand"; Guenther (2013, 232–33) writes that "critique" is a "variant of the phenomenological reduction" that

issues from an experiential "provocation" arising in the "interruptive *encounter with the other*" (emphasis in original). While the works whence these examples are drawn eventually are taken in different directions (e.g., social critique, political activism, ethical theory, epistemology), they all have in common the fact that they "ground" their work in an experiential "unground," in the abysses of anarchic alterity, rather than the *archē* of a transcendental, a priori logic or the *archē* of historical discourse. Hence, inasmuch as these efforts of tracing the impulses of critical potential lead back into the *anarchic* excesses of lived experience, I suggest that they display a version of what we might call *anarchaeological reduction*.[5]

If this is so—if critical phenomenology is fundamentally anarchaeological in its method—the movements of critique must be emplaced rigorously in an interruptive spacing somehow opened and circumscribed by anarchic alterity, and they must proceed by meticulously tracing the contours of potentiation as they carve out this opening, this interval. In addition to a methodological impact, then, interruptive experiences also form a basic "phenomenon" of critical phenomenology.

(ii) Interruptive Openness as the Phenomenon
of Critical Phenomenology

The phenomena with which such an anarchaeological phenomenology is concerned are phenomena that are somehow experientially indicative of *interruptions* taken in this ontological sense of a visceral potentiation. To avoid prevalent misunderstandings: these interruptions are not dissociated from ordinary life, they are not pure states of exceptions, and they do not occur in a dialectical logic as the absolute negation of a previously operative order. It is not a question of a binary architecture with two settings; order vs. chaos, the ordinary vs. the extraordinary. What happens in the interruption is not the absence of all order, but the assailment of constitutive unsettlements that haunt any order and *indicate experientially* an openness, an interval that recedes from the functioning orders. Such interruptions might befall lived experience in a wide variety of intensities, temporalities, and moods.

Interruptions may happen as global events over an extended period like the Anthropocene interruption (see Dyring 2021) or more swiftly like the

COVID-19 interruption; they may happen as more local "ontological break-downs" (Zigon 2018) that interrupt the ability of communities to dwell meaningfully in the world, and hold the potential for a poietic, radically hopeful renewal of a lifeform (Lear 2006). They may happen as intense interruptions that threaten to tear asunder the institutional logics of a residential dementia care unit (Grøn, this volume; see also Dyring and Grøn 2022), or they may happen, as I will explore below, as barely noticeable interruptions in the minutiae of everyday life at such care facilities. However, whatever form they take, interruptions are everywhere, interlacing, forming, deforming, reforming life. The minute interruptions of everyday life are what keeps the world open and dynamic: there are interruptions teeming in the hustle and bustle of daily living, stirring in the most intimate of relationships and vibrating in the minutiae of life's still modes. Even if they do not rise to a reflective level, they pervade the affective undercurrents of lived experience as a most intimate and imponderable potentiation of the imponderabilia of actual life. The interruptive experiences that others undergo are, even when we cannot personally share them with the same intensity, nonetheless *indexical* phenomena that point into resonant potentiated regions of everyday life, and, as such, they form access points for an anarchaeological phenomenology.

Playing on the meaning of the component parts of the word, we might say that what takes place in the lived experience of inter-ruptions is the e-*ruption* of potentiated *inter*-vals.

INTERRUPTIVE OPENNESS IN THE MINUTIAE
OF EVERYDAY LIFE AT A DEMENTIA UNIT

In what follows, I will trace the eruptions of such potentiated intervals in ethnographic *resonance images* drawn from fieldwork at a dementia unit in Denmark. With this term, I refer to an image—*in casu*, an image painted with words, but it might as well be a drawing, a sculpture, a piece of music, etc.—that, like Walter Benjamin's *dialectical image* (Benjamin 2002, 462; see Lynteris 2018), arrests a fleeting phenomenon and captures, in a still, a radical tension (cf. Steward 2007, 18–19). The ethnographic resonance image captures the resonances, the transients and the faint contours of interruptive experiences, in which a profound, but at times unobtrusive potentiation

takes place. Due to this affective, atmospheric quality, the significance of what is captured in the "images" lies not on the level of "discursive modes of knowing" (cf. Stevenson 2014, 10), but, as Kathleen Steward writes about what she calls *ordinary affects*, "in the intensities they build and in what thoughts and feelings they make possible" (Steward 2007, 3). In terms of phenomenological methodology, the resonance image is an "imagistic amplification" (Mattingly 2019, 427) that lays out a path for the anarchaeological plunge into the prediscursive depths of lived experience.

While *image #1*, which opens this chapter, is captured at the residential unit of a dementia unit in Denmark, the images that follow are captured at the day center associated with the unit, where a shifting group of four to eight people with less advanced dementias, who live in their own homes, meet daily from 10 A.M. to 3 P.M. to drink coffee, eat lunch, socialize, and participate in small-group activities such as playing cards, baking, and the like. The female users of the day center are generally widows, who live alone, while the male users generally live with a spouse. In the latter case, the day center is meant to alleviate some of the stress that many close relatives experience in connection with informal caregiving.

The caregivers working in the day center tell me that the users of the day center do not address each other or the caregivers by name, and that only a few of them have something resembling a lasting relationship in spite of the fact that most of them have frequented the day center for several years. However, they generally recognize and feel safe around the staff. While the users of the day center have not lost their linguistic capacities, their dementia-related symptoms, such as frequent repetitions of stories and phrases, a forgetfulness of personal, biographical details, and so on, are quite pronounced in most cases. For some—like Janus, whom I will write about below—there is very little extended communication with the surroundings. Janus moves in his own patterns, and his interactions with the other users often turn conflictual. He is obsessed with his reflection in the mirror, which means that he tends to occupy the restroom in the day center. When others need to use the restroom, he refuses to leave. This is one source of conflict among several. An outing to a nearby beach almost ended in a physical confrontation between Janus and a stranger sitting on a bench with his dog running around loose. As the caregiver put it when she recounted the story to me, "the man on the bench had his own problems to struggle with." So when some of the day center users kept calling his dog over, even though

the man told them not to, he quickly got irritated and told the group off. This made Janus furious. He wanted to fight the man.

"The small conflicts that arise in the day center might likewise end with two gentlemen standing face to face with their fists clutched," the caregiver concludes her story about the trip to the beach.

The caregivers know they have to take special precautions with Janus due to his obsession with the mirror and his tendency to pace restlessly around in the day center, but they also try not to correct his behavior too much in front of the other users so as not to put him in a more exposed position than he already is.

It is 10:15 A.M. The minibus arrives with today's users, a group of seven. The two caregivers and I greet them at the entrance. Some shake my hand. I get a friendly pat on the shoulder. Janus does not say hello. Already before he enters the place, Janus asks why he is there and how long he is supposed to stay.

First item on the agenda: morning coffee. Because we are so many today, we sit around two tables. The caregivers make sure that Janus is placed in a way that blocks his view of the outside parking lot and they strategically close some of the curtains. Otherwise, he will constantly be drawn to the cars coming and going, and get up and try to get out so a car can take him home. Janus is sitting at one table, I am sitting at the other table.

Soon, everybody is busy eating jelly sandwiches and drinking coffee or juice. There is some conversation around the tables, at first initiated by the caregivers at the tables. At my table, one woman—Irene—quickly takes the word, and begins telling me anecdotes from her life. After a short while, I sense, behind me, that Janus gets up from his chair. He walks past our table toward the windows, pulls the curtains slightly apart with two fingers and looks out the window toward the parking lot for a moment.

"Oh! He stresses me out, that one!!" Irene says to me, but quite loudly, sending him an unappreciative look, while rolling her eyes.

Janus does not notice. He is on his way elsewhere.

Always elsewhere.

He goes from the windows facing the parking lot to the restroom. Here he looks at himself in the mirror. He spends a lot of time in front of that mirror. Only when the caregivers come to bring him back to the living room does he leave—but not without protest.

Soon he is back looking out the windows. In an adjacent room, Janus finds a green blanket, which he carries around under his arm.

Now Janus is standing in the restroom again looking into the mirror. One of the caregivers comes and says: "Come on, Janus, let's go."

Janus replies in a quite angry voice, not removing his gaze from this man looking back at him.

"Then he also has to come!"

[*Image #2, Janus and the Mirror, February 14, 2018*]

Janus's restless walks are evidently *interrupted* by the image in the mirror, the image of the face of a man about whom Janus speaks in the third person: "Then *he* also has to come." This man is evidently another to him. But is he also strangely familiar? Is his fixation with the *mirror image* of himself a way for him to hold on to himself? The paradox here is of course that the "self" he is trying to hold on to appears as another: As a "he," not a "me." Rimbaud's oft-cited "I is another" here becomes tragically salient.

Since the image in the mirror is the image of a face, the well-known phenomenological trope of the face of the Other presents itself as an obvious first path into the interruptive opening of the mirror. However, upon closer inspection, the phenomenon, as it is described by Levinas, seems to emphasize traits that are not salient in Janus's encounter with the face of his intimate stranger. The face in Levinas is the "epiphany" of the infinitely Other, who remains "infinitely transcendent, infinitely foreign; his face in which his epiphany is produced and which appeals to me breaks with the world that can be common to us" (1969, 194). This "epiphany of the face" is, as Levinas would have it, an "ethical" phenomenon par excellence, exactly because it is radically incommensurable with the orders of the common world and hence *pulls me out of this world of day-to-day living.* As such, it encroaches as an "ethical resistance that paralyses my powers" (199). Now, the face that haunts Janus seems not to descend from the height of Levinas's face despite the fact that it for Janus obviously is the face of an Other. *This* other does not break with the prevailing orders of Janus's mode of being in the world. If anything, Janus's fixation with the mirror appears to sustain the peculiar order that unfolds in this *mirrored space*, in this interval that opens between the two faces of Janus.

In "Of Other Spaces" Foucault calls the space that opens in the depths of the mirror a *heterotopia* that operates as a "real contestation of the space

in which we live" (1986, 24). Unlike the non-place of the utopia—which is precisely nowhere, characterized by its absence, its not-yet, its perpetual to-come—the heterotopia of the mirror, Foucault writes,

> exists in reality, where it exerts a sort of counteraction on the position that I occupy. From the standpoint of the mirror, I discover my absence from the place where I am since I see myself over there. Starting from this gaze that is, as it were, directed toward me, from the ground of this virtual space that is on the other side of the glass, I come back toward myself; I begin again to direct my eyes toward myself and to reconstitute myself there where I am. The mirror functions as a heterotopia in this respect: it makes this place that I occupy at the moment when I look at myself in the glass at once absolutely real, connected with all the space that surrounds it, and absolutely unreal, since in order to be perceived it has to pass through this virtual point which is over there. (Foucault 1986, 24)

In the case of Janus, the mirror does not result in this "reconstitution" of selfhood: that is, the self's coming back to itself from the other in the mirror, since this dialectical movement, as it is evident in our case, presupposes what it re-constitutes; namely a self that already re-cognizes the other in the mirror as itself. Janus apparently does not recognize the other as himself. Rather than reconstituting himself here in a world that is "absolutely real," Janus seems to be stuck in the heterotopic "contestation of the real world in which we live," stuck in the potentialities of a mirror world. In between the two faces—in the hollow gorge of the specular interval—the heterotopic ordering of Janus's lifeworld congeals.

On the level of this phenomenal field that underlies Janus's mode of being in the world, words have little effect. The caregivers repeatedly call on Janus to come back to the joint space of the living room, and although he understands the semantic content of the words and leaves the restroom, the affective field of existential potentialities in which he lives his life remains conditioned by the heterotopic "contestation," the interruption of the joint world, so emblematically reflected in the depths of the mirror.

In the next image, captured a couple of days later, Janus is back in the day center. He is going through the regular motions, but this time around, a minute interruption comes from an unexpected place.

As usual, the caregivers in the day center have planned some activities. Today, a local day care center for toddlers, run by the mother of one of the caregivers, is visiting the day center. Five children ranging from ages one to three and two grown-ups arrive shortly before 10 A.M. Then the minibus pulls up to the front entrance.

From the very moment Janus steps inside, he wants to leave. He repeatedly asks when he is going home. The caregivers tell him time and time again that the bus will take him home at 3 P.M. Throughout the day, he remains alert and always on the move.

According to the usual routine, it is time for morning coffee as soon as everyone has settled in. Once again we are placed around two tables. Today, I sit at the same table as Janus. The visiting children sit on the floor. They seem comfortable, eating their rolls and looking around in this new, unknown place.

Janus quickly finishes half a roll, gets up, and begins to walk around. First, he goes toward the windows to look out through the half-closed curtains. Then he turns around and heads back toward the hallway, where the restroom and the mirror await. But just as he is about to pass the children, he suddenly stands still. In front of him, with her back turned to him, sits little Christina on her knees, eating her roll. Is he transfixed? No. If you look closely, the fingers on his one hand twitch a little bit. He moves his hand ever so gently into the space between them, as if something draws it in.

But then he is off again.

He was already on his way elsewhere, but for a short moment Christina's curly top stopped Janus in his path. It lasted only a few seconds and could easily have been missed.

His hand gave it away.

[Image #3, Janus's Hand, February 16, 2018]

Here the interruption is of a different kind than the heterotopic interruption of the mirror explored above. The experience that interrupts Janus here arises in an intercorporeal relation that is neither truly frontal (like a face-to-face relationship) nor truly lateral (like a we-relationship). It rises, as it were, before a child's back; nonintrusive and turned on the world in perfect innocence. Instead of "break[ing] with the world that can be common to us," to borrow once again Levinas's description of the phenomenal impact of the face of the Other, the experience rising before the back of this child

seems to elicit a slight rupture, but a rupture, nonetheless, in whose spacing the signs of an affective co-inhabitation, that previously seemed not to be a prevailing potential in Janus's way of inhabiting in the day center, present themselves. With twitching fingers—with a posture as insecure as potentiality is intangible—Janus reaches into the depths of this interval that has opened in between himself and the little girl's back as if to probe it, as if to test its reality.

If this is so, it means that there is something in the phenomenon of *the back of an other* that—akin to Levinas's face, but in a quite different ontological modality—makes for an interruptive saturated phenomenon in which there is much more at stake than simply the acknowledgement of the presence of another being in objective space.

The back, the fleshy surface that lines the rear of the torso, is a carnal boundary par excellence. But like all boundaries, it is not simply that which closes off. It is just as much a potentiated threshold whence a differentiation of existential space begins, whence an opening toward something other surges (Dyring 2020, 98). The back, we might say, leaves a space open exactly by withdrawing from this space, and unlike the face of the Other that, as Levinas writes, "from the depths of defenseless eyes rises firm and absolute in its nudity and destitution" (Levinas 1969, 199–200), thus condemning and accusing me in a way that radically transcends me and undermines my grasp of the world, the back of an other does not soar infinitely over, let alone tribunalize, the interval that it opens.

The opening-withdrawal issuing in the phenomenon of the back entails the radical exposure of the back within this interval. Yet, it simultaneously releases within it an experience of potentiality. Standing behind the backs of others, one registers affectively, in the flesh, the depths of intercorporeal coexistence; one senses the contours of foreign regions of potentiality, traces of intertwining life trajectories, meshes of singular destinies halfway sealed. This depth of potentiality sensed before the back of an other is not a clear biographical catalogue of possibilities that the other can willfully draw upon, or that I may interpret and merge with my own.[6] "Depth and 'back' (and 'behind')—it is preeminently the dimension of the hidden," Merleau-Ponty writes (1968, 219). And yet, this saliently sensed depth of hidden potentiality is the "flesh" of the world, the intercorporeal, prediscursive element whence lived experience emerges (249). Hence, to suggest that Janus here is interrupted by a deep sense of potentiality arising before the girl's back is

not to suggest that a new range of clearly delimited, practical possibilities present themselves, nor even that the experience of potentiality necessarily involves any concrete interaction with the girl or the other visiting children. Intercorporeal depth is not identical to, but the experiential precondition of, such intentional, social action. But if the interruptive experience of intercorporeal potentiality is not the cognizing of definite, practical possibilities, how is it a potentiation of lived experience?

Rather than adding definite possibilities to a repertoire, the interruptive experience before the back of an other elicits a kind of generative unsettlement of the experiential, practical horizon of a lifeworld, a shift or deferment that exposes intervals of indefinite potentiality. With Merleau-Ponty we might say that with the carnal presence of an other, a "vortex forms, toward which my world is drawn and, so to speak, sucked in" (Merleau-Ponty 2002, 411; cf. 1968, 138). It is in the depths of these anarchic maelstroms that subjectivity is bounded and constituted, becoming what it is by emerging out of an intercorporeal element that precedes particular identities (see Dyring 2022; Käll 2017). And it is, conversely, in the deprivation of such intercorporeal experiences—as Lisa Guenther so forcefully shows in her phenomenology of solitary confinement—that social death as a destruction of subjectivity ensues. As Guenther writes:

> The body of the other is not merely a thing among other things but an open-ended "pattern of behavior" defined by its habits of movement, activity, and response, in relation both to my own patterns of behavior and to the animate and inanimate things that we mutually encounter in places within a shared world. In this sense, body, thing, and other are not separate substances that exist first and foremost for themselves and only later enter into relation with each other; rather, they are mutually constitutive relata for whom the relation comes first; a separate identity emerges only through divergence. (Guenther 2013, 179)

Image #3, as related above, captures *experiential indices* that suggest that Janus, on his way through his heterotopic elsewhere, suddenly finds himself sucked into the anarchic depths of an intimate "vortex" in a way that entails a salient experience of openness toward inhabiting the world differently (if ever so slightly). Even if the interruption lasted only a few seconds, the hesitation that comes across in Janus's posture is indicative of such an experience of potentiation. Janus did not stop because Christina blocked his

path. He had no problem going around Christina a few seconds later. His stopping was not caused by a sudden inactivity or indifference. On the contrary. His hesitant posture, and hesitation in general, is a highly affective response to the experience of being irredeemably "sucked in," emplaced, in a situation that *demands* something. And the more intimate the indefiniteness and hidden depths of the situational potentiation are experienced, the more profound is the hesitation. Hesitation, then, is not caused by the logical or practical *impossibility* of responding, but by an unboundedness sensed in the potentials opening in the impending responses. Janus's hesitant posture, on this account, is indicative of a carnal emplacement in, and a creative responsiveness to, the anarchic depths of a potentiated interval.

His probing hand movement adds further details to this phenomenology. Despite the spectral, ephemeral quality of the interruption, it impacts experience in a manner that borders on tangibility. In fact, Janus responds to this experience by extending his hand, reaching for, reaching into its indefinite spacing. The movement of his hand is slow and insecure. But most of all, it is tender and gentle. His minute gesture responding to this minute interruption is expressive of a shift of existential composure. The gesture of his hand expresses a change in his potential for "handling" himself in the world. Before Christina's back, in this potentiated interval that opens between them, Janus appears to suddenly find himself emplaced differently in the world. But just as abruptly as the tender spacing opened, Janus slips back into his heterotopia.

It is now after lunch. I am sitting in an adjacent room close to the restroom, writing field notes. Janus passes by frequently, carrying his companion blanket.

Under his breath, he seems to be cursing at the mirror man.

[*Addendum, Image #3*]

EPILOGUE: THE ANARCHY OF INTIMACY AND WORLD-OPEN CARE

Hannah Arendt writes:

The life span of man running toward death would inevitably carry everything human to ruin and destruction if it were not for the faculty of *interrupting* it and beginning something new, a faculty which is inherent

in action like an ever-present *reminder* that men, though they must die, are not born in order to die but in order to begin. (1998, 246, emphases added)

Even "the smallest act in the most limited circumstances,"[7] as Arendt put it elsewhere, "bears the *seed of the same boundlessness*, because one deed, and sometimes one word"—and we can add to this, one tiny gesture, a turned back, a twitching of fingers—"suffices to change every constellation" (1998, 190, emphasis added). The cultivation of a sensitivity toward the *reminders* of these boundless, yet deeply human "interruptions"—not least in the context of what is sometimes called "memory care"—must be a first imperative, a master virtue in care ethics. I will conclude this chapter by relating the explorations above to the role of "intimate others" in caregiving. While "intimate others" will mostly be taken to be the relatives or close friends who are the active parties in informal caregiving, the analyses above build on images of intimacy that take the phenomenon in a markedly different direction. What happens to the notion of care ethics that underlies dementia care, when the anarchic openness of intimacy is taken into account?

First of all, what is intimacy and how is it related to potentiality? The kind of intimacy encountered above is not to be understood in terms of the proximity of actual bodies in physical space. Intimacy here does not lie in the elimination of distance, but rather in the opening of an interval. Also, intimacy here is not about positive knowledge of a person's biographical data and psychological makeup, nor is it about knowing an "inner core," a soul, or knowing who the other truly is or how the other actually feels before she herself knows it. Intimacy here is not psychological and person-centered in Kitwood's (2019) sense, nor is it properly speaking relationship-centered (e.g., Nolan et al. 2004). As the term itself says: *Inti*-macy is about an *intus*, about the sharing of the interior space of an interval in which the non-exhaustive, non-possessable, and therefore *anarchic* openness of intercorporeal being-with others in a shared world resonates. Interruptive intimacy, then, is to be understood as a prepersonal, prediscursive *ontological event*—albeit, in the present case, like in so many other cases that interlace everyday life, a "small event" (cf. Mattingly 2018)—that opens and configures the spaces of resonance in which bodies, minds, and relations are allowed to concretely take place. The *intus* of intimacy is the potentiated interval that

extends as an anarchic "grounding" for the gathering of community in new compositions. That intimacy, ontologically, is about the opening of a potentiated interval is not gainsaid by the fact that intimacy might be incapacitating, suffocating, and claustrophobic. Intimacy can manifest in such modalities of deficiency exactly because it is a phenomenon in which an ontological modulation of "capacity" takes place by way of an atmospheric spacing.

What are the implications of these social ontological insights for an operative notion of care ethics? In an immediate sense, care seems to be about tending to the somatic and psychological needs of the other person (Kitwood 2019, 92). In this definition, however, the difference between care as biomedical, psychological, pedagogical practice and the *ethics* of care more specifically fades into indistinction. However, recalling Arendt's "reminders" of the interruptive faculty that transforms life from a mortal degenerative process into an excessive event of natality (1998, 176–77), the specifically *ethical* quality of care comes into view in terms of what we could call an *imperative of world-openness* (Dyring 2022). The ethics of care now builds on a demand for tending to those shared prepersonal potentiated intervals that *erupt* anarchically in between persons and hence tending to an openness that in a certain sense precedes individual personhood, rather than tending primarily to what can be conceived in terms of individual needs. The blurring of this distinction lies in the nature of the biopolitical organization of healthcare and culminates in residential care. It is the critical task of a phenomenology of life with dementia to trace the contours of this distinction and help wedge it open, thus exposing the unbounded potentials of everyday life with dementia that are so often eclipsed by a somatic, biomedical gaze. *This is world-open care.*

ACKNOWLEDGMENTS

Most importantly, I would like to thank the users and caregivers at the day center and the residents and the caregivers at the residential care facility in which the fieldwork was carried out. Thank you for your openness! Secondly, I would like to thank the colleagues in the project "Aging as a Human Condition" for their stimulating comments on the presented research, and VELUX FONDEN for their generous support.

NOTES

1. In the work of Agamben, the life of the *homo sacer*, i.e., the bare life (*zoē*) that remains when all politically qualified life (bios) is stripped away, is the life of those "who *may be killed and yet not sacrificed*" (1998, 8).

2. As Merleau-Ponty puts it: "Every perception takes place in an atmosphere of generality and is presented to us anonymously. I cannot say that *I* see the blue of the sky in the sense in which I say that I understand a book or again in which I devote my life to mathematics. . . . If I wanted to render precisely the perceptual experience, I ought to say that *one* perceives in me, and not that I perceive" (2002, 250, passim).

3. Kohn critiques the reductionist tendencies of some flat ontologies, but flattens the ontological plane inasmuch as he thinks of all life as semiotically constituted (2013, 7–9).

4. Elsewhere I have explored the methodological implications for ethnographic experience of this kind of affective emplacement (Dyring 2015b; see also Dyring and Grøn 2022).

5. We can contrast the *anarchaeological reduction* with the archaeological ambitions of both the Husserlian transcendental reduction and the Foucauldian "archaeology." The transcendental reduction for Husserl is the pure reflective effort of tracing the structures of transcendental (inter)subjectivity as the ground, the *archi-region* as Derrida puts it (2011, 10), of all meaningful experience (Husserl 1970, 167–68). Foucault shifts the *archē* firmly onto historical grounds with a method that is "archeological—and not transcendental—in the sense that it will not seek to identify the universal structures of all knowledge or of all possible moral action, but will seek to treat the instances of discourse that articulate what we think, say, and do as so many historical events" (Foucault 1997b, 315). The *an-archaeological* approach explores, *in* lived experience, how the given forms of experience both delimit spaces of significance, while they at the same time (like all boundaries) call experience beyond itself. What it traces, then, is a *constitutive unsettlement* that resonates experientially in all settled orders, rather than a supposed rootedness on historical discursive or a priori transcendental planes. Anarchaeological critique is not a "work carried out by ourselves upon ourselves as free beings," (1997b, 316) but *critique-in-the-flesh* that we ourselves do not initiate and carry out upon ourselves, but that begins from—that has its *(an)archē* in—viscerally felt unsettlements and provocations that assail us and transpose us to the thresholds of the pockets of potentiality hiding in the shadows, fissures, hesitations, deferments of established orders.

6. This is not a matter of the "reflective judgement" and the "visiting imagination" of which Arendt (1992) and Jackson (2009) write, but the affective undercurrents that make possible such a reflective act.

7. The vigilant reader will find it strange that I invoke Arendt's notion of action here, when I earlier wrote that the interruptive potentiation of experience takes place on an affective register prior to, and as the condition of, intentional action. However, at its very heart, Arendt's notion of action is unsettled by traces of an unexplored affective dimension; traces of the abyssal, affectively sensed *an-archē of natality* that precedes any intentional, voluntaristic enactment of the capacity to begin. The "impulse" of action, Arendt writes, "springs from the beginning which came into the world when we were born and *to which we respond* by beginning something new on our own initiative" (1998, 177, emphasis added). Hence, the concrete act is always a deferred beginning that responds to an immemorial beginning.

REFERENCES

Agamben, Giorgio. 1998. *Homo Sacer: Sovereign Power and Bare Life*. Translated by Daniel Heller-Roazen. Stanford, CA: Stanford University Press.
Arendt, Hannah. 1992. *Lectures on Kant's Political Philosophy*. Chicago: University of Chicago Press.
———. 1998. *The Human Condition*. 2nd ed. Chicago: University of Chicago Press.
Aristotle. 1934. *Nicomachean Ethics*. Translated by H. Rackham. Cambridge, MA: Harvard University Press.
Benjamin, Walter. 2002. *The Arcades Project*. Translated by Howard Eiland and Kevin McLaughlin. Cambridge, MA: Harvard University Press.
Butler, Judith. 1997. *Excitable Speech: A Politics of the Performative*. London: Routledge.
Derrida, Jacques. 2011. *Voice and Phenomenon: Introduction to the Problem of the Sign in Husserl's Phenomenology*. Translated by Leonard Lawler. Evanston, IL: Northwestern University Press.
Dyring, Rasmus. 2015a. "A Spectacle of Disappearance: On the Aesthetics and Anthropology of Emancipation." *Tropos* 8 (1): 11–33.
———. 2015b. "Mood and Method: Where Does Ethnographic Experience Truly Take Place?" In *Truth and Experience: Between Phenomenology and Hermeneutics*, edited by Dorthe Jørgensen, Gaetano Chiurazzi, and Søren Tinning, 293–318. Newcastle: Cambridge Scholars.
———. 2020. "Emplaced at the Thresholds of Life: Toward a Phenomenological An-Archeaology of Borders and Human Bounding." In *Debating and Defining Borders: Philosophical and Theoretical Perspectives,* edited by Anthony Cooper and Søren Tinning, 97–111. London: Routledge.
———. 2021. "The Futures of 'Us': A Critical Phenomenology of the Aporias of Ethical Community in the Anthropocene." *Philosophy and Social Criticism* 47 (3): 304–21.

———. 2022. "Dementia Care Ethics, Social Ontology and World-Open Care: Phenomenological Motifs." In *New Perspectives on Moral Change: Anthropologists and Philosophers Engage Transformations of Life Worlds*, edited by Cecilie Eriksen and Nora Hämäläinen, 106–25. New York: Berghahn Books.

Dyring, Rasmus, and Lone Grøn. 2022. "Ellen and the Little One: A Critical Phenomenology of Potentiality in Life with Dementia." *Anthropological Theory* 22 (1): 3–25.

Dyring, Rasmus, Cheryl Mattingly, and Maria Louw. 2018. "Introduction: Moral Engines." In *Moral Engines: Exploring the Ethical Drives in Human Life*, edited by Cheryl Mattingly, Rasmus Dyring, Maria Louw, and Thomas Schwarz Wentzer, 9–36. New York: Berghahn Books.

Fabian, Johannes. 2002. *Time and the Other: How Anthropology Makes Its Object.* New York: Columbia University Press.

Faubion, James D. 2011. *An Anthropology of Ethics.* Cambridge: Cambridge University Press.

Foucault, Michel. 1986. "Of Other Spaces." *Diacritics* 16 (1): 22–27.

———. 1997a. "The Ethics of the Concern for Self as a Practice of Freedom." In *Ethics: Subjectivity and Truth*, vol. 1 of *Essential Works of Foucault, 1954–1984,* edited by Paul Rabinow, 281–301. New York: New Press.

———. 1997b. "What Is Enlightenment?" In *Ethics: Subjectivity and Truth*, vol. 1 of *Essential Works of Foucault, 1954–1984,* edited by Paul Rabinow, 304–19. New York: New Press.

Gadamer, Hans-Georg. 2004. *Truth and Method.* London: Continuum Books.

Geertz, Clifford. 1973. *The Interpretation of Cultures.* New York: Basic Books.

Guenther, Lisa. 2006. *The Gift of the Other: Levinas and the Politics of Reproduction.* Albany: State University of New York Press.

———. 2013. *Solitary Confinement: Social Death and Its Afterlives.* Minneapolis: University of Minnesota Press.

Habermas, Jürgen. 1998. *The Inclusion of the Other: Studies in Political Theory.* Edited by Ciaran Cronin and Pablo De Greiff. Cambridge: Polity.

Hegel, Georg Wilhelm Friedrich. 1977. *Phenomenology of Spirit.* Translated by A. V. Miller. Oxford: Oxford University Press.

Henare, Amiria, Martin Holbraad, and Sari Wastell. 2007. "Introduction: Thinking through Things." In *Thinking through Things: Theorizing Artifacts Ethnographically,* edited by Amiria Henera, Martin Holbraad, and Sari Wastell, 1–31. London: Routledge.

Husserl, Edmund. 1970. *The Crisis of European Sciences and Transcendental Phenomenology: An Introduction to Phenomenological Philosophy.* Translated by David Carr. Evanston, IL: Northwestern University Press.

Ingold, Tim. 2018. "One World Anthropology." *Hau: Journal of Ethnographic Theory* 8 (1–2): 158–71.

Jackson, Michael D. 2009. "Where Thought Belongs: An Anthropological Critique of the Project of Philosophy." *Anthropology Theory* 9 (3): 235–51.

Käll, Lisa Folkmarson. 2017. "Intercorporeal Expression and the Subjectivity of Dementia." In *Body/Self/Other: The Phenomenology of Social Encounters*, edited by Luna Dolezal and Danielle Petherbridge, 359–86. Albany: State University of New York Press.

Kitwood, Tom. 2019. *Dementia Reconsidered, Revisited: The Person Still Comes First*. Edited by Dawn Brooker. 2nd ed. London: Open University Press.

Kohn, Eduardo. 2013. *How Forests Think: Toward an Anthropology beyond the Human*. Berkeley: University of California Press.

Laidlaw, James. 2002. "For an Anthropology of Ethics and Freedom." *Journal of the Royal Anthropological Institute* 8 (2): 311–32.

Lear, Jonathan. 2006. *Radical Hope: Ethics in the Face of Cultural Devastation*. Cambridge, MA: Harvard University Press.

Leistle, Bernhard. 2017. "Anthropology and Alterity—Responding to the Other: Introduction." In *Anthropology and Alterity: Responding to the Other*, edited by Bernhard Leistle, 1–24. London: Routledge.

Levinas, Emanuel. 1969. *Totality and Infinity: An Essay on Exteriority*. Translated by Alphonso Lingis. Pittsburgh: Duquesne University Press.

Lynteris, Christos. 2018. "The Frankfurt School, Critical Theory and Anthropology." In *Schools and Styles of Anthropological Theory*, edited by Matei Candea, 159–72. London: Routledge.

Malinowski, Bronislaw. 1984. *Argonauts of the Western Pacific*. Long Grove: Waveland.

Marder, Michael. 2014. *Phenomena-Critique-Logos: The Project of Critical Phenomenology*. London: Rowman and Littlefield.

Mattingly, Cheryl. 2018. "Ordinary Possibility, Transcendent Immanence, and Responsive Ethics: A Philosophical Anthropology of the Small Event." *Hau: Journal of Ethnographic Theory* 8 (1–2): 172–84.

———. 2019. "Defrosting Concepts, Destabilizing Doxa: Critical Phenomenology and the Perplexing Particular." *Anthropological Theory* 19 (4): 415–39.

McKearney, Patrick, and Tyler Zoanni. 2018. "Introduction: For an Anthropology of Cognitive Disability." *Cambridge Journal of Anthropology* 36 (1): 1–22.

Merleau-Ponty, Maurice. 1968. *The Visible and the Invisible*. Translated by Alphonso Lingis. Evanston, IL: Northwestern University Press.

———. 2002. *The Phenomenology of Perception*. Translated by Colin Smith. London: Routledge.

Nolan, Mike, Sue Davies, Jayne Brown, John Keady, and Janet Nolan. 2004. "Beyond 'Person-Centred' Care: A New Vision for Gerontological Nursing." *International Journal of Older People Nursing* 13 (3a): 45–53.

Salamon, Gayle. 2018. *The Life and Death of Latisha King: A Critical Phenomenology of Transphobia*. New York: New York University Press.

Stevenson, Lisa. 2014. *Life beside Itself: Imagining Care in the Canadian Arctic*. Berkeley: University of California Press.

Steward, Kathleen. 2007. *Ordinary Affect*. Durham, NC: Duke University Press.

Throop, C. Jason. 2012. "On Inaccessibility and Vulnerability: Some Horizons of Compatibility between Phenomenology and Psychoanalysis." *Ethos* 40 (1): 75–96.

———. 2018. "Being Open to the World." *Hau: Journal of Ethnographic Theory* 8 (1–2): 197–210.

Trouillot, Michel-Rolph. 2003. "Anthropology and the Savage Slot: The Poetics and Politics of Otherness." In *Global Transformations: Anthropology and the Modern World*, 7–28. New York: Palgrave Macmillan.

Vermeulen, Laura. 2021. "'When You Do Nothing You Die a Little Bit': On Stillness and Honing Responsive Existence among Community-Dwelling People with Dementia." In *Immobility and Medicine: Exploring Stillness, Waiting and the In-Between*, edited by Cecilia Vindrola-Padros, Bruno Vindrola-Padros, and Kyle Lee-Crossett, 185–206. Singapore: Palgrave Macmillan.

Viveiros de Castro, Eduardo. 2014. *Cannibal Metaphysics*. Translated by Peter Skafish. Minneapolis: University of Minnesota Press.

———. 2015. *The Relative Native: Essays on Indigenous Worlds*. Chicago: Hau Books.

Wagner, Roy. 2016. *The Invention of Culture*. 2nd ed. Chicago: University of Chicago Press.

Waldenfels, Bernhard. 2020. "Threshold Experience and the Delineation of Boundaries." In *Debating and Defining Borders: Philosophical and Theoretical Perspectives*, edited by Anthony Cooper and Søren Tinning, 234–50. New York: Routledge.

Zigon, Jarrett. 2018. *Disappointment: Toward a Critical Hermeneutics of Worldbuilding*. New York: Fordham University Press.

———. 2019. *A War on People: Drug User Politics and a New Ethics of Community*. Berkeley: University of California Press.

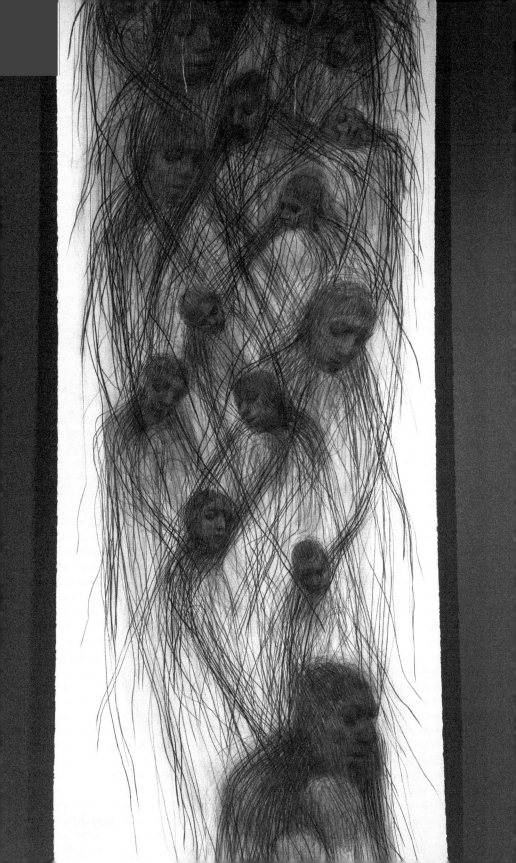

To Share Almost Everything
scattered, falling apart
a sense of self . . . porous self
fencing . . . off and out . . . keeping them close enough
once an elder
to carve out a space and self apart . . . together
to share almost everything
continuous formation (and disintegration)
from one another . . . to each other
now there are almost no internal fences left
to preserve dignity . . . the body, the face, the house
between the poles of the walls
the bones in a body
through the penetrable
carefully shares
he used to have fences like that
To be "someone," to be a person
the recognition of others
with no internal fences left
to give someone . . . through what used to be the wall

Overleaf: Figure 1. Drawing for Lotte Meinert, *To Share Almost Everything*, charcoal and chalk, 2020, 450 × 115 cm

TOGETHER APART

Fence Work in Landscapes of Relationality, Old Age,
and Care in the Ik Mountains

LOTTE MEINERT

Ik County, Uganda, January 2019

FENCE WORK

Komol, the elder and clan leader from Tultul, has been sick for some time. My friend and interpreter Jacob tells me worriedly: "Komol looks weak, there is no one around his place and . . . the place is just scattered." Just scattered—those are Jacob's words—I try to imagine what he means by a place that is scattered . . . The next morning Jacob and I go to visit Komol, taking food and medicine and hoping for an interview.

We approach the place where Tultul village used to be firmly demarcated with an outer stockade of poles, sticks, and thorns (*nyeriwi* in Icetot—the Ik language) intended to keep wild animals and enemies out. In Tultul, part of the stockade has been removed—dismantled when many families in this seminomadic area recently created new villages and took most of the poles with them. Tultul village *does* look scattered, falling apart and bushy, as if nobody is caring for the space any longer. The space is not as well defined and "together" as it used to be, it is becoming increasingly penetrable, and wild plants are slowly taking over as most people are moving their homes to new villages. This seminomadic lifestyle is often accounted for, by people

who live here, as a matter of security and hygiene, but nomadic life also provides a kind of care for mountains by leaving places fallow for a while. Wild plants and trees take over, and they restore and repair the fragile relation between humans and the mountains.

There are two main tracks in this chapter: an empirical one about an old man, his family, trouble with intimate others, and fence work in the physical landscapes of villages and homes in the Ik mountains in Uganda; and a theoretical track doing "conceptual fence work" in the landscape of anthropology, where I try to see through fences as imagistic concepts, as a way of thinking about relationality and care. The empirical and theoretical tracks are closely intertwined, and I will move back and forth between them, because fences are *both* material entities in the village *and* an imagistic concept that helps in thinking about relationality in human lives, and in old age, with more nuance. The poem "Mending Wall" by Robert Frost and drawings by Maria Speyer are woven into the text to provide another layer of imagistic knowing—another access to reflecting upon care and intersubjectivity.

Inside the stockade of a village, the family compounds are usually fenced with a *maring,* a fence made from wooden sticks, which regulates movement between family homes. The *maring* have small door openings, many through which only children or small and nimble persons can pass, and often the openings are shifted from one place to the other, closed off or opened according to the moods and relations between families.

Within the *maring,* selected houses, kitchens, and granaries have the characteristic internal fences called *naguleik,* which create an inner circle, making a separate, semiprivate space where a family can roast maize for brewing beer or carry out other private activities, almost out of the sight of curious neighbors. The neighbors will still smell the roasting maize, but they will not know exactly how much beer is being brewed. Villages often resemble labyrinths where you have to crawl through small openings in the various fences and find the right corridors to get into the homestead of a family.

The materiality of the fences and the sociality of fence work is striking in this lifeworld, where most livelihood and labor resources are scarce, and I find the extensive *internal* fencing particularly intriguing—why is *so* much energy and care put into building, meticulously mending, and continuously changing the position of internal fences and openings? There is a saying in

Icetot: "*Mita maring keseni ngoe*," meaning "the fence is our shield," and people emphasize that fences are for security and protection from the Turkana from Kenya and from animals, wind, sun, and enemies' "evil eyes." But the internal fences (*maring* and *naguleik*) are clearly about more than security and protection against outside forces. They are also about managing "life within," regulating intimate sociality and reciprocity, and establishing a sense of self—even if it is a very porous self. Fences are largely about sharing both resources and problems that you may not want to share with all—and thus the fences are also about trying to keep certain things and issues away from sharing. In the village it seems almost impossible to keep something for yourself and your family. If others see it, hear about it, or smell it and know that you have something, it is shared almost immediately.[1] The fences regulate and slow down the sharing and help establish parts, individuality, and family by dividing physical space—creating a barrier in the intimate space—fencing oneself (and part of one's family) in, fencing others off and out, yet still keeping them close enough for potential sharing. Together, but apart.

The famous and infamous anthropologist Colin Turnbull, who did fieldwork among the Ik in the late 1960s during a period of severe famine, drew maps of all villages and the extended internal and external fencing which were also prominent back then (1972). Turnbull pointed to the lack of a common meeting place in the village architecture, and he saw this as a sign of antisocial behavior and lack of political structure. Turnbull's interpretation of the internal fencing pointed toward individualism and selfishness at a time of severe famine, but as critics have noted, Turnbull was probably mainly commenting on tendencies in his own British and American society at the time (Barth 1974; Heine 1985). The internal fencing practice has continued even after the severe famine periods and after the introduction of democracy, so we cannot make the simple causal link between political structure and material world. My interpretation of the fencing in Ik villages is almost the opposite of Turnbull's—and it is probably guilty of the same kind of fallacy, commenting on a tendency in my own Danish society and situation. I see the fence work as a dynamic of resisting absorption in complete collectivity, carving out a space of individuality from which to be social.

The idea of fence work is, in a sense, a continuation of sociologist Erving Goffman's classical concept of "face-work" (1955). Goffman pointed to how

we all do impression management through face-work when interacting with each other on the public stages of everyday interaction, working to keep up positive images of self and other, preventing embarrassment and discredit in social life. Goffman's key trope is the theater and the stage, where we—the actors—put on and take off masks when we move "frontstage" in public life and "backstage" in private life. The fence work I describe in Ikland is physical, but it is also an image for some of the same kind of social labor Goffman describes in relationships. These relations and this work lay the foundations for cultivating selves. The focus on fence work may turn our attention to the social threshold between frontstage and backstage: the porous place that regulates and constitutes the public from the private, or one private sphere from another private sphere. Fences—physical and social—establish a physical "here" and "there," "this side" and "the other side," you people and us people, humans and animals—and the fences are in themselves a physical manifestation of the relation between and the care, or lack of care, for relationships and privacy. Physical fence work in Ikland is quite labor intensive—collecting and cutting poles, digging holes, and weaving poles and sticks together is hard manual work. On top of this, it requires a set of specific social skills and sensitivity, and some level of negotiation to put up an internal fence in a village or family compound without appearing unnecessarily defensive or offensive. I have not heard the proverb "good fences make good neighbors" in Ikland—as many know it from Robert Frost's famous poem "Mending Wall" from 1914. But I imagine neighbors in the Ik community would recognize the complex sentiments the poem expresses. Frost wrote about two farmers in New England and their custom of mending the wall between their two farms every spring. One neighbor, the narrator, does not really like the wall and wonders why they need it. The other neighbor insists that good fences make good neighbors. Here is a shortened version of Frost's poem "Mending Wall":

Something there is that doesn't love a wall,
. . .

I let my neighbor know beyond the hill;
And on a day we meet to walk the line
And set the wall between us once again.
We keep the wall between us as we go.
. . .

Oh, just another kind of out-door game,
One on a side. It comes to little more:
There where it is we do not need the wall:
He is all pine and I am apple orchard.
My apple trees will never get across
And eat the cones under his pines, I tell him.
He only says, "Good fences make good neighbors."
Spring is the mischief in me, and I wonder
If I could put a notion in his head:
"Why do they make good neighbors? Isn't it
Where there are cows? But here there are no cows.["]
. . .

Similarly, in Ikland there are no cows to keep in or out, but plenty of fences. The experience that neighbors do not always agree about fences, walls, or borders is recognizable, and the small games we play around disagreements are often the everyday stuff of life where relationality can be seen, and where we care for and manifest relations. The small disagreements about fences play out in prosaic ways some of the deepest and most troublesome aspects of sociality. Divergences make it clear that we want to relate to others and our material world—in our specific way. The trouble is that others may also want to relate, and they want to do it in their—often slightly different—specific way.

The issue of fence work in the Ik mountains, as in Frost's poem, obviously speaks to larger-scale dynamics of the history of property rights, territoriality, and the politics of walls and fences in China, Berlin, and the US/Mexico border, to mention a few troubled boundaries. A wealth of excellent literature has been written about this larger-scale and often deeply problematic aspect of fencing and walls (Moré 2011; Eilenberg 2012; Chaichian 2013; Vallet 2014; Guenther 2018, 2019). Here I home in on another side to fencing, which also seems important in understanding the larger-scale and problematic dynamics of fencing: knowing that there is a place where you can retreat to dwell, where others will let you be (see also Guenther 2019).

My Ik interlocutors say, "A good fence is built from two sides," and in this way they too comment on the trouble with fences, because in reality few fences are built from two sides, and some fences are not built or maintained at all, even though one side might wish for it. If fences are not strictly

necessary for security and protection, why bother so much with them? Why not invest the energy in improving roofs or floors, having parties, or growing more crops?

I began to really notice the importance and trouble of fence work in Ikland when I started following elderly people, because the fences were ambiguous to many of them. The sturdy and rugged fences were hard to navigate and crawl through for people with old backs and knees, but the fences and fence work were still considered essential by old people like Komol, who was once an elder with high status and someone who used to have good fences, but who was getting physically weak and increasingly dependent on others to build the fences.

The chapter is based on my ongoing episodic fieldwork in the Ik mountains in Uganda since 2010, and I draw in particular on a study among elderly Ik in the period 2017–19.[2] In this study, I have been following six elderly people and their intimate others, making repeated visits to their homes and having conversations with them. With Jacob, my field assistant, I have interviewed twenty-seven elderly people, some of them more than once. I know many of these families and elderly people from previous studies in the area, and I make use of material from these previous studies as well (Meinert, Willerslev, and Seebach 2017; Willerslev and Meinert 2017; Gade, Willerslev, and Meinert 2015).

LIVED RELATIONALITY

In the two tracks in this chapter I explore two kinds of trouble with relationality, selves, and others. There is the Ik elders' practical trouble with their intimate others, with fences, and with sustaining a sense of self; and there is the conceptual trouble with relationality—of delineating self and other[3] in theoretical work and ideas about the social and individual in anthropology. My overall theoretical strategy here follows phenomenology's insistence on radical empiricism (Jackson 1989), so the inquiry goes primarily through my ethnographic material. Mattingly's idea about "perplexing particulars" as vital parts of critical phenomenology is a central inspiration here, as is her revival of Arendt's idea of "defrosting concepts" and destabilizing doxa (2019). Through attention to the perplexing particulars, the peculiar findings in our ethnographies that sometimes go against the grain, we can work toward disrupting concepts that have become canonical (Mattingly 2019).

If concepts are images of thought (Vivieros de Castro in Strathern 2020, x) that have a tendency to stiffen and become dominant, we sometimes need to defrost them, wake them up with empirical trouble. The dominating concepts I intend to disrupt here, or at least try to disquiet slightly, concern "the social" and "the individual." I endeavor this disruption as a way of troubling Turnbull's image of the "suffering, selfish Ik," on the one hand, and as a way of challenging doxa (including my own) about collectivity, sociality, and care, on the other hand. I propose that seeing with and through fences is a form of imagistic knowing (Stevenson 2014) that allows us to pay attention to something about relationality we do not always notice.

I want to highlight the deeply ambiguous features of practical relationality and elderly Ik people's work of cultivating "others" and space—keeping close but still at some distance, being together by being apart—as a way to live in a sharing community and sustain a sense of self. Taking the lived intersubjectivity of bodies, materialities, and spaces as a starting point (Jackson 1998), we see something quite different (than Turnbull did) when considering elderly people's efforts of creating separate spaces and units for themselves and their families. The common sense, what is taken for granted in the Ik context, I would argue (unlike Turnbull), is togetherness, because the basic human units are families, villages, clans, ethnic groups; individuals are part of those units and appear out of that togetherness. Thus, human work and effort are needed to carve out a space and a self apart, and this in turn is a necessity for being able to be together. So, one might wonder, is this something specific and different about Ik or Ugandan or even African conceptions of the human being? While relationality is probably a universal trait inherent in all (human) life, and the social, collective, relational have been cultivated (and highlighted in scholarship) in particular ways in African contexts, individuality has received less attention.

Anthropologists, African philosophers, political scientists, and Africanists have long argued about the particularity of African sociality and humanity. Some hold that African philosophy and ways of life are characterized by a profound humanistic morality in which the human being is considered social *by nature*. This idea resembles Aristotle's dictum that the human being is *by nature* a social animal. This sociality or relationality prescribes a *social* ethos rather than an ethos of *individualism*. Sayings from across African contexts are sometimes brought forward to express this ethos, such as "Man is not a tree" (i.e., self-sufficient), and "the right arm washes the

left arm, and the left arm washes the right arm" (Akan proverbs). Postcolonial political leaders across the continent have referred to various "narratives of return" (Gade 2011) to something inherently African, such as former Tanzanian president Julius Nyerere's ideas about *Ujaama*—"familyhood" as a specific African kind of socialism in Tanzania and former Ghanaian prime minister Kwame Nkrumah's ideas about the philosophy of *consciencism* as an expression of African humanism in Ghana. The general concept of *ubuntu* from Southern Africa has a long history and a broad range of meanings, from human qualities, African humanism, and philosophy to ethics and worldviews (Gade 2011), which describe or prescribe "a humanity towards others." During and after the peace and reconciliation process following the end of apartheid in South Africa (Gade 2013), *ubuntu* became associated with the saying *"umuntu ngumuntu ngabantu"* (a person becomes a person through other persons) (Lötter 1997, 46).

While relationality is a universal human trait, there is something empirically specific about "the social" in many African contexts and in the Ik context in particular. Turnbull contrasted Ik selfishness during times of hunger with other Ugandans' social ethos, but I wonder whether Turnbull mistook selfishness for something that was a consequence of extreme sociality and sharing. If we think of the Ik community as a sharing economy, what are the implications of this for lived relationality? Prior to the establishment of the nearby Kidepo National Park, the Ik community was more nomadic and depended more on hunting and gathering. They have, however, long been doing subsistence agriculture as well and storing food in granaries and caves. Yet, part of the social organization is egalitarian and resembles former hunter-gatherer societies, and the relatively minimalistic material lifestyle makes seminomadic life easier (minimalistic and easier except for moving the fences). I am reminded that in the 1960s Marshall Sahlins challenged the popular view of hunter-gatherers' lives as "solitary, poor, nasty, and short," as Thomas Hobbes had described them in 1651, and Sahlins pointed to the affluence inherent in being satisfied with very little in a material sense. Accumulation of wealth beyond what is necessary for survival does not make much sense in this kind of community.[4] There *is* an element of the building of fences in Ik villages that serves to protect and hide wealth, and to slow down the sharing. But rather than being seen as selfish and avoiding sharing, there is great prestige in being

able to share whatever one has. The sharing ethos is strong, and there is very little accumulation of wealth—so the internal fences are clearly about more than economy.

They are, I will argue, about living human relational ontology in a specific way: when living close together and urged to share almost everything, there is simultaneously a pronounced need for distance, privacy, and keeping something for oneself—*and* for potential sharing. I use the term ontology here not as a synonym for culture, but rather to describe traits of our universal plural human condition. Relationality is part of human ontology, and this is lived and expressed in particular ways. Ik fence work is exemplary, a practice and image of our human relational ontology.

CASH TRANSFERS, SHARING, AND CARE

In this specific lifeworld of relations and fences, the elderly's efforts of creating separate spaces and selves of their own stand out as particularly vulnerable. At the same time, the intimate others in this context (children, grandchildren, neighbors) who are expected to care for the elderly are often quite vulnerable themselves. The work of humanitarian organizations and development programs in the region could benefit from paying more attention to this intervulnerability (Meinert 2021). Often humanitarian and development programs work at population level but single out individuals considered Extremely Vulnerable Individuals (EVIs) for help. The so-called EVIs in humanitarian lingo may include malnourished children, people with disabilities, HIV-positive individuals, lactating mothers, or undernourished elderly. But in this context where vulnerability is a radically social phenomenon and sharing is a basic principle, the strategy of targeting individuals in this way often falls short. Even though this is a form of individual care, it is still anonymous and population based (Stevenson 2014), because it does not consider the relations particular individuals have.

An example of this is a recent cash transfer program for the elderly, which meant that in Ik county most elderly over sixty years of age could receive 25,000 shillings per month (about 8 USD). Jacob and I followed a group of the elderly over two years to learn how they spend the money and what difference it makes. There was variety, of course, but roughly two common scenarios: One is exemplified by Nakong, a widow who shares most of the

money with her family and friends, but also keeps a little for herself. The other is represented by Lokol, who used to live alone, but was moved to his son's family when the cash transfer started. In Lokol's case, the family saw an option to care for the father and also get access to his money. This created bitter accusations when Lokol died shortly after (Meinert 2021). The cash program was obviously conceived to help vulnerable individuals—the elderly—and this works, sometimes and for some. However, in other cases it has detrimental effects, because it creates inequality and does not recognize sufficiently how individual vulnerability is firmly grounded in intervulnerability in this fragile context.

This intervulnerability is heavily influenced by and interwoven with the political economy and history in the region. The indigenous Ik community in the mountains is still one of the most fragile in Uganda. Historically the Karamoja region has witnessed long-term conflicts of cattle raiding, prolonged droughts, and consequent famines. As mentioned earlier, most Ik people live from subsistence farming, supplemented with seasonal hunting and gathering, and many Ik were displaced from their former hunting grounds when Kidepo National Park was established under colonial rule (Turnbull 1972). This displacement made the community particularly prone to hunger during periods of drought because it restricted their mobility and flexibility between farming, hunting, and gathering.

According to Turnbull, the Ik community basically fell apart morally during the prolonged famine in the 1960s, because Ik culture was "individualistic and loveless," in Turnbull's words. While it is highly questionable whether Turnbull's account was accurate and ethically sound (Barth 1974; Heine 1985; Townsend et al. 2020), there is no doubt that it describes a situation of extreme poverty, famine, and social fragility (Willerslev and Meinert 2017).[5] The Ik population has more than doubled since Turnbull's study; and the standard of living has without doubt improved. Yet, deep poverty, drought, hunger, and various other forms of insecurity still persist in the mountains, and these realities weave into the ways people relate, share, and care.

Often those who are considered important and intimate others by elderly Ik are close kin, neighbors, and friends who are proximate in space. Keeping these important others at some distance, but still close, is essential but also troublesome for elderly people as they lose their physical strength and grow increasingly dependent on others to build their houses and fences. In

this interdependent world, elderly people share wisdom, blessings, alcohol, and tobacco in exchange for intimate others' labor, food, water, firewood, and care. But they also are concerned about keeping something for themselves. This sharing and keeping speaks to larger questions of relationality. This is not simply a theoretical enigma of what comes first, the individual or the intersubjective (hen or egg), but a point about the dynamics between the individual and intersubjective over time.

PERSPECTIVES ON RELATIONALITY AND INTERSUBJECTIVITY

Numerous anthropologists and philosophers have addressed these issues of relationality and intersubjectivity. Here I will only engage with four of what I find to be the most significant contributions and positions for my discussion of elderly Ik and fence work. Marriott (1976) and later Strathern (1988) have argued that in Southeast Asia there is no conception of individuals without relations, but rather relational "dividuals." By the turn of the century, it was a widely accepted wisdom in anthropology that "all persons are both dividuals and individuals" (Englund and Leach 2000, 229). Roughly defined, the individual is perceived to have an indivisible self or personhood, an essential core, and a whole that defines its particularity (Smith 2012, 53). The dividual is conceived as divisible, comprising a complex set of relational dimensions. The individual is atomistic, while the dividual is fractal; the individual is egocentric, while the dividual is sociocentric (Smith 2012, 53; Sökefeld 1999, 419). Later on Strathern elaborated that "dividuals"—relational persons—"have their own kind of relations and their own kind of individuality" (Strathern 2015, 208).

From a critical phenomenological perspective, Mattingly (2014) has also given us a frame for understanding the individual in her careful development of a first-person virtue ethics, based on her American ethnography, as an alternative to the most famous anthropological versions of the early Foucauldian self where all is considered social and discursive to the core.[6] Mattingly's conception of the first-person perspective human is both singular and plural (I and we), and it is inherently relational to different you's (singular and plural), but this individual is capable of cultivating character, striving, hoping, and forming herself and others morally. Mattingly offers a strong argument for considering and understanding the individual voice and effort in the midst of relationality (2014).

Feminist phenomenological philosopher Lisa Guenther's work on solitary confinement in prisons (2013) provides us with distinctive thoughts about intersubjective being. Forced solitude is one of the most effective ways of destroying a person, writes Guenther, and this tells us about the nature of subjectivity: we can become "unhinged from ourselves when we are separated from others" (xii).[7] Guenther's position is phenomenological by being rooted in first-person accounts but is also "critical of classical phenomenology's claim that the first-person singular is absolutely prior to intersubjectivity" (xiii). "There is no individual without relations, no subject without complications, no life without resistance" (xv). This is the very structure of our being-in-the-world, according to Guenther. We are fundamentally hinged on each other.

Michael Jackson's (1998) phenomenological and existential conception of the intersubjective constitution of lifeworlds that includes the material world is also a central source of thinking here. Jackson points out that what is "inter'" about intersubjectivity comes in many different forms as experienced, embodied, remembered, narrated, and materialized. Human reality is relational to the core and throughout different scales, from nations to objects, concepts, and intimate processes. Thinking with this idea of the intersubjective as also material, I do not regard the fences as a symbol of the psyche, the self, or the social, but as a lived physical relationality: a lifeworld where the continuous formation (and disintegration) of relations creates physical units in the village by dividing the common space with fences. Jackson points out, referring to Sartre, that a human being is never an individual; rather, a human being is a singular universal (Sartre 1981, in Jackson 2018). In Arendt's thinking this is the paradox of plurality: each one of us is a unique part, but we are all part of the same species. We are "being a part of and apart from" each other (Jackson 2018, 17) and constantly oscillate between feeling at one with others and at odds with them. Human beings and societies are tied up in an ebb and flow, where we withdraw from one another in one moment only to open up to each other in the next moment. It is a never-ending struggle, both intellectual and practical, to work out a positioning that reconciles one's own needs with the needs of others (Jackson 2018, 2).

Strongly inspired by these four related, but also different, positions and contributions from anthropology and philosophy, I explore the dynamics of intersubjectivity and subjectivity appearing through the fences in Uganda:

How do fences work to carve out spaces for selves and other units of humans, in a world where everything is shared and divided—and how does that matter when growing old?

ALMOST NO FENCES

At Komol's place now there are almost no internal fences left, and only pieces of the outer stockade. Jacob and I can practically walk straight into the family compound. We almost automatically slow down a bit when we enter the compound because it feels like intruding. Komol is lying outside the house on an old mosquito net, with his head resting on a pair of black gum boots. The fragility and transformation since I saw him about six months ago is immense. His body has shrunk to about half his earlier size, from the days when he was an active clan leader. He is too weak to sit up, and his metal lip plug (the proud body decoration from his youth) is threatening to fall out when he tries to speak. It is hard work to preserve dignity when the body, the face, the house, and the fences are physically disintegrating. We leave the food and medicine with him. Komol's grandchildren are around, and their eyes are fixed on the bags of food. One of the grandchildren, Amok, is still more malnourished than the others. Komol's sons are not around; one is in prison in Kenya, a deaf son is wandering about, and the son called Cosmas is drinking at the trading center.

INTERWOVEN VULNERABILITY

Komol's daughter-in-law Jennifer (mother of Amok and wife of Komol's son in prison) comes running, with a new baby on her back. I try to hide my surprise, but wonder: Who is the father of the new baby, when her husband is still in prison? As if Jennifer can read my thoughts, she explains that this is Cosmas's and her child. Later Komol relates how Jennifer had asked his permission to be with the brother Cosmas, because her husband had "shown no signs of life," and she could hardly manage to care for the children on her own. Komol had not been happy about it. It is custom that if a husband dies, the wife, whom the family paid bride wealth and bride service for, will be taken care of and inherited by another brother in the family. Marriages are not simple relations between two persons, but a long-term relationship of exchange between two families, two clans. However, as Komol pointed

out, it is not custom to inherit a wife before the husband is confirmed to be dead. Komol expressed his regret about giving up hope that the son was alive and would come back, but he still agreed. I pondered, but did not ask if Jennifer was already pregnant by then. My point with these intimate details is to show how the vulnerability of an old person like Komol is an "inter" phenomenon to the core and at various scales. The interwoven complications and interdependencies in the home are obvious. If Cosmas does not treat Jennifer and her pregnancy well and help ensure that she has some degree of independence, then Jennifer will not care as well for her father-in-law and help protect his potential ability to share with others.

Jennifer questions why we have left the food with the old man. "Is it for me to cook?" she asks. "Yes, and for sharing with the family," we propose, knowing how her care of Komol depends intimately on whether she can also take care of her children, husband, and others around.

STUCK WITH YOUR SHIT

The next day Komol is lying inside his house, but he is slightly better and able to sit on his sleeping skin and talk quietly, even though his lip plug still dangles dangerously when he speaks. He has eaten the food Jennifer cooked yesterday and the grandchildren are still enjoying the leftovers. We converse inside Komol's small house even though this is his most private space, not for visitors, but he cannot walk yet, so he invites us in. The house is falling apart. The grass thatch on the roof is thin and the walls are decomposing. We could see the ruination from outside, but from inside the devastation is even more striking as the light pours in through the roof and walls. There used to be mud between the poles of the walls. Now mainly only the poles remain. Like the bones in a body with little flesh left. The smell of urine is sharp and reminds me of what Komol had said in an interview a year earlier about growing old.

With his characteristic smiling but serious mien, Komol said: "One of the worst things about getting old is when the body gets so weak that you cannot get away from your own faeces . . . you are stuck with your shit—and you may not even be able to see it." He was giggling about the comical situation he had evoked in our minds, but added with a more serious expression: "You lose some of your dignity and become very dependent on others."

SHARING A PINCH OF TOBACCO THROUGH THE WALL

Curious neighbors and grandchildren are sitting right outside Komol's house, looking in through what used to be a wall, and one of the neighbors is asking: What have we brought today? What is for sharing? It is hard to get privacy to talk, and I am slightly annoyed, but Komol seems quite happy to have people nearby and engaged. The neighbor's arm sticks through the penetrable wall and asks for tobacco with a characteristic hand move. Komol carefully shares a pinch of tobacco from his little plastic tobacco container strapped around his neck for safekeeping, and I notice how, at this point of sharing, some of his old dignity seems to reinhabit his body and posture.

The next day Komol is up and out of the house. We sit in the compound dominated by his son Cosmas's well-maintained house with a small but significant padlock on the door, signaling that Cosmas is currently absent from the home but always powerfully present in absentia. He holds the key to the padlock and controls access to the stores of food. Behind his house there is a line of granaries and a half-built *maring*, fencing off the neighbors.

IMAGINING FENCES

I ask Komol about the fence—one of his favorite subjects—hoping this might provide a bridge into talking about "the good old life"—the overall subject of our research project on aging.[8] "It is a strong fence," says Komol, with a small acknowledging smile, and adds, "Cosmas has a lot of energy and he is building it with the neighbor. It keeps the enemies out, granaries out of sight, and it is good for shade and privacy." Nostalgically, Komol remembers that he used to have fences like that, and he wishes to build a new one around his own house, fencing him in with Cosmas's family, and a *nagule* to provide a little privacy and distance between them. Komol goes on to talk about who might build it. "Maybe Cosmas will build it? And the other sons and the neighbors should contribute. If they brew beer for a working party . . . ?" Komol's monologue moves further into a nostalgic mood about the good old days when all fences (read relations) were strong and properly maintained.

When you grow old it is essential to have resourceful children nearby who will take care of you. If your children are weak, are not around, or have too

many problems of their own, you are doubly vulnerable. Resources are important, but care is also dependent on cultivating relations and a respectful attitude in your children as they grow up. Komol remarks: "You have to show children to take care of and respect the old ones. . . . [Caring for the elderly] is not easy if the children are not strong or if they don't have that heart." Komol has a "trusted daughter," who seems to have that heart. He trusts her with money, and she invests in brewing beer that she sells to generate an income for the entire family. The problem is that this daughter lives far away with her husband, and she cannot be present to care for Komol when he needs it.

CULTIVATING RELATIONS OF CARE: OLD AGE IN THE HANDS OF VULNERABLE OTHERS

I think of this relational existence as a starting point for understanding elderly Ik lives and vulnerabilities (Meinert 2021), with an already socially embedded and embodied conception of experience, in which relationality and interdependence are key. This is in line with the philosopher Knud E. Løgstrup's argument (against utilitarianism, Kantianism, Kierkegaard, and subjectivism) that our being is fundamentally "in the hands of others"—and that this interdependence constantly demands ethical responses in our everyday lives (1956).

Lisa Guenther (2013) has shown how individuals fall apart, mentally and physically, in solitary confinement when deprived of contact with others. Ik fence work and elders nuance this position, I believe, because in the midst of relationality there is also a need to carve out a space for oneself. For the elderly Ik the problem is not only about falling apart in solitude, but also the opposite—being absorbed and squeezed in collectivity and intervulnerability. Because we humans are so fundamentally hinged and in the hands of others, we need that personal space. "Dividual" persons are constituted through relations with others, but dividuals have their own kind of individuality (Strathern 2015). In the Ik case, this dividual individuality is facilitated by fences.

"No body can sustain itself," writes Judith Butler (2021). The point Butler makes is about how a body needs others to sustain itself, and this speaks directly and practically to the situation I describe in Ikland. Creating a

separate living body, a self and space, is so clearly a social accomplishment in Ik villages, in a very literal way and in old age very often mainly in the hands of others—others who cook, fetch water, build your fences. This, however, does not take away individuality and agency. As pointed out by Mattingly (2014), in a very different but also radically uncertain context, sustaining an everyday life, being a person, having a family, require on-going individual and social moral work, and for many it is a hard-won accomplishment.

In Uganda bodily competences of others are often "borrowed" by elderly people who have lost these competences themselves. When they cannot see something, old people often call someone with a "pair of young eyes" to see for them and tell them about it. The small fingers of grandchildren are often appreciated for getting jiggers out of the skin, and the strong arms of a daughter or son are necessary for old people to get access to water and firewood. Thus families in Uganda are often "shared bodies of competence," as pointed out by Susan Whyte (1999). This intersubjective reality is largely about care and recognition. To be "someone," to be a person, you need others' recognition. As an elderly per-son in the Ik community, you can only be recognized as an elder by others. You grow old, but to become an elder is to achieve an informal political position and a distinction by initiation[9] and continued practice. You can strive to live up to the qualities of an elder—being wise, blessing others, tak-ing responsibility—but you can only accomplish and maintain the status of an elder through the recognition of others, others who experience you as responsible and thus respect you as an elder. When this succeeds—temporarily—as Komol relates that it did for him, during the years when he was a respected elder, this is close to local definitions of the ideal "good old life" in the Ik context. Yet, Komol talks more about old age as a time of los-ing importance and strength, observing that "one of the difficulties of growing old is thinking that when you die you are no longer important and people will not cry for you. They may say: Ah, his days are already over, he has even eaten, so why should we cry for him? . . . If you die when you are strong, your people cry for you." It is in situations of difficult aging and dependency that old people harvest the fruits—sometimes bitter—of how they have been cultivating relationships with their families and intimate others during their lives.

Even at death and during burial rituals, fencing plays a key role in the Ik community. The first time I experienced how a widow, who had just lost her husband, had been fenced into her *nagule*, locked in her kitchen area, I was shocked because it seemed brutal, and I asked the reason for the ritual. "Because she is alone now, she is grieving, so we have to protect her [against herself]," I was told. Other family members, who were also in grief, were fenced and locked in by the *maring* fence surrounding the home. It took me years to understand this "locking in" as a form of care for mourners. Jackson describes the quarantine of widows among the Kuranko as part of the burial ritual, which speaks directly to the dynamics of physical proximity and to intersubjective and intrasubjective dynamics: "The intersubjective separation of the widows from others who are less deeply or directly touched by bereavement is paralleled on the intrapsychic plane by forgetting—which is, in essence, an inward strategy for detaching the living from the dead. But whether separation is accomplished physically or psychologically, the goal is to ensure that a death does not pollute, overshadow or destroy the lives of the living, and that life itself goes on" (2018, 10). Bereavement throws one in upon oneself and fosters a sense that one's reality cannot be shared; aloneness and the intensity of affect increase the sense of subjectivity and interiority (17). The Ik burial rituals, as Kuranko mortuary practices, physically separate grief-stricken widows by fences from other mourners, as a social expression and acknowledgement of aloneness.

Ik County, Uganda, July 2019

In Denmark I received a whatsapp message from Jacob that Komol had sadly passed on. During my next trip to Uganda, Jacob and I went to Komol's family to express our condolences and see the grave. Komol's grave was placed near a relatively strong section of the outer stockade, *nyeriwi*, overlooking one of the steep green valleys in the mountains. Jennifer, the daughter-in-law, explained that many people had come to the burial from near and far, because he was a respected elder. People had cried, but they had left with anger because there was no food and beer at the burial, and with no internal fences left, it was obvious that there had been no places to lock in the mourners. No fencing-in of feelings of grief and of being alone. Jacob tried to console us all: "Remember how Komol was an elder of ideas, who knew about Ik history. Remember how people used to come to consult him."

CONCLUSION: SEEING WITH AND THROUGH
FENCES AS A WAY OF THINKING

I have attended closely to the perplexing particulars of Komol's decaying fences, his intimate others, and small actions of sharing to try to wake up and shake up our understanding and "defrost" conventions about intersubjectivity, relationality, and individuality. Ideas about relationality in African popular as well as scholarly discourse have (with exceptions) highlighted the social and positive side of relationality. In the Ik context, Turnbull (1972) was quick to label what he saw during the famine as selfishness, but there is another side of individuality and sharing to notice as well: the need to be able to withdraw from the social, being "apart" to be able to be "a part" of sociality (Jackson 2018). The management of fences, and of fences within fences, in Ik villages is largely about managing closeness and distance in social relations, and this speaks to the universal importance of these modalities. In Simmel's profound essay on secret societies, he notes in the conclusion: "Concord, harmony, coefficacy, which are unquestionably held to be socializing forces, must nevertheless be interspersed with distance, competition, repulsion, in order to yield the actual configuration of society" (1906, 448). Similarly, Norbert Elias pointed out in *Involvement and Detachment* that "the very existence of ordered group life depends on the interplay in people's thoughts and actions of impulses in both directions, those that involve and those that detach keeping each other in check" (1956, 226). The question the Ik fence work has raised is whether part of what makes aging a challenge to living a good life is not only the increasing distance from others but also the way growing dependence in and on others collapses the dialectic to which both Simmel and Elias point—making intimacy too hard to avoid, rather than too hard to achieve. When even one's bodily functions cannot be fenced off, the good life, reckoned as successful management of closeness and distance, is hard to attain.

I have attempted to understand fence work in Ikland and have discovered how seeing with and through fences may be a form of imagistic knowing (Stevenson 2014) that allows us to pay attention to the ebbs and flows of relationality. As Stevenson reminds us with Foucault: the image expresses without formulating (Foucault 1993, 36; in Stevenson 2014, 14). Fences seem to be an image that expresses something about relationality without

formulating it. At first sight, and from outside, a fence might express: "Keep out. This is mine/ours, not yours." At a second look, and from inside, it might express: "I/we are trying to protect, to keep something in here." The expression of both sides and sights can be simultaneous or oscillate between in and out. With their materiality, fences express immediately an imagistic way of knowing. Seeing with fences, I have attempted to also formulate how fences can do a kind of conceptual work: fence work may provide us with a way of thinking that can help "defrost" our concepts and stiffened ideas of relationality. We might get a glimpse at something through the fence that we would not otherwise notice.

I conclude by returning to Komol's tobacco and Guenther's (2013) idea of hingedness. Relationality is the foundation of life in Ik villages in a profound way. The ebb and flow of being together and apart is a particular rhythm and balance in this sharing community. When you get old and increasingly dependent, it is extra troublesome to be so absolutely hinged on intimate others, because they too are vulnerable, at times. The ambiguous features of practical relationality are made quite clear in the internal fencing structures in Ik villages. Because lives, bodies, subjectivities, and materialities are fundamentally social "interphenomena," "dividuals" and families spend a lot of energy fencing in something for themselves, and fencing off others.

The decay of the fences around Komol's space was a sign that others were withdrawing from helping Komol fence himself in and off from others, and this basic condition of relationality was paradoxically also what made him increasingly vulnerable. Komol had few ways of keeping something for himself, and this in turn made him less of an individual able to contribute and share. The telling point of the importance of this dividual individuality in old age was Komol's satisfaction at being able to give someone a pinch of his tobacco through what used to be the wall of his house.

ACKNOWLEDGMENTS

I would like to thank Susan Whyte for her comments and ever sharp ethnographic serendipity. Warm thanks to Joel Robbins for his excellent suggestions, and to Lisa Stevenson for her imagistic thinking and splendid review comments. Finally, special thanks to the editors, Cheryl Mattingly and Lone Grøn, for their generous ideas and enthusiasm for this chapter, book, and project.

1. In the anthropology of sharing, this is often termed immediate return vs. delayed return (Woodburn 1982).

2. The study is part of the collaborative project "Aging as a Human Condition: Radical Uncertainty and the Search for a Good (Old) Life," funded by VELUX FONDEN, and involves anthropologists, philosophers, and artists. Together with Susan Reynolds Whyte I have obtained ethical clearance for the Ugandan studies through Makerere University and from Uganda National Council for Science and Technology.

3. See Grøn (2019) for an intriguing discussion of the phenomenological dynamics between self and other, the individual and social in relation to obesity and kinship in Denmark through the image of cutting/belonging. Grøn's study was part of EPICENTER: Center for Cultural Epidemics at Aarhus University, where we among other things developed phenomenological perspectives on social contagion (see Meinert and Grøn 2020; Grøn and Meinert 2017).

4. Accumulation of wealth only works to a limited extent and for very few elite families in Ik county who have cement walls, barbed wire, and metal gates, and often also a home in a different location in town or in another district.

5. Turnbull's misguided recommendation to dissolve the Ik community and disperse the Ik around Uganda was probably not even considered seriously by the Ugandan government; and fortunately, Turnbull's prediction that the Ik faced extinction if they were not dispersed did not come true.

6. This is the early Foucauldian self, as articulated within anthropology, that has emphasized the social and discursive and played down the individual side. It is debatable whether Foucault would endorse this emphasis. To me there is a fundamental insight in the fact that we are created biologically, and born into the world through the relation between two individuals (who each were created by two, etc.), our humanity is formed throughout through relations, and individuals have many relational layers and identities. This is a somewhat different "relationality to the core" than Foucault's idea of selves that are produced discursively. "I" am not just one I, simply because the individual is limited by the skin of one body. Even the individual body is relational to the core. We cannot form or sustain our selves and bodies alone; we always do this in relation to others, but still in individual ways.

7. Guenther (2013) argues that "the very possibility of being broken in this way suggests that we are not simply atomistic individuals but rather hinged subjects who can become unhinged when the concrete experience of other embodied subjects is denied for too long" (xxi).

8. When asking directly what might be good about growing old, I got prompt answers from most elderly people: *Bera!*, meaning Nothing! And they would

laugh in a way that made it clear that I had to find better ways of asking. Questioning what is difficult about growing old, on the other hand, provided numerous narratives.

9. Initiation ceremonies into age sets used to be of great political and social importance throughout Karamoja (Knighton 2005; Turnbull 1972). With the introduction of democracy, initiation ceremonies are no longer carried out in Karamoja, but the respectful title of "elder" is still used.

REFERENCES

Barth, Fredrik. 1974. "On Responsibility and Humanity: Calling a Colleague to Account." *Current Anthropology* 15 (1): 99–103.

Butler, Judith. 2021. "Bodies That Still Matter." In *Vulnerability and the Politics of Care: Transdisciplinary Dialogues*, edited by Victoria Browne, Jason Danely, and Doerthe Rosenow. Oxford: Oxford University Press.

Chaichian, Mohammad A. 2013. *Empires and Walls: Globalization, Migration, and Colonial Domination*. Leiden: Brill.

Eilenberg, Michael. 2012. *At the Edges of States: Dynamics of State Formation in the Indonesian Borderlands*. Leiden: KITLV Press.

Elias, Norbert. 1956. "Problems of Involvement and Detachment." *British Journal of Sociology* 7 (3): 226–52.

Englund, Harri, and James Leach. 2000. "Ethnography and the Meta-Narratives of Modernity." *Current Anthropology* 41 (2): 225–48.

Evans-Pritchard, E. E. 1956. *Nuer Religion*. Oxford: Clarendon.

Fortes, Meyer. 1973. "On the Concept of the Person among the Tallensi." In *La notion de personne en Afrique Noire*, edited by G. Dieterlen, 283–319. Paris: Centre National de Recherche Scientifique.

Frost, Robert. 1914. "Mending Wall." In *North of Boston*. New York: Henry Holt.

Gade, Christian B. N. 2011. "The Historical Development of the Written Discourses on Ubuntu." *South African Journal of Philosophy* 30 (3): 303–29.

———. 2013. "Restorative Justice and the South African Truth and Reconciliation Process." *South African Journal of Philosophy* 32 (1): 10–35.

Gade, Christian B. N., Rane Willerslev, and Lotte Meinert. 2015. "'Half-Trust' and Enmity in Ikland, Northern Uganda." Themed Issue: "Enmity." *Common Knowledge* 21 (3): 406–19.

Goffman, Erving. 1955. "On Face-Work: An Analysis of Ritual Elements in Social Interaction." *Psychiatry* 18 (3): 213–31.

Guenther, Lisa. 2013. *Solitary Confinement: Social Death and Its Afterlives*. Minneapolis: University of Minnesota Press.

———. 2018. "Unmaking and Remaking the World in Long-Term Solitary Confinement." *Social Philosophy Today* 34:7–25.

————. 2019. "Dwelling in Carceral Space in Advance." *Levinas Studies* 12: n.p. doi: 10.5840/levinas20197101.

Grøn, Lone. 2020. "Cutting/Belonging. Sameness and Difference in the Lived Experience of Obesity and Kinship in Denmark." *Ethnos* 85 (4): 1–17.

Grøn, Lone, and Lotte Meinert. 2017. "Social Contagion and Cultural Epidemics: Phenomenological and 'Experience-Near' Explorations." *Ethos* 45 (2): 165–81.

Heine, Bernd. 1985. "The Mountain People: Some Notes on the Ik of North-Eastern Uganda." *Africa: Journal of the International African Institute* 55 (1): 3–16.

Jackson, Michael. 1989. *Paths toward a Clearing: Radical Empiricism and Ethnographic Inquiry*. Bloomington: Indiana University Press.

————. 1998. *Minima Ethnographica: Intersubjectivity and the Anthropological Project*. Chicago: University of Chicago Press.

————. 2018. "Surviving Loss and Remaking the World: Reflections on the Singular Universal in a West African Setting." *HAU: Journal of Ethnographic Theory* 8 (1–2): 185–96.

Knighton, Ben. 2005. *The Vitality of Karamojong Religion: Dying Tradition or Living Faith?* Burlington, VT: Ashgate.

Løgstrup, Knud E. 1956. *The Ethical Demand*. Translation edited by Hans Fink and Alasdair MacIntyre. Notre Dame, IN: University of Notre Dame Press.

Lötter, Hennie. 1997. *Injustice, Violence and Crime: The Case of South Africa*. Amsterdam: Editions Rodopi B.V.

Marriott, McKim. 1976. "Hindu Transactions: Diversity without Dualism." In *Transaction and Meaning*, edited by B. Kapferer. Philadelphia: ISHI Publications.

Mattingly, Cheryl. 2014. *Moral Laboratories: Family Peril and the Struggle for a Good Life*. Berkeley: University of California Press.

————. 2019. "Defrosting Concepts, Destabilizing Doxa: Critical Phenomenology and Perplexing Particular." *Anthropological Theory* 19 (4): 1–25.

Meinert, Lotte. 2021. "Vulnerability as Relational: Cash and Care for the Elderly in Uganda." In *Vulnerability and the Politics of Care: Cross-Disciplinary Dialogues*, edited by Victoria Browne, Jason Danely, and Doerthe Rosenow. Oxford: Oxford University Press.

Meinert, Lotte, and Lone Grøn. 2020. "'It Runs in the Family': Exploring Contagious Kinship Connections." *Ethnos* 85 (4): 581–94.

Meinert, Lotte, Rane Willerslev, and Sophie Seebach. 2017. "Cement, Graves, and Pillars in Land Disputes in Northern Uganda." *African Studies Review* 60 (3): 37–57.

Moré Martínez, Íñigo. 2011. *The Borders of Inequality: Where Wealth and Poverty Collide*. Tucson: University of Arizona Press.

Simmel, Georg. 1906. "The Sociology of Secrecy and of Secret Societies." *American Journal of Sociology* 11 (4): 441–98.

Smith, Karl. 2012. "From Dividual and Individual Selves to Porous Subjects." *Australian Journal of Anthropology* 23 (1): 50–64.

Sökefeld, Martin. 1999. "'Debating Self, Identity, and Culture in Anthropology' with CA Comments." *Current Anthropology* 40 (4): 417–47. Print.

Stevenson, Lisa. 2014. *Life beside Itself: Imagining Care in the Canadian Arctic.* Berkeley: University of California Press.

Strathern, Marilyn. 1988. *The Gender of the Gift: Problems with Women and Problems with Society in Melanesia.* Berkeley: University of California Press, 1988.

———. 2015. "Afterword: Taking Relationality to Extremes." In *Suicide and Agency: Anthropological Perspectives on Self-Destruction, Personhood, and Power,* edited by Ludek Broz and Daniel Münster. New York: Routledge.

———. 2020. *Relations: An Anthropological Account.* Durham, NC: Duke University Press.

Townsend, Cathryn, Athena Aktipis, Daniel Balliet, and Lee Cronk. 2020. "Generosity among the Ik of Uganda." *Evolutionary Human Sciences* 2:1–13. doi:10.1017/ehs.2020.22.

Turnbull, Colin. 1972. *The Mountain People.* New York: Simon and Schuster.

Vallet, Élisabeth. 2014. *Borders, Fences and Walls: State of Insecurity?* Farnham, UK: Ashgate.

Whyte, Susan Reynolds. 1999. "Slow Cookers and Madmen: Competence of Heart and Head in Rural Uganda." In *Questions of Competence: Culture, Classification and Intellectual Disability,* edited by Richard Jenkins, 153–75. Cambridge: Cambridge University Press.

Willerslev, Rane, and Lotte Meinert. 2017. "Understanding Hunger with Ik Elders and Turnbull's 'The Mountain People.'" *Ethnos* 82 (5): 820–45.

Woodburn, James. 1982. "Egalitarian Societies." *Man,* n.s., 17 (3): 431–51.

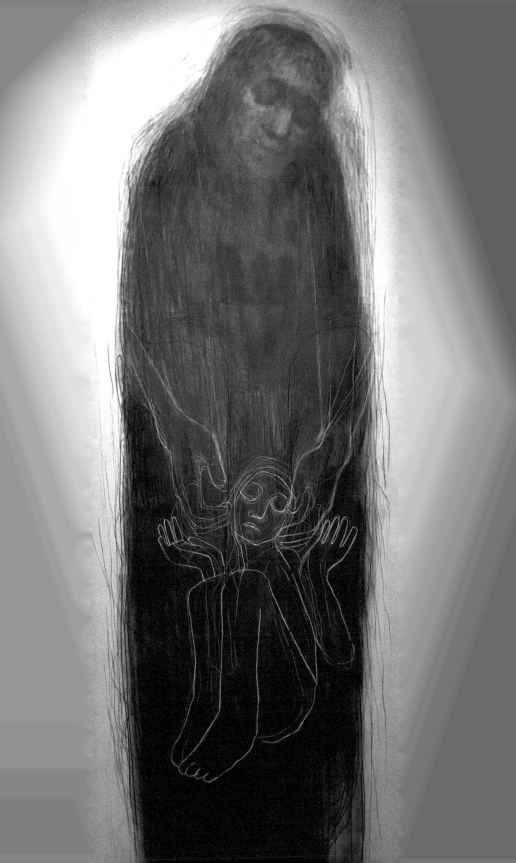

To Be Seen
empty room surrounding
her thoughts . . . sinking
heavier like that unmoving body of hers?
Sometimes my legs go completely stiff
I have to always stare at others' faces and say please, please
to be seen . . . to be recognized
There would be some freedom in that
how . . . they imagined her: reduced . . . dependent
how she had treated others
her own . . . helping
resisted responding to them
As if . . . they ignored her humanity
the person she believed herself to be
invested in her legs
that effortful touch
someone who could also care for others
had chosen to put up a barrier between
allowed herself to be known
to be seen . . . and responded to

Overleaf: Figure 1. Drawing for Harmandeep Kaur Gill, *To Be Seen*, charcoal and chalk, 2020, 450 × 115 cm

IMAGINING SELF AND OTHER

Carers, TV, and Touch

HARMANDEEP KAUR GILL

Spring was just around the corner, and the small hill station of Dharamsala was bustling with life. But for Mola (grandmother) Tsering Wangmo, it did not make much difference. She was confined to her chair, just as she was in all the other seasons. The promise of spring did not bring any more life into her compound. It did not lift her spirits as it would have in the past. And there she was, seated in her chair and staring into the empty room surrounding her. The TV was off. It was comforting for me to know that the morning sun at least was peeking through the windows and keeping her company. She turned her head slowly and greeted me. "Come in," she told me politely. Dawa la,[1] her carer, was absent. Mola Tsering told me that he had gone to town for some work. It was soon lunchtime, but Dawa la had not prepared any food before leaving. Not knowing whether he would return on time, I offered to cook lunch. Mola Tsering hesitated and ordered me to sit down instead, relax and eat *kha zas*[2] (a fried Tibetan snack). She was more patient with Dawa la's delay that day because he had gone to do some important work. Yet that day was no exception when it came to her daily complaints about him. She shared the same story I had been listening to for a month. It was her daily catharsis. So, I tried my best to listen with patience and let her empty her heart. In between her complaints, she shared news about Tenzin Tsomo (a distant relative of hers), who must have arrived back in the USA, or her daughter's phone call, before she returned to Dawa la. I felt terrible thinking about how tortured her mind was. How will she find relief,

I wondered, when her thoughts are constantly sinking her deeper into unrest, making her heavier like that unmoving body of hers? What is the solution?, I asked myself, and I am sure Mola Tsering Wangmo did too.

As she continued speaking, I got down to massage her legs. And that is when she told me about the solution. She lowered her voice and whispered to me as if the echo of her words would linger until Dawa la's return. "I am looking for a new girl. Don't tell Dawa la," she told me. The news surprised me. I knew that Mola Tsering had the option of getting a new carer, but she had previously announced that she would get one only when Dawa la had moved away from Dharamsala. But now Mola Tsering had decided to fire him, much earlier than planned. "He doesn't stay here much anyway," she defended her decision. Mola Tsering repeated the exact time he left to wander around town after preparing breakfast, when he returned to make lunch, when he left after lunch to wander around some more and then returned to make dinner before he took off again only to return around nine or ten p.m. to sleep. "What if I fell down while he is out? Sometimes my legs go completely stiff, you know that. I am old. I need assistance," she said. I wondered whether Dawa la would be more present if he were paid more. Mola had told me that he had often complained about his low salary; and while he had offered to stay with her for a few more months, he had also threatened to leave. Mola Tsering carried on, "It's better I die. It's better to die than to sit in this chair always, isn't it? I have to always stare at others' faces and say please, please." The fact that she always had to ask other people for help and assistance made her feel vulnerable. All she sought was to be seen and to have her suffering recognized.

This chapter takes up the case of an elderly Tibetan woman called Tsering Wangmo. Mola Tsering Wangmo has lived in exile in India since 1990, when she came to India to attend a teaching by the highest spiritual leader of the Tibetan people, the fourteenth Dalai Lama, Tenzin Gyatso. She never returned home to the Tibetan capital of Lhasa, Tibet. Mola Tsering Wangmo's family comes from the eastern part of Tibet, known among Tibetans as the Kham region. The family had a trading business and moved to Lhasa when Tsering Wangmo was a small child. After the Chinese occupation of Tibet, and following the fourteenth Dalai Lama's escape into exile in India in 1959, Mola Tsering's family, like other wealthy and aristocratic families in Lhasa, lost everything they owned. She referred to the time after the occupation as the hardest period in her life. When she was about forty years

old, she gave birth to a daughter and life got a little better. The father of the girl found another woman while she was pregnant, a betrayal that angers her to this day. When her daughter, Tenzin Jigme, was old enough, and in accordance with the practice of Tibetans living in Tibet at the time, Tsering Wangmo took Jigme into exile in India and enrolled her at the Tibetan Children's Village School (TCV) in Dharamsala, which has been the home-in-exile of the fourteenth Dalai Lama since 1960. Mola Tsering Wangmo visited her daughter several times after returning to Lhasa; and when she was in India in 1990, she decided to stay back. She settled down in Dharamsala; and like most Tibetans living in India and Nepal, she made her livelihood in the seasonal sweater business. Nine years ago, she had a bad fall and fractured her right hip. Since then she has been confined to her home.

Today Mola Tsering is in her late seventies. Like many elderly Tibetans in exile in India and Nepal, she is aging in the absence of family. She still lives in Dharamsala but is separated now by thousands of miles from her daughter, who moved to Canada about ten years ago, while there is no hope that Mola will be able to return to Tibet. Mola was able to manage her everyday life for quite some time after the fall. But in the last five years, she has become completely dependent on paid care. In most cases, children living abroad provide aging parents or relatives with financial support (Wangmo and Teaster 2009; Wangmo 2010). And Jigme, too, covers all of Mola Tsering's living expenses, including the carer's salary, something Mola is very proud about. Jigme also tries to be present for her mother through weekly phone calls.

These days, the condition of Mola Tsering's legs is always uncertain. Even her daily toilet visits would be impossible without her walker. She never knows how her legs will react from one day to the next, and even from one part of the day to the next. There are days or moments during a day when her legs turn completely stiff, and she is unable to make her way to the toilet. On other days, she is surprised at how flexible her legs can be. I became acquainted with Mola Tsering Wangmo through volunteer work with an NGO known as Tibet Charity. One section of this NGO provides welfare services for elderly Tibetans. Their small team of nurses and healthcare workers had been visiting Mola Tsering to give her leg massages for nine years. I learned to massage from the nurses, and after my volunteer period ended, I started visiting several elderly Tibetans to give them daily leg massages. Mola Tsering Wangmo was one of them.

This chapter explores Mola Tsering Wangmo's search for care. Her everyday life was pervaded by uncertainty in relation to both her own body and the non-kin networks she relied on in the absence of family. By exploring these non-kin networks of support, I attempt to make sense of Mola Tsering's notions of good and bad care and what she looked for in the different non-kin others in her everyday life. I argue that her expectations of care have to be understood in relation to her physical condition, cultural expectations, and the singularities of her life. Building upon the ethics of the Danish philosopher Knud. E. Løgstrup and the philosopher Emmanuel Levinas, which are grounded in interdependence, I explore what was at stake for Mola Tsering. Although Løgstrup and Levinas offer an abstract and idealized ethics, feminist scholars of Levinas (e.g., Guenther 2011; Taylor 2005) have articulated a more concrete approach inspired by his. I draw upon these feminists to flesh out how their ethics of care can speak to Mola Tsering's situation. Finally, taking my starting point in Douglas Hollan's (2008) focus on the imaginative dimensions of empathy, I argue that care in Mola Tsering's life was very much dependent on how she allowed herself to be understood by the different categories of intimate others in her everyday life, and also how she imagined and understood them in return. Thus, I approach the imagistic as imaginations of oneself and others. They have a mirror-like quality, mutually reflecting self and other, in both supportive and destructive ways.

Emphasizing internal or emotional orientation in caregiving work has been challenged as a "Western" bias by, among others, Felicity Aulino (2016), who argues that care procedures achieve their effects through repetition and correct performativity. Aulino makes an important point regarding physical care procedures, something I will return to. However, Mola Tsering's complaints about the carers were directed toward their emotional orientation or motivation. Furthermore, by emphasizing the role of imagination, I bring another dimension in understanding the mediations and frictions of receiving and giving care. For Mola Tsering Wangmo, living with disability and being closed off from her surroundings, the imagistic gained increased importance. The diverse imaginations of herself and a possible old age, grounded in the singularities of her life, were a means for transcending the closure imposed by a disabled body. Moreover, living a worthy old age for Mola Tsering involved, among other things, that others reflected these imaginations in their singular responses to her.

Engaging with Mola Tsering's expectations of care through the lens of imaginations of self and other resonates with the Tibetan Buddhist idea of the self being an illusion. Old age in the Tibetan Buddhist context is the time to let go of attachments to self and other. However, as I will show with Mola Tsering's story, in the absence of vitality and loved ones, imaginations of self and other realities become crucial in sustaining moral worlds.

A MULTITUDE OF CARERS

As the ethnographic description above illustrates, Mola Tsering did not have an easy relationship with her carers. Her complaints about Dawa la and subsequent carers focused on their neglect of her needs and their disrespect. In fact, from the moment a new carer started the job, she expected that they would turn out to be just like the rest.

In June 2018, about a month and a half after the incident described above, Mola Tsering got a new carer. This carer was an Indian woman in her late forties who spoke Tibetan like a native. Unlike Dawa la, she seemed to have a calm and gentle nature. Not being familiar with Mola Tsering's history of carers at that point, I felt hopeful that the new carer, Bhuti la, would satisfy her needs. But Mola Tsering did not seem very optimistic. "Now she is good, but who knows what will happen later," she said, and things did indeed soon take a turn for the worse. Her first complaints about Bhuti la began three weeks later. She complained that Bhuti la did not listen to her and purposely ignored things she told her to do. In addition, she accused her of lying about the cost of groceries and taking money for herself. I felt that Mola Tsering was being unjust. Bhuti la stayed with her throughout the day, something Dawa la never did. She did all the work on time, helping Mola Tsering to pee and even massaging her legs most mornings for half the salary Dawa la had been paid. I also felt that Mola Tsering looked down on her new carer in a way she had not done with Dawa la, who was both a male and a fellow Tibetan. By contrast, Bhuti la was a poor woman who had grown up working as a servant for Tibetan families in a Tibetan settlement in central India. While Mola Tsering had referred to her male Tibetan carer with the honorific term "la," as Dawa la, she referred to Bhuti la as simply Bhuti. It also took a while before she began calling her by her name instead of just referring to her as "girl" (*bu mo*) or "my worker" (*nga'i las ka byed mkhan*) or "helper" (*nga'i rogs pa byed mkhan*). It was clear that Mola Tsering did

not regard her as an equal. An acquaintance of Mola Tsering said that this might be because Mola herself had belonged to a rich family of traders and had grown up with servants in their household. Even though her family lost everything they owned upon the Chinese occupation of Tibet, the aristocratic ways of dealing with servants were still clearly visible in her attitude toward her carers. She provided them with everything: food, shelter, and occasionally also pocket money. She was often generous to them, but she never confided in them. In return, Mola Tsering expected them to be accommodating and obedient with regard to her needs. Although Bhuti la and some of the other carers accompanied her on a daily basis in everything she did, Mola Tsering did not consider herself to be "'*cham po*" (close/intimate)[3] with them. The relationship between Mola Tsering and her carers was clearly hierarchical, and its degree of intimacy seemed to be dependent on the gender and social class of the carer in question. As a male, Dawa la was given more respect than the female carers, while Bhuti la was treated worse than the other female Tibetan carers.

Over time, the relationship between Mola Tsering and Bhuti la grew steadily worse, and after two months, it seemed unlikely that it had any future. Whenever Bhuti la stepped out of the room to do some work, Mola Tsering would immediately begin to gossip about her. Once again, her restlessness and uncertainty regarding the future took over. Mola Tsering told me that Bhuti la had started answering back in a rude manner on a regular basis, and that her calm composure during my visits was nothing but a pretense. Had I been so wrong in understanding Bhuti la, or was Mola Tsering exaggerating in a desperate effort to be understood? Mola Tsering's hostility toward Bhuti la became so strong that she even accused her of deliberately trying to hurt her. One incident that she kept bringing up on a regular basis was that Bhuti la once forcefully bent her leg when putting on Mola Tsering's shoes. This is an accusation she had also directed toward Dawa la. In October, four months after Bhuti la started working for her, Mola Tsering decided to get a new carer.

Bhuti la was replaced by a Nepalese girl in her early twenties, who knew only a few phrases of spoken Tibetan. This young girl, Sarasvati, seemed very shy, obedient, and adaptable. She carried out the same tasks as Bhuti la for the same salary. On top of everything, she was an excellent cook. Once again, I was hopeful that things would work out, and in particular, I expected the age gap to reduce the number of confrontations between them.

In addition, due to language barriers, they could not hold a conversation, which would also prevent Mola Tsering from making complaints and Sarasvati from answering back. Sarasvati was a petite girl with a small appetite. Mola Tsering would affectionately nag her to eat more, just as she did with me. I noticed that she was also getting tired of changing carers. But by that point I had gotten to know Mola Tsering well, so when her first complaints about Sarasvati began shortly after, I was not exactly surprised. She told me that the young Sarasvati had a bad temper: "She gets very angry, and whatever I say, she does not respond to me." Once again, I was left to listen, nod, and try to understand.

Sarasvati was still with Mola Tsering when I ended my fieldwork at the end of December 2018. When I called Mola Tsering in February 2019, during the Tibetan new year (*lo gsar*), she informed me in panic that Sarasvati had run off with a large amount of money and some things from the house. I was shocked by the turn of events and disappointed by my own naïveté. At the time, Mola Tsering did not have a new carer and was being taken care of by a distant relative. When I returned to Dharamsala a few weeks later, in March 2019, she had a new helper. This time it was a Tibetan woman in her midthirties. I had missed out on their glory days, however, and by the time I returned, Mola Tsering's complaints about the new carer had begun. This time she complained that the carer did not have good speaking manners, and that when she went out, she stayed out for a long time, just like Dawa la. Once again, she expressed the need to get a new carer.

MOLA TSERING'S NOTIONS OF CARE

On nearly all my visits to Mola Tsering, I entered her room with a greeting and then asked her if she was doing well. I cannot recall her ever replying positively. Instead, she would often laugh at my question, finding it ridiculous to ask this, given her bodily condition. Regarding her happiness, she said:

> I am not happy. I am disabled. I cannot do anything on my own. Tibet Charity takes me to hospital. The helper cooks for me. As long as I cannot do things by myself and have dependency on others, I am not happy. If I could do things by myself even while using the walker/crutch, just to get by, it would be good, you know. There would be some freedom in that.

Moreover, she told me that she was always waiting for death.

> In this condition, I am dependent on others. I wish to die. Relatives from Gangtok and Bhutan came to take me with them, but I didn't go. I want to die here. I know my condition. I am not able to work, walk, or cook myself. I am dependent on others and that's difficult. If I die, it will bring an end to all this. I wish to die. Others tell me not to think like this, that even an extra day in life is worth living, because one can say mantra (ma ni). But I think it's better to die. I am not afraid of dying. One has to die anyway.

The main reason she wanted to die was that she was forced to depend on others, in particular her carers. She had no freedom. Dependency on others made her feel helpless and vulnerable. I have struggled to come to grips with Mola Tsering's problematic relationship with all her carers. They were all individuals with different personalities, yet she did not get along with any of them. Having reflected on Mola Tsering's statements about her carers and her own condition, I suggest that the main reason for her problematic relationship with her carers was how she felt they imagined her: reduced to being an old and dependent woman. She did not feel she was seen or respected as an elderly person with authority and wisdom. Her bodily condition had come to define her, and she had no freedom because of her body. She also felt that the carers ignored her sufferings of living with a disabled body and that they failed to embrace her.

Mola Tsering and another elderly companion, Mola Sangye (age sixty-five), who also relied on paid care, both stated that good care can only be provided by one's own children. Both had daughters who lived abroad. Relying on strangers, even when they are paid, made the elderly women uncomfortable, and they both found it hard to trust their carers. "My daughter is my own," Mola Tsering once said, unlike the paid carers or also someone like me. She was trying to say that for her own daughter, she is not merely a dependent and old body. She is a mother. Her daughter is also the main person who can see the continuity in Mola Tsering's life and recognize her for the unique person she is.

I suggest that Mola Tsering sought a type of response from the carers, from me, or from others that is usually typical of parent/child relationships. The relationship is not simply an exchange, as she perceived her relationship to be with the carers or other non-kin networks of support. In a

child-parent relationship, one is bound to the other not only out of a moral obligation, but also—at least ideally—by love and respect. Tsering Wangmo's notions of good care were guided by the traditional Tibetan norms of filial piety (Goldstein and Beall 1997; Childs 2001, 2004; Childs, Goldstein, and Wangdui 2011; Desjarlais 2016; Choedup 2018), which in the Tibetan Buddhist context are made meaningful in relation to Tibetan Buddhist virtues, such as compassion. My elderly companions said that taking care of one's aging parents was the foremost practice of *chos* (Buddhadharma: the teachings of the Buddha). Through interactions with several elderly Tibetans, I learned that financial support provided by children simply out of a sense of obligation was not regarded as living up to Tibetan Buddhist virtues. My elderly companions also expressed the need for emotional and moral support through regular phone calls, visits, or assistance during periods of illness. Mola Tsering Wangmo also sought this from her carers and other non-kin networks of support. Good care, thus, for Mola Tsering was not only financial and supportive care, such as cooking, washing, or help with more intimate tasks such as toileting or cleaning the body. Good care also involved emotional and moral support, sharing her troubles and joys, listening to and embracing her (Buch 2014; Taylor 2008; Thornton 2015).

Furthermore, Mola Tsering's expectations regarding good care were also grounded in the singularities of her own life: the hardships she had faced in life with poverty, illness, and raising a daughter on her own, and how she had treated others. Whenever Mola Tsering spoke about the importance of helping others, she also mentioned her own experience of helping others, such as poor people in Lhasa and a poor elderly Tibetan man she used to meet in Dharamsala. The way Mola Tsering had responded to others throughout her life informed her own expectations of good care. Finally, having been raised in a wealthy household with servants also affected how she expected the carers to behave toward her.

It is in light of all the above that we must make sense of Mola Tsering's problematic relationship with the carers. I propose that in her relationship with them, Mola Tsering imagined a particular version of herself, which was nothing but a "body that is dependent on others" (Thornton 2015). This image overshadowed the complexity of her being and her history. She had led an independent life, which included raising a daughter on her own. She told me that she used to be fearless, once even threatening an Indian rickshaw driver with a knife when he attempted to rob her. She had traveled all over

India: "I went everywhere, and now I can't even go to the toilet," she once said. In spite of being confined to her home for years, Mola Tsering was the most engaged among my elderly companions. She had an interest in everything from Bollywood actors to international politics. When we watched TV together, she would cheer, cry, and sometimes even be on the brink of shouting. In the following, I focus on Mola Tsering Wangmo's relationship to a different kind of intimate other in her life: TV characters. Her relationship to them opened up a possibility to transcend her bodily condition; she was also a moral person who could care for others.

THE TV AS AN ETHICAL OTHER

Watching TV with Mola Tsering was always an exciting experience. I witnessed a range of emotions depending on what show we were watching. She was almost jumping up and down in her chair, shouting with desperation, "Go, go, go!" when an Indian girl in the famous Indian reality-based *Crime Patrol* attempted to escape from her kidnapper, after being sold to him by her own mother. On another occasion, I witnessed her anger during the live Tibetan parliament sessions. She laughed mockingly at one of the parliament speakers; and when she could no longer bear to listen to him she pressed the "off" button on the remote control as hard as she could, telling the speaker to "eat shit" (*skyag pa za*), and then threw the remote control onto the bed. Her favorite show was a Bhutanese singing competition for young students. She watched it with great passion. When the young singers were given negative feedback by the judges, Mola Tsering was easily moved to tears. "It hurts them. They are so young," she would say. She grew particularly protective toward one male contestant who was the most destitute person on the show. Throughout her life, she had felt particularly strongly about destitute individuals, perhaps because she had experienced being one herself after the Chinese occupation of Tibet. Moreover, Mola Tsering referred to the young boy as her "male-friend" (*grogs po*). She wanted him to win but, in the end, he only came in third. Still, Mola Tsering did not feel too bad about it because he still won a large sum of money. And she was quite fond of the boy who won, anyway. To my surprise, Mola Tsering suddenly turned hostile toward one of the youngsters on the show, a young girl who came in fourth, who was very disappointed with the outcome and said that she should have won instead. "What a greedy girl" (*ham pa tsha ba la*

bu mo di), Mola Tsering repeated several times with great annoyance, even a week after the show had finished. She seemed unable to accept that the girl wanted to win over the poor boys, especially Mola's "male friend." I sensed in Mola Tsering a deep empathetic concern for the Bhutanese youngsters that was hard to find in her relationship with her carers.

The TV was also a face of the "other" in Levinasian terms, calling her to responsibility, and in her response, she gained her own singularity. The TV enabled her to engage with the world outside her four walls and to be someone who could care for others. As Andrew Irving remarks (2017), a disabled person is not merely a passive entity, but can "retain a sense of social and existential continuity amid the disruption of illness by listening to the radio, making conversation, and forming relationships" (50). Through her connections to the TV personalities and by acting upon their situation, Mola Tsering regained her sense of being a moral person who was invested in the world. The TV personalities did not react to her in return, but her own investment in them made it possible to imagine herself as someone else and to retain a social and existential continuity. She was not simply someone who was a burden, but also a moral person who could care for others.

Witnessing Mola Tsering's level of engagement with the young Bhutanese singers helped me realize what good care meant to her. It was a form of care that, in the words of Arthur Kleinman (2012, 1551), meant to recognize the other's sufferings and to engage in practices in words and emotional states that attended, supported, and collaborated with the contestants or the kidnapped Indian girl. Mola Tsering's happiness for their success was genuine and so were her tears for their setbacks. While the TV personalities had a singular face she did not turn away from, but in fact responded to, it was as if the carers had no singularity—she deliberately resisted responding to them. As if she felt that if they ignored her humanity, she treated them similarly in return: "If they are good to me, I will also be good to them," she said.

GOOD CARE: RESPONDING TO MOLA TSERING
IN HER SINGULARITY

The literature on care suggests that morality is a central component in our understanding of care (Buch 2013, 2014; Kleinman 2012, 2019). Rebecca Thornton's work (2015) among socially abandoned elderly people and her

involvement in the life of one elderly woman offer us an excellent ethno-graphic example of attempting to respond to the commitment we face when meeting people in vulnerable life conditions. Thornton argues that care for these elderly people involves "someone who recognized their existence and tried to honour their personhood" (67). Thornton's conceptualization of care as a form of recognition of the other's existence and personhood goes hand in hand with Janelle Taylor's (2008) explorations of care for elderly people with dementia, which is informed by the ethnographic case of her own mother. Her interest in the term "recognition" is triggered by people's con-stant questions regarding whether her mother recognized her. Taylor ex-plores the linkages between recognition and care and how claims to social or political recognition are connected to the cognitive ability to recognize phenomena (2008, 313). She argues that the loss of normal cognitive abili-ties often means that people stop recognizing and caring about elderly people with dementia (318). Furthermore, following philosophers such as Charles Taylor and Nancy Fraser, Janelle Taylor argues that denying others recog-nition and care is the same as denying them selfhood, as selfhood is not in-herent in individuals themselves, but "is distributed among networks, sustained by supportive environments, emergent within practices of care" (2008, 326).

The work of Buch, Thornton, and Janelle Taylor takes seriously the to-getherness of our lives. This complicates the distinction between the self and others, and the way we think about care. Mola was in search of someone who listened to her, recognized her sufferings, and tried to honor her for the singular person she was. For her, being recognized and honored for her wealthy family background, her generous nature, her struggles in life since the Chinese occupation, her caring and intelligent daughter, and her status as an elderly person with authority and a lifetime of wisdom were all vital components of who she imagined herself to be. She sought caregiving prac-tices that not only kept her physical body alive but also nurtured the per-son she believed herself to be. In other words, she sought care practices that responded to her in her singularity, and not only as a category of difference of the old and disabled.

To think about this, I now turn to the ethics of philosophers Levinas and Løgstrup, who have both written on the ethics of care by focusing on an asymmetrical ethical relationality and the importance of responding to whatever the other brings forward. According to Løgstrup (1997), we self-

surrender to the other in any type of encounter. We trust that the other will accept or embrace that part of us we have given over to their hands (9). Thus, regardless of whether we want it or not, we have a certain power over the other's state of being and even destiny. In any type of encounter with the other, one is exposed to a certain extent, because one is present with a body or a face. The face has a particular significance in Levinas's ethics (Levinas 1962; Guenther 2011; Benson and O'Neill 2007). It is not merely the features or an object we perceive. The face is present with a certain expression: a nudity and vulnerability (Morgan 2013, 10, 19–21), which is both an appeal and a demand. Likewise, for Løgstrup, in the self-surrender to the other lies a similar demand or plea to the other to respond, or "to take care of that part of the other's life that is within my power, and which I therefore am responsible towards" (Pahuus 2018, 32). This is what Løgstrup conceptualizes as the ethical demand, which gains significance through the basic condition that our lives are hinged onto the lives of others (Pahuus 2018, 31; Guenther 2013). It demands that one protect that part of life that has been delivered "into the hand of another" (Løgstrup 1997, 14). In other words, for Løgstrup and for Levinas, care involves accepting or embracing what the other has dared to come forward with (Løgstrup 1997, 10), while not accepting it is a form of rejection. More importantly, one must respond to the other in their singularity and not to a category of difference such as old age or physical disability, which is what Mola Tsering felt her carers did.

Levinas's and Løgstrup's arguments remain limited to an ideal world in which we meet the other without considering categories of difference and inherent judgments. Levinas's thinking also means that every single encounter with another person on a daily basis has a nexus of demand or plea, and thus an inescapable responsibility (Morgan 2013, 66). This is impossible to uphold in practical terms. In caregiving work, as argued by feminist thinkers (C. Taylor 2005), the ethical responsibility toward the other is put under pressure because of hierarchical relations and the physically and emotionally draining nature of care work. This adds to the difficulty of responding to Mola Tsering in her singularity—and especially because she failed to respond to the carers in their singularity. She also reduced them to the category of "carers/helpers."

With these thoughts in mind, I move on to explore the relationship between Mola and myself, first to exemplify what good care meant for her; and second to show how her relationship to me and the TV personalities enabled

her to reimagine herself as a moral and independent person who could influence the world around her. Unlike her relationship to the carers, our relationship was nurtured with kind words, praise, and care.

MASSAGES AND GOOD CARE

"If I could only walk on my own to the toilet, I would be happy. I just want to be able to go to the toilet without the fear of falling. It's too difficult like this," Mola Tsering said countless times—a statement that was often followed up by her appreciation of what I was doing for her. "The way you look after old people, massaging my legs will bring you merit *(dge ba)*." She would tell me that she prayed for me and shared her praise of me with the nurses from Tibet Charity and her daughter.

While Tibet Charity tried to visit her on a weekly basis, their visits were not always reliable, and Mola Tsering never knew when to expect them. After concluding my volunteer period with Tibet Charity, I started visiting Mola Tsering to massage her legs. For several months, I massaged her legs for up to fifty or sixty minutes each day, from Monday to Saturday; but I had to cut it down to thirty minutes and three times a week in the second half of my fieldwork, due to exhaustion. Mola Tsering insisted that I eat my lunch with her during my visits. I believe it was her way of doing something for me and caring back. If I ate too little, she would scold me like a mother. When I felt tired from my walks between different households and massages, she would affectionately tell me to take rest and sleep. Over a short period, Mola Tsering and I became rather close. She could count on my presence on a daily basis and began dreading my departure from Dharamsala. "When you leave, I am done," she would say. "Who will massage my legs like you?" In the beginning, I often also stepped in for other things in Dawa la's absence, such as serving food, helping her to pee in the bedpan, washing her hair, and performing other minor tasks. Mola Tsering referred to our relationship as "'cham po" (close/intimate).[4] Occasionally, she even likened it to a mother-daughter relationship. What fostered this intimacy between us?

One of the main reasons why Mola Tsering and I became close, I suggest, was because of the massages. In spite of a bleak future, the massages offered some hope that perhaps, if they continued on a regular basis, she would be able to make her way to the toilet on her own, without relying on

her walker and the constant fear of falling. Her hopes for a better life were invested in her legs. I propose that for Mola Tsering, the act of massaging was an act of care, because it recognized her sufferings and, through the massages, I was taking part in her hope for a better future. I believe that we grew close because, for Mola Tsering, I had responded to the ethical demand of our relationship by embracing the most vulnerable part of her, that is, her legs, which she literally had placed in my hands. For her, I had responded to the appeal or demand she had put forward through my commitment of massaging and also because I massaged in the "correct" way. She would often contrast my massages with Bhuti la's or Sarasvati's massages—she said that they put in no effort. I believe that in that effortful touch and my commitment over time, she sensed a recognition for her unique person and her sufferings. I had responded to her in singularity.

Giving massages to elderly people is also regarded as an honorific act among Tibetans. During my rounds around Dharamsala with Tibet Charity, the nurses were usually stopped by many elderly Tibetans. They greeted the nurses with gratitude. Their massages and donations of medicine were immensely appreciated. The act of massaging an elderly person is also understood as a virtuous action, motivated by compassion. It would not be incorrect to say that I was acting as a virtuous Tibetan Buddhist for Mola Tsering Wangmo. This was clearly stated when she referred to the act of massaging by saying, "This is *chos* (Buddhadharma—the teachings of the Buddha)," as I was massaging her legs. When she and other elderly people referred to the act of massaging as *chos*, they were attributing certain (virtuous) motivations to it and therefore also commenting on what qualifies as good care for them.

CARING IN RETURN

In her article on gift exchanges between older adults and home carers in Chicago's home care industry, Elana Buch (2014) points out that elderly people regard monetary exchange relations entering the home space as problematic because they are part of the capitalist care provision, where care is provided as a form of commodity. As Anna Tsing points out (2013), a commodity system is driven by values different from the moral values of social and gift relations (Buch 2014, 603). In a capitalist market system, care has been purified from its initial gift relation, holding certain values, and has

been transformed into a commodity, with a different set of values (603). The elderly people in Buch's article attempt to surpass the capitalist-driven care provision and build more intimate relationships to the carers, for example by giving informal gifts of money to their working-class carers.

The monetary exchange relation was an issue for Mola Tsering. It created a certain amount of distrust from the beginning and led to certain judgments about the carers. For Mola Tsering, their care practices were only a job on their part, and not motivated by moral obligations and connections that Tsing describes in a gift system. My relationship with her, by contrast, was not defined by the values in a monetary exchange. Although she was well aware that our relationship was also a form of exchange, I suggest that it was an exchange based on the moral values of social and gift relations. Furthermore, it was a relationship in which she could care for me in return.

Like the carers in Buch's paper, I offered a possibility in Mola Tsering's everyday life to reimagine and assert herself as a moral and independent person. She was not merely a dependent, old body, but someone who could also care for others. Being cared for by others is not the only component of care; caring and engaging in others is equally important in sustaining one's self (Kleinman and van der Geest 2009, 169). Mola Tsering cared for me by insisting on feeding me on a daily basis, medicating me during illness, telling me to take a rest when she could see that I was tired from running between households, or reminding me to call my own mother. Like the elderly people in Buch's studies (2013, 2014), Mola Tsering also sought to influence the world around her and engage in it despite her impairment. This was apparent in her level of engagement with the Bhutanese singers, other people, and me.

Moreover, I suggest that my presence or the presence of others was crucial in enabling her to assert her independence from the carers. Keeping us around was one way she communicated to the carers that even though she was dependent on them, she still had a network of intimate others she could count on who cared for her in return. Her destiny, in other words, was not bound to the carers, something that became particularly important for her to demonstrate once the relationships turned problematic. I understand this not only as an attempt to assert her independence, but also as a strategy to keep the hierarchical relationship with her carers intact. Thus, my presence was important for Mola Tsering not only because of the massages, but also

because it opened up the possibility for her to reimagine herself as a moral and independent person. The nurses, TV personalities, and I made these imaginations of herself possible, although only momentarily.

IMAGINATION AND CARE

Douglas Hollan and Jason Throop have written extensively on empathy (Hollan and Throop 2008; Throop 2010) and suggest that it must be studied "within the much broader context of the ways in which people gain knowledge of others and reveal, allow, or conceal knowledge of themselves" (Hollan and Throop 2008, 389). I will argue that this insight also applies to care. In the last part of this chapter, I want to follow up Throop and Hollan's suggestion by taking my point of departure in what Hollan calls the flip side of empathy, the ways in which people allow or imagine themselves to be known and understood (Hollan 2008, 487), and apply his insight to an exploration of care. While Løgstrup and Levinas make compelling arguments for an ethics of care, they do not pay sufficient attention to how our response to the other is not only evoked by the vulnerability of the face, but also limited or enhanced by the other's response to us and how they want to be understood or embraced.

I see this as a crucial aspect in Mola Tsering's notions of care because they varied considerably—depending on whom she imagined the other to be and how she wanted to be seen or understood by the other. From my own experience of her carers, I gathered that it was not always the case that they did not care for her. It was as if Mola Tsering had chosen to put up a barrier between herself and any potential carer from the outset. She did not allow them to get close to her or to see her in the way she allowed me or the Tibet Charity nurses to see her. This was perhaps due to her history of negative experiences with various carers, or because she did not want to expose herself in all her vulnerability. Or it may have been because she perceived the carers to be of lower social status. Her reasons were multiple.

Mola Tsering's relationship to the carers versus her relationships to the nurses from Tibet Charity and to me represented two extremes. At one extreme, she allowed herself to be known and understood by the nurses and me; while the opposite seemed to be the case with the carers. Her ideas about what constituted good care, and the fact that she placed her carers in a specific category, prevented her from imagining them otherwise. It rendered

Imagining Self and Other: Carers, TV, and Touch 179

their daily care practices as ungenuine, disrespectful, and often harmful. Hollan's (2008) further elaborations on the imaginative aspects of empathy can help us understand this better.

Hollan's argument is partially informed by psychoanalyst D. W. Winnicott's view on illusion and the ways in which illusion aids us in integrating our subjective notion of (being in) the world with our objective perceptions of it (Hollan 2008, 482–83). Hollan explains that for Winnicott a large portion of our cultural experience "lies in a 'transitional space' somewhere between the poles of pure subjectivity and fantasy, on the one hand, and pure, detached perception of an external world, on the other hand" (482–83). In this space, people and real cultural objects have their own objective characteristics, which become filled with so much personal significance and meaning that "it is almost as if we have imagined them into being" (482–83). I propose that Mola Tsering filled the category of carers with certain imaginings, which over time were transformed into almost objective characteristics of the carers. A certain gesture could quickly be subject to the same "objective" judgments she had imposed on former carers.[5] Occasionally, Mola Tsering sympathized with particular incidents in the carers' lives; but on the whole she did not allow herself to imagine the carers in their singularity, to invest in them, and to care for them as she cared for the TV characters, or me. The image of the carers pinned them down as a certain category of person. At the other extreme, Mola Tsering imagined people who did not belong to the category of carers differently. The image of them was dynamic, open, and singular. In my own case, contrary to what Mola Tsering might have felt, and in spite of my own best efforts, I did not always succeed in embracing her, especially when the helpers were subjected to unfair treatment or gossip or when she attempted to establish a hierarchy between me and them, for example by praising me in their presence. Nor were my massages always inspired by a sense of genuine care. Over time, due to the repetitiveness of the massages and visits, I started to relate to them as a sense of duty. Perhaps the gesture of listening or massaging—and doing it in a certain way (e.g., massaging for a long time and with a powerful force, as Mola put it)—had an effect in itself. As argued by Aulino (2016), my internal orientation was not always necessary for her to imagine being cared for. At the other extreme, the same act of massaging by the carers was never appreciated by Mola Tsering. She described their massages as too slack, saying once again that they were merely doing it out of obligation and not genuine concern

for her well-being. They too offered real gestures of understanding and care, especially at first, such as cooking delicious food or doing as they were told. But these actions were rarely met or received by Mola Tsering. In Hollan's words, she did not let them "in" (2008, 483), something he suggests is essential in someone imagining being understood.

Occasionally, it was clear that Mola Tsering was also disappointed in me or the nurses from Tibet Charity and questioned our care for her. But she always tended to forgive us—something that did not happen with the carers. Not only were the nurses and I trying to use our imaginative ability to empathize with and care for Mola Tsering, but she did the same for us in return. Thus, our imaginations of others end up creating real affects and moral worlds. Mola Tsering's notions of care depended on how she imagined the people around her and the ways she allowed herself to be imagined, understood, and cared for by these different others.

While Mola Tsering Wangmo opened up a space of intimacy and coexistence with some, this was completely absent with others. The need for a space of coexistence where she could momentarily regain her sense of being a moral and independent person who could not only be cared for, but also care for others, emerged partly in response to the nonintimate space which closed off the diverse imaginations of herself and a worthy old age. I suggest that moving in between these different spaces, Mola Tsering was able to negotiate her old age; she was an old and disabled body fully dependent on her carers, but during certain parts of the day, by acting upon the young Bhutanese singers' fates or through her conversations with me and the nurses, she could transcend the reality of old age and imagine her world being otherwise. The momentary hinges onto different selves and worlds were critical in order for Mola Tsering to endure things falling apart.

SUMMARY

This chapter has focused on how old age and care is lived in the everyday life of a lay Tibetan woman. I have explored Mola Tsering Wangmo's search for good care in the absence of family while living with a disabled body. Through a closer look at her relationships with several non-kin others, I have explored how she imagined herself in these relationships. I have suggested that her expectations of care have to be considered in light of her physical condition, Tibetan cultural expectations, and the singularities of her own

life. Building upon the ethics of Løgstrup and Levinas, I have proposed that what Mola Tsering sought in care relationships was to be seen by the other and responded to in her singularity. Finally, I have drawn attention to what Hollan refers to as the flip side of empathy and have applied his insight to care. I have suggested that Mola Tsering's notions of care were hinged onto her imaginations of various others and the ways in which she imagined and allowed herself to be understood by them. These imaginations were essential to enduring things falling apart in old age.

NOTES

1. Tibetans use "la" as a polite affix to names and titles (transliteration in Wylie: *lags*).

2. I use the Wylie system to transliterate Tibetan words, while "Mola" and all names are transliterated according to the pronounceable transliteration used by Tibetans.

3. To be "*'cham po*" with someone means to be close and friendly. It also involves a two-way process of giving and receiving care.

4. She also described her relationship with two of the nurses from Tibet Charity as "*'cham po*."

5. E.g., if they used too much force to put on her shoes, or responded to her in an undesirable tone.

REFERENCES

Aulino, Felicity. 2016. "Rituals of Care for the Elderly in Northern Thailand." *American Ethnologist* 43 (1): 91–102.

Benson, Peter, and Kevin L. O'Neill. 2007. "Facing Risk: Levinas, Ethnography, and Ethics." *Anthropology of Consciousness* 18 (2): 29–55.

Buch, Elana. 2013. "Senses of Care: Embodying Inequality and Sustaining Personhood in the Home Care of Older Adults in Chicago." *American Ethnologist* 40 (4): 637–50.

———. 2014. "Troubling Gifts of Care: Vulnerable Persons and Threatening Exchanges in Chicago's Home Care Industry." *Medical Anthropology Quarterly* 28 (4): 599–615.

Childs, Geoff. 2001. "Old-Age Security, Religious Celibacy, and Aggregate Fertility in a Tibetan Population." *Journal of Population Research* 18 (1): 52–67.

———. 2004. *Tibetan Diary: From Birth to Death and Beyond in a Himalayan Valley of Nepal.* Berkeley: University of California Press.

Childs, Geoff, Melvyn C. Goldstein, and Puchung Wangdui. 2011. "Externally-Resident Daughters, Social Capital, and Support for the Elderly in Rural Tibet." *Journal of Cross-Cultural Gerontology* 26 (1): 1–22.

Choedup, Namgyal. 2018. "'Old People's Homes,' Filial Piety, and Transnational Families: Change and Continuity in Elderly Care in the Tibetan Settlements in India." In *Care across Distance: Ethnographic Explorations of Aging and Migration*, edited by Azra Hromadžić and Monika Palmberger, 75–94. New York: Berghahn Books.

Desjarlais, Robert. 2016. *Subject to Death: Life and Loss in a Buddhist World.* Chicago: University of Chicago Press.

Fink, Hans, and Alasdair MacIntyre. 1997. Introduction to *The Ethical Demand* by Knud E. Løgstrup, edited by Hans Fink and Alasdair MacIntyre, xv–xxxvii. Notre Dame, IN: University of Notre Dame Press.

Goldstein, Melvyn C., and Cynthia M. Beall. 1997. "Growing Old in Tibet: Tradition, Family and Change." *Aging: Asian Concepts and Experiences, Past and Present*, edited by Susanne Formanek and Sepp Linhart, 155–76. Vienna: Verlag der Oesterreichischen Akademie der Wissenschaften.

Guenther, Lisa. 2011. "The Ethics of Politics of Otherness: Negotiating Alterity and Radical Differences." *Philosophia* 1 (2): 195–214.

Hollan, Douglas. 2008. "Being There: On the Imaginative Aspects of Understanding Others and Being Understood." *Ethnos: Journal of the Society of Psychological Anthropology* 36 (4): 475–89.

Hollan, Douglas, and C. Jason Throop. 2008. "Whatever Happened to Empathy?: Introduction." *Ethos: Journal of the Society for Psychological Anthropology* 36 (4): 385–401.

Irving, Andrew. 2017. *The Art of Life and Death: Radical Aesthetics and Ethnographic Practice.* London: Hau Books.

Kleinman, Arthur. 2012. "The Art of Medicine: Caregiving as Moral Experience." *The Lancet* 380: 1550–51.

———. 2019. *The Soul of Care.* New York: Penguin.

Kleinman, Arthur, and Sjaak van der Geest. 2009. "'Care' in Health Care: Remaking the Moral World of Medicine." *Medische Antropologie* 21 (1): 159–68.

Levinas, Emmanuel. 1962. "Transcendence and Height." In *Emmanuel Levinas: Basic Philosophical Writings*, edited by Adriaan T. Peperzak, Simon Critchley, and Robert Bernasconi (1996), 11–31. Bloomington: Indiana University Press.

Løgstrup, Knud E. 1997. *The Ethical Demand.* Translation edited by Hans Fink and Alasdair MacIntyre. Notre Dame, IN: University of Notre Dame Press.

Morgan, Michael L. 2013. *The Cambridge Introduction to Emmanuel Levinas.* Cambridge: Cambridge University Press.

Pahuus, Mogens. 2018. *Dialog med Løgstrup: Løgstrups Fænomenologi.* Aalborg: Aalborg Universitetsforlag.

Taylor, Chloe. 2005. "Levinasian Ethics and Feminist Ethics of Care." *Contemporary Issues in Philosophical Ethics* 9 (2): 217–39.

Taylor, Janelle. 2008. "On Recognition, Caring, and Dementia." *Medical Anthropology Quarterly* 22 (4): 313–35.

Thornton, Rebecca. 2015. "Speaking an Elderly Body into a Visible Space: Defining Moments." *Qualitative Theory* 21 (1): 66–76.

Throop, C. Jason. 2010. "Latitudes of Loss: On the Vicissitudes of Empathy." *American Ethnologist* 37 (4): 771–82.

Tsing, Anna. 2013. "Sorting Out Commodities: How Capitalist Value Is Made through Gifts." *Hau: Journal of Ethnographic Theory* 3 (1): 21–43.

Wangmo, Tenzin. 2010. "Changing Expectations of Care among Older Tibetans Living in India and Switzerland." *Ageing and Society* 30:879–96.

Wangmo, Tenzin, and Pamela B. Teaster. 2009. "The Bridge from Then to Now: Tibetan Elders Living in Diaspora." *Journal of Applied Gerontology* 29 (4): 434–54.

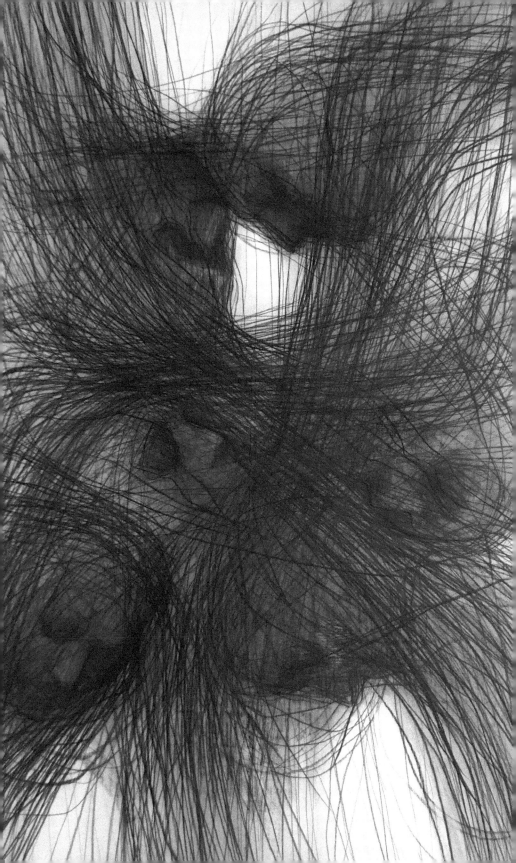

Away . . . Toward
fallen . . . had been living
his father's brother's son, but still a brother
looked in and went again
shouting, shoving, murmuring . . . and trying to calm
should assemble and mourn
involves many
intimacy and its gradations
turned away from me and toward other
care as best they can
visit and converse
who may also be consociates
unmet needs and how much better
constellations of care
blamed
excused
disapprovingly . . . left to sleep alone
If we were We
not unchanging . . . revised, adjusted . . . doubted . . .
 shifting

Overleaf: Figure 1. Drawing for Susan Reynolds Whyte, *Away . . . Toward*, charcoal and chalk, 2021, 200 × 115 cm

VIRTUES AND VEXATIONS

Intimate Others Caring for Elders in Eastern Uganda

SUSAN REYNOLDS WHYTE

We found Musa lying on the cement floor of a small brick house on the outskirts of the trading center. His daughter Fatuma had been bathing him and asked my companion Lily to help move him back onto the mattress. There were tears in Fatuma's eyes: "It's so hard to care for my father all alone. Moreover, a daughter to bathe her father . . ." Fatuma lived with her husband and six children in a house just behind the one where her father lay. It would have been shameful for him to stay under the same roof with his son-in-law, so a kind neighbor had lent Fatuma this house when Musa was discharged from hospital.

Musa seemed to be unconscious. Fatuma poured a little passion fruit juice into his mouth, but his teeth were clenched and most of the juice ran out and down his chin. She showed us his catheter tube; the urine looked worryingly pink. He had fallen gravely ill in Iganga, the town about 50 miles away where he had been living. His brother Tomas (actually his father's brother's son, but still a brother) instructed Tomas's daughter, also living in Iganga, to bring him to the district hospital here near the family homes. As a retired health worker, Tomas supervised his treatment in hospital, and Musa's daughter and sister stayed with him in the ward. The district hospital could not do much for him. Fatuma said he was referred to the larger regional hospital 35 miles away, and she blamed Tomas and his other brothers for not mobilizing money to take him there. Tomas said that the district hospital staff had told him it was hopeless; Musa was dying. He wondered why

they had not told Fatuma, instead of leaving her to blame him and the other men in the family for failing to save her father's life. Two days later, Tomas rang at 5:30 in the morning to say Musa had just passed away. Anger and accusations about the care of Musa intensified.

Musa had been a wanderer. He sold most of his ancestral land and worked menial jobs in towns. He had four children by four different women, but at the age of seventy-four he was without a wife or a house of his own. Of close family in his home area, he could count one son and his daughter Fatuma, a sister, and his clan people, including Tomas and the many other children of his father's brother. They visited him in his final illness. Tomas came every day to check on the catheter. The nearby son came too but, according to Fatuma, not every day, and he just looked in briefly. Tomas told me that son does not care about his father; they have been on bad terms. The other son came from Kampala for one day, but did not stay, said Fatuma bitterly. When I arrived with Musa's son and others from the family home to take his corpse to its proper resting place on his dead father's land, she cried angrily: "Now you are coming when he is dead! Nobody wanted to keep him when he was sick!" Later, the brothers explained to me all the reasons why they could not care for him in their homes. Tomas had a good house in the trading center, but it was already packed to overflowing with dependents. At the family home in the countryside, there was no good supply of food and water, as there was at Fatuma's place in the trading center. There was not even a proper house. He could have stayed in his sister's house, but it was in total disrepair. "We would have been ashamed for people to come visit the patient in an old collapsing house."

Musa had said he wanted to be buried at the home of his fathers and brothers, and on the next day, he was—but only after scenes of shouting, shoving, muttering vicious insults, and trying to calm a hysterical Fatuma. She was determined that her father's body should be cleansed and made ready at the house where he died, and that her friends and in-laws should assemble and mourn there first. She had a strong circle of supporters, market vendors and Muslims like herself, who had already come to sit with her as soon as they heard about the death. When we arrived with a vehicle to fetch the body for burial, she sobbed and threw herself about. At one point she locked herself in the house with the corpse, while some among our party banged on the door. It was not until we agreed that they should bring the

body in their own time that she settled and joined the songs and prayers her friends had started.

The clan people tried diplomatically to keep a lid on the old conflicts between Musa's children. They organized to receive the many mourners, including local dignitaries. The funeral had to be worthy and well attended—and it was, pretty much. Musa and his own children were Muslims, unlike the other clan people, so there were compromises about how the burial was to be done. The grave was dug at a distance from those of his parents "because his father was a drunkard and their ghosts might quarrel if they are too close." Musa's body lay overnight in his sister's ruined house; some grass had been thrown on the roof to cover the worst of the holes and luckily, it did not rain.

Three characteristics emerge in these negotiations about elder care in eastern Uganda. Care is composite; it has multiple elements and involves many people. Care is a heavily moral matter, where virtue is mirrored in vexation with others who are criticized for not caring enough. Care is contingent, in that it depends on histories and events in the lives of care givers and receivers. Across these features of care run overall themes of intimacy and its gradations.

INTIMACY AND IMAGES

My approach to these themes is ethnographic. In addition to repeated stays in Bunyole (now Butaleja District) over the years since my initial fieldwork (1969–71), I focused on aging during visits since 2017. Together with my assistant and friend, I regularly visited seven old men and women, and called on others once or twice. I brought small gifts, and they served us food and showed us grandchildren and graves in their homes. I talked to their families and neighbors, some of whom were also elderly, and in several cases got directly involved in their care by helping them access medical treatment. From earlier fieldwork and through general participant observation, I gained familiarity with life conditions, family constellations, forms of support, and tensions.

Fieldwork, and particularly fieldwork about care, is methodologically pronomial—it requires awareness of pronouns. It involves different kinds

of relationship and different realms of sociality, beginning with the experiencing "I," the fieldworker, seeking to understand others through interaction. This was the approach of Alfred Schutz (1972; Schutz and Luckmann 1973), who proposed a phenomenology of the social world. He too started with an experiencing I, always a social I oriented to an Other. He called this the "thou-orientation," which arises in "advertence," the attitude of turning attention face-to-face to an Other, a fellow-human, a "consociate" with whom one shares temporal and spatial immediacy (Schutz and Luckmann 1973, 61ff.). I do not necessarily like or know well that fellow-human; what is characteristic is the immediacy of attention. If the Other reciprocates attention, a We relation exists; we mirror each other and are interlocked. Ethnographic fieldwork is in the attitude of advertence, attending immediately to Others, who sometimes reciprocate. When Fatuma shouted and wept hysterically, I put my arm around her and tried to calm her with soothing words. I focused on her as Thou, but she soon turned away from me and toward other consociates who began to chant a prayer in Arabic.

Schutz points out that the immediacy of Thou and We relationships fades when I begin to reflect on the Other and the situation, and when we are no longer together. Thou becomes He or She; consociates, those in our immediate experience, become contemporaries—those we know about, who live in our time. They are potentially within reach, but we do not share a flow of subjectivity as in a face-to-face relationship.

When you with whom I was a consociate are no longer present, I remember you as you were in our We relationship, writes Schutz.

> I remember you as a person vividly present to me with a maximum of symptoms of inner life, as one whose experiences I witnessed in the actual process of formation. . . . I remember you as one whose consciousness was continuously changing in content. However, now that you are out of my direct experience . . . I am no longer in contact with the living you, but with the you of yesterday. . . . I carry your image with me, and it remains the same. (1972, 178)

Schutz uses the notion of an unchanging image to contrast with the vivid changing Thou of immediate experience. Of course this is an oversimplification; my image of Fatuma that day has changed as I later reflect on the situation. But Schutz's concern is the difference between an image of an Other and the immediate shared experience of another conscious person.

Schutz takes the concept of an image further in considering other types of relationship. "A . . . way in which I come to know a contemporary is to construct a picture of him, from the past experience of someone with whom I am now speaking" (1972, 182). I constructed a picture of Musa from conversations with people who had been his consociates to varying degrees. Schutz continues in this vein with the "personal ideal type," a synthesis built up of my interpretations of another person's experiences, which may be constituted also by my experience of more than one person, as "the synthesis of recognition does not apprehend the unique person as he exists within his living present. Instead it pictures him as always the same and homogeneous, leaving out of account all the changes and rough edges that go along with individuality" (1972, 184). Schutz goes on to discuss ideal types, which influence our expectations of how "They" behave. Ideal types are images that provide schemes for interpreting the social world of contemporaries and even the world of predecessors (185).

Schutz's image or picture does not refer to a material representation such as a photo or drawing. He is close to dictionary (*OED*) definitions of "image" that are cognitive: "the character or reputation of a person or thing as generally perceived"; "a typical example"; "a mental representation, an idea or conception"; "the general impression that a person, organization, or product presents to the public." Schutz states that all images or ideal types are constituted in part by my own stream of consciousness and in part by the stock of knowledge I acquire about my social world, knowledge that can be modified in immediate We and Thou relationships. Perhaps in this sense he relates to another dictionary definition of image: "an optical appearance or counterpart produced by light from an object reflected in a mirror or refracted through a lens." I imagine Him or Her or Them refracted through my own experience and knowledge. Schutz's images pertain to the social world; they concern interaction with various kinds of others, rather than the content of my own or the Other's inner life and feelings. They are useful for grasping some aspects of ethnographic fieldwork and some problems around care. But clearly not all. As we shall see when considering contingency, the images, expectations, and hopes people hold of intimate others can crack. Elements of uncertainty infuse our dealings with images.

Care is always a social relation, as many have pointed out; as such, it involves some degree of intimacy. But what is intimacy? I will suggest that it can be several things, some of which are at odds with one another. It can be

the immediate sharing of time and space, the face-to-face interaction between consociates that is fundamental to the lifeworld, according to Schutz. In such interaction we sense the other's feelings and disposition directly, and if we both attend to each other, we may indeed become We at that time and place. Intimacy can also be the biographical histories of shared experience in earlier We relationships with others who are contemporaries, but only intermittently consociates in that we do not frequently share time and space. The quality and depth of Fatuma's intimacy with others in Musa's care constellation varied greatly. Some, with whom she was close through kinship and earlier immediate interactions, she typified critically as "he" or "they" when talking to consociates. Finally, fieldwork has shown that the quality of intimacy is culturally inflected by values of propriety as well as notions of virtue. The importance of bodily modesty between certain intimate others can inhibit the intimacy of sharing time and place. In considering care of elderly people by intimate others, practical aspects of resource distribution and biographical contingency influence intimacy in crucial ways.

CARE IS COMPOSITE

In Lunyole, the language of my interlocutors, there are many words for care,[1] none of which corresponds exactly with the capacious English term (Buch 2015, 279). The Ugandan practice of what we call care is an aggregate of different activities and dispositions. For many aging people, there are at least three phases of care. As physical abilities weaken, practical help and economic support increase. Children and younger people, generally expected to assist older people in household tasks in any case, double their efforts. Competence becomes more and more distributive as chores are shifted and productive activities, whether farming or income generation, are taken over by stronger hands. When health fails, as was the case with Musa, care means finding money for treatment, making contact with health practitioners, taking the patient to a health facility, staying with them in hospital, and providing bodily assistance for feeding, moving, bathing, and toileting. Care does not end at death, but extends to preparing the corpse, arranging the home burial, and mourning publicly. Funerals are the most important rituals in much of rural Uganda, and they are an enormously important form of care for old people. Mourners care for the dead and the bereaved by con-

tributing money or other necessities, and by attending. Indeed, some must stay for days.

The conviction that a worthy burial is part of care for an old person was also reported from research in an Akan village in Ghana (van der Geest 2000). There, people were ambivalent about the large resources mobilized for public postmortem care in contrast to sometimes minimal premortem care for the individual. An elaborate funeral was a bid for family prestige, they said. There is something of this, on a much smaller scale, in eastern Uganda. However, we should bear in mind that the deceased shares in the respect that a good funeral brings to the family. A well-attended home burial confirms that even a wanderer like Musa belongs to a family.

Important scholarly work on care in the global North focuses on the dyad of care giver and care receiver (Mol 2008; Taylor 2008; Kleinman 2013). Attempts to move beyond this duality of interaction have considered the broader political economy of care (Tronto 2015), particularly the role of the state in providing for vulnerable citizens. Feminist scholars of care write of moral principles: attentiveness, responsibility, competence, responsiveness, trust, respect (Barnes 2012, 19–25). But these seem to pertain to relationships that are either dyadic or between states and frail citizens. Barnes (2015) acknowledges that getting "beyond the dyad" means considering the family as a network of potential caregivers, but she does not write of the collaboration and conflicts that might characterize such a network. Anthropologists working in North America have been varyingly attuned to the complexities of care and family life (Stack and Burton 1993; Garcia 2010; Rapp and Ginsburg 2011; Stevenson 2014, to name a few). A few have focused on the relations between those giving care to older persons (Taylor 2017; Mattingly, this volume). But it is ethnographic research on elder care in African settings that most consistently highlights the cooperation and criticism that permeate such networks (Cattell 1997; van der Geest 2002a, b; de Klerk 2011, 2016; Hoffman and Pype 2016; Kaiser-Grolimund 2018).[2]

Butaleja District is rural, heavily populated, and generally poor. With an average total fertility rate of eight births per woman, families are large. While some members move to towns to (search for) work, there is still a vibrant rural society based on farming and small business. Incomes are meager and expenses, especially for schooling and medical care, are high. Yet unlike parts of Africa suffering a care deficit (Schatz and Seeley 2015) because

younger people have emigrated and AIDS has decimated a generation of middle-aged caregivers (Coe 2017; Ingstad et al. 1992; Ingstad 2004), rural eastern Uganda has homes and extended families that provide care as best they can for weak old people.[3] The common situation was that an elderly man or woman lived close to children and grandchildren and was cared for by them. But even people like Musa, who was not a consociate of his children, achieved care. Men who had no children or who had lost touch with them stayed with siblings and were cared for by their siblings' children and grandchildren. Women who never had children might stay with a husband and co-wife and their children and grandchildren. The national program of senior citizen grants had not been extended to this district at the time of fieldwork, so the only older people with any income were the very few retired civil servants who managed to obtain the pensions to which they were entitled.

If care is composite, then arrangements must constantly be worked out about who provides what kind of care. Some family members have more useful resources than others. The son, or more rarely daughter, who has a salaried job "outside" is expected to build a house for the aging parent and to provide cash for surgical operations or expensive medical tests and medicines. As we saw, Musa's brother Tomas had medical experience and contacts; he was the one to talk to the health workers and check the catheter. Fatuma believed that he and other brothers had, or could mobilize, financial resources that she lacked for treatment. They saw Fatuma as having (or being able to borrow) suitable accommodation, which was not available in their homes. Both parties had images and expectations of the other.

The question of who provides what kind of care is partly about the gendered divisions of activity. Men mobilize money for what needs to be purchased, including medical care. They organize transport and orchestrate funerals. Building or repairing houses for elderly parents is men's work, and it is important that there is a good house to lay out the deceased when mourners come to pay respects at a funeral. In fact, there is sometimes criticism of men who do not build permanent houses for their parents until very late in their lives. Having neglected for years to provide good accommodation, they do so in anticipation of how they will be judged by mourners. Women cook, clean, and care for old people's bodies. When a son or grandson is caring for an old person, it is usually the women of the home who are doing much of the daily work. Both men and women visit and con-

verse with the elderly. An old person who has difficulty walking spends long hours seated outside, under certain trees or on the verandah, according to the movement of the sun and the rhythm of shade through the day. Old women are often surrounded by younger ones shelling groundnuts, sorting greens, or breastfeeding babies, since most domestic activities take place outdoors. Old men wait for neighbor men to stop by. Another interlocutor, Aloysius, had a friend who made string and often sat with him braiding it under the tamarind tree that has good shade in the afternoon.

Aside from resources and gender, the configuration of care depends on intimacy. Family relations are close by definition. Children and siblings, and their children, are assumed to be nearer—more intimate—than unrelated neighbors, and therefore more responsible for care. Some are consociates, who share time and place regularly. Spouses generally live together in daily proximity in the same house and are, or have been, intimate sexually. There is often a considerable age difference between men and their first wives. When a man has two wives, the second one is commonly much younger than the first. So younger wives tend to care for older, more frail husbands. Old women are more often cared for by children and grandchildren, who may also be consociates. Grandchildren often sleep in their grandmother's house; sometimes visiting daughters do as well. Grown sons have their own houses, so an old person's home may contain within a few hundred yards the homes of sons and daughters-in-law, and sometimes adult grandchildren, whom they see every day. The decline of marriage, evident in the presence of never-married or divorced daughters in their parents' home, has been a boon for elder care. Although they often have children, unmarried women have no husbands for whom to care, so they are available to attend to the needs of their parents or grandparents.

Yet sharing time and space is only one kind of intimacy. Some family members are closer than others even if they do not live in the same home. They care more about the old person. And elders too have preferences among their children and siblings and children-in-law. A middle-aged woman, Lusi, told me how her mother-in-law, who used to dislike her, began to favor her in her last years, preferring Lusi's food to any other. Being consociates, even having a We relationship, does not necessarily mean affection. Among those I knew there were several instances of the opposite—grandchildren and a daughter-in-law who were not always on speaking terms with their old relatives, though they saw each other every day.

The composition of care was also influenced by notions of propriety in bodily matters. In this patrilineal, virilocal society, *obuhwe*,[4] loosely translated as modesty and respect or fear, pertains to matters of partnership and enjoins physical separation between parents and children-in-law. They should not be consociates. This is most assiduously observed between a man and his wife's parents. Tomas, who prided himself on being a caring son-in-law, was nevertheless uncomfortable if his wife's mother, who lived some distance away, had to spend a day or two in his home when she was being treated at the district hospital. The consciousness of *obuhwe* reminds us that intimacy is culturally shaped.

So Musa could not stay in the house of his daughter and son-in-law. That would be too intimate. There were many examples of married women going to stay with their ailing mothers, rather than bringing them to their own homes. Sometimes two or more daughters shared this obligation, taking turns to leave their husbands and children weeks at a time to care for their mothers. Daughters-in-law lived near their parents-in-law and helped them in old age, but many thought it improper for a woman to bathe her mother-in-law; to be that intimate with her father-in-law would be out of the question. Once adult children were old enough to engage in sexual relations, they became a little like in-laws, especially in relation to parents of the opposite sex. Thus Fatuma was pained at having to bathe her father; if he had been married, his wife would have done it. His brothers or sons or grandchildren or even a sister would not have felt the shame of *obuhwe* as she did.

VIRTUE IS MIRRORED IN VEXATION

To care for an old person is good, and it is easy enough to articulate the virtues of care. Sometimes people did remark about proper care. Marko reported that Anna's sons-in-law were good because they provided the coffin and cement for the grave when she died. Many commented that Veria cared devotedly for her old mama, coming regularly to bring food, bathe her, and wash her clothes. Tomas praised the care his wife had provided for his mother, and promised to care as well for her mother. Good care is seen on the body (de Klerk 2016, 146). To say jokingly, as I heard a couple of times, that an old woman looks so good that men will soon be bringing bridewealth for her is to appreciate the care that intimate others have provided.

But just as common were the criticisms of insufficient care. Other researchers have noted the "discourses of neglect" or "complaint discourses" that point to failures of care. In her study from western Kenya, Cattell sees these not as a portrayal of actual practice, but as "a way of reinforcing or attempting to recast and justify changes in social norms regarding the social contract of caregiving obligations" (1997, 158). Her examples of complaint discourses are generalizations in the media about the decline of family care and statements by old people themselves, who complained about neglect, not necessarily by blaming a specific person, but by talking about their unmet needs and how much better the elderly were treated in the old days. Such expressions of dissatisfaction have been reported from other parts of Africa as well (van Dongen 2008; van der Geest 2004). The common point is that complaints about inadequate care reflect norms or ideals or nostalgia about better care.

De Klerk (2016), writing about aging among Haya people in northwestern Tanzania, has a slightly different approach to the ways people talk about neglect. Although she also heard implicit or explicit complaints of neglect from elders themselves, she found that different actors told different stories about the very same constellations of care. Sometimes they blamed an elder herself for not laying the ground well for her care in old age. Or they excused a neglectful grandson and his wife on the grounds of their youth. In these stories too, one can detect notions of better care implied by stories about neglect. What distinguishes de Klerk's exposition is the attention to the care constellation and the different opinions about neglect and, by implication, virtue.

Among my interlocutors, I did not hear many complaints of neglect from old people themselves. It would have been shameful for them to admit that they were not valued; they tended instead to appreciate that their family members were trying, despite their other problems. It was rather caregivers who complained about and criticized other potential members of the care network. Tomas remarked disapprovingly that his mother-in-law was left to sleep alone when her sons had plenty of children who could be sent to keep her company at night. Eriya told me that his daughter-in-law did not help his sickly wife with cooking. Veria was convinced that her brother's son, who lived next to her mother, did not ensure that his wife and children fed her well and kept her waterpot full. Lily spoke to me with sympathy for her

old frail kinsman and with deep disparagement of his young wife, who said to his face that he was useless, like another child. He had confided to Lily that he knew she was having an affair with another younger kinsman in the neighborhood and other kinsmen were not stopping her. She who had to care for him despised him because he was old and poor. No respect and no love. Lily wondered: "Did she think marriage was just for fun?"

Such acts of blaming could be seen as indications of the weakening of care in situations of rural impoverishment and the decline of kinship support. However, I would like to suggest that critical statements are part of the ethical work of care. By drawing attention to the shortcomings of others, Fatuma implicitly confirms her own virtue. The image she conveys of Them reflects herself in a favorable light. She contributes to the continuing discussion of what care efforts are possible for a given person in a given situation. And she confirms the bad character of persons she was predisposed against, keeping old conflicts alive.

The ways an unchanging image of an Other's failure to care are confirmed came home to me on another occasion. One evening we sat in the dark in Stella's house talking about the care of her old mother Hiisa, who had died after being sick and weak for seven years. Stella's sister was there and so was her brother's wife, Lusi, who lived in an adjacent compound. That evening we were "We" in Schutz's sense; he wrote of consociates as "fellow men," but we were fellow women, who had known each other for years. In animated conversation, each woman attended to the other, while I attended even more keenly, struggling to understand all the words they exchanged.

Stella and Lusi were neighbors and saw each other every day. Stella had left her husband long before and brought up her children in her parents' home. She had played a major role in caring for her mother, Hiisa. There were many other carers as well. One was her son, who had built the good house for Hiisa where we now sat. He was mostly away working, but his first wife, Edisa, lived just nearby. If we were We, Edisa quickly became She as we talked of old Hiisa's care. An image of "typical Edisa" took shape, one I had often heard before. She had not gotten on well with the rest of the family for years, so criticism of her failures to care properly for her mother-in-law fell in line with preexisting patterns. Stella told me that Edisa kept the sorely needed money her husband sent for his mother, and sometimes deceived him by telling him that his mother was not even sick. Stella and Lusi spoke of Edisa's rudeness to Hiisa's old brother when he came to visit. Whereas

they always offered him food and a place to stay, Edisa just said she was busy. Caring for the old lady meant being hospitable to her relatives. But Lusi pointed out that at the time of Hiisa's funeral, Edisa refused to allow mourners from Hiisa's family to sleep in her house. Even Edisa's attempts to help were condemned. She sent her daughter to bring tea and bread to the old lady the day before she died; in her grief next day Stella screamed that Edisa had poisoned the bread. If not the bread, then surely the relations between the carers were poisoned. "We" confirmed our virtue. We cared for the old lady by caring for her old brother when he visited, while "She" just told him that her husband was not there to buy sugar for his tea. We shared the little money we had to buy food the old mama liked; She deceived her generous husband and selfishly kept for herself the money he sent. Old antagonisms are reconfirmed in criticizing shortcomings of care; virtues are implied in expressing vexation with the (image of) behavior and character of others. This is especially so when the care receiver is an old person, since potential caregivers have had long histories with one another.

CARE IS CONTINGENT

Images of a neglectful She or They were revealing to me in my attempts to understand the situations of older people in eastern Uganda. But I also found that images were not unchanging; they were revised, adjusted, and doubted in the shifting contingencies of life. Catching the dynamics and multiplicity in care arrangements needs an appreciation of the tentative, subjunctive, and ongoing practice of care. To be contingent is to be dependent upon. Good care, virtuous care, depends firstly on the social and physical condition of the elderly person. Secondly, it depends on the vagaries of lives within the constellation of caregivers.

"Virtues cannot be defined in an absolute sense but only insofar as they are contingently applied to specific actions, in specific circumstances" (Lambek 2010, 19). There are always specificities that must be dealt with. Musa lived alone and far away; he had no house on his ancestral land. Musa's children had well-known antagonisms and there were rumors that one son had cheated the other over land. The reason why his sister's house was so dilapidated was because his son had quarreled with her and forced her to leave. These discords, already evident while he was still alive, flared up when he died. At that point, personal care for the sick old man shifted to public

care for "the late" (*omugenzi*) family member. Fatuma's struggles with the living body were abruptly superseded by demands for the corpse and the male work of burial.[5] Conflicts were exacerbated by the fact that Musa and Fatuma were practicing Muslims; Fatuma and the Muslim mourners insisted on caring for his body in the manner that was virtuous according to Muslim practice. They wanted to care for him as a Muslim, while his son and brothers wanted to care for him virtuously as a family and clan member. The opposition between Muslims and Christians is of little import in many aspects of everyday life, but it was magnified here because it coincided with the opposition between Fatuma and her father's brother's sons. Care of Musa, in life and in death, was contingent upon his history, his social situation, his character (or "personal ideal type"), his illness, and incompatible ideas about what was possible and desirable.

By contrast, Hiisa lived with her daughter and grandchildren in a solid house surrounded by relatives and neighbors she had known for decades. She had been a respected and influential person, and she had four concerned children of her own as well as thirteen stepchildren, not to mention the affines of those children. Hiisa was sickly for seven years, which put a long strain on her network of caregivers, while Musa needed care for only about a month before he died. Hiisa was a consociate of many of her caregivers in that she was present with them in daily life over decades; Musa was a contemporary in that he was absent for long periods until his last weeks. For both, there were periods of uncertainty about their health and care, though care for Hiisa was always more secure than that for Musa. Their specific circumstances were vastly different, and efforts to care were contingent on situations. So too were reflections on virtuous caregiving in each case.

In another sense, if contingency means being dependent on, then it is extreme where care depends not on the state or stable institutions but on the history and changing life situations of people in the constellation of care. While the care needs of a frail person are more or less constant (though of course their condition may change), the lives of their younger caregivers are often dynamic. The continuing shifts in the network sustaining the frail old lady I call Mama illustrate this kind of contingency. Mama is a widow who has buried five of her eight children. They left children, however, and her house is surrounded by the houses of her grandsons and their families. Mama's teenage great-granddaughter Janet slept in her house and helped her so well that Mama said she should wait to marry until Mama died. She

was also well cared for by her daughter Veria, who lived nearby and brought her cooked meals every day. But Janet left to learn tailoring and Veria's husband retired and moved away with Veria. One of Mama's grandsons and his family supplied meals and fetched water for her, but Veria did not think they cared well enough. She took the old lady to stay with her married sons, but when one of them was accused of complicity in a murder, Mama moved home again. "Fortunately," a granddaughter left her partner and came with her new baby to stay in Mama's house and care for her. I visit Mama whenever I can and receive regular reports on the phone from a friend of the family. It is not easy to follow the shifts in the lives and relationships of her family members. Now Janet has had a baby by a man who refuses to support her, so she is home again staying in her father's nearby house. A grandson's wife, who sometimes cooked for Mama, has left him. When Mama was very ill recently, she called her only living son to declare her last wishes to him alone, which caused tension and suspicion among those hoping to take over Mama's house. The momentous developments in such an interdependent constellation bring running changes that we can appreciate as contingency.

The images I have formed of various situations of care, and the pictures my consociates and contemporaries in the neighborhood convey to me, are subject to revision, as my acquaintance with Simon reveals. In an attempt to make an overall assessment, I once asked Marko, the village council chairman, whether there were any old people in the village who were really neglected. "No," he answered promptly, "even Simon, with no wife and no children and no strength to dig, even he is cared for." Lily and I visited Simon early in 2019 and found him looking fine, sitting outside his small house talking to Ronald, his brother's son. He told us how he had worked in different factories in Kampala for thirty years "until my strength began to fail and I saw my hair was turning gray." He came home with nothing; all seven siblings had died but for one sister who was married nearby. Still, he reckoned he might have a hundred grandchildren from his brothers' children—*his* children in local kinship terms. One brother's son gave him bricks, others contributed money for roofing sheets, another helped build the house. Ronald was the (brother's) son caring for Simon most; he ate from the kitchen of Ronald's wife, and one of Ronald's sons together with another boy helped him with daily chores. Ronald told us that he cared for the old man when he was in hospital and tried to get medicine to help him urinate, although it turned out the tablets were too expensive. Lily and I came away

with a positive impression as we talked of Him and They who cared. Ronald was truly being a good son to his father's brother.

A year later, when I was back, Ronald came to say that Simon was very sick. When my friend and I went to his house a few days later, there was no one around. We found him lying inside the smelly house on a papyrus mat, emaciated and dirty. He was asleep, but we first thought he was dead. He could not speak or sit up by himself. There was a plate of food and a mug of water nearby, untouched. As we propped him up and helped him drink the soda we had brought, I realized there were feces on the mat. When we went out, Ronald's wife came. She had been at a funeral celebration for a neighbor, together with everyone else, drinking the banana beer that follows several days after a death. She said Simon's sickness came on three months earlier. At first he could not speak, later he could not walk or move. He messes where he lies and does not like to be bathed, though they try to wash him once a week.

A short time after that visit, when I had returned to Denmark, the village chairman, Marko, rang to say Simon had just died and added, "I think he died of neglect." Simon had not kept up with his tithes to the Catholic church and Marko did not know if there would be money to pay the priest to come for the burial. A few days later, I spoke to Marko again to hear about the funeral. In the event, people contributed money for the priest and a (brother's) son working in Kampala sponsored the coffin. Marko told me that the mourners were saying Simon died for lack of care, and even the priest remarked in his address that it is hard to be well cared for if you have no children. Those who should have cared for Simon were busy drinking. Ronald, his brother's son, was drunk on the day Simon died. And Ronald was still drunk at the burial, having been drinking heavily the night before. They had collected money and bought maize to feed the mourners, but Ronald took 10 kilograms to sell, presumably to get cash to keep on drinking. When I said that I had thought Ronald was responsible and caring, Marko said yes, but when he starts drinking, he changes.

Did Simon die of neglect? Was Ronald a caring son? Did Simon's extended family look after him well? The contingencies of an incapacitating stroke (perhaps several), lack of money for hospital care, a weakness for alcohol, and the remarkable pulling together to mobilize resources for the funeral are all part of the puzzle. And so much else that I can only *imagine*,

that is, according to the *OED*: "form a mental image or concept of"; "believe something (unreal or untrue) to exist"; "suppose or assume." Why did Simon have no children of his own to care for him? Someone told me that he once seduced the wife of his mother's brother, so his uncle cursed him never to marry or have children. The curse was never lifted because the uncle died while Simon was in Kampala. But when I asked Simon how it was that he never married, he just said he did not know and had never gone to the diviner to inquire. My two face-to-face encounters with Simon, and what others have told me about him and his caregivers, are enough to form an image of the situation. But it is partial and tentative and contingent. I and they have made revisions as time passed and conditions changed, but the image is still insufficiently clear.

Images are necessary, but we should treat them as incomplete, in the mode commended by Biehl and Locke (2017, 44). They urge "increased focus on our receptivity to others, the kinds of evidence we assemble and use—the voices we listen to, the silences we notice, and the experiences and turns we account for—and how we craft our explanations. Our analyses must remain attuned to the intricacy, uncertainty and unfinishedness of individual and collective lives." Receptivity to others is possible in the advertence of attending to an Other in his or her immediacy and fluidity. Crafting explanations or analyses inevitably involves the creation of images. My attempts to consider these images together with my interlocutors, in conversation, often lead to the realization that there is much I do not understand—I have not gotten the whole picture. Sometimes, though, I come away feeling that they are clinging to an image that is too fixed.

INTERDEPENDENT INTIMATES

Being interdependent means collaborating in providing care. In resource-poor settings, that almost inevitably involves tensions and vexations among potential caregivers about who cares how. Criticism supports awareness of virtue and entails reflections about how to deal with the specificities and contingencies of the older person and of all those who should provide care. Care is virtuous, not only for the caring individual, but for the entire family of a frail elder. Concern about care extends even to the wider community, not least in the final act of a respectable funeral.

I as a researcher, trying to understand care in a social world of which I am intermittently a part, do so by occasional face-to-face immediate experience with consociates. Very often, I hear about Him and Them from conversations with You, who becomes She as I write my notes. Through these kinds of sociality, I form images, just as my interlocutors do. I have tried to convey some of these to you, the reader. Yet the processes of care for older people are so marked by contingency that we should not fix too tightly on any one image. Rather we must attend to degrees and occasions of intimacy and the linked consequences of interdependence.

NOTES

1. In Lunyole there are different words for "to care for" (*ohuhuuma* [to keep or watch over], *ohujanjaba* [to nurse or treat illness], *ohulabirira* [to look after]) and "to care about" (*ohwenda* [to like or love], *ohufaayo* [to be concerned about]). The *Lunyole Dictionary* (Musimami and Diprose 2011) lists eight Lunyole words for "to care," all having the meaning "to care for."

2. The ethnographic literature on care is large. Here I am only considering some of the work from North America and Africa.

3. With only 3.7 percent of the Ugandan population over the age of sixty, the "burden of care" for the elderly is not one of numbers but rather one of scarce resources.

4. The root of the word *obuhwe* denotes marriage and in-laws. Once adult children begin to have sexual relations, they observe modesty with their own parents and even more so with the parents of their partners.

5. This pattern of men turning up to fetch the body of a person they had not cared for during a long illness is a known one, as are conflicts over where a person whose belonging is in question should be buried (Whyte 2005). In eastern Uganda, there are no cemeteries; everyone is buried at home, but sometimes home is contested.

REFERENCES

Barnes, Marian. 2012. *Care in Everyday Life: An Ethic of Care in Practice*. Bristol: Policy.

———. 2015. "Beyond the Dyad: Exploring the Multidimensionality of Care." In *Ethics of Care: Critical Advances in International Perspective*, edited by Marian Barnes, Tula Brannelly, Lizzie Ward, and Nicki Ward, 31–43. Bristol: Policy.

Biehl, João, and Peter Locke. 2017. "The Anthropology of Becoming." In *Unfinished: The Anthropology of Becoming*, edited by João Biehl and Peter Locke, 41–89. Durham, NC: Duke University Press.

Buch, Elana D. 2015. "Anthropology of Aging and Care." *Annual Review of Anthropology* 44:277–93.

Cattell, Maria G. 1997. "The Discourse of Neglect: Family Support for the Elderly in Samia." In *African Families and the Crisis of Social Change*, edited by Thomas S. Weisner, Candice Bradley, and Philip L. Kilbride, 157–83. Westport, CT: Bergin and Garvey.

Coe, Cati. 2017. "Negotiating Eldercare in Akuapem, Ghana: Care-Scripts and the Role of Non-kin." *Africa* 87 (1): 137–54.

de Klerk, Josien. 2011. *Being Old in Times of AIDS: Aging, Caring and Relating in Northwest Tanzania*. Leiden: African Studies Centre.

———. 2016. "Making Sense of Neglect in Northwest Tanzania." In *Ageing in Sub-Saharan Africa: Spaces and Practices of Care*, edited by Jaco Hoffman and Katrien Pype, 137–57. Bristol: Policy.

Garcia, Angela. 2010. *The Pastoral Clinic: Addiction and Dispossession along the Rio Grande*. Berkeley: University of California Press.

Hoffman, Jaco, and Katrien Pype, eds. 2016. *Ageing in Sub-Saharan Africa: Spaces and Practices of Care*. Bristol: Policy.

Ingstad, Benedicte. 2004. "The Value of Grandchildren: Changing Relations between Generations in Botswana." *Africa* 74 (1): 62–75.

Ingstad, Benedicte, Frank Bruun, Edwin Sandberg, and Sheila Tlou. 1992. "Care for the Elderly, Care by the Elderly: The Role of Elderly Women in a Changing Tswana Society." *Journal of Cross-cultural Gerontology* 7 (4): 379–98.

Kaiser-Grolimund, Andrea Patricia. 2018. "Healthy Aging, Middle-Classness, and Transnational Care between Tanzania and the United States." In *Care across Distance: Ethnographic Explorations of Aging and Migration*, edited by Azra Hromadžić and Monika Palmberger, 32–52. New York: Berghahn Books.

Kleinman, Arthur. 2013. "From Illness as Culture to Caregiving as Moral Experience." *New England Journal of Medicine* 368 (15): 1376–77.

Lambek, Michael. 2010. Introduction to *Ordinary Ethics: Anthropology, Language, and Action*, edited by Michael Lambek, 1–36. New York: Fordham University Press.

Livingston, Julie. 2003. "Reconfiguring Old Age: Elderly Women and Concerns over Care in Southeastern Botswana." *Medical Anthropology* 22 (3): 205–31.

Mol, Annemarie. 2008. *The Logic of Care: Health and the Problem of Patient Choice*. London: Routledge.

Musimami, Sylvester, and Martin Diprose. 2011. *Ehyagi hy'Ebibono by'Olunyole* [Lunyole dictionary]. Entebbe: Lunyole Language Association.

Rapp, Rayna, and Faye Ginsburg. 2011. "Reverberations: Disability and the New Kinship Imaginary." *Anthropological Quarterly* 84 (2): 379–410.

Schatz, Enid, and Janet Seeley. 2015. "Gender, Ageing and Carework in East and Southern Africa." *Global Public Health* 10 (10): 1185–200. http://dx.doi.org/10.1080/17441692.2015.1035664.

Schutz, Alfred. 1972 [orig. pub. 1932]. *The Phenomenology of the Social World.* Translated by George Walsh and Frederick Lehnert. London: Heinemann.

Schutz, Alfred, and Thomas Luckmann. 1973. *The Structures of the Life-World,* vol. 1. Evanston, IL: Northwestern University Press.

Stack, Carol B., and Linda M. Burton. 1993. "Kinscripts." *Journal of Comparative Family Studies* 24 (2): 157–70.

Stevenson, Lisa. 2014. *Life beside Itself: Imagining Care in the Canadian Arctic.* Berkeley: University of California Press.

Taylor, Janelle S. 2008. "On Recognition, Caring, and Dementia." *Medical Anthropology Quarterly* 22 (4): 313–35.

———. 2017. "Should Old Acquaintance Be Forgot? Friendship in the Face of Dementia." In *Successful Aging as a Contemporary Obsession: Global Perspectives*, edited by Sarah Lamb, 126–38. New Brunswick, NJ: Rutgers University Press.

Tronto, Joan C. 2015. "Democratic Caring and Global Care Responsibilities." In *Ethics of Care: Critical Advances in International Perspective*, edited by Marian Barnes, Tula Brannelly, Lizzie Ward, and Nicki Ward, 21–30. Bristol: Policy.

van der Geest, Sjaak. 2000. "Funerals for the Living: Conversations with Elderly People in Kwahu, Ghana." *African Studies Review* 43 (3): 103–29.

———. 2002a. "The Toilet: Dignity, Privacy and Care of Elderly People in Kwahu, Ghana." In *Ageing in Africa: Sociolinguistic and Anthropological Approaches*, edited by Sinfree Makoni and Koen Stroeken, 227–44. Aldershot, UK: Ashgate.

———. 2002b. "Respect and Reciprocity: Care of Elderly People in Rural Ghana. *Journal of Cross-cultural Gerontology* 17 (1): 3–31.

———. 2004. "'They Don't Come to Listen': The Experience of Loneliness among Older People in Kwahu, Ghana." *Journal of Cross-cultural Gerontology* 19: 77–96.

van Dongen, Els. 2008. "'That Was Your Time . . . This Time Is Ours!' Memories and Intergenerational Conflicts in South Africa." In *Generations in Africa: Connections and Conflicts*, edited by Erdmute Alber, Sjaak van der Geest, and Susan R. Whyte, 183–206. Münster: LIT Verlag.

Whyte, Susan R. 2005. "Going Home? Burial and Belonging in the Era of AIDS." *Africa* 75 (2): 154–72.

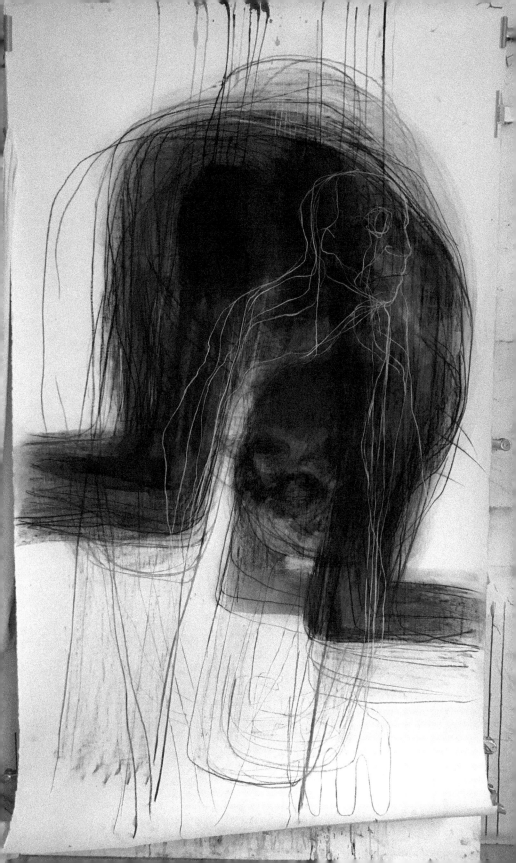

His Full Height
he falls backwards
for some time
He has been there before
to stay within reach
fallen apart
home is a place to belong to . . . to escape from
how to meet each other
to reconfigure
his body . . . speaking
Things cannot go back
open for everybody to see
Something *more* is said
falls down again
head upright . . . Walk . . . Change . . . Increase . . . Eat
his own abilities again
who are you?
to see and hear the needs of his body . . . return to home
his full height

Overleaf: Figure 1. Drawing for Helle Sofie Wentzer, *His Full Height*, charcoal and chalk, 2021, 200 × 115 cm

THE STAIRCASE

The Ethics of "Transcendence and Height" in Welfare Care

HELLE SOFIE WENTZER

Imagistic inquiry is unfolded in this chapter through the image of a stair-case—an image everybody can recall mentally along with physical sensa-tions of climbing and descending stairs. Walking up and down stairs requires bodily directedness, balance, attention, and muscular strength. Along with the concrete experience, the staircase is also a metaphor of de-velopment and change, of progression and falling off. This two-sidedness of walking on stairs points to an embodied and ethical dimension of our re-lationship to others; how we meet and are met by the Other. Drawing on "Transcendence and Height," an essay on ethics by the philosopher Emman-uel Levinas, this chapter presents the staircase as a learning case that re-flects the dependency of frail elderly persons after hospitalization on being met by the "welfare Others" in ways that afford "transcendence and height," that is, resurrection and hope of returning home and to oneself. In partic-ular, when the present situation of the elderly person and his/her prospects for the future are related to loss and fundamental change. Patient care path-ways of elderly persons are indeterminate and subjunctive with uncertain dimensions of care (Strauss 1997; Wentzer 2020). These uncertainties add to the frailty of elderly persons and draw critical attention to the organ-ization of care pathways, the homecoming and dwelling of the elderly, es-pecially with loss of a functional level of self-care and daily living. In the

following story about Ben's transition to home, the staircase demonstrates the importance of ethical judgment as a sensibility toward "the Good" in the face of the embodied Other (Merleau-Ponty 1962; Altez-Albela 2011). Thus, this chapter claims that phenomenology with imagistic dimensions of care opens up an ethical sensibility in decisions on the elderly person's return to home and needs of self-care.

THE FALL

The first time Ben falls down the stairs of his small two-story town house, he falls backward. He grasps the banister, which absorbs some of his fall. He lands on the parterre in front of the main entrance to his house. He hits his head, but luckily, he remains conscious and has his cell phone with him to call for help. His front door happens to be unlocked, so the paramedics can get in. Ben is taken directly to the emergency hospital. He has severe damage to his abdomen. He goes into surgery and has an ostomy. He is hospitalized for some time and later discharged to care at home. Ben would prefer to be transferred to intermediate care at his municipality's rehabilitation unit, where he has been some years earlier to recover after a knee operation, but Ben's request gets rejected. The rehab unit has no spare beds, and because Ben has family, his son is expected to help with care and to keep him company. Ben finds it more important, though, for the son to focus on his girlfriend and his apprenticeship than on his father's needs. Instead, transportation by taxi is arranged to take Ben home. He remembers sitting on the doorstep of his house waiting for someone to let him in, because he did not take his house key with him to the hospital. He is appalled by just being left outside his home. Ben worked for many years with orphans, addicts, and psychiatric patients and knows how important it is that somebody welcomes you and supports you between institution and home: "We would never send children or anybody home like that. They need somebody to meet them and care for them to make the transition safe."

Ben feels frustrated and abandoned while sitting and waiting on his doorstep. He recalls his many years as a social worker: "Nobody takes care of you; you have to take care of yourself." He knows from working in closed psychiatric wards with dangerous patients how important it is

always to stay within reach of the help-button: "I always avoid getting into conflicts, I cannot win, physically. And I always stay within reach of the help-button. If you push it, help comes immediately! You know, working in public health care you will have to draw your own boundaries. Nobody else does it for you."

Ben used to take care of himself. He is a tall and strongly built man. He used to be a blacksmith until the liberal and feminist winds of the seventies made it possible for him to change profession by following his call of becoming a social worker. He was forced into retirement when he turned seventy. He then started working as a woodcutter in the forest, with a small group of male friends whose company he enjoys. After the ostomy, he is not able to leave the house long enough to go to the forest, where he has a small cabin. His daily life has changed dramatically, as he has become dependent on others to help him. He is practically confined to his combined kitchen-living room on the ground floor, where a care-bed has been installed by the municipality. Ben has suffered what you could term an ontological break-down (Lear 2006; Grøn and Mattingly 2018). His lifeworld with its everyday activities and social relations has fallen apart. He is uncertain about his near future. Ben is also vexed by the relationship with the municipality, upset about not knowing what to expect after the rejection of his applications for a bed in the rehab unit, and uneasy about the prospect of being sick at home alone.

ASCENDING STAIRS

"I am very scared of walking on stairs," Ben states and repeats, "*VERY scared*." There are good reasons for his strong dislike of walking on stairs. The staircase is the *mise en intrigue*, the plot that opens up an understanding of Ben, as somebody more than a scary man with fierce eyes, which is how I perceived him the first time I met him as an interlocutor in an ethnographic study of elderly persons' care pathways from hospital to home (Wentzer 2020). That study explores hidden and often unintended aspects of accelerated patient care pathways in the Danish healthcare system, which include shorter hospital stays, implying more care and rehabilitation being assigned to family members, friends, and the municipality in which the elderly persons live.

The Danish healthcare system—of the type often referred to as the Scandinavian welfare model—is universal and based on the principles of free and equal access to health care for all citizens. A significant number of services are available to citizens free of charge. The healthcare system offers high-quality services, the majority of which are financed by general taxes. Life expectancy for Denmark in 2020 is 80.97 years (Macrotrends 2020). The primary healthcare system covers a number of health services as well as disease prevention and health promotion measures at the local level. Primary healthcare services are provided by general practitioners (GPs); by other private practicing healthcare professionals, such as dentists, physiotherapists, and psychologists; and by the municipalities, which are responsible for home nursing, prevention measures, and rehabilitation (Ministry of Health 2017).

The goal of the intermediate healthcare system is to create effective patient care pathways and efficient flow across sectors from hospital to home in terms of shortened hospital stays—and a quicker return to independent living at home. Average bed time has been shortened substantially over the past decade (Sørensen 2017), especially for elderly patients discharged from surgery and medical wards (Hansen 2017).

Patients in intermediate care pathways between specialized care at the hospital and the primary care system can expect specialized home nursing, including IV (IntraVenous treatment) and homecare from the municipality. The municipality Ben lives in also offers three kinds of rehabilitation services: care provided directly at home by visiting "home trainers"; outpatient treatment at the local training center; or a two-to-twelve-week stay at the municipality's rehabilitation unit. The unit has twenty-four beds with care services 24/7 and training in the morning and afternoon on weekdays. The unit specializes in rehabilitation of patients after neurological damage and orthopedic surgery, and of geriatric patients with multiple morbidities. The patients either are referred by doctors or apply directly themselves via the municipality's website. Citizens granted a stay at the rehabilitation unit are expected to bring and wash their own clothes and to pay a daily fee for food. The amount is automatically drawn from the elderly persons' monthly state pension. Training and care are organized around principles of rehabilitation for daily living (Barthel Index; COPM; Mahoney and Barthel 1965).

UNSAFE HOME

Ben's case is an example of an intermediated patient care pathway between specialized treatment at the hospital and primary health care with rehabilitation and care in the municipality. After he is discharged from hospital the first time, he receives nightly visits (*tryghedsbesøg*), and daily nursing and homecare help from the municipality. He has three meals brought in every day and gets help with washing, cleaning, and laundry. His ostomy bag is emptied every day and replaced completely every second day. Ben is far away, though, from the ideal of independent living at home. In fact, he has an ambiguous relation to home, as for him, home is a place to belong to as well as a place to escape from. This ambiguity becomes amplified by the healthcare system's goal of discharging patients to their home as quickly as possible. Ben's relation to the healthcare system is problematical. Both he and the healthcare others find themselves in an ethical limbo on how to meet each other, and on what grounds. The home is considered private, as a safe space of family life, but in Ben's case his home is not a safe space, and his son is not trained to help with Ben's need of specialized care. The image of the home as a safe haven is thus destroyed in cases of frail persons living alone, like Ben. It needs to be restored to being the safe end point of his care pathway.

THE ETHICAL MEETING

In the essay "Transcendence and Height," Levinas argues for the ethical good as an event that comes out of the meeting with the alien Other. The origin and the measure of ethics are based on otherness and the infinite request of the Other, and not on some normative principle, as in deontic Kantian ethics, or on consequentialist calculation, as in utilitarianism. The face of the Other is the interface that allows you to "transcend" your own understanding, as something limited, and opens you to a new understanding, to "height." It is the Other, who enables you to transcend yourself, to reconfigure who you are. This is also the case with Ben, I will argue, but as the *welfare Other*, who transcends the bonds and intimacy of kin (family and blood relation) and the borderlines of home to a sociality that is ethically borderless, though guided by *corporeality*.

Sometimes Levinas's Other can seem like a disembodied abstract Other. The analysis of Ben's transition to "home" in the sense of a place to belong draws on Altez-Albela's "The Body and Transcendence in Emmanuel Levinas' Phenomenological Ethics" (2011), which shows how the ethical encounter is in fact guided by corporeality. Ben's bodily condition is the center of concern, placing an alien demand on him as well as his caregivers in the mutual yet asymmetric relation of alterity. Embodiment is thus central to transcendence and phenomenological ethics: "While it is oftentimes said that ethics starts with the encounter of the Other in the Face; it could have started at corporeality, at the moment of self-embodiment" (Altez-Albela 2011, 45).

The body is not the intimate asylum of immanence, but itself the root of transcendence. It conditions, challenges, tames, and directs consciousness. The analysis of Ben's patient care pathways shows the role of his body, which is not reducible to the "somatic realm" of health care and his physical injuries after the accidents. Instead, one can think of his body as a speaking image: "The Body (then) is an effective agent to speak of Levinas' ethics of transcendence. This is possible by understanding the Body as a vital metaphor—a living image, a Said escaping through its very Saying" (Altez-Albela 2011, 44).

The body has something to say that guides the ethical meeting. In Ben's rather dramatic case, the event of his falling down the staircase might be seen to entail a message that indicates the need for change or escape, a necessity that is expressed through his very fall. The fallen body—the "Said"—is not just a contingent event or neutral statement but an expression of something more; a need, a crying out for change from an unbearable situation. His falling—the event of "Saying"—is the point of no return in its momentousness that cannot be ignored. Things cannot go back and be undone. His unbearable situation is out in the open for everybody to see, that is, as emergency health care of his damaged body. Ben's fallen body—in its eventual (saying) as well as propositional (said) dimension—poses a request to be seen and understood by himself and others, rising as an urgent ethical demand for change in his life. The fallen body displays the necessity to alter Ben's being-in-the-world to a degree that requires severe adjustments of Ben's everyday life. The urge of the event by all means exceeds the available answers and requires ongoing interpretation and negotiation. Accordingly, Ben is met and responded to in numerous ways by the welfare

Others, who initially find him at the foot of the staircase in need of emergency care. He receives abdominal surgery and is finally discharged to continuous care at home. These actions are all responses to Ben's fall. They make his transformation possible, but the transformational process does not follow the smooth pathway that the institutional patterns try to facilitate. Ben's journey is not without conflicts; institutional plans are not sufficient to give him a safe homecoming. Something *more* is said by Ben's fall, which requests individual *sensibility* toward Ben's home as the place of his body dwelling that exceeds what rehabilitation patterns approved by municipal structures can foresee.

SENSIBILITY OF THE BODY DWELLING

According to Altez-Albela's embodied reading of Levinas's ethics of the Other, "the Good is given and received through sensibility held by the body dwelling in the world. . . . Through the work of corporeality, the subject is weakened by pain despite virility, suffers despite being at home and longs for a sublime unknown in the face of plenitude" (Altez-Albela 2011, 36). The ethical good in the encounter with the embodied Other is, thus, neither a rule nor the result of calculation—instead it is conditioned by sensibility toward "the body dwelling in the world." This dwelling, *"the work of corporeality"*—is not unproblematic, but has dichotomous tensions because the *body* is both the seat of virility and of pain; the *home* a place of suffering and of longing; and the *future* a sublime unknown in terms of possibility and finality at the same time. In Ben's case his body dwelling in the world is characterized by a broken-down body, an unsafe home, and unknown prospects in relation to the meaningfulness of his everyday life. This shows his ontological breakdown in concreteness, and his fall as a "saying," a cry for change.

The sensibility toward the dichotomous dwelling and thus the ethical good is mediated in a dialectic with three ethical moments or dimensions that facilitate and accompany the embodied-guided transformation. One might capture these in terms of the ideal typical moments of "saying," "sacrifice," and "substitution" (see also Altez-Albela 2011, 42ff.). *The Saying* marks the event of a risky uncovering of the Self, which breaks human inwardness by allowing oneself to be exposed to traumas and pain, hence be vulnerable to suffering. *Sacrifice* points to the struggle to exist despite

losing elements of one's lifeworld that was otherwise constitutive of who one is. In Ben's case it is the loss of his independence and his self-understanding from his inability after the accident physically to take care of himself, and thus also to uphold his daily life and lifeworld, like cutting wood with his friends. *Substitution* points to new arrangements and meanings that come into place instead. Ben is unsettled with his situation at home, with the practical limitations in his daily way of living related to his ostomy bag, and with the expectation by the system that his son should take over more of his care.

The embodied transformation is, thus, realized in a dialectic between the receptive embodied Other of expression (saying), the letting go or loss of something valuable (sacrifice), replacing it with something else (substitution), which might entail a new beginning or meaning that offers the prospect of being experienced as good. In the case of Ben, the staircase is the dramatic catalyzer of an event that ultimately triggers the ethical transformation toward a new prospect of a good or better life.

THE SECOND FALL

One evening going up the stairs, Ben loses hold of the banister and falls down again. This time he hits his head badly in the fall. He is knocked unconscious. When he wakes up he does not know how he got to the emergency room. He is admitted to hospital again, where he undergoes surgery. After a week, he is discharged and brought home in an ambulance. He is bedridden and receives care and treatment by the municipality at home again. His application for a stay at the rehabilitation unit of the municipality is turned down a second time. Sick and feeling weak and alone, he remembers with sadness the feeling of lying at home:

> I haven't been out of bed much. That's also why I am so afraid. Afraid of starting to walk again, because I just collapsed. I didn't get much help in the beginning either. So then I just got really dehydrated! I just lay there. Nobody looked in on me. I didn't get any warm food . . . Well, what's the point then.

One day the nurse comes by, and because he feels worse, being in a lot of pain, he insists that she test him for infection. The lab results are positive.

Ben is hospitalized again with dehydration and a bacterial infection in his abdomen. For some reason, feces had got into his abdomen and caused the infection. His abdomen has to be reopened and cleaned, and he has to stay at the medical ward for some time for medical treatment to fight the infection. But this time, after three months of being bedridden, his application is positively received by the municipality and accepted. After being discharged to home for only a few days, he is granted a stay at the rehabilitation unit.

THE TRANSCENDENCE

The first time I meet Ben is at the rehab unit. He has arrived earlier the same day to a single bedroom with a bathroom, small kitchen, and patio. His full name is on the doorpost outside the room. This is Ben's protected residence for a while. Ben is sitting in a wheelchair, waiting for the first meeting with his rehabilitation team, with me as an observer. His big arms are hanging down beside him, close to the ground. He has a huge, slumped body and a desperate look in his restless eyes, as if he does not know whether to fight, flee, or appeal for sympathy. He can hardly hold his head up. When I look into his face, I think, with some apprehension, How will I ever get to know this man? Levinas describes this meeting with the face of the Other as alterity, with the request of "do not murder me": "The Other (*l'Autre*) thus presents itself as human Other (*Autrui*); it shows a face and opens the dimension of height, that is to say, it infinitely overflows the bounds of knowledge. Positively, this means that the Other puts in question the freedom which attempts to invest it; the Other lays him- or herself bare to the total negation of murder but forbids it through the original language of his defenseless eyes" (Levinas 1996, 12).

This alterity was reflected not only in my eyes and in the restless eyes of Ben. A Levinasian approach suggests that this meeting is an ethical situation, because self-knowledge is questioned, and the idea of the Infinite is experienced. It is also a situation of vulnerability ("do not murder" or hurt me) and uncertainty as to whom and how to trust when alienation dominates. Although Levinas does not speak of a concrete Other—he purposely avoids this—I would like to amend his abstract Other and call upon him to think through my encounter with Ben. My modification of Levinas is in accord with the notion of the embodied Other, the corporeal Other.

Following the perspective of the embodied Other and the corporeality that directs ethical sensibility outlined above, the meeting starts between Ben and his interdisciplinary rehabilitation team of three persons: a nurse, a physiotherapist, and an occupational therapist. They all sit at some distance from him. The nurse initiates the conversation. She starts by repeating information from the letter Ben received from the municipality, confirming his stay at the unit for two weeks. Ben raises his head up for a short moment, in order for his eyes to meet hers in protest. Two weeks are not enough. He needs four. A small argument ensues. The nurse tries to calm Ben down by promising to look into the possibility of his staying for one week longer. "Two extra weeks," Ben corrects her, and she nods her head. The purpose of the conversation is to bid him welcome and develop a plan for his rehabilitation stay, that is, to determine the rehabilitation goals of his stay and evaluate the progress at the end. They continue the talk by asking Ben about his daily life. The nurse has been to his house, and comments on his many paintings as an expression of the interesting life he must have led. This is an icebreaker, and Ben gradually lowers his guard. He tells about the woods he used to go to, the friends he used to hang out with at the bar next door. He then tells how he has trouble staying upright and lacks strength in his hands, also for cooking. He mentions the nausea he has been having, and how good it is to get "real food" again at the rehabilitation center. He admits his forgetfulness regarding appointments, which his son has also commented on. Ben thinks it is from hitting his head in the last fall. Going to the bathroom and living with the ostomy bag is also a central theme in their conversation. Ben expresses disgust and despair over not being able to control the bag, and the risk of feces coming out of the hole in his skin if he is going to learn to change it himself. The ostomy bag has a ring on the inner side of his skin, and another one on the outside. Ben is not up for learning how to change the inner ring. They agree on six goals for Ben to train toward while he is staying at the center. These are:

1. To keep his head upright, 2. Walk without a walker, 3. Change his ostomy bag himself, 4. Increase the strength in his hand so he can become able to cook again without the risk of burning himself, 5. Remember appointments and structure things, 6. Eat without becoming nauseous, perhaps become able to drink coffee again.

The meeting with the rehab team is one of the first turning points in Ben's transition into another sort of homecoming than the previous times. His body is the focus of their shared attention. A living body that might be partly broken but can be built up again. Perhaps not like before the accidents ("sacrifice"), but to a form that would allow him to take up much of his daily life as before ("substitution"). Their shared work on his body becomes an important part of Ben's transformation from being in many ways a broken man to being a person with trust in his own abilities again.

THE ESCAPE¹

Ben also gets an unexpected visit from the hospital. An operation nurse comes to see him after hours at the rehabilitation center. She witnessed his behavior on a night watch last time he was hospitalized. "She saw me in full vim, vigor, and vitality!" Ben ironically explains, and continues, "Actually, I just wanted to go home." Nightmares and hallucinations haunted him at the hospital, and one night he tried to leave the ward. He tore out the IV tubes in his arm, but only got to the hallway before he collapsed. He woke up the next morning in a bed full of bodily fluids: "It was disgusting." The hospital staff must have found him and carried him back to his bed. He found it all very humiliating. When he thinks back, he understands why others have withdrawn from him, as he puts it: "I looked like a wild man with long hair and a long beard." Ben gets a haircut and has his beard trimmed before his stay at the rehabilitation unit.

The operation nurse describes Ben's behavior that night. She thinks that he suffered, Ben quotes her, from a "psychological shock." Ben thinks it makes sense. They continue their talks while Ben is at the rehabilitation unit and also after he returns home—this time to a safe homecoming.

HEIGHT

The rehabilitation ward becomes a turning point in Ben's long transition to a safe return to his home. Levinas describes, in *Humanism of the Other* (2006), how homecoming is an essential need and longing of every self: "Need opens onto a world that is for me; it returns to self. Even when it is sublime, like the need for salvation—it is longing for home, longing for return. Need is precisely return. The Ego's anxiety for the self, egoism, the

original form of identification, assimilation of the world in view of coincidence with self, in view of happiness" (Levinas 2006, 29).

Ben's return—or resurrection in the literal sense of becoming able to walk and stand upright in his full height—is made possible by welfare Others, his rehabilitation team, and the operation nurse. They make his transcendence possible, to a new return to self and home, "in view of happiness."

ADJUSTED DAILY LIFE

After four weeks of training in the mornings and afternoons, Ben succeeds in his stated goals above expectations. He is now able to walk upright, straight, and steady without a walker. He still refuses to walk on stairs, though. Ben is proud of the progress he has made. The last time we meet at the rehabilitation unit he walks me at a good pace to the staircase on the first floor where I descend, alone, to the exit on the ground floor. Ben is expected to return home the next day. He will be met by the rehabilitation nurse (who is off-hours, but lives close by) in his team. She will help him with his luggage and support him up the three steps to his front door. Ben has now learned to change the outer part of the ostomy bag by himself, which means he will only need help from the ostomy nurse every second day. This makes it possible for him to go to his cabin in the woods and stay the night there. He is also comfortable with doing his own shopping and cooking again. He can walk back and forth between the grocery shop and his small city house, a distance of 100 meters. The team also recommends that he keep the walker and use it in case he needs a break or more support for carrying the groceries. Ben is in good spirits and thinks that this will not be necessary. At the last meeting before Ben is discharged from the rehabilitation unit, Ben, the rehab team, and a representative of the municipalities homecare unit go through all these small elements of maintaining a daily life in detail. The municipality still grants him cleaning of his floors every second week, but Ben is now expected to dust the shelves and the frames of the many paintings in his home himself. When I visit him after his homecoming, he shows me how he is now learning to change the inner ring of his ostomy bag as well, something he would have found impossible before the rehabilitation stay. He is not able to see the hole in his stomach directly, so he needs a big mirror to allow him to see what he is doing. The ostomy nurse teaches him how to do it. It will give him more freedom if he can learn to change the whole ostomy bag himself.

Ben has a photograph of his son on the front door of his refrigerator. He is wearing a soldier's uniform. The photograph shows his son just before he went into military service. Ben recalls how he promised his son to look after his mother, Ben's ex-wife, while his son was away.

Alcohol put an end to their marriage. He did the best thing for her, Ben says, by divorcing her. That gave their then four-year-old son a second home, his home, to go to when the drinking in the mother's house became too heavy.

Ben's son calls him on the phone one evening, while he is away on military service. He is worried about his mother and asks Ben to look in on her. Ben recalls: "I promised him to look after her, but she drank herself to death. We hadn't seen her for six days. Her door was locked, so we broke a small window to get in. I didn't dare to go up, so my son ran up the stairs. He called me from upstairs: 'Yes, Dad, we were right. She is dead.'"

This time, Ben's utterance opens the embodied Other—in this case myself as a listener to his story—to the childhood fear of being abandoned by a parent, of orphanage, and, as an adult, the parental fear of deserting one's child. Ben's pain echoes something within me. It is painful to witness the harsh tragedy of Others. There is perhaps a mythical sorrow to this bond between child and parent of trust and protection that eventually gets broken. Because we age, we get frail and leave each other at some radical endpoint. The tragedy of Ben's family resonates with my own fears and sadness. It is a sadness that echoes an archaic fear in us of being forsaken, of becoming a failure in the care of loved ones, and of dying alone. It is a fear that reminds us of our embodiment, and of our intercorporeal connectedness to each other, as parent and child, as generations and species.

THE MORAL BREAKDOWN

Ben's ex-wife had died two and a half years earlier, but her death seems to have cast a shadow over his home, his relationship to his son, and himself. The anthropologist Jarrett Zigon describes such disconnectedness from usual relationships in the world as moments of "moral breakdown. Breakdowns where ethics must be performed" (2007, 138). One might say that letting his son go up the stairs to find his mother dead is Ben's biggest fall, a "moral

fall" from being the strong and protective father. His price—or "sacrifice," paraphrasing Altez-Albela's reading of Levinas—is not only his damaged abdomen, the ostomy bag, and loss of physical strength after many months of hospitalization and isolation at home, but also his loss of a self-understanding as a father and family man, of his independence, and of his relation to his son.

One might wonder why Ben let his son pass him on the way up the stairs to his mother's bedroom, leaving him to find her dead. They did expect that something was seriously wrong. Ben's first answer is that he hesitated to go up because he was afraid of the police, as they had broken the window to get into her house. Another time, he explained that he had already lost his best and lifelong friend to alcohol. Rephrasing Levinas's profound experience of otherness in the face of the Other—the appeal "Do not murder me"—I wonder if Ben hesitated on his way up the stairs because he was afraid of seeing death in her face. A death that would also remind him of his own finality, and of a failed family project. It is a face where "the murder" (as a self-murder from alcohol) has happened, and her "defenseless eyes" are not (timely) met. It would be a face that reflected the inescapability of death, and perhaps also the limitations in care for the Other, even among intimate family members.

WHO ARE YOU?

A turning point in Ben's care pathway, and his perception of himself and his homecoming, has been meeting the operation nurse from the hospital. She is the ethical Other who "sees" him in the sense that she is not scared away by his wild appearance or aggressive behavior but looks beyond his outer appearance, seeing his facial expressions and "defenseless eyes," and genuinely asks: *Who are you*? She releases Ben from his vice by attaching words to his suffering: giving the diagnosis that he has suffered a "psychological shock." The utterance of the words "psychological shock" brings comfort to Ben; it allows him to reinterpret his being, to feel sorry for himself, and thus to care for himself and to mourn. To mourn his losses, the death of his son's mother, his own insufficiency as a parent, the fate of his family life, his physical condition. Ben's dialogues with the operation nurse provide relief to his suffering. They *substitute* for his "sacrifices" a narrative order that gives meaning to his losses, and thus allows him to rise again.

The retelling of past events reopens the understanding of his care pathways and of the meaning of his previous falls on the staircase. In an abductive manner of reasoning, a new coherence of his care path is created, one that is aligned with the initial fall of his family.

SENSIBILITY IN TRANSITION TO UNCANNY HOMES

Ben's story is an example of a care path that is not a unidirectional flow, as intended by the care system. It is a meandering path, going back and forth between home, hospital, municipality, and home again. On the one hand, his patient care process goes too fast and causes several readmissions to hospital; on the other hand, a transformation is established via the stay at the rehabilitation unit in addition to the meetings with welfare Others that facilitate the conditions for a safe homecoming for Ben, the homecoming that he had longed for. It is obvious that in Ben's case home is not necessarily a safe place. It can be the site of family trauma. Families are seldom complete, and in some cases, they are not able to provide the right competencies to see and to care for each other as an embodied Other in need of transformation.

The story staged on Ben's staircase is an example showing that health care is not reducible to technologies of high-efficiency care-flows but demands ethics. It recalls the need for skilled sensibility toward the patient—even when this person shows a scary and fierce-looking face—as an embodied Other that affords transformation. Following Zigon's phenomenological virtue ethics and theoretical framework for an anthropology of moralities: "The primary goal of ethics is to move back into the world; to once again dwell in the unreflective comfort of the familiar. . . . It is in the moment of breakdown that it can be said that people work on themselves, and in so doing, alter their way of being-in-the-world" (Zigon 2007, 138). Ben's two nurses, the one from the rehabilitation team and the operation nurse from the hospital, personified this kind of skilled ethical sensibility. Both nurses supported him in his transition to home, physically and psychologically, in the process also stepping out of the predefined tasks and workflows. They saw his need of being accompanied, literally and figuratively, to accomplish a safe return to home. He needed both to walk up the few stairs to the front door of his house and to find a way of living and of being at ease with the past and his family relations.

Highlighting ethical sensibility recalls the importance of ethical judgment as a sensibility toward "the Good" in the face of the embodied Other—that is, the importance of a sensibility by welfare Others to the breakdowns and lost world and relationships in the care pathways of elderly persons: breakdowns in need of rehabilitation and ethical work to enable the patient to return safely to home and alter their way of being-in-the-world. Only Ben's third return from hospital finally transforms his home into the place that allows Ben to come home in the Levinasian sense of "return to self," "in view of happiness." This mending of his complex relationship to home, as expressed in his fear of stairs, is therefore not only a result of surgery and medical care but a complex intervention that includes rehabilitation for daily life in a practical, goal-oriented way. It also is the result of an expanded, "existential" version of ethical work that allows for his nightmares and the ghosts that haunt him, for his ex-wife and the relationship to his son, to become visible, articulated, and "Said" in the meeting with welfare Others. This "Saying" makes a new homecoming, the "return to self," of "moving back into the world" possible. Thus, Ben's "transcendence and height" very much depend on the welfare Others to see and hear the needs of his body dwelling in the world as a call for the self's return to home.

After Ben's final homecoming, he says he has some "good talks" with his son. The son will help him put up grab bars in Ben's house to hold on to. This will support him when he has to get up the three steps outside his front door. They have talked about his mother, "that it wasn't all right what she did." They have also started to make plans for Ben's future, about him moving into a one-level house or flat. When I wave good-bye to Ben for the last time I see him, he waves back. He is standing in the doorway of his small town house at his full height.

NOTES

1. *On Escape* is the title of Levinas's book from 1935 in which "malaise reveals the longing to be loosened from a very unbearable situation despite the absence of the knowledge of what should be bearable" (Altez-Albela 2011). Again, the "malaise" is an embodied sensation, and a form of Saying, that needs to be addressed to solve the unbearable situation.

REFERENCES

Altez-Albela, Fleurdeliz R. 2011. "The Body and Transcendence in Emmanuel Levinas' Phenomenological Ethics." *Kritike* 5 (1): 36–50.

Barthel Index for Activities of Daily Living (ADL). Accessed March 15, 2019. https://www.mdcalc.com/barthel-index-activities-daily-living-adl.

COPM. The Canadian Occupational Performance Measure. Accessed March 15, 2019. http://www.thecopm.ca/.

Grøn, Lone, and Cheryl Mattingly. 2018. "In Search of the Good Old Life: Ontological Breakdown and Responsive Hope at the Margins of Life." *Death Studies* 42 (5): 306–13. doi: 10.1080/07481187.2017.1396409.

Hansen, B. H. 2017. "Udvikling i indlæggelsesvarighed for somatiske indlæggelser. KL Analysenotat, August 21, 2017." Copenhagen: KL—Kommunernes Landsforening.

Lear, Jonathan. 2006. *Radical Hope: Ethics in the Face of Cultural Devastation.* Cambridge, MA: Harvard University Press.

Levinas, Emmanuel. 1996. "Transcendence and Height." In *Basic Philosophical Writings*, edited by A. T. Peperzak, S. Critchley, and R. Bernasconi, 11–31. Bloomington: Indiana University Press.

———. 2003. *On Escape.* Translated by Bettina Bergo. Stanford, CA: Stanford University Press. (*De l'évasion*, 1982).

———. 2006. "Signification and Sense." In *Humanism of the Other* [1972]. Translated by Nidra Poller. Urbana: University of Illinois Press.

———. 2016. *Mening og etik. I: Den andens humanisme—en postmoderne etik.* Translated by Leif Ebbesen. Braband, Denmark: Forlaget Reflect. (*L'humanisme de l'autre homme*, 1972).

Macrotrends. "Denmark Life Expectancy 1950–2022." Accessed May 12, 2020. https://www.macrotrends.net/countries/DNK/denmark/life-expectancy.

Mahoney, F. I., and D. W. Barthel. 1965. "Functional Evaluation: The Barthel Index." *Maryland State Medical Journal* 14 (February): 61–65.

Merleau-Ponty, Maurice. 1962. *Phenomenology of Perception.* Translated by Colin Smith. London: Routledge.

Ministry of Health, Healthcare Denmark. 2017. "Health Care in Denmark—An Overview." https://www.sum.dk/.

Strauss, Anselm L. 1997. "Chronic Illness." In *Where Medicine Fails*, 5th ed., edited by Carolyn L. Wiener and Anselm L. Strauss, 11–24. New Brunswick, NJ: Transaction.

Sørensen, T. K. 2017. "Danske sygehuse er blandt Europas hurtigste til at sende patienter hjem: På 10 år er der skåret næsten en fjerdedel af indlæggelsestiden hos danske patienter, viser en ny analyse fra Momentum." *Jyllands-Posten*, February 13, 2017.

Wentzer, Helle Sofie. 2020. "Fra hospital til hjem—skrøbeligheder i ældres forløb i en landkommune." VIVE, Copenhagen.

Zigon, Jarrett. 2007. "Moral Breakdown and the Ethical Demand: A Theoretical Framework for an Anthropology of Moralities." *Anthropological Theory* 7 (2): 131–50.

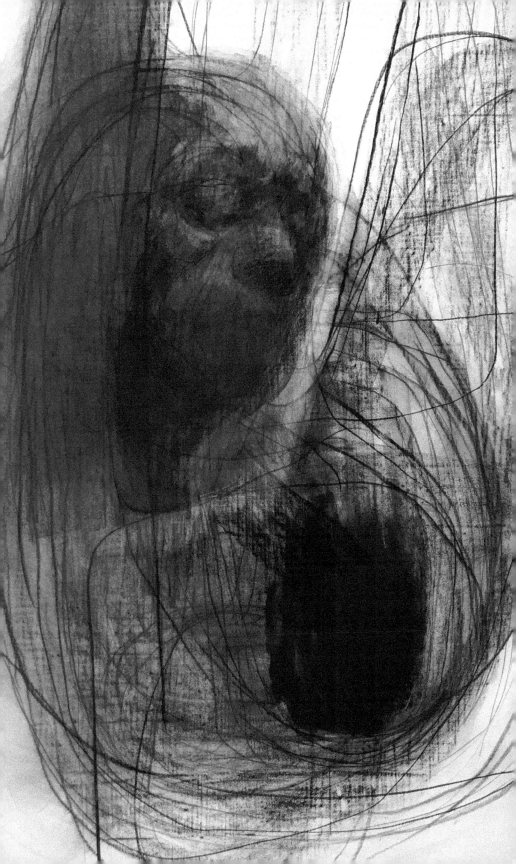

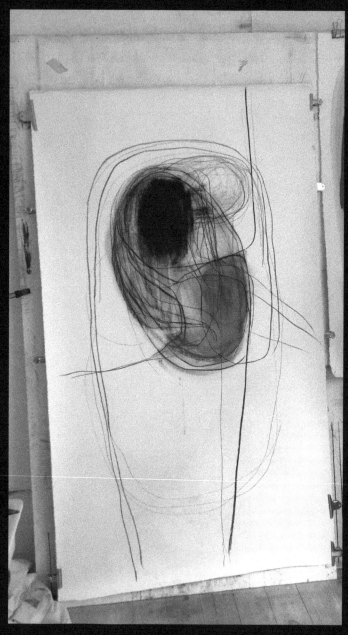

Overleaf: Figures 1 and 1a. Drawings underneath *His Full Height* (see Wentzer, fig. 1)

THE DRAWING UNDERNEATH

MARIA SPEYER

The charcoal drawings that precede each chapter in this book were drawn in response to the authors and their accounts of aging. The poems on the back of the drawings were extracted from the chapters without changing their conjugations or order. The following account, with process images interspersed, is about drawing figures, about the words that have guided these particular drawings, and about how we might consider the notion of *image* as our own action toward it.

When I look at the drawings now, I don't see them as others will, that is, as their topmost and visible layer. What I see is the paper below. I see the lines that I began with, the smudges, and the subsequent layers, drawn over, erased, and changed. What follows here, therefore, is not a reading of seven finished drawings, but a story, told from an artist's point of view, about the drawing underneath. It is possible—likely even—that this story won't clarify the process of drawing but instead expose the uncertainty and ambiguity in drawing the human figure. Figure drawing is an inherently confounding process of the person drawing, of the figure that is drawn, and of the person looking at the drawing, which involves notions of responsibility and exemption, of action and reception, that can't readily be prized apart.

I'd like to start by admitting that I never know when to stop drawing and declare the drawing finished. I always feel that I could or should add more layers of charcoal or rub out whole areas of a drawing, or that I ought to erase lines and try again. I know that knowing when to stop is considered

an artistic virtue—to render just enough lines to convey what one wishes to convey. Emmanuel Levinas echoes a common assumption when he writes: "The artist stops because the work refuses to accept anything more, appears saturated" (Hand 1989, 131). And perhaps he is right, but no quantity of lines or black ever seems to me to saturate a drawing.

This is because I don't draw to reach saturation or to arrive at some ideal, ultimate appearance. I don't draw to make visible something already conceived of in my mind, or to capture something observed, or, in the case of the drawings in this book, to give appearance to something already pictured in the words.

I think, as audience, when we look at artworks, generally, we tend to approach them as offerings of a sort. We assume the artist is showing us something, and we expect the image to be "a reconstitution of the artist's vision," which "allows us to share the artist's experience of the visible," as John Berger writes in his seminal book *Ways of Seeing* (2008, 3). There's an assumption here of control and mastery, and we rarely inquire whether the artist has achieved what they set out to do. And why shouldn't we receive the artwork as an offering, that is, a saturated surface left behind by the artist (a statement, an expression, a presentation)? After all, if we were to approach an artwork as something possibly judged inadequate or unfinished by the artist, what basis would we have to judge it for ourselves? And anyway, what artist would want to show a work they feel falls short?

And yet, in my experience, a drawing starts as an unsettling confusion, progresses toward a resolution, but never arrives at it. A line follows the line before in order to correct it. With lines, I try and keep trying. Perhaps this line, or perhaps this next one, or the many lines that follow, will move me closer to . . . what? To clarity? To a clear and unencumbered view? To a firm and secure grasp? To comprehension? Closer to the author of a particular chapter, perhaps? I'm responsible for the drawing, of course, and remain always responsible for it, but at the same time I feel unsure about my control of it.

It is for this reason that I struggle to pronounce any drawing finished. Instead, I feel as if I abandon drawings. I leave them behind. But I don't leave them behind as offerings. Perhaps, rather, I leave them behind as a sort of trace of a reaching.

All the same, I have declared the drawings in this book finished: they have been varnished, exhibited, and reproduced in this book, and I ought

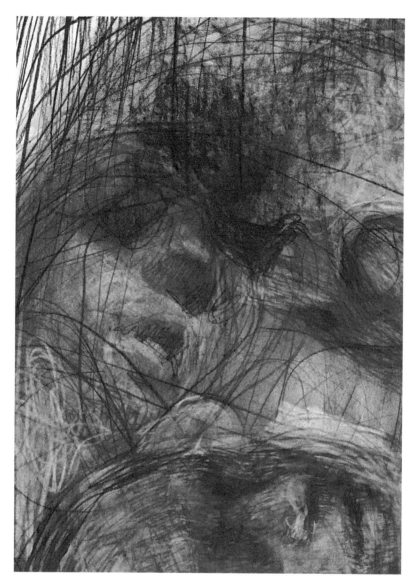

FIGURE 2. A drawing underneath *For Somebody That Needs It* (see Mattingly, fig. 1)

to suppress any urge to add or to erase. I try to position myself opposite them and look at the surface they have become. And suddenly they seem so limited and so small. They no longer contain everything they might have been but simply appear as this single, flat surface. Now I see exactly the extent of them. They have a particular width (1.15 m) and length (some are 2 m, some 4.5 m tall), and all the other dimensions these drawings might have had, now they never will have. They are no longer possible but settled, impervious, and immobile. They no longer stretch outward from me but are detached and face me. They no longer contain everything they might still become but now appear as something given—and I see now how they might look like offerings.

Until the moment I stopped working on them, they were something that might be otherwise. They were not yet contained and had all at once many possible trajectories. They existed in my mind only hazily and were therefore boundless. They had a multitude of lives and seemed to spread everywhere. They were limitless—infinite, even. And then I stopped drawing. I varnished the surface and closed off the drawings. Perhaps here I will try to pry them open again and have a closer look at the porous and still possible drawing underneath.

To talk about the drawings as unfinished also makes sense in the context of this book, because that is how the authors have experienced them for the best part of our collaboration. From the outset, they were implicated in the drawings—sometimes in the drawing process itself—and have approached the drawings throughout as something not yet there, as considerations and possibilities.

I wonder if others, as they look at the finished drawings (or the drawings in their current state, if you like) might also approach them as still possible? What happens if we consider a drawing not as audience, but as maker? And not as something we receive, but as our own action toward it?

TOWARD THE SURFACE

Faced as something that is unfinished, the image is no longer an offering from the artist, or a representation of the artist's vision brought confidently into focus as a varnished and closed surface. As uncertain and indeterminate, the image becomes an opening toward which we move. Might we think

of this movement toward the image as an ethical approach? As we step in front of the surface, does the image provide a target at which we might aim our ethical response?

I don't want to suggest that the image—a drawing—inherently contains an ethical demand; it is only paper and charcoal, after all. The image (in this context meaning an artwork, i.e., a considered configuration on a surface, something created by someone) isn't a face (even when a face is drawn on the surface), and it does not demand, the way a human face does, your ethical response. So, when Emmanuel Levinas with some suspicion asks: "Is not art an activity that lends faces to things?" (1996, 10) he reveals a distrust of the visual arts and images that seems reasonable to me. After all, isn't the image essentially an imitation? Something that we pretend is real, but which isn't? Form reduced to its reflection? Doesn't the flatness of an image (its collapse of form, its collapse of being and the real) make it, well, superficial? And any emotional or ethical response it provokes in us, is this not in lieu of the other human and therefore hopelessly insufficient, if not downright wrong? "Art," says Levinas, "essentially disengaged, constitutes, in a world of initiative and responsibility, a dimension of evasion" (1989, 141).

Yet, when I draw, I don't feel as though I'm engaging in a dubious act of evasion or pretense or that the drawing is an "obscuring of being in images" (Levinas 1989, 142). Rather, I recognize, in the act of drawing, the relation to the other that Levinas describes when he says: "Instead of seizing the Other through comprehension . . . the I loses its hold before the absolute Other, before the human other" (1996, 17). Implied here is the need to comprehend which is so often associated with drawing (we're told that to draw is to properly *see* and to properly *grasp* something), and yet an ambition to comprehend is not what propels a drawing, because I have already given up (to comprehend seems a kind of overpowering or victory over the other, that I am neither capable of, nor interested in). Much more closely related to the act of drawing is Levinas's assertion that before the other, "the I is infinitely responsible" (1996, 18).

The fact that the image is *not* the other, however, does not mean that our relation to it is a sort of pretense, or, as Levinas would have it, a dodging of responsibility. Rather, I would like to consider the image as something that we feel moves us, because we move ourselves toward it. Whatever the image is or isn't, the question here is what our position in front of it—our

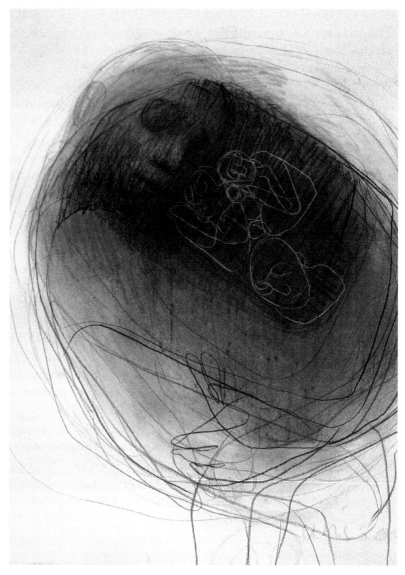

FIGURE 3. A drawing underneath *With Unlived Lives* (see Louw, fig. 1)

relation to it—might tell us a about care and connection, about solitude and communion, about responsibility and action. Of course, this is not to say that the image, a drawing, *shows* nothing, and it certainly doesn't mean that the artist is exempt from responsibility. What I want to suggest is that as audience we are not simply a receiver, and we are not exempt from responsibility. Rather, our looking is an action into the drawing and an opportunity to invest ourselves in it. A drawing, then, for both artist and audience is an act, and its significance, its meaning, if you like, is not what the drawing gives us but what we give it.

Still, it's hard to argue with the fact that my drawings show something. In fact, they often look very solid—monumental, even. My drawings clearly show figures. They may be abstracted, convoluted, or distorted, but I'm evidently exploring the human form. I want to maintain, though, that a drawing remains merely paper and charcoal, and so although a drawing suggests a form on its surface, to me as the maker, a drawing is a means of reaching for something—a trace of a gesture, rather than an evocation.

It is not fair, of course, to ask of someone looking at my drawings to take the position as their maker, since I am the only person reasonably positioned to add more lines to the drawings or delete them (I wonder if I might still). However, to approach images, even as audience, not merely as something presented, but as something that happens toward the surface—as our own propulsion toward it—allows us to consider not what they present to us, but how we move ourselves to action in front of them. Approached like this, the image is not a stand-in for the other, but perhaps precisely, starkly, the other's absence. "It approaches across a distance," writes Jean-Luc Nancy about the image (the "it," the image, is what Nancy calls "the distinct"), "but what it brings into such close proximity is distance" (Nancy 2005, 4).

And so, when we feel that an image is striking, perhaps instead we might imagine that it is we who strike the image, like lightning strikes a rod. The positional difference is the difference between exemption and responsibility—one position receives, the other gives. Accordingly, to consider things imagistically, that is, to think with the image, might suggests an attention to, a search for and an assumption of responsibility for something not yet settled, indeterminate and uncertain, and something which does rest in the image itself, but happens as we move towards it.

But if an image is absence of the other, how do I account for the figures that I form with charcoal and chalk on the paper surface? Who or what are the figures, and if they are drawn in response to words that speak of old age, where are the visible signs of aging?

I know the figures in my drawings look dense. There are so many layers of charcoal in places that they are quite opaque. Yet, as I draw a figure, I'm not actually trying to delineate or close off a mass, because, although figures are matter, they are also somehow infinite. How can they be both?

I'd like to consider here the figure, the body, a being, you or me, as something that happens toward others, as directedness beyond our own mass—as propulsion. Even a still figure has a sort of charge. Even stillness is action. We can't not act. Even when we choose inaction, even if we are completely still, this choice is like a step toward or away from others. "A body begins and ends against another body," writes Nancy (2008, 204). We are not contained by our mass, then, but move always from ourselves, out of the figure, toward the other.

What is a person in isolation? What am I when I'm alone? Am I everything? Or do I disappear? Or am I at once nothing and everything because alone I am not different to the other? Perhaps alone I am indifference? "When I am alone," writes Maurice Blanchot, "it is not I who am there, and it is not from you that I stay away, or from others, or from the world. . . . When I am alone, I am not there" (1989, 251). This directionless solitude, however, is a kind of forgetfulness, because a body is originally prepositioned, as the other reminds us when we come face-to-face.

Alberto Giacometti, whose sculptures were a kind of continual positioning and repositioning of figures, writes: "Man only leaves his unbearable solitude when the face of one of his fellows emerges from the void of everything else" (Didi-Huberman 2015, 99).

And so, the figure is precisely not contained by its mass, or containable but a continual impulsion across from me, toward me, against me. "A body is a difference," writes Nancy. "Since it is a difference from every other body . . . it's never done with differing" (2008, 206). By differing you interrupt my indifference. You interject, you appeal, and I am infinitely answerable to you. Levinas writes: "the I is, by its very position, responsibility through and through" (1996, 17).

So rather than making us equal, our directedness toward other figures is an asymmetrical relationship—an unsettling, one-sided mutuality. Although I see you *as* me (or am *I* seen as *you*?) I can't access your viewpoint and I can't fathom you because you are *not* me.

In the meeting with the other, I am unsettled, moved to action, pulled out of my indifferent solitude and at the same time put in my place as another figure. When I meet you, I am reminded that I am situated and have a front and a back, an up and a down. I had this all along, of course, but because I was alone, I could forget it. Now, you aim back at me—and I am forced to recognize that I am not neutral and directionless. We use the same words, "front" and "back," but in opposition to one another. The confrontation orients as well as disorients me, because I am forced to acknowledge my own situatedness. I am forced into my own limitation and simultaneously feel propelled out of my figure. Across from you, I am at once located and unsettled, because when I see you I don't see a figure that resembles my form; rather, I see you *as* me—but me as inaccessible, particular and other. We're configured and oriented in the same way (our concentration is somewhere behind our eyes, our face opens to the world, our back shields us from it, and our arms try to fathom it) and this sameness forces our continual differing.

Figures, then, are not contained in their mass but are continual movement. "They are moving mass, a pace" writes Giacometti, "a changing and never quite perceptible form" (Didi-Huberman 2015, 107). In a similar way, the figures in my drawings are not meant to be anyone in particular but an exploration of figures as propulsion toward something other. To differ, to make a difference, to be moved by the other and to move toward the other—that is the figure.

In this sense, I don't draw to produce imitations of visible bodies—to sum up or to flatten form. Instead, the figures in my drawings are a trace of a sort of performing of propulsion. They are not meant to represent anyone because propulsion and directedness don't have a surface. As a result, I end up with figures that appear somewhat alike—as general or standard—as if I'm trying to capture a universal body. But of course there is no such thing! The figure, the other, is precisely the different and particular. And so, in attempting to make visible our impetus toward each other, do I not precisely end up reducing the figure to indifferent mass, and reducing us to sameness, to indifference?

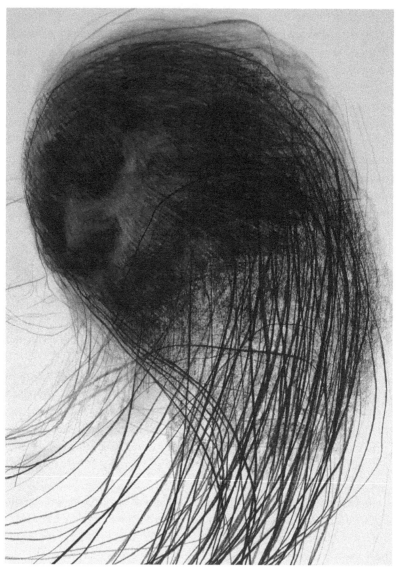

FIGURE 4. A drawing underneath *Stay With . . . the Other* (see Grøn, fig. 1)

Giacometti once told his brother: "If I can manage to make your head, I'll be able to make any head, because they all look alike" (Wiesinger 2012, 215). And it is true that Giacometti's portraits do look like the same face over and over again. However, during an interview Giacometti was asked: "This face you are looking for, is it not so general as to become abstract?" "Oh no!" Giacometti replied, "you get to the general . . . only through the infinitely particular" (Wiesinger 2012, 230). What Giacometti aimed for was a "re-creation of the human face" (Wiesinger 2012, 233), and so although you might think of the figure that seems to recur in his sculptures and drawings as a reduction into sameness (certainly if you regard them as finished or as offerings), it was neither intended as a token in a narrative, nor as symbol, nor as likeness.

Rather, Giacometti was on a quest to "get to" the infinitely particular. By the infinitely particular, I think he was referring to the other, or the figure as it differs, as it happens, and therefore as something which is the opposite of an object or of mass. From the inside, as lived, the figure is boundless, because there is no internal limit to experience. And when we meet the other, this boundlessness is a sort of excess that aims at and spills over you, infinitely. The figure, then, is somehow at once particular and infinite—the specific infinite (even if this is an impossibility) and so, however my figures appear on the surface of a drawing that I have reluctantly declared finished, as far as I am concerned (and again I take the position as artist, the maker) they do not sum up anything or show anything. They are, in fact, essentially insufficient and never saturated.

It is not that I think of the figures in my drawings as failed, but rather that I consider them unfinishable. Drawn as movement rather than object (even if they look dense and still), a figure has no surface, no finish. And so, throughout this project, where I have responded to written accounts of aging, I have wanted to draw figures that don't represent old age as it marks our skin, as if to define or delineate an old person. This is not because I think that visible signs of aging—wrinkles, for example—aren't a very big part of life in old age, but because when I draw, I never really feel that I'm able to reach this surface.

Or perhaps I feel I have no right to limit a figure—to define it or to finish it off. After all, I can't pretend that my drawings represent an understanding of the figure when I don't have this understanding, and when, in fact, the process of drawing feels like an awkward lunge into the paper.

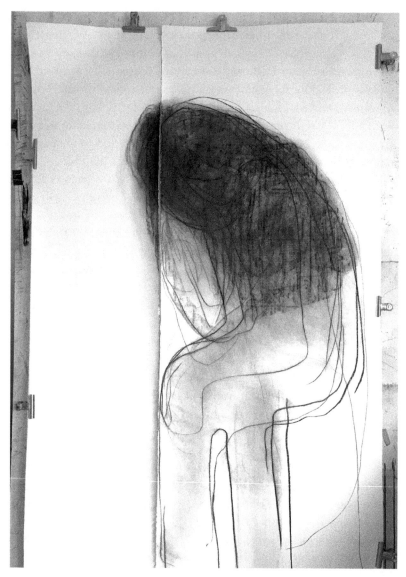

FIGURE 5. A drawing underneath *Life . . . Still* (see Dyring, fig. 1)

In what way is drawing a lunge into the paper?

In the following, I'd like to invite you to imagine you are drawing with me. Perhaps the presence of another, even an imagined other, might orient me in the process.

INTO THE PAPER

We're going to draw with a compressed, very black charcoal, although we might use chalk as well. We'll draw on thick, hot-pressed paper, which means it's very tough, dense, and smooth. This particular paper, Arches 300gsm, can take a lot of erasure and overworking, so we don't have to be careful with it—its surface won't break. It feels good to know the materials aren't delicate.

The paper is roughly the width of our arm span and comes in 10-meter rolls. We like to draw big, or rather, we prefer to draw 1:1. The drawing is direct that way and not transposed or translated.

We mount a piece of paper to the wall and stand back. We're feeling tentative, but it's a good feeling. We're enjoying this moment of endless possibilities, and there's something calming about the absence of lines. We begin to draw with no sense of control or mastery, and these first lines are not assured or even convincing, but awkward. And yet, the lines we begin to draw are deliberate. They are deliberate in the same way grasping or holding on is deliberate, or catching a fall is deliberate. Unplanned, perhaps, but intentional.

There's no image in our mind's eye for our hand to reconstitute—no outline to trace. What we have, to begin with, typically, is an attention to some sort of directedness or physicality of experience—we might call it a spatial tension. It may be a sense of heaviness or a plunge, or perhaps a collapse or a dependency—or today it could be a cradle-like interiority, or an entanglement, perhaps.

The lines, as we draw them, are not guided by something that we want to appear on the paper (an imagined projection). Rather, they are driven by something we sense, rather than see, and something we don't understand, rather than something already conceived. We're confused, and so lunge, or stumble into the paper as our hand grasps for comprehension.

To *comprehend* means to *seize*, to *fathom* means to *embrace,* and to *perceive* means to *grasp.* Perhaps these words reveal us as creatures who feel

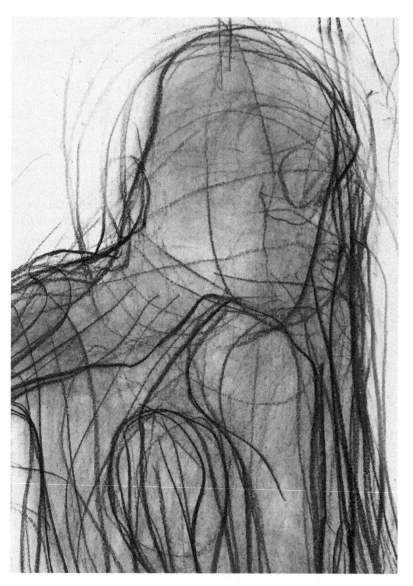

FIGURE 6. A drawing underneath *To Share Almost Everything* (see Meinert, fig. 1)

always at a distance, or somehow always outside? Outside the real? Or outside others but grasping for them?

In fact, we know that comprehension is too ambitious a goal, but we can aim for it, at least. Are our lines as we draw them over and over just struggling to point to something, perhaps? To gesture toward it, in order to put ourselves in relation to it?

But what are we gesturing toward?

We always draw figures, but we don't think of them as representations of bodies. In fact, we don't think of them as anything. Perhaps they are incidental and a sort of residue of bafflement. What baffles us, and what we're trying to get a grip on, is the presence of others—our co-presence. How is it possible that we exist together? How could we possibly not?

Others meet us with an openness that threatens to absorb us. It's an openness that seems to give endlessly and take endlessly. They face us with limitlessness. They seem to have no internal boundary, and so they are always *still more, still not finished*, uncontainable and therefore, in spite of the limits of the space they occupy, somehow not present in their entirety yet. How can a presence be not present yet?

Faces, in particular, pull us into their openness. How can a face have form but no limit? And so, this same face that we always seem to draw is not a representation of a particular face but a trace of a gesture toward the other. Do we secretly wish we could smooth over the other, close them up or push against them? Are we resisting absorption? Are we trying to draw lines over and around others to delineate, to define, to conclude? Is our drawing driven by a desire to limit others?

In that case, our drawing will fail. We can't enclose something that has no boundaries.

Or is our drawing precisely a move toward absorption and a desire for inclusion? Perhaps we're casting our lines around others to put ourselves within some great web of personhood. Perhaps then the charcoal that we're holding is simply there to record the hand as it reaches for a mutuality that we hope exists.

Again, we fail. The paper and others stay at arm's length.

Our drawing is turning very black now, but that's OK. Nothing is indelible, even if everything leaves a mark. Erasure will not make the black go away. A gray remains as evidence, which makes the drawing, perhaps, an archive of unmade marks.

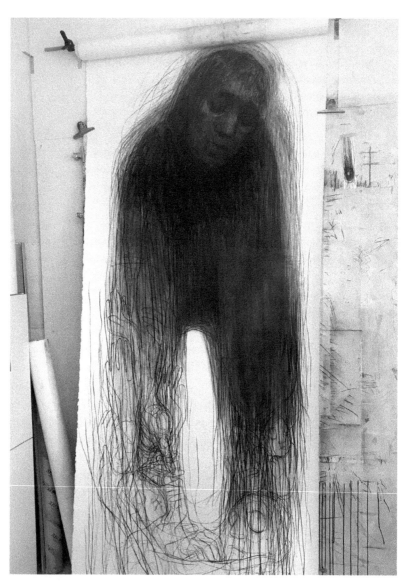

FIGURE 7. A drawing underneath *To Be Seen* (see Gill, fig. 1)

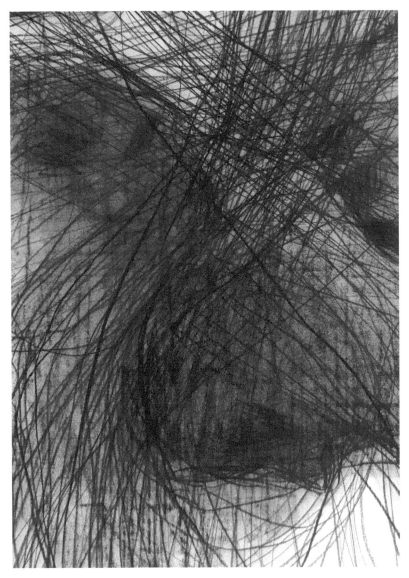

FIGURE 8. A drawing underneath *Away . . . Toward* (see Whyte, fig. 1)

And then, as we draw lines and rub them out, this face, again, looks more and more like a representation of a form, black and assertive. It looks sculpted, even, or carved out. Perhaps in lunging toward the paper we have simply pushed our own face into it. How did all this pushing into the paper make something appear? Did we even intend for something to *appear*?

We decide to abandon our drawing for the moment, and so it becomes . . . what? Not a picture, exactly, but a past. Again, we didn't manage to reconcile form and limitlessness, but perhaps that wasn't really why we started this drawing.

In fact, *we* didn't start this drawing, because you weren't ever really included. I was just imagining that you were, as if I were hoping that you and I could somehow combine viewpoints and become some sort of a human continuum. But then again, that would just turn us into the same—into indifference.

Perhaps, then, I don't draw to contain or to be contained. Perhaps the lunge into the paper is, instead, a gesture toward a kind of being that might include the other as other. A company of difference? As such, the drawing is not an attempt of an "I" to grasp the other, but an offering of myself to a "we."

STILL BECOMING

"I am by saying 'I am,'" Nancy writes. "*We*, on the contrary, constitutes an inchoate performative: in the process of being formed, but not yet performed. 'We' is always in *statu nascendi*" (2005, 103). "We" is an uncertain, volatile, and ongoing process. Every "I" is responsible for it, yet no one feels in control of it. It is a constant becoming—"a distinctive alterity aimed at, desired, held at a distance" (Nancy 2005, 103). The "we" requires much more effort than the "I," because although I am easily unsettled by the other, at least I am able to say so with authority.

"We," on the other hand, is something I can't experience, because "we" includes the other. I can't experience "us," because experience is something that happens from a singular viewpoint. "We," then, will always be something that we aren't yet and something that requires effort and care.

I would like to mention another artist here: the German printmaker, drawer, and sculptor Käthe Kollwitz. Kollwitz's drawings and prints seem to me to work toward this *still becoming*. Unlike Giacometti's figures, the people in Kollwitz's drawings do not all look the same. Yet her focus was

not the individual firstly, but what you might call a binding together of a differing humankind. In her configurations of separated or merged figures, isolation equals despair, and only the company of others can offer a degree of solace.

I think Kollwitz thought of humanity as an entity—but an entity split by individual perception. Our connection, in Kollwitz's drawings, is not an underlying fact that makes everyone the same. Rather our connectedness, the always *still becoming* "we," exists as a directedness toward others, as propulsion, and as an essential need for the company of the differing other. Perhaps what she drew in Germany in the first half of the twentieth century was a plea for a *still becoming* "us" at a time of dissolution, of disorientation, and of violent indifference. Perhaps her drawings were a fight against monumental efforts to turn away from the other. Shortly before her death in 1945 (just weeks before the end of the war), Kollwitz wrote to her son: "I am very old now; am I to add still another year to my age? Every night I dream about you. I must see you once more . . . without having seen you one more time, I cannot go" (Kollwitz 1988, 196). Without a last *being together* with her son, Kollwitz felt she would not be able to die. This was more than a wish to say good-bye; it was a *need* for the *still becoming*. Although Kollwitz knew she was at the end of her life, the "we" she craved was still in *statu nascendi*, as Nancy put it.

Does it make sense to ask if we're *still becoming* even as we face finality? Are we in *statu nascendi* even in old age? It is a provocative question to ask someone at the end of their life, but the question might as well be posed to their intimate others, or to anyone who decides to enter into our formation. Perhaps then, the question is not only about how we experience aging as an old person, but equally how we might orient ourselves toward the other (the aging other or the frail or vulnerable other, the carer, the child), not in order to subsume the other or to patronize the other, but rather to invest the "I" in the *still becoming* "us."

This was perhaps the fundamental concern during the process of making the seven drawings. I didn't feel my task was to portray aging or to evoke particular experiences of aging. The portrayals are already there beautifully throughout the chapters. Instead, I wanted to respond to the written accounts of living in old age as part of an ongoing attention to, and formation of, "us." The drawings, then, are guided not just by the accounts of aging in the chapters, but equally by their authors, and by particular words in the

chapters that seemed to me to crave an "us." The accounts I read didn't seem to try to conclude but rather to pry open. Certain words and phrases seemed to create an openness or an opening that allowed readers to position themselves within the space of the account, but they were not firstly the words that in themselves contained pictures, scenes, or settings. The passages that struck me in the texts were those that suggested connection as directedness—as propulsion or rejection, as tension and need, as solidity, or attachment.

I pulled these words from the accounts and assembled them, roughly, into the extracts that you'll find on the back of each drawing throughout. I say "roughly" because in these extracts—or "drawn out" poems—I haven't changed the words at all, and so they appear as a sort of disjointed grammar, dodging closure, perhaps, and leaving the words ajar.

I'll give an example: in her chapter, Lone Grøn tells us how the transcript of a conversation with Henry doesn't fully convey the connection they had when they spoke. She writes: "It feels like a genuine conversation, like a meeting between us is taking place."

From this passage, I extracted just these words: "meeting between . . . taking place," because they position us and put us in relation, rather than conjuring up a picture in front of us. The preposition *between* becomes central, and the extraction of *taking place* suggests that this phrase might mean more than just *happening*. Perhaps the *taking place* of the conversation with Henry is a much more urgent *grasping* or *claiming of the space* between them.

The words I took from the poems, then, are ones that seem to me to position us in situations of spatial tensions where fragility of body and self makes the question of our connection to others a fraught but essential one. Through those words I have approached each account and its drawing as a struggle for a part in our continuing becoming "us." How might the eight situations, in their own ways, be considered a demand for an existence and a presence that is still not there in its entirety, still not delineated, still not finished, still not complete? How do we insist on our difference? How do we resist indifference?

Perhaps the drawings in this book are traces of a desire to form (or perform) our connection. The directedness of the figures, toward or against others, in this sense, is our disconnection made visible (even as these traces are rubbed out and drawn over).

In the end, then, a drawing is simply evidence of an effort to move between form and limitlessness and to move still closer to "us," and all along its meaning—certainly for me as the maker, but I would like to suggest for the audience as well—exists in our action toward it.

REFERENCES

Berger, John. 2008. *Ways of Seeing*. London: Penguin Books.
Blanchot, Maurice. 1989. *The Space of Literature*. Lincoln: University of Nebraska Press.
Didi-Huberman, Georges. 2015. *The Cube and the Face: Around a Sculpture by Alberto Giacometti*. Zurich: Diaphanes.
Kollwitz, Hans, ed. 1988. *The Diary and Letters of Kaethe Kollwitz*. Translated by Richard and Clara Winston. Evanston, IL: Northwestern University Press.
Levinas, Emmanuel. 1989. *The Levinas Reader*. 1989. Edited by Seán Hand. Oxford: Blackwell.
———. 1996. *Basic Philosophical Writings*. Edited by R. Bernasconi, S. Critchley, and A. T. Peperzak. Bloomington: Indiana University Press.
Nancy, Jean-Luc. 2005. *The Ground of the Image*. New York: Fordham University Press. Kindle.
———. 2008. *Corpus*. New York: Fordham University Press. Kindle.
Wiesinger, Véronique, ed. 2012. *Alberto Giacometti: A Retrospective*. Barcelona: Ediciones Poligrafa.

AFTERWORD

These Images Burn

ROBERT DESJARLAIS

A clan leader from a village in the Ik mountains of northeast Uganda takes a pinch of tobacco from the small plastic tobacco container strapped around his neck and passes it through the porous walls of a decaying house into the waiting hand of a neighbor; through this act of sharing, the elder's dignity suddenly appears to re-inhabit his body.

An elderly woman, living in absence in a cluttered, memory-strewn apartment in Kyrgyzstan, dreams of building a beautiful house for newlywed couples to inhabit during the first forty days of their marriages.

A woman living in a dementia ward in Denmark traces her finger four times around the edges of an orange napkin on which she has placed a bright pink hair band, as her interlocutor looks on.

A man is found, seemingly unconscious, on the cement floor of a small brick house on the outskirts of a trading center in eastern Uganda.

An elderly Tibetan woman living in the Tibetan exile community in Dharamsala, India, animatedly watches the Indian television show *Crime Patrol*, shouting with desperation "Go, go, go!" to an Indian girl seen fleeing her kidnapper.

An elderly man residing in a dementia ward looks at himself in a mirror and apparently sees the regard of another man, looking back at him. In another moment, this man seems to be cursing at the mirror man.

A Danish man, after falling backward down a flight of stairs at his two-story town house, seriously damaging his abdomen, becomes wary of staircases, for fear of falling again.

In Los Angeles, a grandmother lies down at night in the bed where her grandson, who has cerebral palsy, is falling to sleep, rubbing noses with him, bringing her face close to his, letting him know that she is right there with him, in the joy and comfort of familial care.

While an artist based in Sydney, Australia, strives to give figurative expression to these and other intensive moments through acts of drawing that feel like "an awkward lunge into paper."

Each of these moments, evident in the chapters of this fine collection on imagistic care and aging, conveys singular intensities of image and experience within diverse worlds of possibility in life. They are brief instances in life—of a life, or two—that convey, in tender, poignant ways, circumstances of aging, fragility, relationality, and continued vitality. They are images, of a kind, and powerful ones at that, within texts that are deeply imagistic in concept and conveyance.

In their sudden appearance in charged social moments—and in the fluid prose of ethnographic, philosophic writing—the images apparent in this volume bring to mind the "fireflies" of which Georges Didi-Huberman writes in his 2009 book *Survivance des lucioles*, translated into English as *Survival of the Fireflies*. In this brief, mesmerizing work, the art historian reflects on Pier Paolo Pasolini's fascination with fireflies, which the Italian filmmaker likened to fleeting glimmers of image, creativity, and human expression, erratic *luciole* instances that were disappearing with the advent of stronger, more consistent, more devastating forms of light, optics, and surveillance in European societies; in nights and days to come "there will only be signs, singularities, fragments—brief, weakly luminous flashes" (Didi-Huberman 2008, 19). For Didi-Huberman, fireflies are like images, and images, like fireflies: "the image is characterized by its intermittence, its fragility, its pulse of appearance and disappearance, of reappearances and redisappearances without end" (2018, 43). And again: "In its fragility, in its firefly intermittence, doesn't the image take on this very power each time it shows its ability to reappear, to *survive*?" (2018, 67).

The chapters of this volume contain many instances of such "firefly images" (2018, 84), intermittent pulses of appearance and disappearance within the uneven textures of lives—flashes of light and life within the densities of

anthropological and philosophical discourses. And with this, there are moments in which, as Didi-Huberman poetically envisions, and Pasolini's literature and cinematographic and political work so powerfully expresses, "human beings become fireflies—luminescent beings, dancing, erratic, elusive, and *resistant* as they are—before our amazed eyes" (2018, 8).

This is one way, at least, to trace the imagistic presences and absences of the human beings known in this volume as Komol, Tajinisa, Ellen, Janus, Musa, Ben, Mola Tsering Wangmo, and Gigi, Camille, and Nicholas, among others, each with their own ineluctable singularities, each caught up in complex circumstances of life, patterned by intricate arrangements of bodies, consciousness, time, power, relationality, alterity, cultural sensibilities, and institutional matrices. Luminescent beings dance through the pages of this work, erratically, elusively, obscurely so; intermittent figures that move in ways resistant to constraints of time, reality, or isolation; brief flashes that illumine the spirit of a life, in joy, regret, anger, sadness, or connection.

Firefly images, then. Such intermittently luminous beings appear and disappear at times within acoustic registers, through statements uttered and heard.

"Nobody takes care of you; you have to take care of yourself."

"I am very scared of walking on stairs."

"Well, that is better, don't you think? Yeah . . . Yeah. It has to be like that."

"Do not leave me!"

"He shouts, 'Noooo,' 'I am afraid,' 'I am homeless.' It is pretty intense."

"You do know that Søren Peter has died, don't you?"

"Remember how Komol was the elder of ideas, who knew about Ik history. Remember how people used to come to consult him."

"He is a human like anyone else."

These voicings consist of *speech-images* as much they involve any kind of direct or indirect speech-acts.

Through these and other lines of attentive listening, the authors of this volume get at key concepts and insights within the philosophy and anthropology of images and imagistic knowing and becoming. From incisive explorations of "imagistic concepts" to endeavors in "imagistic knowing," the writings open up thought to diverse ways of knowing and thinking about images and imagistic care, be it within the realms of aging, dementia, or life and death more generally.

"The image: a unique, precious apparition, even though it is such a very small thing, a thing that burns, a thing that falls," writes Didi-Huberman in *Survival of the Fireflies* (2018, 63). The idea that an image is something that "burns" (*brûle*) is one that appears, sporadically, in this art historian's writings on images. In an essay published in 2007 titled "Emotion Does Not Say 'I': Ten Fragments on Aesthetic Expression," one of the fragments is titled "The Image Is Burning" (*L'image brûle*).[1] The first two paragraphs read in part:

> The image invented by the artist is of course something other than a simple section cut out from the world of visible appearances. It is an imprint, a groove, a visual trail of the time it wanted to affect, but also of the other times—inevitably all anachronous and heterogeneous—that as an art of memory it cannot fail to stick on. It is the mixed-up ashes, hot or less hot, from several fires.
>
> Therefore in this respect *the image is burning*. It is burning with the *reality* it has at one moment drawn near to (as people say when playing hunt the thimble, "you're burning," to suggest "you're almost touching the hidden object"). It is burning with the *desire* that animates it, the intentionality that structures it, the enunciation, indeed the urgency it demonstrates (as people say "I'm burning with desire for you" or "I'm burning with impatience"). . . . It is burning with the *pain* from which it comes and will cause to anyone who takes the time to become attached to it. Finally the image is burning with the *memory*, i.e. of the fact that it is still burning, even when it is only ashes: a way of expressing its crucial vocation for survival, against all odds. (Didi-Huberman 2007, 63)

For Didi-Huberman, an image burns with the traces of its making and the histories that contribute to its conception and significances. An image is burning with the desires that disseminate from its imagery. An image burns with destruction and glow and any trace of suffering embroiled with it.

Many of the images searing through the pages of the present volume similarly burn. They burn with motifs of aging, of a slow decline in a person's life or a sudden disaster, illness, injury, loss, death. They are burning with concerns about frailty, weakness, impairment; with fears of debility or dementia—and intimations of dementia, sudden, stark ghosts of absent self and memory. They burn with concerns of increased dependency on others, and of complex weaves of interdependency, including within the "demen-

tia socialities" found within dementia wards in northern Europe. The images burn with the span of generations and inheritance and the emergences of time. They burn with the appearance of ontological breakdown and the scary possibility of breakdown and rupture in any given life. They burn with the fragility of bodies and selves, as well as the continued strength and vitality and potential in a life, even if that vitality and potential come to be largely imaginative in nature.

The images are burning with time. They burn with the multiple, interlacing temporalities constituting an aging life, and with the many histories that course through a life and relationalities in life more generally. The images burn with open-ended potentialities, in this moment or that. They burn with the actualities and constraints and driving force of institutional time—including the track of an "institutional aging process." They burn with the complexities of care in multistranded flows of time—"care paths" that are not a unidirectional flow, but more like a meandering path.

The images burn with alterities of aging, and with alterity more generally. Marked otherwise are gaps in understanding, displacements, otherness in self and other; obscurities and minute interruptions of everyday life; awkward, uncomfortable moments; moments of dislike or displeasure; loud voices, gruff demeanors; incomprehensible actions, unfathomable lifeworlds. All this feeds into the vital charges of everyday life: "The minute interruptions of everyday life are what keeps the world open and dynamic: there are interruptions teeming in the hustle and bustle of daily living, stirring in the most intimate of relationships and vibrating in the minutiae of life's still modes" (Dyring, this volume). The images point to encounters with the "alien Other" and the affective and epistemological challenges of such encounters: "When I look into his face, I think, with some apprehension, How will I ever get to know this man?" (Wentzer, this volume); "the deeply haunting and unsettling alterity that inhabits the dementia ward" (Grøn, this volume). Also noted are the alterities of selfhood that aging can bring: "He is not able to see the hole in his stomach directly, so he needs a big mirror to allow him to see what he is doing" (Wentzer). With such markings of alterity, the authors keep in mind the need to write and imagine and craft images in ways that do not lose the sting of alterity in weaving cohering thought and language around moments of alterity, difference, otherness. The non-mandate, here: stay clear of any kind of "all-encompassing ordering principle" (Dyring) and trace, instead, within the abysses of anarchic alterity,

a radical nonreferential kind of alterity at the fringes of any social or psychological or ontological order.

The images are burning with an ethics of care, of the challenges and responsibilities that come with living and becoming amid others. They burn with the intimation of the ethical demands placed on us, and others, especially in moments of hardship or suffering. They burn with moments of care, attentiveness, intercorporeal responsibility, ethical regard or disregard. They sear with instances of co-presence or non-presence, anti-presence. They burn with the intricate latticework of care invested in many lives: "Care is composite; it has multiple elements and involves many people" (Whyte); "a mobile network of carers pushing and dragging all at once" (Mattingly). The imaginaries of these essays burn with the compositional, contingent, ever-shifting dynamics of such care, or presumptions and expectations or denials of care. They burn with the gist and substrates of relationality; the "always *still becoming* 'we'" (Speyer) that spirals through our lives.

The images burn with the white heat of fantasy, of imaginations and re-imaginings of self and other, imaginative potentialities, and phantasmal dimensions of life, death, subjectivity, and intersubjectivity. The images hold, within their searing imaginal forms, the play of the actual and the virtual, presence and absence, within lifeworlds that hold not just the actualities of books and lunchtime conversations and medicine bottles but also apparitions, ghosts, and specters, broods of spectral images. A veritable forcefield of spectrality and apparitional forms runs through many situations of aging, dementia, and dying. Certain persons become "hinged" with ancestor spirits. The lives of others might become more "imagistic" in time, within realms of solitude and aloneness and fecund spaces of fabulation that work to sustain a moral world. Others might be haunted by elements of the past, future, or present ("these unrelenting specters live on" [Mattingly]; "his nightmares and the ghosts that haunt him" [Wentzer]). There is the specter of a vanishing person. Beyond the spectral intimacies of a lifeworld there are the hauntologics of the media, wherein spooky, unsettling images of dementia and debility circulate and carry the unlivening potential of fixing people in images. Within families and or communities one finds images of neglect, or salvation, with these images forever "subject to revision." Institutions, too, have their own ghost images to offer: "You do not leave this place, some say, unless in a coffin" (Grøn). Images can haunt, indeed. Aging implies a phantasmatics of life and death—a biophantasmatics, if you

will. Biophantasmatics, the phantasmal flows and currents of life, can be taken as a counterpart to biopolitics, the field of biopower, politics of life itself. The phantasmal is as much a part of life and death as power is and the phantasmal reach of power. For good reasons, the authors of several of the chapters in this volume take "imagistic steps into the realms of the invisible, the spectral, and the possible" (Louw). With all this, one risks becoming haunted by the reality of aging, and at times one looks away. "Something very real, and very disturbing, haunts us and we all . . . respond in the ways we can" (Grøn).

The images invested in the essays—and the essays as a whole—burn with a certain kind of singularity. They burn with particulars, interruptive intimacy, moments of transcendence, and "singular otherness." From the "imagistic signatures" conveyed by residents of a dementia ward (Grøn), to acute moments of alterity noticed in passing moments (Dyring), to imaginal-moral moments when a person might gain in singularity (Gill), the authors respond to the others encountered in their research studies within the grounds of singularity, and not, simply, within categories of difference, such as old age or physical debility. "The figure, the other, is precisely the different and the particular" (Speyer). Each essay carries its own imagistic signature.

The images here burn with tenderness. There are tender moments of care, presence, and co-presence, including the tender care and attentiveness of the researchers who have authored the essays here. A certain kind of "tender empiricism" (Goethe's *zarte Empirie*) marks the occasion of these writings. "An analytics of the modest, the close-at-hand" (Mattingly). Such ethnographic tenderness is within the orbit of a possible anthropology in the contemporary world.

The images are burning with the glow and ember of life. This is life in all its complexities, constraints, and possibilities, perplexities, challenges, difficulties, hopes, and aspirations, interruptive potentialities, and those sweet tender moments that can mark a passage in time. Still life, at times. Molten life, at others; obscure life. The images burn with the tracework of actions toward life and toward others. They burn with the fire of life-death.

"But in order to know this," Didi-Huberman notes in the concluding paragraph of his fragment on *l'image brûle*, "in order to feel it, it is necessary to dare, it is necessary to put one's face close to the ashes. And blow gently on them so that the embers underneath begin to emit their heat, their

glow, their danger. As if a voice rose from the gray image saying: 'Can't you see I'm burning?'" (2007, 63).[2]

The authors of this volume see that the images are burning. They dare, in effect, to come close to the ashes of aging and care and blow gently on them, until the embers emit their heat, their glow, their danger.

With the charcoal drawings that limn each chapter Maria Speyer gives striking figurative image to the lives and relations involved. The artist Francis Bacon once remarked, "It is a very, very close and difficult thing to know why some paint comes across directly onto the nervous system and other paint tells you the story in a long diatribe through the brain" (Sylvester 1975, 18). The same could be said of the charcoal of line drawings. Speyer's drawings come directly into the nervous system. Each drawing is an intensity of line, trace, and affect; dense forms emergent, or trapped, possibly, caught up, spectered, and this within "continual movement." Born of an intricate creative process, of unfinished acts of drawing and erasure of lines and subsequent redrawing and re-erasures, trying again, and again, until what is left behind is "a sort of a trace of a reaching," the drawings lead us to move toward them and sense the forms of life held within expanses of deep figuration. The "drawn out" poems that accompany each of the drawings intimate words that radiate as crystallized emanations of the energies within a drawing; or, the lines of the poem correlate, indirectly, with the lines traced and erased in a drawing; both drawing and poem carry open-ended, graphic resonances of human forms, and the figure of the human in *statu nascendi*, the "we" in an uncertain, volatile, ongoing process.

In "The Drawing Underneath," Speyer writes insightfully of the ways in which our position in front of one of her drawings "might tell us about care and connection, about solitude and communion, about responsibility and action." In approaching one of the drawings, we step into the space of an ethical relation, indicative of relations to others in life and the many imaginal, spectral, ethical forms that such relations carry. To be noted here as well are the ways in which Speyer's drawings—and, tellingly, the processes involved in making such intensive art, smudges and erasures and all—reach toward processes involved in many lives. A life, like a drawing, "starts as an unsettling confusion, progresses toward a resolution, but never arrives at it." "Until the moment I stopped working on them, they were something that might be otherwise. They were not yet contained and had all at once many possible trajectories. . . . They were limitless—infinite, even."

Like one of the artist's drawings, a life, too, can be ever-emergent, bound-less, propelled toward something other, containing many possible trajectories, *still more, still not finished*, until the moment the work is stopped. Continuing on, others might have a close look at the porous and still possible drawing underneath.

Can't you see that we are burning?

NOTES

1. Didi-Huberman's essay, for an edited volume on the political art of Alfredo Jaar, appears in both English and French texts, placed side by side on each page of the essay. The French phrase "*l'image brûle*" can be effectively translated into English as either "the image is burning" or "the image burns."

2. Didi-Huberman is alluding here to a passage in Sigmund Freud's *The Interpretation of Dreams*, in which Freud relates a dream related to him by a patient, who herself had heard mention of the dream at a public lecture on dreams. The dream narrated is that of a father whose child, who had just died, asks him reproachfully: "Father, can't you see that I am burning?" The child's corpse was in fact burning because of a candle that had fallen in the room adjacent to where the father was dreaming (see Freud 1999, 330).

REFERENCES

Didi-Huberman, Georges. 2007. "Emotion Does Not Say 'I': Ten Fragments on Aesthetic Freedom." In *Alfredo Jaar: La politique des images*, edited by Nicole Schweizer, 57–69. Zurich: JRP/Ringier.

———. 2008. *Survivance des lucioles*. Paris: Éditions du Minuit.

———. 2018. *Survival of the Fireflies*. Translated by Lia Swope Mitchell. Minneapolis: University of Minnesota Press.

Freud, Sigmund. 1999 [1899]. *The Interpretation of Dreams*. Oxford: Oxford University Press.

Sylvester, David. 1975. *Interviews with Francis Bacon*. London: Thames and Hudson.

CONTRIBUTORS

Robert Desjarlais is Professor of Anthropology at Sarah Lawrence College. He is the author of several books, including *Subject to Death: Life and Loss in a Buddhist World* (University of California Press, 2016); *The Blind Man: A Phantasmography* (Fordham University Press, 2019); and *Traces of Violence: Writings on the Disaster in Paris, France* (University of California Press, 2022; coauthored with Khalil Habrih).

Rasmus Dyring is Associate Professor of Philosophy at Aarhus University. Among Dyring's works are "From Moral Facts to Human Finitude: On the Problem of Freedom in the Anthropology of Ethics" (*HAU*, 2018); "The Futures of 'Us': A Critical Phenomenology of the Aporias of Ethical Community in the Anthropocene" (*Philosophy and Social Criticism*, 2021); and "Ellen and the Little One: A Critical Phenomenology of Potentiality in Life with Dementia" (coauthored with Lone Grøn, *Anthropological Theory*, 2022).

Harmandeep Kaur Gill is the recipient of the Carlsberg Foundation Visiting Postdoctoral Fellowship at University of Oxford (2022–24). Gill works with Tibetans living in exile in India and Nepal. Her PhD dissertation (2020), "Things Fall Apart: Coming to Terms with Old Age, Solitude, and Death among Elderly Tibetans in Exile," explored experiences of old age and attitudes toward death and rebirth among elderly Tibetans.

Lone Grøn is Professor (WSR) at VIVE—The Danish Center for Social Science Research. She has published numerous articles and book chapters on the lived experience of chronic illness, obesity, kinship, aging, and dementia in

Denmark, including several coedited volumes of journal special issues: "Contagious Kinship Connections" (Grøn and Meinert 2020, *Ethnos*); "Social Contagion and Cultural Epidemics: Phenomenological Perspectives" (Meinert and Grøn 2017, *Ethos*); and "Moral (and Other) Laboratories" (Grøn and Kuan 2017, *Culture, Medicine and Psychiatry*).

Maria Louw is Associate Professor at the Department of Anthropology, Aarhus University. She is the author of *Everyday Islam in Post-Soviet Central Asia* (Routledge, 2007) and coeditor, with Cheryl Mattingly, Rasmus Dyring, and Thomas Schwarz Wentzer, of *Moral Engines: Exploring the Ethical Drives in Human Life* (Berghahn, 2018), as well as author of numerous articles and book chapters dealing with religion, secularism, atheism, morality, ethics, and care in Central Asia.

Cheryl Mattingly is Professor, Department of Anthropology, University of Southern California. She is an award-winning author and coeditor of multiple books, journal special issues, and articles on chronic illness, disability, and ethics from phenomenological perspectives. Single-authored books include *Healing Dramas and Clinical Plots: The Narrative Structure of Experience* (Cambridge, 1998); *The Paradox of Hope* (University of California Press, 2010); and *Moral Laboratories: Family Peril and the Struggle for a Good Life* (University of California Press, 2014). Coedited collections include *Moral Engines: Exploring the Ethical Drives in Human Life* (Berghahn, 2018); "Toward a New Humanism: An Approach from Philosophical Anthropology" (*HAU*, 2018); and *Narrative and the Cultural Construction of Illness and Healing* (University of California Press, 2000).

Lotte Meinert is Professor of Anthropology at Aarhus University. She is the author of *Hopes in Friction: Schooling, Health, and Everyday Life in Uganda* (Information Age, 2009) and the coeditor of *In the Event: The Anthropology of Generic Moments* (Berghahn, 2015); *Ethnographies of Youth and Temporality: Time Objectified* (Temple University Press, 2014); *Time Work: Studies of Temporal Agency* (Berghahn, 2020); *Bio-Social Worlds: Anthropology of Health Environments beyond Determinism* (UCL Press, 2020); and *Configuring Contagion: Ethnographies of Biosocial Epidemics* (Berghahn, 2021).

Maria Speyer is a visual artist represented by Galleri Stokkebro, Denmark. She has illustrated picture books for Høst & Søn and Turbine, Denmark. Her most recent picture book, *A Feather on A Wing* (University of Queensland Press, 2022), seeks to alleviate feelings of disconnection and loneliness by exploring metaphors that speak of the singular and the collective.

Lisa Stevenson is Associate Professor and William Dawson Scholar in the Department of Anthropology at McGill University and author of *Life beside Itself: Imagining Care in the Canadian Arctic* (University of California Press, 2014). Her recent work (e.g., "Looking Away" [*Cultural Anthropology* 2020]) focuses on what it means to think in images. As an anthropologist she has attempted to trace and describe such imagistic forms of thought in the everyday worlds of people in situations of violence—among the Inuit in the Canadian Arctic and among Colombian refugees in Ecuador.

Helle Sofie Wentzer is Senior Researcher at VIVE—The Danish Center for Social Science Research. She has written numerous book chapters and articles on health care interaction, communication, and technology, including "Technology in Context: Vulnerability in Surgery" in *Context in Action and How to Study It* (Oxford University Press, 2019). She is currently writing the monograph (in Danish) *A Safe Meeting—Reorganizing Outpatient Clinics for Covid-19* (VIVE), and contributing to the book *Interdisciplinary and Cross-sectorial Collaboration in Nursing* (Danish), ed. Ditte Høgsgaard (FADL), with the chapter "Complexity and Entirety in the Care Pathways of Patient-Citizens."

Susan Reynolds Whyte is Professor at the Department of Anthropology, University of Copenhagen. She carries out research in East Africa on social efforts to secure well-being in the face of poverty, ill health, conflict, and rapid change. Among other works, she has authored or edited *Disability and Culture* (University of California Press, 1995); *Questioning Misfortune: The Pragmatics of Uncertainty in Eastern Uganda* (Cambridge University Press, 1997); *Social Lives of Medicine* (Cambridge University Press, 2002); *Disability in Local and Global Worlds* (University of California Press, 2007); and *Second Chances: Surviving AIDS in Uganda* (Duke University Press, 2014).

INDEX

intimate others: troubling, in old age, 14–17; virtuous aging in absence of, 63–65
Irving, Andrew, 173
Islam, 62, 188, 189, 200
isolation, 71–72, 222, 236, 247

Jackson, Michael, 130n6, 148
James, William, 2

Kahn, R., 12, 87
Katz, S., 12,
Keats, John, 2
kinship, 34, 36–37, 192, 198, 201
Kleinman, Arthur, 67
Kohn, Eduardo, 130n3
Kollwitz, Käthe, 246–47
Kondo, D., 10
Kyrgyzstan, 62–63, 70, 71, 74, 76n2

Laidlaw, James, 111
Lamb, S., 12, 87
Lambek, Michael, 8, 199
Levinas, Emmanuel, 19–20, 69, 166, 173, 174–75, 179, 209, 213, 214, 219–20, 222, 225n1, 230, 233
Life . . . Still (Speyer), 107, 108, 240
lifeworld, 6–10, 21, 85, 100, 116, 123, 126, 138, 145, 148, 192, 211, 216, 255, 256
Lock, Margaret, 86–87
logos, 110
Løgstrup, Knud E., 152, 166, 174–75, 179

MacDougall, D., 3
Mattingly, Cheryl, 31–52
Merleau-Ponty, Maurice, vii, viii, viii–ix, xiii, xiv–n2, 111, 126, 130n2
Moesgaard Museum (MOMU), 11

Nancy, Jean-Luc, 235, 236, 246
natality, 35, 43–49, 51, 52, 54n10, 129, 131n7

Nkrumah, Kwame, 144
Nyerere, Julius, 144
Nyholm, Tove, 11

O'Byrne, Anne, 54n10

Pandian, A., 2, 3, 22, 60, 83, 84, 94, 100
personhood, 64, 88, 100, 129, 147, 174, 243
phantasmography, 9–10
phenomenology: critical, 20, 21, 49, 50–52, 71, 115–19, 142, 147; responsive, 38, 43, 85, 86, 89–90; transcendental, 116
poststructuralism, 113
Pound, Ezra, 4
precarity, 8, 32, 34–35, 38
pronouns, 189–90
Puig de la Bellacasa, Maria, 67

racism, 12, 46, 48
referentiality, 98, 113–14, 115, 256
relationality, 15, 16, 20, 41, 71, 138, 141, 142–45, 147–49, 152, 155, 156, 157n6, 174, 252, 253, 256
resonance images, 1, 2, 112, 119–20
Robbins, J., 18, 64, 68
Rowe, J., 12, 87

Schutz, Alfred, 4, 6–7, 8, 35, 190, 191
selfhood, 39, 64, 69, 123, 174, 255
sharing, 145–47, 157n1
signatures, imagistic, 89–90, 91–94, 99
Singh, B. 8, 22, 52
solitary confinement, 16, 71, 126, 148, 152
solitude, 16, 71–72, 148, 152, 235, 236, 237, 256, 258
South Africa, 144
Speyer, Maria, 10, 11, 29, 30, 57, 58, 81, 82, 84–85, 107, 108, 135, 136, 161, 162, 185, 186, 207, 208, 227, 228, 231, 234, 238, 240, 242, 244, 245, 258